LECTURES ON ART AND POEMS, AND MONALDI

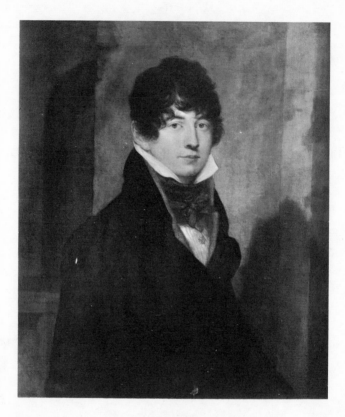

SELF PORTRAIT, 1805

Courtesy of the Museum of Fine Arts, Boston

LECTURES ON ART AND POEMS,

(1850)

AND

MONALDI

(1841)

BY

WASHINGTON ALLSTON

FACSIMILE REPRODUCTIONS
INCLUDING EIGHT PAINTINGS
WITH AN INTRODUCTION

BY

NATHALIA WRIGHT

Two Volumes in One

GAINESVILLE, FLORIDA
SCHOLARS' FACSIMILES & REPRINTS
1967

SCHOLARS' FACSIMILES & REPRINTS
1605 N.W. 14TH AVENUE
GAINESVILLE, FLORIDA, 32601, U.S.A.
HARRY R. WARFEL, GENERAL EDITOR

L.C. CATALOG CARD NUMBER: 67-10124

MANUFACTURED IN THE U.S.A.

INTRODUCTION

In the history of American arts and letters Washington Allston (1779-1843) occupies a unique position as both artist and writer. Many other artists—Thomas Cole, Rembrandt Peale, Horatio Greenough, William Page, and W. W. Story, for example—have written for publication, and several writers—among them Washington Irving, E. E. Cummings, John Dos Passos, William Carlos Williams, and Sherwood Anderson—have drawn or painted. Allston's achievement in both areas, however, is without parallel.

The first important American painter to emerge after the Revolution, Allston went beyond portraiture, to which most of his predecessors were limited, into landscape and dramatic scenes. In the latter, his subjects typically verged on the supernatural and much of his inspiration was literary, as may be seen in such works as *The Dead Man Revived by Touching the Bones of the Prophet Elisha, The Angel Releasing St. Peter from Prison,* the unfinished *Belshazzar's Feast, The Flight of Florimel* (from *The Faerie Queene), Uriel in the Sun* (from *Paradise Lost),* and the unfinished *Death of King John* (from Shakespeare's *King John).*

The chief characteristic of Allston's painting, however, is its subjectivity. He was the first American painter to transcend external forms and project the visions within his own mind. His landscapes, on the whole his most successful works, are in effect reveries

on nature, the figures in them appearing as dreamers. Such are his several European and American landscapes, *Lorenzo and Jessica, The Evening Hymn,* and the sea-scapes *Rising of a Thunderstorm at Sea* and *Ship in a Squall.* Most of the European ones were in fact painted from memory, long after he had left the scene. Even his portraits have this dream-like character, without accessory objects as they are and seeming to probe the inner life of the subject. Those of Coleridge, W. E. Channing, and himself are particularly notable.

Allston's writings are contained in three separately published volumes: *The Sylphs of the Seasons, and Other Poems* (1813), the Gothic romance *Monaldi* (1841), and *Lectures on Art, and Poems* (1850). The last incorporates the contents of the first volume and includes other poems, a collection of aphorisms, and the Gothic tale or sketch "The Hypochondriac." Varied as all these writings are, they have a distinctly homogeneous character, and they form a kind of literary counterpart of his painting.

Most of Allston's poems and pieces of fiction are minor in aim and achievement and obviously indebted to the Romantic tradition. When all of them are considered as one body of writing, however, it is seen, significantly, to be pervaded by a single theme and dominated by one character type: the theme of an interior life, independent of nature and of society, and the character of a dreamer or an artist whose works embody what are essentially his own visions or memories. The mind or soul of man is the main concern of several poems: the rather conventional "Man" and "Fragment" ("Who knows himself must needs in prophecy"); the orthodox "The Atonement" and "Immortality"; "Gloria Mundi," with its typically mystical picture of the negative nature of the soul's experience; and the sonnet "Thought," which is more Allstonian in its repeated question:

What master-voice shall from the dim profound
Of Thought evoke its fearful, mighty Powers?
 ... Ay, who to sense
Shall bring them forth?—those subtle
 Powers that wear
No shape their own, yet to the mind dispense
All shapes that be.

A few other poems are typically transcental in
their picture of nature taking its life from the human
spirit. Even spring cannot bring hope and joy to the
miserable man, the poet declares in "Written in
Spring":

For all that seems in this fair world to live,
 To live to man, must catch the quickening ray
From man's free soul; and they but freely give
 Back unto him the life he gave; for they
Are dead to him who lives not unto them.

Esther in "The Betrothed" imparts the love in her
heart "to all around/To every form, to every sound."

The interior life is seen chiefly in Allston's poems,
however, as the experience of certain characters or
speakers, who have withdrawn from the physical scene
around them either in surrender to a new emotion or
in the exercise of memory or who as artists have pro-
duced works inspired by that life.

Two young girls—Ursulina in "The Tuscan Girl"
and Rosalie in the poem of that name—experience
the birth of a new consciousness in which earthly
scenes take on a supernal appearance, the first in the
process of passing from childhood into womanhood,
the second as she falls in love. Both poems, inci-
dentally, are matched by Allston paintings of the
same names, two of his "dreamer" portraits; the young
girl in the painting Rosalie, moreover, is the same as
the one in *The Evening Hymn*, one of his typical
landscapes.

Allston himself is a dreamer in several poems. In the complimentary "The Magic Slippers. To Mrs. S_____, on her presenting the writer a pair of crimson slippers wrought by herself," he fancies that he received the slippers from fairy boats in a spring beside which he lay musing.

In three other poems Allston recreates by memory scenes and experiences in his past. In "To my Sister. Lines suggested by the recollection of a little bird, carved by the writer, when six years old, out of a stalk of Indian corn, as a parting gift to his sister," he assures his sister that the toy still lives with him:

> The life imparted by the loving Boy
> Is truer life than now his Art can give:
> I see its emerald wing,
> Nay, almost hear it sing!
> And oft that little vegetable bird
> Shall flit between us when we part again;
> Its bright, perennial form shall skim the main,
> A silent sigh,—nor need an uttered word.

"The Calycanthus," inscribed to his mother, was written "on seeing this favorite flower of my childhood after an interval of many years." Looking at it, he seems to tread again the land and even dreams again the dreams of his childhood. Even then his "teeming mind / Had gifted with some wondrous story" all that he saw, making the oak, for instance, an ogre. The "dreamed-o'er dream" makes him exclaim:

> Deep mystery! that the Soul, as not content
> To see, to hear, should thus her own moods vent,—
> Living as 'twere in all that lives!

The third of these poems, in which Allston recollects experiences of his own young manhood in Italy, is "To the Author of "The Diary of an Ennuyée,' one of the truest and most beautiful books ever written

on Italy," namely Mrs. Anna Jameson. Again it is a
dream within a dream which he has, since Italy is
for him

> that vision clime,
> Which, having seen, no eye the second time
> May ever see in its own glorious truth;—
> As if it *were not,* in this world of strife,
> Save to the first deep consciousness of life.

Apparently Allston is also to be identified with
the central consciousness in "The Angel and the
Nightingale," which seems to be a fable of his artistic
career. Singled out for patronage by an Angel, the
nightingale sings beautifully for some time, partly on
this account:

> Nor knows the soul her own distinctive birth
> Till some deep inward joy from sense hath made
> her free.

She also enjoys widespread popularity. When at last
she loses her voice, she incurs the criticism of other
birds. (During Allston's later years, spent in America,
both his productivity and his fame were far less than
they were during his early years in England.) But
though her "celestial trance" is over, she is consoled
by the memory of it until she is at last transported
to the realm from which it came.

The supremely creative dreamers in Allston's
poems are, indeed, poets and artists. In "The Sylphs
of the Seasons, A Poet's Dream," the Poet is wooed in
a dream by the spirits of the four seasons. Though
he wakes before making his choice, winter clearly has
the most pressing claims. The other sylphs are able
only "Through mortal *sense* to reach the mind," she tells
him, but it was her "purer" power that ministered
to him

> unseen
> Unfelt, unheard, when every sense
> Did sleep in drowsy indolence,

And silence deep and night intense
 Enshrouded every scene;
That o'er thy teeming brain did raise
The spirits of departed days
 Through all the varying year,
And images of things remote,
And sounds that long had ceased to float,
With every hue, and every note,
 As living now they were. . . .

She finally implores him to turn

 To me, whose plastic powers combine
 The harvest of the mind;
 To me whose magic coffers bear
 The spoils of all the toiling year,
 That still in mental vision wear
 A lustre more refined.

Though no dreamer, the poet in the courtly "To a Lady, who spoke slightingly of poets" also has visionary powers. He is able to perceive not only fairy creatures playing about the lady's person but her soul or spirit as well.

In his poems dealing with historical artists and works of art Allston applies a single standard of judgment: the great works are representations of the artists' own inner experiences rather than of natural forms. Michelangelo gave birth

 To forms unseen to man, unknown to Earth.
 Now living habitants;

he responded to the touch of art "that brought to view / The invisible Idea"; in the *Last Judgment* he projected "the thought / Of space interminable." In Raphael's group of Abraham and the three angels
 embodied lives

 The subtile mystery, that speaking gives
 Itself resolved; the essences combined
 Of Motion ceaseless, Unity complete.

Tibaldi's painting of AEolus reveals that the painter
had "The gift of intercourse with worlds unknown,"
"held strange converse wuth the viewless wind," saw
"the Spirits, in embodied forms; / of gales and whirl-
winds, hurricanes and storms." Rembrandt's *Jacob's
Dream* is one of his "visionary scenes"

> That, like the rambling of an idiot's speech,
> No image giving of a thing on earth,
> Nor thought significant in Reason's reach,
> Yet in their random shadowings give birth
> To thoughts and things from other worlds that
> come,
> And fill the soul, and strike the reason dumb.

Bienaimé's angel is not "material Art,—/But e'en
the Sculptor's soul to sense unsealed." Greenough's
group *The Angel and Child is*

> that deep mystery,—for aye unknown,—
> The living presence of Another's mind.

> Another mind was there—the gift of few,—
> That by its own strong will can all that's true
> In its own nature unto others give,
> And, mingling life with life, seem there to live.

The tribute to Coleridge is paid to him as a conversa-
tionalist rather than as a poet, but in any case it is
to the profundity of his mind and imagination:

> And I no more
> Shall with thee gaze on that unfathomed deep,
> The Human Soul—as when, pushed off the shore,
> Thy mystic bark would through the darkness sweep,
> Itself the while so bright! For oft we seemed
> As on some starless sea,—all dark above,
> All dark below,—yet, onward as we drove,
> To plough up light that ever round us streamed.

The title character in Allston's Gothic romance *Monaldi* (which was written by 1822) is also an artist who draws his inspiration from his own inner life. Apparently passive and even vacant, he shuts out the external world in order "to combine and give another life to the images it had left in his memory; as if he would sleep to the real and be awake only to a world of shadows." To him "every object had a charm, and its harmony and beauty, its expression and character, all passed into his soul in all their varieties, while his quickening spirit brooded over them as over the elementary forms of a creation of his own." In his own painting he "infused the human emotion into the surrounding elements" yet with the result that it had to seem "unnatural . . . to him who *sees only with his eyes*."

Monaldi is further described as being a true successor to Raphael, who, he says, "speaks to the heart" and is an admirer of Michelangelo, whose figures seem to him to have been born in a "higher sphere." Another character deplores the current fashion to talk of the latter artist's "extravagance, of his want of truth, and *what not*—as if truth were only in what we have *seen!*"

In contrast to Monaldi is the poet Maldura, who lives "only in externals," cannot see "beyond the regions of discovered knowledge," and lacks the "realizing quality" that "gives the living principle to thought." He is only temporarily successful. Nevertheless Monaldi is destroyed by the machinations of Maldura and his accomplice Count Fialtro. In a typically Gothic sequence, Monaldi is persuaded that his wife is unfaithful to him, attempts to kill her, goes mad, and after some time dies, though in his right mind and reconciled with her. In terms of Allston's allegory, Maldura and Fialtro represent the influences of the world and of evil or sin, which are equally hostile to the pure interior life of the true artist.

As for the burlesque "The Hypochondriac," it is the confession of a man who, unable to satisfy an inordinate yet unidentifiable desire or want in a series of solitary studies and travels, at last becomes a happy member of a tavern coterie. His conclusion is that "the only natural mode . . . of preventing the mind preying on itself,—the only rational, because the only interminable employment,—is to be busy about other people's business."

Allston's most important prose literary compositions are his "Lectures on Art," the five essays and "Preliminary Note," substantially written in the 1830's, which are all that he finished of a projected complete statement of his theory of art. In themselves, nevertheless, they constitute a coherent treatise and one which has several distinctions. It is not only the first American art treatise, but the only one which combines actual creative experience and a clearly defined philosophical position. It is also the only treatise on art in English during the Romantic period which is based on the German idealist philosophy pervading the Romantic movement. In its conception of art as expression and communication, moreover, it anticipates developments in aesthetic theory in the present century.

In brief, Allston defined a work of art as the "form" in which an "Idea" of the artist is manifested, the "Idea" having been called into consciousness by an "objective correlative" or physical phenomenon having a "predetermined correspondence, or correlation" with it. Though he thus acknowledged a *"dual"* reality" —of the mind and the senses, "the actual and the ideal," he identified the ultimate power in the universe as intellectual or spiritual rather than physical. The mind of the artist is unquestionably the presiding force in the creative act as Allston described it, since the work of art finally produced does not correspond

to anything in nature. Its most distinctive character-
istic—by which it is to be verified as "the inward . . .
outwardly manifested"—is "Human or Poetic Truth,"
which he defined as "that which may be said to exist
in and for the mind, and as contradistinguished from
the truth of things in the natural or external world,"
yet which he conceded might simply be called *"inward
life."* The "intuitive power" whereby the artist creates
forms is, moreover, the same as the faculty by means
of which man has knowledge of a divinely created
world and of God himself. Finally, as an expression of
the artist's mind or inner life, the work of art, Allston
insisted, is addressed to this faculty or experience in
the spectator, whose response is properly "the life,
or truth within, answering to the life, or rather its
sign" before him.

Insofar as Allston's "lectures on Art" emphasize
the subjective element in the creation and the appre-
ciation of a work of art they presuppose the existence
of an interior life capable of projecting itself in its
own terms. His theory is thus peculiarly consonant
with his own painting and generally parallel with the
theme of many of his poems and of his fiction.

The most interesting characteristic of Allston's
essays in relation to these other products of his crea-
tive activity, however, is the recurring image of the
dreamer or a mind in reverie. In each of the essays
except the last a definition of the key concept is offered
by means of such an image. In the "Introductory Dis-
course," which proposes that the *"mental* pleasures"
such as art gives have their source in a single univer-
sal principle of Harmony whose several phases are
Beauty, Truth, and Holiness, he suggests that a re-
living in memory of one's youthful experiences would
restore one's faith in the unity of these phases or
Ideas: "we doubt not that the truest witness to the
common source of these inborn Ideas would readily

be acknowledged by all, could they return to it [their youth] now with their matured power of introspection, which is, at least, one of the few advantages of advancing years. But, though we cannot bring back youth, we may still recover much of its purer revelations of our nature from what has been left in the memory. From the dim present, then, we would appeal to that fresher time, ere the young spirit had shrunk from the overbearing pride of the understanding, and confidently ask, if the emotions we then felt from the Beautiful, the True, and the Good, did not seem in some way to refer to a common origin. And we would also ask, if it was then frequent that the influence from one was *singly* felt,—if it did not rather bring with it, however remotely, a sense of something, though widely differing, yet still akin to it. When we have basked in the beauty of a summer sunset, was there nothing in the sky that spoke to the soul of Truth and Goodness? And when the opening intellect first received the truth of the great law of gravitation, or felt itself mounting through the profound of space, to travel with the planets in their unerring rounds, did never then the kindred Ideas of Goodness and Beauty chime in, as it were, with the fabled music, —not fabled to the soul,—which led you on like one entranced? And again, when, in the passive quiet of your mortal nature, so predisposed in youth to all things genial, you have looked abroad on this marvellous, ever teeming Earth,—ever teeming alike for mind and body,—and have felt upon you flow, as from ten thousand springs of Goodness, Truth, and Beauty, ten thousand streams of innocent enjoyment; did you not then *almost hear* them shout in confluence, and almost *see* them gushing upwards, as if they would prove their unity, in one harmonious fountain?"

The second essay, "Art," attributes to its subject four characteristics—Originality, Human or Poetic

Truth, Invention, and Unity, of which the second is most important. In addition to analysing its operation in psychological terms, Allston dramatized its "human" character by describing the reverie of a poet lying in a field on a summer evening, among members of "the brute creation" but differing from them in his response to it: "What . . . can we suppose to be the effect of the purple haze of a summer sunset on the cows and sheep, or even on the more delicate inhabitants of the air? From what we know of their habits, we cannot suppose more than the mere physical enjoyment of its genial temperature. But how is it with the poet, whom we shall suppose an object in the same scene, stretched on the same bank with the ruminating cattle, and basking in the same light that flickers from the skimming birds. Does he feel nothing more than the genial warmth? Ask him, and he perhaps will say, —'This is my soul's hour; this purpled air the heart's atmosphere, melting by its breath the sealed fountains of love, which the cold commonplace of the world had frozen: I feel them gushing forth on every thing around me; and how worthy of love now appear to me these innocent animals, nay, these whispering leaves, that seem to kiss the passing air, and blush the while at their own fondness! Surely they are happy, and grateful too that they are so; for hark! how the little birds send up their song of praise! and see how the waving trees and waving grass, in mute accordance, keep time with the hymn!' This is but one of the thousand forms in which the human spirit is wont to effuse itself on the things without, making to the mind a new and fairer world,—even the shadowing of that which its immortal craving will sometimes dream of in the unknown future."

In the third essay, "Form," Allston repudiated the old, typically neo-classical and academic conception of a Standard or Ideal Form to guide painters

and sculptors of the human body, arguing that "the only efficient Rule must be found in the Artist's mind." Proceeding to consider the idea of a perfect human form, he proposed that a perfect physical exterior would be matched by a perfect moral interior and, further, that proof of such correspondence could be found in the experience of a "dreamer" and introspectionist: "In a . . . striking form may we find the evidence of the law [of the correspondence of physical and moral beauty] supposed, if we turn to the young, and especially to those of a poetic temperament,—to the sanguine, the open, and confiding, the creatures of impulse, who reason best when trusting only to the spontaneous suggestions of feeling. What is more common than implicit faith in their youthful daydreams,—a faith that lives, though dream after dream vanish into common air when the sorcerer Fact touches their eyes? And whence this pertinacious faith that *will* not die, but from a spring of life, that neither custom nor the dry understanding can destroy? Look at the same Youth at a more advanced age, when the refining intellect has mixed with his affections, adding thought and sentiment to every thing attractive, converting all things fair to things also of good report. Let us turn, at the same time, to one still more advanced,—even so far as to have entered into the conventional valley of dry bones,—one whom the world is preparing, by its daily practical lessons, to enlighten with unbelief. If we see them together, perhaps we shall hear the senior scoff at his younger companion as a poetic dreamer, as a hunter after phantoms that never were, nor could be, in nature: then may follow a homily on the virtues of experience, as the only security against disappointment. But there are some hearts that never suffer the mind to grow old. And such we may suppose that of the dreamer. If he is one, too, who is accustomed to look into himself,—

not as a reasoner,—but with an abiding faith in his
nature,—we shall, perhaps, hear him reply,—Experi-
ence, it is true, has often brought me disappointment;
yet I cannot distrust those dreams, as you call them,
bitterly as I have felt their passing off; for I feel
the truth of the source whence they come. They could
not have been so responded to by my living nature,
were they but phantoms; they could not have taken
such forms of truth, but from a possible ground."

In the conclusion of "Form" Allston urged young
artists, while finding the true Rule in their own minds,
to study the work of artists of the past, particularly
Raphael and Michelangelo, whom he designated "the
two great sovereigns of the two distinct empires of
Truth,—the Actual and the Imaginative." Of the sev-
eral works he cited by the latter artist, who was to him
the greatest, the meditative figure of Lorenzo dei Medici
is most notable: "The genius of Michael Angelo . . .
seems rarely to have been excited by the objects with
which we are daily familiar; and when he did treat
them, it was rather as things past, as they appear to
us through the atmosphere of the hallowing memory.
We have a striking instance of this in his statue of
Lorenzo de' Medici; where, retaining of the original
only enough to mark the individual and investing the
rest with an air of grandeur that should accord with
his actions, he has left to his country, not a mere effigy
of the person, but an embodiment of the mind; a por-
trait for posterity, in which the unborn might recognize
Lorenzo the Magnificent."

It might be added that several of Allston's descrip-
tions of his own responses to works of art in effect de-
pict him in a state of reverie or recollection, engrossed
in an interior experience. Of the *Farnese Hercules* he
wrote: "Perhaps the attempt to give form and substance
to a pure Idea was never so perfectly accomplished as
in this wonderful figure. Who has ever seen the ocean

in repose, in its awful sleep, that smooths it like glass, yet cannot level its unfathomed swell? So seems to us the repose of this tremendous personification of strength: the laboring eye heaves on its slumbering sea of muscles, and trembles like a skiff as it passes over them: but the silent intimations of the spirit beneath at length become audible; the startled imagination hears it in its rage, sees it in motion, and sees its resist-less might in the passive wrecks that follow the uproar. And this from a piece of marble, cold, immovable, life-less! Surely there is that in man, which the sense can-not reach, nor the plumb of the understanding sound." The *Apollo Belvedere* gave him a virtual vision: "In this supernal being, the human form seems to have been assumed as if to make visible the harmonious con-fluence of the pure ideas of grace, fleetness, and maj-esty; nor do we think it too fanciful to add celestial splendor; for such, in effect, are the thoughts which crowd, or rather rush, into the mind on first beholding it. Who that saw it in what may be called the place of its glory, the Gallery of Napoleon, ever thought of it as a man, much less as a statue; but did not feel rather as if the vision before him were of another world,—of one who had just lighted on the earth, and with a step so ethereal, that the next instant he would vault into the air? If I may be permitted to recall the impression which it made on myself, I know now that I could not better describe it than as a sudden intellectual flash, filling the whole mind with light,—and light in mo-tion. It seemed to the mind what the first sight of the sun is to the senses, as it emerges from the ocean; when from a point of light the whole orb at once appears to bound from the waters, and to dart its rays, as by a visible explosion, through the profound of space. But, as the deified Sun, how completely is the conception veri-fied in the thoughts that follow the effulgent original and its marble counterpart! Perennial youth, perennial

brightness follow them both. Who can imagine the old age of the sun? As soon may we think of an old Apollo." It was clearly his own experience of awakening from sleep which he reported when he declared of Michelangelo's *Aurora*: ". . . if there be but one in a thousand to whose mind it recalls the deep stillness of Night, gradually broken by the awakening stir of Day, with its myriad forms of life emerging into motion, while their lengthened shadows, undistinguished from their objects, seem to people the earth with gigantic beings; then the dim, gray monotony of color transforming them to stone, yet leaving them in motion, till the whole scene becomes awful and mysterious as with moving statues;—if there be but one in ten thousand who shall have thus imagined, as he stands before this embodied Dawn, then is it, for every purpose of feeling through the excited imagination, as true and real as if instinct with life, and possessing the mind by its living will."

Thus Allston belongs in the forefront, indeed at the very head of the whole company of American creative dreamers—writers as well as artists. Later artists like Page, Ryder, Vedder, Burchfield, and Andrew Wyeth have depicted the intangible reaches of landscapes, the thoughts and feelings of those whose portraits they painted, and unique figures of their own imaginations. Writers like Poe, Emerson, Hawthorne, Melville, James, and Faulkner have explored the dream world and the remembered past through their characters or speakers and have recorded their own transcendental visions. Only Allston, however, has left a comprehensive record of this type of art and artist, in his brooding canvases, in his poems of memories and dreams, and in his fictional and expository accounts of the creative mind.

NATHALIA WRIGHT

University of Tennessee
January 18, 1966

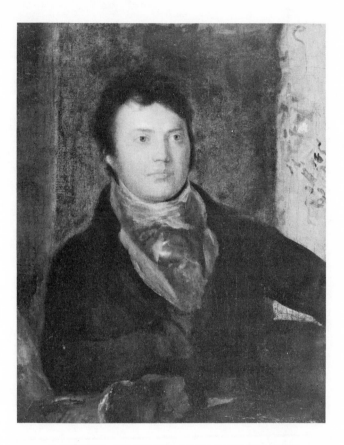

SAMUEL TAYLOR COLERIDGE, 1806

Courtesy of the Fogg Art Museum, Harvard University

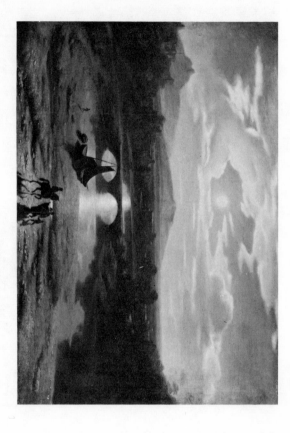

MOONLIGHT LANDSCAPE, 1819

Courtesy of the Museum of Fine Arts, Boston

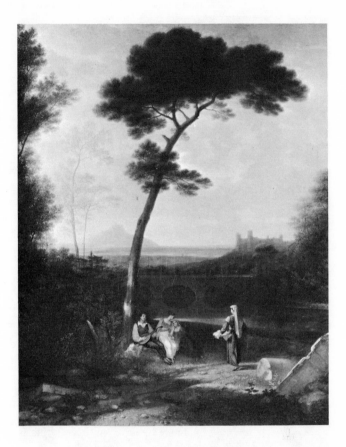

ITALIAN LANDSCAPE, c. 1830

Courtesy of the Detroit Institute of Arts

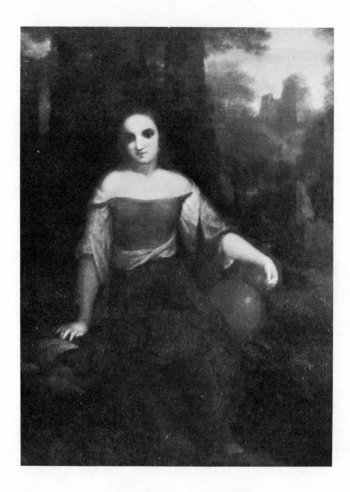

A TUSCAN GIRL, 1831

Courtesy of Mrs. J. J. Minot, Boston

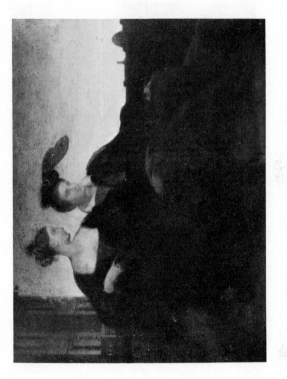

LORENZO AND JESSICA, 1832

Courtesy of Mr. John M. Cabot, Manchester, Massachusetts

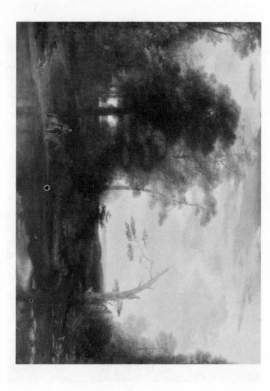

LANDSCAPE, AMERICAN SCENERY:
TIME, AFTERNOON, WITH A SOUTHWEST HAZE, 1835

Courtesy of the Museum of Fine Arts, Boston

LECTURES ON ART,

AND

POEMS,

BY

WASHINGTON ALLSTON.

EDITED

BY RICHARD HENRY DANA, JR.

NEW YORK:
BAKER AND SCRIBNER.
M DCCC L.

CAMBRIDGE.

STEREOTYPED BY METCALF AND COMPANY,

PRINTERS TO THE UNIVERSITY.

PREFACE BY THE EDITOR.

UPON the death of Mr. Allston, it was determined, by those who had charge of his papers, to prepare his biography and correspondence, and publish them with his writings in prose and verse; a work which would have occupied two volumes of about the same size with the present. A delay has unfortunately occurred in the preparation of the biography and correspondence; and, as there have been frequent calls for a publication of his poems, and of the Lectures on Art he is known to have written, it has been thought best to give them to the public in the present form, without awaiting the completion of the whole design. It may be understood, however, that, when the biography and correspondence are published, it will be in a volume precisely corresponding with the present, so as to carry out the original design.

I will not anticipate the duty of the biographer by an extended notice of the life of Mr. Allston; but it may be interesting to some readers to know the outline of his life, and the different circumstances under which the several pieces in this volume were written.

WASHINGTON ALLSTON was born at Charleston, in South Carolina, on the 5th of November, 1779, of a family distinguished in the history of that State and of the country, being a

branch of a family of the baronet rank in the titled commonalty of England. Like most young men of the South in his position at that period, he was sent to New England to receive his school and college education. His school days were passed at Newport, in Rhode Island, under the charge of Mr. Robert Rogers. He entered Harvard College in 1796, and graduated in 1800. While at school and college, he developed in a marked manner a love of nature, music, poetry, and painting. Endowed with senses capable of the nicest perceptions, and with a mental and moral constitution which tended always, with the certainty of a physical law, to the beautiful, the pure, and the sublime, he led what many might call an ideal life. Yet was he far from being a recluse, or from being disposed to an excess of introversion. On the contrary, he was a popular, high-spirited youth, almost passionately fond of society, maintaining an unusual number of warm friendships, and unsurpassed by any of the young men of his day in adaptedness to the elegancies and courtesies of the more refined portions of the moving world. Romances of love, knighthood, and heroic deeds, tales of banditti, and stories of supernatural beings, were his chief delight in his early days. Yet his classical attainments were considerable, and, as a scholar in the literature of his own language, his reputation was early established. He delivered a poem on taking his degree, which was much admired in its day.

On leaving college, he returned to South Carolina. Having determined to devote his life to the fine arts, he sold, hastily and at a sacrifice, his share of a considerable patrimonial estate, and embarked for London in the autumn of 1801. Immediately upon his arrival, he became a student of the Royal Academy, of which his countryman, West, was President, with whom he formed an intimate and lasting friendship. After three years

spent in England, and a shorter stay at Paris, he went to Italy, where he spent four years devoted exclusively to the study of his art. At Rome began his intimacy with Coleridge. Among the many subsequent expressions of his feeling toward this great man, none, perhaps, is more striking than the following extract from one of his letters: — "To no other man do I owe so much, intellectually, as to Mr. Coleridge, with whom I became acquainted in Rome, and who has honored me with his friendship for more than five-and-twenty years. He used to call Rome the silent city; but I never could think of it as such while with him; for, meet him when and where I would, the fountain of his mind was never dry, but, like the far-reaching aqueducts that once supplied this mistress of the world, its living stream seemed specially to flow for every classic ruin over which we wandered. And when I recall some of our walks under the pines of the Villa Borghese, I am almost tempted to dream that I have once listened to Plato in the groves of the Academy." Readers of Coleridge know in what estimation he held the qualities and the friendship of Mr. Allston. Beside Coleridge and West, he numbered among his friends in England, Wordsworth, Southey, Lamb, Sir George Beaumont, Reynolds, and Fuseli.

In 1809, Mr. Allston returned to America, and remained two years in Boston, his adopted home, and there married the sister of Dr. Channing. In 1811, he went again to England, where his reputation as an artist had been completely established. Before his departure, he delivered a poem before the Phi Beta Kappa Society at Cambridge. During a severe illness, he removed from London to Clifton, at which place he wrote "The Sylphs of the Seasons." In 1813, he made his first, and, with

a *

the exception of " Monaldi," twenty-eight years afterwards, his
only publication. This was a small volume, entitled " The
Sylphs of the Seasons, and other Poems," published in Lon-
don ; and, during the same year, republished in Boston under
the direction of his friends, Professor Willard of Cambridge
and Mr. Edmund T. Dana. This volume was well received,
and gave him a place among the first poets of his country.
The smaller poems in that edition extend as far as page 289 of
the present volume.

 Beside the long and serious illness through which he passed,
his spirit was destined to suffer a deeper wound by the death of
Mrs. Allston, in London, during the same year. These events
gave to his mind a more earnest and undivided interest in his
spiritual relations, and drew him more closely than ever before
to his religious duties. He received the rite of confirmation,
and through life was a devout adherent to the Christian doctrine
and discipline.

 The character of Mr. Allston's religious feelings may be gath-
ered, incidentally, from many of his writings. It is a subject to
be treated with the reserve and delicacy with which he himself
would have had it invested. Few minds have been more thor-
oughly imbued with belief in the reality of the unseen world ;
few have given more full assent to the truth, that " the things
which are seen are temporal, the things which are not seen are
eternal." This was not merely an adopted opinion, a convic-
tion imposed upon his understanding ; it was of the essence of
his spiritual constitution, one of the conditions of his rational
existence. To him, the Supreme Being was no vague, mystical
source of light and truth, or an impersonation of goodness and
truth themselves ; nor, on the other hand, a cold rationalistic

notion of an unapproachable executor of natural and moral laws. His spirit rested in the faith of a sympathetic God. His belief was in a Being as infinitely minute and sympathetic in his providences, as unlimited in his power and knowledge. Nor need it be said, that he was a firm believer in the central truths of Christianity, the Incarnation and Redemption ; that he turned from unaided speculation to the inspired record and the visible Church ; that he sought aid in the sacraments ordained for the strengthening of infirm humanity, and looked for the resurrection of the dead, and the life of the world to come.

After a second residence of seven years in Europe, he returned to America in 1818, and again made Boston his home. There, in a circle of warmly attached friends, surrounded by a sympathy and admiration which his elevation and purity, the entire harmony of his life and pursuits, could not fail to create, he devoted himself to his art, the labor of his love.

This is not the place to enumerate his paintings, or to speak of his character as an artist. His general reading he continued to the last, with the earnestness of youth. As he retired from society, his taste inclined him to metaphysical studies, the more, perhaps, from their contrast with the usual occupations of his mind. He took particular pleasure in works of devout Christian speculation, without, however, neglecting a due proportion of strictly devotional literature. These he varied by a constant recurrence to the great epic and dramatic masters, and occasional reading of the earlier and the living novelists, tales of wild romance and lighter fiction, voyages and travels, biographies and letters. Nor was he without a strong interest in the current politics of his own country and of England, as to which his principles were highly conservative.

Upon his marriage with the daughter of the late Judge Dana, in 1830, he removed to Cambridge, and soon afterwards began the preparation of a course of lectures on Art, which he intended to deliver to a select audience of artists and men of letters in Boston. Four of these he completed. Rough drafts of two others were found among his papers, but not in a state fit for publication. In 1841, he published his tale of " Monaldi," a production of his early life. The poems in the present volume, not included in the volume of 1813, are, with two exceptions, the work of his later years. In them, as in his paintings of the same period, may be seen the extreme attention to finish, always his characteristic, which, added to increasing bodily pain and infirmity, was the cause of his leaving so much that is unfinished behind him.

His death occurred at his own house, in Cambridge, a little past midnight on the morning of Sunday, the 9th of July, 1843. He had finished a day and week of labor in his studio, upon his great picture of Belshazzar's Feast ; the fresh paint denoting that the last touches of his pencil were given to that glorious but melancholy monument of the best years of his later life. Having conversed with his retiring family with peculiar solemnity and earnestness upon the obligation and beauty of a pure spiritual life, and on the realities of the world to come, he had seated himself at his nightly employment of reading and writing, which he usually carried into the early hours of the morning. In the silence and solitude of this occupation, in a moment, " with touch as gentle as the morning light," which was even then approaching, his spirit was called away to its proper home.

CONTENTS.

CONTENTS. xi

LECTURES ON ART.

1

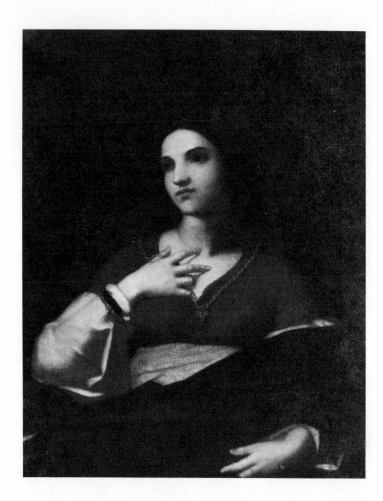

ROSALIE, 1835

Courtesy of the Society for the Preservation of New England Antiquities, Boston

PRELIMINARY NOTE.

IDEAS.

As the word *idea* will frequently occur, and will be found also to hold an important relation to our present subject, we shall endeavour, *in limine*, to possess our readers of the particular sense in which we understand and apply it.

An Idea, then, according to our apprehension, is the highest or most perfect *form* in which any thing, whether of the physical, the intellectual, or the spiritual, may exist to the mind. By form, we do not mean *figure* or *image* (though these may be included in relation to the physical); but that condition, or state, in which such objects become cognizable to the mind, or, in other words, become objects of consciousness.

Ideas are of two kinds; which we shall distinguish by the terms *primary* and *secondary*: the first being the *manifestation* of objective realities; the second, that of the reflex product, so to speak, of the mental constitution. In both cases, they may be said to be self-affirmed, — that is, they carry in themselves their own evidence; being therefore not only independent of the reflective faculties, but constituting the only unchangeable ground of Truth, to which those faculties may ultimately refer. Yet have these Ideas no living energy in themselves; they are but the *forms*, as we have said, through or in which a higher Power manifests to the consciousness the su-

preme truth of all things real, in respect to the first class; and, in respect to the second, the imaginative truths of the mental products, or mental combinations. Of the nature and mode of operation of the Power to which we refer, we know, and can know, nothing; it is one of those secrets of our being which He who made us has kept to himself. And we should be content with the assurance, that we have in it a sure and intuitive guide to a reverent knowledge of the beauty and grandeur of his works, — nay, of his own adorable reality. And who shall gainsay it, should we add, that this mysterious Power is essentially immanent in that " breath of life," by which man becomes " a living soul " ?

In the following remarks we shall confine ourself to the first class of Ideas, namely, the Real; leaving the second to be noticed hereafter.

As to number, ideas are limited only by the number of kinds, without direct relation to degrees; every object, therefore, having in itself a *distinctive essential*, has also its distinct idea; while two or more objects of the same kind, however differing in degree, must consequently refer only to one and the same. For instance, though a hundred animals should differ in size, strength, or color, yet, if none of these peculiarities are essential to the species, they would all refer to the same supreme idea.

The same law applies equally, and with the same limitation, to the essential differences in the intellectual, the moral, and the spiritual. All ideas, however, have but a potential existence until they are called into the consciousness by some real object; the required condition of the object being a predetermined correspondence, or correlation. Every such object we term an *assimilant*.

With respect to those ideas which relate to the physical world, we remark, that, though the assimilants required are supplied by the senses, the senses have in themselves no *productive, coöperating* energy, being but the passive instruments, or medium, through which they are conveyed. That the

senses, in this relation, are merely passive, admits of no question, from the obvious difference between the idea and the objects. The senses can do no more than transmit the external in its actual forms, leaving the images in the mind exactly as they found them; whereas the intuitive power rejects, or assimilates, indefinitely, until they are resolved into the proper perfect form. Now the power which prescribes that form must, of necessity, be antecedent to the presentation of the objects which it thus assimilates, as it could not else give consistence and unity to what was before separate or fragmentary. And every one who has ever realized an idea of the class in which alone we compare the assimilants with the ideal form, be he poet, painter, or philosopher, well knows the wide difference between the materials and their result. When an idea is thus realized and made objective, it affirms its own truth, nor can any process of the understanding shake its foundation; nay, it is to the mind an essential, imperative truth, then emerging, as it were, from the dark potential into the light of reality.

If this be so, the inference is plain, that the relation between the actual and the ideal is one of necessity, and therefore, also, is the predetermined correspondence between the prescribed form of an idea and its assimilant; for how otherwise could the former become recipient of that which was repugnant or indifferent, when the presence of the latter constitutes the very condition by which it is manifested, or can be known to exist? By actual, here, we do not mean the exclusively physical, but whatever, in the strictest sense, can be called an *object*, as forming the opposite to a mere subject of the mind.

It would appear, then, that what we call ourself must have a *dual* reality, that is, in the mind and in the senses, since neither *alone* could possibly explain the phenomena of the other; consequently, in the existence of either we have clearly implied the reality of both. And hence must follow the still more important truth, that, in the *conscious presence* of any *spiritual*

1 *

idea, we have the surest proof of a spiritual object ; nor is this the less certain, though we perceive not the assimilant. Nay, a spiritual assimilant cannot be perceived, but, to use the words of St. Paul, is " spiritually discerned," that is, by a sense, so to speak, of our own spirit. But to illustrate by example : we could not, for instance, have the ideas of good and evil without their objective realities, nor of right and wrong, in any intelligible form, without the moral law to which they refer, — which law we call the Conscience ; nor could we have the idea of a moral law without a moral lawgiver, and, if moral, then intelligent, and, if intelligent, then personal ; in a word, we could not now have, as we know we have, the idea of conscience, without an objective, personal God. Such ideas may well be called revelations, since, without any perceived assimilant, we find them equally affirmed with those ideas which relate to the purely physical.

But here it may be asked, How are we to distinguish an Idea from a mere *notion* ? We answer, By its self-affirmation. For an ideal truth, having its own evidence in itself, can neither be proved nor disproved by any thing out of itself ; whatever, then, impresses the mind *as* truth, *is* truth until it can be *shown* to be false ; and consequently, in the converse, whatever can be brought into the sphere of the understanding, as a dialectic subject, is not an Idea. It will be observed, however, that we do not say an idea may not be denied ; but to deny is not to disprove. Many things are denied in direct contradiction to fact ; for the mind can command, and in no measured degree, the power of self-blinding, so that it cannot see what is actually before it. This is a psychological fact, which may be attested by thousands, who can well remember the time when they had once clearly discerned what has now vanished from their minds. Nor does the actual cessation of these primeval forms, or the after presence of their fragmentary, nay, disfigured relics, disprove their reality, or their original integrity, as we could not else call them up in their proper forms at any future time, to the reacknowledging their

truth : a *resuscitation* and result, so to speak, which many have experienced.

In conclusion : though it be but one and the same Power that prescribes the form and determines the truth of all Ideas, there is yet an essential difference between the two classes of ideas to which we have referred ; for it may well be doubted whether any Primary Idea can ever be fully realized by a finite mind, — at least in the present state. Take, for instance, the idea of beauty. In its highest form, as presented to the consciousness, we still find it referring to something beyond and above itself, as if it were but an approximation to a still higher form. The truth of this, we think, will be particularly felt by the artist, whether poet or painter, whose mind may be supposed, from his natural bias, to be more peculiarly capable of its highest developement ; and what true artist was ever satisfied with any idea of beauty of which he is conscious ? From this approximated form, however, he doubtless derives a high degree of pleasure, nay, one of the purest of which his nature is capable ; yet still is the pleasure modified, if we may so express it, by an undefined yearning for what he feels can never be realized. And wherefore this craving, but for the archetype of that which called it forth ? — When we say not satisfied, we do not mean discontented, but simply not in full fruition. And it is better that it should be so, since one of the happiest elements of our nature is that which continually impels it towards the indefinite and unattainable. So far as we know, the like limits may be set to every other primary idea, — as if the Creator had reserved to himself alone the possible contemplation of the archetypes of his universe.

With regard to the other class, that of Secondary Ideas, which we have called the reflex product of the mind, their distinguishing characteristic is, that they not only admit of a perfect realization, but also of outward manifestation, so as to be communicated to others. All works of imagination, so called, present examples of this. Hence they may also be termed imitative or imaginative. For, though they draw their

assimilants from the actual world, and are likewise regulated by the unknown Power before mentioned, yet are they but the forms of what, *as a whole*, have no actual existence ; — they are nevertheless true to the mind, and are made so by the same Power which affirms their possibility. This species of Truth we shall hereafter have occasion to distinguish as Poetic Truth.

INTRODUCTORY DISCOURSE.

NEXT to the developement of our moral nature, to have subordinated the senses to the mind is the highest triumph of the civilized state. Were it possible to embody the present complicated scheme of society, so as to bring it before us as a visible object, there is perhaps nothing in the world of sense that would so fill us with wonder; for what is there in nature that may not fall within its limits? and yet how small a portion of this stupendous fabric will be found to have any direct, much less exclusive, relation to the actual wants of the body! It might seem, indeed, to an unreflecting observer, that our physical necessities, which, truly estimated, are few and simple, have rather been increased than diminished by the civilized man. But this is not true; for, if a wider duty is imposed on the senses, it is only to minister to the increased demands of the imagination, which is now so mingled with our every-day concerns, even with our dress, houses, and furniture, that, except with the brutalized, the purely sensuous wants might almost be said to have become extinct: with the cultivated and refined, they are at least so modified as to be no longer prominent.

But this refining on the physical, like every thing else,

has had its opponents: it is declaimed against as artificial. If by artificial is meant unnatural, we cannot so consider it; but hold, on the contrary, that the whole multiform scheme of the civilized state is not only in accordance with our nature, but an essential condition to the proper developement of the human being. It is presupposed by the very wants of his mind; nor could it otherwise have been, any more than could have been the cabin of the beaver, or the curious hive of the bee, without their preëxisting instincts; it is therefore in the highest sense natural, as growing out of the inherent desires of the mind.

But we would not be misunderstood. When we speak of the refined state as not out of nature, we mean such results as proceed from the legitimate growth of our mental constitution, which we suppose to be grounded in permanent, universal principles; and, whatever modifications, however subtile, and apparently visionary, may follow their operation in the world of sense, so long as that operation diverge not from its original ground, its effect must be, in the strictest sense, natural. Thus the wildest visions of poetry, the unsubstantial forms of painting, and the mysterious harmonies of music, that seem to disembody the spirit, and make us creatures of the air, — even these, unreal as they are, may all have their foundation in immutable truth; and we may moreover know of this truth by its own evidence. Of this species of evidence we shall have occasion to speak hereafter. But there is another kind of growth, which may well be called unnatural; we mean, of those diseased appetites, whose effects are seen in the distorted forms of the *conventional*, having no ground but in weariness of the true; and it cannot be denied that this morbid growth has its full share,

inwardly and outwardly, both of space and importance. These, however, must sooner or later end as they began; they perish in the lie they make; and it were well did not other falsehoods take their places, to prolong a life whose only tenure is inconsequential succession, — in other words, Fashion.

If it be true, then, that even the commonplaces of life must all in some degree partake of the mental, there can be but one rule by which to determine the proper rank of any object of pursuit, and that is by its nearer or more remote relation to our inward nature. Every system, therefore, which tends to degrade a mental pleasure to the subordinate or superfluous, is both narrow and false, as virtually reversing its natural order.

It pleased our Creator, when he endowed us with appetites and functions by which to sustain the economy of life, at the same time to annex to their exercise a sense of pleasure; hence our daily food, and the daily alternation of repose and action, are no less grateful than imperative. That life may be sustained, and most of its functions performed, without any coincident enjoyment, is certainly possible. Our food may be distasteful, action painful, and rest unrefreshing; and yet we may eat, and exercise, and sleep, nay, live thus for years. But this is not our natural condition, and we call it disease. Were man a mere animal, the very act of living, in his natural or healthy state, would be to him a continuous enjoyment. But he is also a moral and an intellectual being; and, in like manner, is the healthful condition of these, the nobler parts of his nature, attended with something more than a consciousness of the mere process of existence. To the exercise of his intellectual faculties and moral attributes

the same benevolent law has superadded a sense of pleasure, — of a kind, too, in the same degree transcending the highest bodily sensation, as must that which is immortal transcend the perishable. It is not for us to ask why it is so; much less, because it squares not with the poor notion of material usefulness, to call in question a fact that announces a nature to which the senses are but passing ministers. Let us rather receive this ennobling law, at least without misgiving, lest in our sensuous wisdom we exchange an enduring gift for a transient gratification.

Of the peculiar fruits of this law, which we shall here distinguish by the general term *mental pleasures*, it is our purpose to treat in the present discourse.

It is with no assumed diffidence that we venture on this subject; for, though we shall offer nothing not believed to be true, we are but too sensible how small a portion of truth it is in our power to present. But, were it far greater, and the present writer of a much higher order of intellect, there would still be sufficient cause for humility in view of those impassable bounds that have ever met every self-questioning of the mind.

But whilst the narrowness of human knowledge may well preclude all self-exaltation, it would be worse than folly to hold as naught the many important truths which have been wrought out for us by the mighty intellects of the past. If they have left us nothing for vainglory, they have left us at least enough to be grateful for. Nor is it a little, that they have taught us to look into those mysterious chambers of our being, — the abode of the spirit; and not a little, indeed, if what we are there permitted to know shall have brought with it the conviction, that we are not abandoned to a blind empiricism, to waste life in guesses, and to guess

at last that we have all our lives been guessing wrong, — but, unapproachable though it be to the subordinate Understanding, that we have still within us an abiding Interpreter, which cannot be gainsaid, which makes our duty to God and man clear as the light, which ever guards the fountain of all true pleasures, nay, which holds in subjection the last high gift of the Creator, that imaginative faculty whereby his exalted creature, made in his image, might mould at will, from his most marvellous world, yet unborn forms, even forms of beauty, grandeur, and majesty, having all of truth but his own divine prerogative, — *the mystery of Life.*

As the greater part of those Pleasures which we propose to discuss are intimately connected with the material world, it may be well, perhaps, to assign some reason for the epithet *mental.* To many, we know, this will seem superfluous; but, when it is remembered how often we hear of this and that object delighting the eye, or of certain sounds charming the ear, it may not be amiss to show that such expressions have really no meaning except as metaphors. When the senses, as the medium of communication, have conveyed to the mind either the sounds or images, their function ceases. So also with respect to the objects: their end is attained, at least as to us, when the sounds or images are thus transmitted, which, so far as they are concerned, must for ever remain the same within as without the mind. For, where the ultimate end is not in mere bodily sensation, neither the senses nor the objects possess, of themselves, any productive power; of the product that follows, the *tertium aliquid,* whether the pleasure we feel be in a beautiful animal or in according sounds, neither the one nor the other is really the cause, but simply the *occasion.* It is clear, then,

2

that the effect realized supposes of necessity another
agent, which must therefore exist only in the mind.
But of this hereafter.

If the cause of any emotion, which we seem to de-
rive from an outward object, were inherent exclusive-
ly in the object itself, there could be no failure in
any instance, except where the organs of sense were
either diseased or imperfect. But it is a matter of fact
that they often do fail where there is no disease or or-
ganic defect. Many of us, perhaps, can call to mind
certain individuals, whose sense of hearing is as acute
as our own, who yet can by no possibility be made to
recognize the slightest relation between the according
notes of the simplest melody; and, though they can
as readily as others distinguish the individual sounds,
even to the degrees of flatness and sharpness, the har-
monic agreement is to them as mere noise. Let us
suppose ourselves present at a concert, in company
with one such person and another who possesses what
is called musical sensibility. How are they affected,
for instance, by a piece of Mozart's? In the sense of
hearing they are equal: look at them. In the one we
perceive perplexity, annoyance, perhaps pain; he hears
nothing but a confused medley of sounds. In the
other, the whole being is rapt in ecstasy, the unutter-
able pleasure gushes from his eyes, he cannot articulate
his emotion; — in the words of one, who felt and em-
bodied the subtile mystery in immortal verse, his very
soul seems "lapped in Elysium." Now, could this
difference be possible, were the sole cause, strictly
speaking, in mere matter?

Nor do we contradict our position, when we ad-
mit, in certain cases, — for instance, in the producer, —
the necessity of a nicer organization, in order to the

more perfect *transmission* of the finer emotions; inasmuch as what is to be communicated in space and time must needs be by some medium adapted thereto.

Such a person as Paganini, it is said, was able to "discourse most excellent music" on a ballad-monger's fiddle; yet will any one question that he needed an instrument of somewhat finer construction to show forth his full powers? Nay, we might add, that he needed no less than the most delicate *Cremona*, — some instrument, as it were, articulated into humanity, — to have inhaled and respired those attenuated strains, which, those who heard them think it hardly extravagant to say, seemed almost to embody silence.

Now this mechanical instrument, by means of which such marvels were wrought, is but one of the many visible symbols of that more subtile instrument through which the mind acts when it would manifest itself. It would be too absurd to ask if any one believed that the music we speak of was created, as well as conveyed, by the instrument. The violin of Paganini may still be seen and handled; but the soul that inspired it is buried with its master.

If we admit a distinction between mind and matter, and the result we speak of be purely mental, we should contradict the universal law of nature to assign such a product to mere matter, inasmuch as the natural law forbids in the lower the production of the higher. Take an example from one of the lower forms of organic life, — a common vegetable. Will any one assert that the surrounding inorganic elements of air, earth, heat, and water produce its peculiar form? Though some, or all, of these may be essential to its developement, they are so only as its predetermined correlatives, without which its existence could not be manifested; and in

like manner must the peculiar form of the vegetable preëxist in its life, — in its *idea*, — in order to evolve by these assimilants its own proper organism.

No possible modification in the degrees or proportion of these elements can change the specific form of a plant, — for instance, a cabbage into a cauliflower; it must ever remain a cabbage, *small or large, good or bad.* So, too, is the external world to the mind ; which needs, also, as the condition of its manifestation, its objective correlative. Hence the presence of some outward object, predetermined to correspond to the preëxisting idea in its living power, is essential to the evolution of its proper end, — the pleasurable emotion. We beg it may be noted that we do not say *sensation.* And hence we hold ourself justified in speaking of such presence as simply the occasion, or condition, and not, *per se,* the cause. And hence, moreover, may be inferred the absolute necessity of Dual Forces in order to the actual existence of any thing. One alone, the incomprehensible Author of all things, is self-subsisting in his perfect Unity.

We shall now endeavour to establish the following proposition: namely, that the Pleasures in question have their true source in One Intuitive Universal Principle or living Power, and that the three Ideas of Beauty, Truth, and Holiness, which we assume to represent the *perfect* in the physical, intellectual, and moral worlds, are but the several realized phases of this sovereign principle, which we shall call *Harmony.*

Our first step, then, is to possess ourself of the essential or distinctive characteristic of these pleasurable emotions. Apparently, there is nothing more simple. And yet we are acquainted with no single term that shall fully express it. But what every one has more or

less felt may certainly be made intelligible in a more extended form, and, we should think, by any one in the slightest degree competent to self-examination. Let a person, then, be appealed to; and let him put the question as to what passes within him when possessed by these emotions; and the spontaneous feeling will answer for us, that what we call *self* has no part in them. Nay, we further assert, that, when singly felt, that is, when unallied to other emotions as modifying forces, they are wholly unmixed with *any personal considerations, or any conscious advantage to the individual.*

Nor is this assigning too high a character to the feelings in question because awakened in so many instances by the purely physical; since their true origin may clearly be traced to a common source with those profounder emotions which we are wont to ascribe to the intellectual and moral. Besides, it should be borne in mind, that no physical object can be otherwise to the mind than a mere *occasion;* its inward product, or mental effect, being from another Power. The proper view therefore is, not that such alliance can ever degrade the higher agent, but that its more humble and material *assimilant* is thus elevated by it. So that nothing in nature should be counted mean, which can thus be exalted; but rather be honored, since no object can become so assimilated except by its predetermined correlation to our better nature.

Neither is it the privilege of the exclusive few, the refined and cultivated, to feel them deeply. If we look beyond ourselves, even to the promiscuous multitude, the instance will be rare, if existing at all, where some transient touch of these purer feelings has not raised the individual to, at least, a momentary exemption from

2 *

the common thraldom of self. And we greatly err if
their universality is not solely limited by those " shades
of the prison-house," which, in the words of the poet,
too often "close upon the growing boy." Nay, so far
as we have observed, we cannot admit it as a question
whether any person through a whole life has always
been wholly insensible, — we will not say (though well
we might) to the good and true, — but to beauty ; at
least, to some one kind, or degree, of the beautiful.
The most abject wretch, however animalized by vice,
may still be able to recall the time when a morning or
evening sky, a bird, a flower, or the sight of some other
object in nature, has given him a pleasure, which he
felt to be distinct from that of his animal appetites, and
to which he could attach not a thought of self-interest.
And, though crime and misery may close the heart for
years, and seal it up for ever to every redeeming thought,
they cannot so shut out from the memory these gleams
of innocence ; even the brutified spirit, the castaway
of his kind, has been made to blush at this enduring
light ; for it tells him of a truth, which might else
have never been remembered, — that he has once been
a man.

 And here may occur a question, —which might well
be left to the ultra advocates of the *cui bono*, — whether
a simple flower may not sometimes be of higher use
than a labor-saving machine.

 As to the objects whose effect on the mind is here
discussed, it is needless to specify them ; they are, in
general, all such as are known to affect us in the
manner described. The catalogue will vary both in
number and kind with different persons, according to
the degree of force or developement in the overruling
Principle.

We proceed, then, to reply to such objections as will doubtless be urged against the characteristic assumed. And first, as regards the Beautiful, we shall probably be met by the received notion, that we experience in Beauty one of the most powerful incentives to passion; while examples without number will be brought in array to prove it also the wonder-working cause of almost fabulous transformations, — as giving energy to the indolent, patience to the quick, perseverance to the fickle, even courage to the timid; and, *vice versâ*, as unmanning the hero, — nay, urging the honorable to falsehood, treason, and murder; in a word, through the mastered, bewildered, sophisticated *self*, as indifferently raising and sinking the fascinated object to the heights and depths of pleasure and misery, of virtue and vice.

Now, if the Beauty here referred to is of the *human being*, we do not gainsay it; but this is beauty in its *mixed mode*, — not in its high, passionless form, its singleness and purity. It is not Beauty as it descended from heaven, in the cloud, the rainbow, the flower, the bird, or in the concord of sweet sounds, that seem to carry back the soul to whence it came.

Could we look, indeed, at the human form in its simple, unallied physical structure, — on that, for instance, of a beautiful woman, — and forget, or rather not feel, that it is other than a *form*, there could be but one feeling: that nothing visible was ever so framed to banish from the soul every ignoble thought, and imbue it, as it were, with primeval innocence.

We are quite aware that the doctrine assumed in our main proposition with regard to Beauty, as holding exclusive relation to the Physical, is not very likely to forestall favor; we therefore beg for it only such candid attention as, for the reasons advanced, it may appear to deserve.

That such effects as have just been objected could
not be from Beauty alone, in its pure and single form,
but rather from its coincidence with some real or sup-
posed moral or intellectual quality, or with the animal
appetites, seems to us clear; as, were it otherwise, we
might infer the same from a beautiful infant, — the very
thought of which is revolting to common sense. In
such conjunction, indeed, it cannot but have a certain
influence, but so modified as often to become a mere
accessory, subordinated to the animal or moral object,
and for the attainment of an end not its own ; in proof
of which, we find it almost uniformly partaking the
penalty imposed on its incidental associates, should
ever their desires result in illusion, — namely, in the
aversion that follows. But the result of Beauty can
never be such; when it seems otherwise, the effect, we
think, can readily be traced to other causes, as we shall
presently endeavour to show.

It cannot be a matter of controversy whether Beauty
is limited to the human form; the daily experience of
the most ordinary man would answer No: he finds it in
the woods, the fields, in plants and animals, nay, in a
thousand objects, as he looks upon nature ; nor, though
indefinitely diversified, does he hesitate to assign to
each the same epithet. And why? Because the feel-
ings awakened by all are similar in kind, though vary-
ing, doubtless, by many degrees in intenseness. Now
suppose he is asked of what personal advantage is all
this beauty to him. Verily, he would be puzzled to
answer. It gives him pleasure, perhaps great pleasure.
And this is all he could say. But why should the effect
be different, except in degree, from the beauty of a
human being? We have already the answer in this
concluding term. For what is a human being but one

who unites in himself a physical, intellectual, and moral
nature, which cannot in one become even an object of
thought without at least some obscure shadowings of
its natural allies? How, then, can we separate that
which has an exclusive relation to his physical form,
without some perception of the moral and intellectual
with which it is joined? But how do we know that
Beauty is limited to such exclusive relation? This
brings us to the great problem; so simple and easy of
solution in all other cases, yet so intricate and appar-
ently inexplicable in man. In other things, it would be
felt absurd to make it a question, whether referring to
form, color, or sound. A single instance will suffice.
Let us suppose, then, an unfamiliar object, whose
habits, disposition, and so forth, are wholly unknown,
for instance, a bird of paradise, to be seen for the first
time by twenty persons, and they all instantly call it
beautiful; — could there be any doubt that the pleasure
it produced in each was of the same kind? or would
any one of them ascribe his pleasure to any thing but
its form and plumage? Concerning natural objects,
and those inferior animals which are not under the in-
fluence of domestic associations, there is little or no dif-
ference among men: if they differ, it is only in degree,
according to their sensibility. Men do not dispute
about a rose. And why? Because there is nothing
beside the physical to interfere with the impression it
was predetermined to make; and the idea of beauty
is realized instantly. So, also, with respect to other
objects of an opposite character; they can speak with-
out deliberating, and call them plain, homely, ugly, and
so on, thus instinctively expressing even their degree of
remoteness from the condition of beauty. Who ever
called a pelican beautiful, or even many animals en-

deared to us by their valuable qualities, — such as the intelligent and docile elephant, or the affectionate orang-outang, or the faithful mastiff? Nay, we may run through a long list of most useful and amiable creatures, that could not, under any circumstances, give birth to an emotion corresponding to that which we ascribe to the beautiful.

But there is scarcely a subject on which mankind are wider at variance, than on the beauty of their own species, — some preferring this, and others that, particular conformation; which can only be accounted for on the supposition of some predominant expression, either moral, intellectual, or sensual, with which they are in sympathy, or else the reverse. While some will task their memory, and resort to the schools, for their supposed infallible *rules;* — forgetting, meanwhile, that ultimate tribunal to which their canon must itself appeal, the ever-living principle which first evolved its truth, and which now, as then, is not to be reasoned about, but *felt.* It need not be added how fruitful of blunders is this mechanical ground.

Now we venture to assert that no mistake was ever made, even in a single glance, concerning any natural object, not disfigured by human caprice, or which the eye had not been trained to look at through some conventional medium. Under this latter circumstance, there are doubtless many things in nature which affect men very differently; and more especially such as, from their familiar nearness, have come under the influence of *opinion*, and been incrusted, as it were, by the successive deposits of many generations. But of the vast and various multitude of objects which have thus been forced from their original state, there is perhaps no one which has undergone so many and such strange

disfigurements as the human form; or in relation to
which our "ideas," as we are pleased to call them, but
in truth our opinions, have been so fluctuating. If an
Idea, indeed, had any thing to do with Fashion, we
should call many things monstrous to which custom
has reconciled us. Let us suppose a case, by way
of illustration. A gentleman and lady, from one of
our fashionable cities, are making a tour on the borders
of some of our new settlements in the West. They are
standing on the edge of a forest, perhaps admiring
the grandeur of nature; perhaps, also, they are lovers,
and sharing with nature their admiration for each other,
whose personal charms are set off to the utmost, ac-
cording to the most approved notions, by the taste and
elegance of their dress. Then suppose an Indian hun-
ter, who had never seen one of our civilized world, or
heard of our costume, coming suddenly upon them,
their faces being turned from him. Would it be pos-
sible for him to imagine what kind of animals they
were? We think not; and least of all, that he would
suppose them to be of his own species. This is no
improbable case; and we very much fear, should it ever
occur, that the unrefined savage would go home with
an impression not very flattering either to the milliner
or the tailor.

That, under such disguises, we should consider human
beauty as a kind of enigma, or a thing to dispute about,
is not surprising; nor even that we should often differ
from ourselves, when so much of the outward man is
thus made to depend on the shifting humors of some
paramount Petronius of the shears. But, admitting it
to be an easy matter to divest the form, or, what is still
more important, our own minds, of every thing con-
ventional, there is the still greater obstacle to any true

effect from the person alone, in that moral admixture, already mentioned, which, more or less, must color the most of our impressions from every individual. Is there not, then, sufficient ground for at least a doubt if, excepting idiots, there is one human being in whom the purely physical is *at all times* the sole agent? We do not say that it does not generally predominate. But, in a compound being like man, it seems next to impossible that the nature within should not at times, in some degree, transpire through the most rigid texture of the outward form. We may not, indeed, always read aright the character thus obscurely indexed, or even be able to guess at it, one way or the other; still, it will affect us; nay, most so, perhaps, when most indefinite. Every man is, to a certain extent, a physiognomist : we do not mean, according to the common acceptation, that he is an interpreter of lines and quantities, which may be reduced to rules; but that he is born one, judging, not by any conscious rule, but by an instinct, which he can neither explain nor comprehend, and which compels him to sit in judgment, whether he will or no. How else can we account for those instantaneous sympathies and antipathies towards an utter stranger?

Now this moral influence has a twofold source, one in the object, and another in ourselves; nor is it easy to determine which is the stronger as a counteracting force. Hitherto we have considered only the former; we now proceed with a few remarks upon the latter.

Will any man say, that he is wholly without some natural or acquired bias? This is the source of the counteracting influence which we speak of in ourselves; but which, like many other of the secret springs, both of thought and feeling, few men think of. It is never-

theless one which, on this particular subject, is scarcely ever inactive; and according to the bias will be our impressions, whether we be intellectual or sensual, coldly speculative or ardently imaginative. We do not mean that it is always called forth by every thing we approach; we speak only of its usual activity between man and man; for there seems to be a mysterious something in our nature, that, in spite of our wishes, will rarely allow of an absolute indifference towards any of the species; some effect, however slight, even as that of the air which we unconsciously inhale and again respire, must follow, whether directly from the object or reacting from ourselves. Nay, so strong is the law, whether in attraction or repulsion, that we cannot resist it even in relation to those human shadows projected on air by the mere imagination; for we feel it in art only less than in nature, provided, however, that the imagined being possess but the indication of a human soul: yet not so is it, if presenting only the outward form, since a mere form can in itself have no affinity with either the heart or intellect. And here we would ask, Does not this striking exception in the present argument cast back, as it were, a confirmatory reflection?

We have often thought, that the power of the mere form could not be more strongly exemplified than at a common paint-shop. Among the annual importations from the various marts of Europe, how many beautiful faces, without an atom of meaning, attract the passengers,—stopping high and low, people of all descriptions, and actually giving pleasure, if not to every one, at least to the majority; and very justly, for they have beauty, and *nothing else*. But let another artist, some man of genius, copy the same faces, and add character,—breathe into them souls: from that moment the passers-

3

by would see as if with other eyes; the affections and
the imagination then become the spectators; and, ac-
cording to the quickness or dulness, the vulgarity or
refinement, of these, would be the impression. Thus
a coarse mind may feel the beauty in the hard, soul-
less forms of Van der Werf, yet turn away with apathy
from the sanctified loveliness of a Madonna by Raf-
faelle.

But to return to the individual bias, which is con-
tinually inclining to, or repelling What is more com-
mon, especially with women, than a high admiration
of a plain person, if connected with wit, or a pleasing
address ? Can we have a stronger case in point than
that of the celebrated Wilkes, one of the ugliest, yet
one of the most admired men of his time? Even his
own sex, blinded no doubt by their sympathetic bias,
could see no fault in him, either in mind or person; for,
when it was objected to the latter, that " he squinted
confoundedl ," the reply was, " No, Sir, not more than a
gentleman ought to squint."

Of the tendency to particular pursuits, —to art, sci-
ence, or any particular course of life, — we do not
speak; the bias we allude to is in the more personal dis-
position of the man, — in that which gives a tone to his
internal character; nor is it material of what proportions
compounded, of the affections, or the intellect, or the
senses,—whether of some only, or the whole ; that these
form the ground of every man's bias is no less certain,
than the fact that there is scarcely any secret which men
are in the habit of guarding with such sedulous care.
Nay, it would seem as if every one were impelled to it
by some superstitious instinct, that every one might
have it to say to himself, There is one thing in me which
is all *my own*. Be this as it may, there are few things

more hazardous than to pronounce with confidence on any man's bias. Indeed, most men would be puzzled to name it to themselves; but its existence in them is not the less a fact, because the form assumed may be so mixed and complicated as to be utterly undefinable. It is enough, however, that every one feels, and is more or less led by it, whether definite or not.

This being the case, how is it possible that it should not in some degree affect our feelings towards every one we meet, — that it should not leave some speck of leaven on each impression, which shall impregnate it with something that we admire and love, or else with that which we hate and despise?

And what is the most beautiful or the most ungainly form before a sorcerer like this, who can endow a fair simpleton with the rarest intellect, or transform, by a glance, the intellectual, noble-hearted dwarf to an angel of light? These, of course, are extreme cases. But if true in these, as we have reason to believe, how formidable the power!

But though, as before observed, we may not read this secret with precision, it is sometimes possible to make a shrewd guess at the prevailing tendency in certain individuals. Perhaps the most obvious cases are among the sanguine and imaginative; and the guess would be, that a beautiful person would presently be enriched with all possible virtues, while the colder speculatist would only see in it, not what it possessed, but the mind that it wanted. Now it would be curious to imagine (and the case is not impossible) how the eyes of each might be opened, with the probable consequence, how each might feel when his eyes were opened, and the object was seen as it really is. Some untoward circumstance comes unawares on the perfect

creature: a burst of temper knits the brow, inflames the
eye, inflates the nostril, gnashes the teeth, and converts
the angel into a storming fury. What then becomes
of the visionary virtues? They have passed into air,
and taken with them, also, what was the fair creature's
right, — her very beauty. Yet a different change takes
place with the dry man of intellect. The mindless
object has taken shame of her ignorance; she begins to
cultivate her powers, which are gradually developed
until they expand and brighten; they inform her fea-
tures, so that no one can look upon them without seeing
the evidence of no common intellect: the dry man, at
last, is struck with their superior intelligence, and
what more surprises him is the grace and beauty,
which, for the first time, they reveal to his eyes. The
learned dust which had so long buried his heart is
quickly brushed away, and he weds the embodied mind.
What third change may follow, it is not to our purpose
to foresee.

Has human beauty, then, no power? When united
with virtue and intellect, we might almost answer, —
All power. It is the embodied harmony of the true
poet; his visible Muse; the guardian angel of his better
nature; the inspiring sibyl of his best affections, draw-
ing him to her with a purifying charm, from the selfish-
ness of the world, from poverty and neglect, from the low
and base, nay, from his own frailty or vices: — for he
cannot approach her with unhallowed thoughts, whom
the unlettered and ignorant look up to with awe, as to
one of a race above them; before whom the wisest and
best bow down without abasement, and would bow
in idolatry but for a higher reverence. No! there is
no power like this of mortal birth. But against the
antagonist moral, the human beauty of itself has no

power, no self-sustaining life. While it panders to evil
desires, then, indeed, there are few things may par-
allel its fearful might. But the unholy alliance must at
last have an end. Look at it then, when the beautiful
serpent has cast her slough.

Let us turn to it for a moment, and behold it in
league with elegant accomplishments and a subtile in-
tellect: how complete its triumph! If ever the soul
may be said to be intoxicated, it is then, when it feels
the full power of a beautiful, bad woman. The fabled
enchantments of the East are less strange and wonder-
working than the marvellous changes which her spell
has wrought. For a time every thought seems bound
to her will; the eternal eye of the conscience closes be-
fore her; the everlasting truths of right and wrong sleep
at her bidding; nay, things most gross and abhorred
become suddenly invested with a seeming purity: till
the whole mind is hers, and the bewildered victim,
drunk with her charms, calls evil good. Then, what may
follow? Read the annals of crime; it will tell us what
follows the broken spell, — broken by the first degrad-
ing theft, the first stroke of the dagger, or the first drop
of poison. The felon's eye turns upon the beautiful
sorceress with loathing and abhorrence : an asp, a toad,
is not more hateful! The story of Milwood has many
counterparts.

But, although Beauty cannot sustain itself perma-
nently against what is morally bad, and has no direct
power of producing good, it yet may, and often does,
when unobstructed, through its unimpassioned purity,
predispose to the good, except, perhaps, in natures
grossly depraved; inasmuch as all affinities to the pure
are so many reproaches to the vitiated mind, unless
convertible to some selfish end. Witness the beautiful

3 *

wife, wedded for what is misnamed love, yet becoming the scorn of a brutal husband, — the more bitter, perhaps, if she be also good. But, aside from those counteracting causes so often mentioned, it is as we have said: we are predisposed to feel kindly, and to think purely, of every beautiful object, until we have reason to think otherwise; and according to our own hearts will be our thoughts.

We are aware of but one other objection which has not been noticed, and which might be made to the intuitive nature of the Idea. How is it, we may be asked, that artists, who are supposed, from their early discipline, to have overcome all conventional bias, and also to have acquired the more difficult power of analyzing their models, so as to contemplate them in their separate elements, have so often varied as to their ideas of Beauty? Whether artists have really the power thus ascribed to them, we shall not here inquire; it is no doubt, if possible, their business to acquire it. But, admitting it as true, we deny the position: they do not change their ideas. They can have but one Idea of Beauty, inasmuch as that Idea is but a specific phase of one immutable Principle,—if there be such a principle; as we shall hereafter endeavour to show. Nor can they have of it any essentially different, much less opposite, conceptions: but their *apprehension* of it may undergo many apparent changes, which, nevertheless, are but the various degrees that only mark a fuller conception; as their more extended acquaintance with the higher outward assimilants of Beauty brings them, of course, nearer to a perfect realization of the preëxisting Idea. By *perfect*, here, we mean only the nearest approximation by man. And we appeal to every artist, competent to answer, if it be not so. Does he ever

descend from a higher assimilant to a lower? Suppose him to have been born in Italy; would he go to Holland to realize his Idea? But many a Dutchman has sought in Italy what he could not find in his own country. We do not by this intend any reflection on the latter, — a country so fruitful of genius; it is only saying that the human form in Italy is from a finer mould. Then, what directs the artist from one object to another, and determines him which to choose, if he has not the guide within him? And why else should all nations instinctively bow before the superior forms of Greece?

We add but one remark. Supposing the artist to be wholly freed from all modifying biases, such is seldom the case with those who criticize his work, — especially those who would show their superiority by detecting faults, and who frequently condemn the painter simply for not expressing what he never aimed at. As to some, they are never content if they do not find beauty, whatever the subject, though it may neutralize the character, if not render it ridiculous. Were Raffaelle, who seldom sought the purely beautiful, to be judged by the want of it, he would fall below Guido. But his object was much higher, — in the intellect and the affections; it was the human being in his endless inflections of thought and passion, in which there is little probability he will ever be approached. Yet false criticism has been as prodigal to him in the ascription of beauty, as parsimonious and unjust to many others.

In conclusion, may there not be, in the difficulty we have thus endeavoured to solve, a probable significance of the responsible, as well as distinct, position which the Human being holds in the world of life? Are there no shadowings, in that reciprocal influence between

soul and soul, of some mysterious chain which links together the human family in its two extremes, giving to the very lowest an indefeasible claim on the highest, so that we cannot be independent if we would, or indifferent even to the very meanest, without violation of an imperative law of our nature? And does it not at least *hint* of duties and affections towards the most deformed in body, the most depraved in mind, — of interminable consequences? If man were a mere animal, though the highest animal, could these inscrutable influences affect us as they do? Would not the animal appetites be our true and sole end? What even would Beauty be to the sated appetite? If it did not, as in the last instance, of the brutal husband, become an object of scorn, — which it could not be, from the necessary absence of moral obliquity, — would it be better than a picked bone to a gorged dog? Least of all could it resemble the visible sign of that pure idea, in which so many lofty minds have recognized the type of a far higher love than that of earth, which the soul shall know, when, in a better world, she shall realize the ultimate reunion of Beauty with the coëternal forms of Truth and Holiness.

We will now apply the characteristic assumed to the second leading Idea, namely, to Truth. In the first place, we take it for granted, that no one will deny to the perception of truth some positive pleasure; no one, at least, who is not at the same time prepared to contradict the general sense of mankind, nay, we will add, their universal experience. The moment we begin to think, we begin to acquire, whether it be in trifles or otherwise, some kind of knowledge; and of two things presented to our notice, supposing one to be true and the other false, no one ever knowingly, and for its own

sake, chooses the false: whatever he may do in after life, for some selfish purpose, he cannot do so in childhood, where there is no such motive, without violence to his nature. And here we are supposing the understanding, with its triumphant pride and subtilty, out of the question, and the child making his choice under the spontaneous sense of the true and the false. For, were it otherwise, and the choice indifferent, what possible foundation for the commonest acts of life, even as it respects himself, would there be to him who should sow with lies the very soil of his growing nature. It is time enough in manhood to begin to lie to one's self: but a self-lying youth can have no proper self to rest on, at any period. So that the greatest liar, even Ferdinand Mendez Pinto, must have loved the truth, — at least at one time of his life. We say *loved;* for a voluntary choice implies of necessity some degree of pleasure in the choosing, however faint the emotion or insignificant the object. It is, therefore, *cæteris paribus,* not only necessary, but natural, to find pleasure in truth.

Now the question is, whether the pleasurable emotion, which is, so to speak, the indigenous growth of Truth, can in any case be free of self, or some personal gratification. To this, we apprehend, there will be no lack of answer. Nay, the answer has already been given from the dark antiquity of ages, that even for her own exceeding loveliness has Truth been canonized. If there was any thing of self in the *Eureka* of Pythagoras, there was not in the acclamations of his country who rejoiced with him. But we may doubt the feeling, if applied to him. If wealth or fame has sometimes followed in the track of Genius, it has followed as an accident, but never preceded, as the efficient conductor to any great discovery. For what is Genius but the

prophetic revealer of the unseen True, that can neither be purchased nor bribed into light? If it come, then, at all, it must needs be evoked by a kindred love as pure as itself. Shall we appeal to the artist? If he deserve the name, he will disdain the imputation that either wealth or fame has ever aided at the birth of his ideal offspring: it was Truth that smiled upon him, that made light his travail, that blessed their birth, and, by her fond recognition, imparted to his breast her own most pure, unimpassioned emotion. But, whatever mixed feeling, through the infirmity of the agent, may have influenced the artist, whether poet or painter, there can be but one feeling in the reader or spectator.

Indeed, so imperishable is this property of Truth, that it seems to lose nothing of its power, even when causing itself to be reflected from things that in themselves have, properly speaking, no truth. Of this we have abundant examples in some of the Dutch pictures, where the principal object is simply a dish of oysters or a pickled herring. We remember a picture of this kind, consisting solely of these very objects, from which we experienced a pleasure *almost* exquisite. And we would here remark, that the appetite then was in no way concerned. The pleasure, therefore, must have been from the imitated truth. It is certainly a curious question why this should be, while the things themselves, that is, the actual objects, should produce no such effect. And it seems to be because, in the latter case, there was no truth involved. The real oysters, &c., were indeed so far true as they were actual objects, but they did not contain a *truth* in *relation* to any thing. Whereas, in the pictured oysters, their relation to the actual was shown and verified in the mutual resemblance.

If this be true, as we doubt not, we have at least

one evidence, where it might not be looked for, that there is that in Truth which is satisfying of itself. But a stronger testimony may still be found where, from all *à priori* reasoning, we might expect, if not positive pain, at least no pleasure; and that is, where we find it united with human suffering, as in the deep scenes of tragedy. Now it cannot be doubted, that some of our most refined pleasures are often derived from this source, and from scenes that in nature we could not look upon. And why is this, but for the reason assigned in the preceding instance of a still-life picture? the only difference being, that the latter is addressed to the senses, and the former to the heart and intellect: which difference, however, well accounts for their vast disparity of effect. But may not these tragic pleasures have their source in sympathy alone? We answer, No. For who ever felt it in watching the progress of actual villany or the betrayal of innocence, or in being an eyewitness of murder? Now, though we revolt at these and the like atrocities in actual life, it would be both new and false to assert that they have no attraction in Art.

Nor do we believe that this acknowledged interest can well be traced to any other source than the one assumed; namely, to the truth of *relation*. And in this capacity does Truth stand to the Imagination, which is the proper medium through which the artist, whether poet or painter, projects his scenes.

The seat of interest here, then, being *in* the imagination, it is precisely on that account, and because it cannot be brought home to self, that the pleasure ensues; which is plainly, therefore, derived from its verisimilitude to the actual, and, though together with its appropriate excitement, yet without its imperative condition, namely, its call of *life* on the living affections.

The proper word here is *interest*, not sympathy, for sympathy with actual suffering, be the object good or bad, is in its nature painful; an obvious reason why so few in the more prosaic world have the virtue to seek it.

But is it not the business of the artist to touch the heart? True, — and it is his high privilege, as its liege-lord, to sound its very depths; nay, from its lowest deep to touch alike its loftiest breathing pinnacle. Yet he may not even approach it, except through the transforming atmosphere of the imagination, where alone the saddest notes of woe, even the appalling shriek of despair, are softened, as it were, by the tempering dews of this visionary region, ere they fall upon the heart. Else how could we stand the smothered moan of Desdemona, or the fiendish adjuration of Lady Macbeth, — more frightful even than the after-deed of her husband, — or look upon the agony of the wretched Judas, in the terrible picture of Rembrandt, when he returns the purchase of blood to the impenetrable Sanhedrim? Ay, how could we ever stand these but for that ideal panoply through which we feel only their modified vibrations?

Let the imitation, or rather copy, be so close as to trench on deception, the effect will be far different; for, the *condition* of *relation* being thus virtually lost, the copy becomes as the original, — circumscribed by its own qualities, repulsive or attractive, as the case may be. I remember a striking instance of this in a celebrated actress, whose copies of actual suffering were so painfully accurate, that I was forced to turn away from the scene, unable to endure it; her scream of agony in Belvidera seemed to ring in my ears for hours after. Not so was it with the great Mrs. Siddons, who

moved not a step but in a poetic atmosphere, through which the fiercest passions seemed rather to *loom* like distant mountains when first descried at sea, — massive and solid, yet resting on air.

It would appear, then, that there is something in truth, though but seen in the dim shadow of relation, that enforces interest, — and, so it be without pain, at least some degree of pleasure; which, however slight, is not unimportant, as presenting an impassable barrier to the mere animal. We must not, however, be understood as claiming for this Relative Truth the power of exciting a pleasurable interest in all possible cases; there are exceptions, as in the horrible, the loathsome, &c., which under no condition can be otherwise than revolting. It is enough for our purpose, to have shown that its effect is in most cases similar to that we have ascribed to Truth absolute.

But objections are the natural adversaries of every adventurer: there is one in our path which we soon descried at our first setting out. And we find it especially opposed to the assertion respecting children; namely, that between two things, where there is no personal advantage to bias the decision, they will always choose that which seems to them true, rather than the other which appears false. To this is opposed the notorious fact of the remarkable propensity which children have to lying This is readily admitted; but it does not meet us, unless it can be shown that they have not in the act of lying an eye to its *reward*, — setting aside any outward advantage, — in the shape of self-complacent thought at their superior wit or ingenuity. Now it is equally notorious, that such secret triumph will often betray itself by a smile, or wink, or some other sign from the chuckling urchin, which proves any

4

thing but that the lie was gratuitous. No, not even a child can love a lie purely for its own sake; he would else love it in another, which is against fact. Indeed, so far from it, that, long before he can have had any notion of what is meant by honor, the word *liar* becomes one of his first and most opprobrious terms of reproach. Look at any child's face when he tells his companion he lies. We ask no more than that most logical expression; and, if it speak not of a natural abhorrence only to be overcome by self-interest, there is no trust in any thing. No. We cannot believe that man or child, however depraved, *could* tell an *unproductive, gratuitous lie.*

Of the last and highest source of our pleasurable emotions we need say little; since no one will question that, if sought at all, it can only be for its own sake. But it does not become us — at least in this place — to enter on the subject of Holiness; of that angelic state, whose only manifestation is in the perfect unison with the Divine Will. We may, however, consider it in the next degree, as it is known, and as we believe often realized, among men: we mean Goodness.

We presume it is superfluous to define a good act; for every one knows, or ought to know, that no act is good in its true sense, which has any, the least, reference to the agent's self. Nor is it necessary to adduce examples; our object being rather to show that the recognition of goodness — and we beg that the word be especially noted — must result, of necessity, in such an emotion as shall partake of its own character, that is, be entirely devoid of self-interest.

This will no doubt appear to many a startling position. But let it be observed, that we have not said it will *always* be recognized. There are many reasons

why it should not be, and is not. We all know how
easy it is to turn away from what gives us no pleasure.
A long course of vice, together with the consciousness
that goodness has departed from ourselves, may make
it painful to look upon it. Nay, the contemplation of
it may become, on this account, so painful as to
amount to agony. But that Goodness can be hated
for its own sake we do not believe, except by a devil,
or some irredeemable incarnation of evil, if such there
be on this side the grave. But it is objected, that
bad men have sometimes a pleasure in Evil from which
they neither derive nor hope for any personal advantage,
that is, simply *because it is evil*. But we deny the
fact. We deny that an unmixed pleasure, which is
purely abstracted from all reference to self, is in the
power of Evil. Should any man assert this even of
himself, he is not to be believed; he lies to his own
heart, — and this he may do without being conscious of
it. But how can this be? Nothing more easy: by a
simple dislocation of words; by the aid of that false
nomenclature which began with the first Fratricide, and
has continued to accumulate through successive ages,
till it reached its consummation, for every possible sin,
in the French Revolution. Indeed, there are few things
more easy; it is only to transfer to the evil the name
of its opposite. Some of us, perhaps, may have wit-
nessed the savage exultation of some hardened wretch,
when the accidental spectator of an atrocious act.
But is such exultation pleasure? Is it at all akin to
what is recognized as pleasure even by this hardened
wretch? Yet so he may call it. But should we, could
we look into his heart? Should we not rather pause
for a time, from mere ignorance of the true vernacular
of sin. What he feels may thus be a mystery to all

but the reprobate; but it is not pleasure either in the deed or the doer: for, as the law of Good is Harmony, so is Discord that of Evil; and as sympathy to Harmony, so is revulsion to Discord. And where is hatred deepest and deadliest? Among the wicked. Yet they often hate the good. True: but not goodness, not the good man's virtues; these they envy, and hate him for possessing them. But more commonly the object of dislike is first stripped of his virtues by detraction; the detractor then supplies their place by the needful vices, — perhaps with his own; then, indeed, he is ripe for hatred. When a sinful act is made personal, it is another affair; it then becomes a *part* of *the man;* and he may then worship it with the idolatry of a devil. But there is a vast gulf between his own idol and that of another.

To prevent misapprehension, we would here observe, that we do not affirm of either Good or Evil any irresistible power of enforcing love or exciting abhorrence, having evidence to the contrary in the multitudes about us; all we affirm is, that, when contemplated abstractly, they cannot be viewed otherwise. Nor is the fact of their inefficiency in many cases difficult of solution, when it is remembered that the very condition to their *true* effect is the complete absence of self, that they must clearly be viewed *ab extra;* a hard, not to say impracticable, condition to the very depraved; for it may well be doubted if to such minds any act or object having a moral nature can be presented without some personal relation. It is not therefore surprising, that, where the condition is so precluded, there should be, not only no proper response to the law of Good or Evil, but such frequent misapprehension of their true character. Were it possible to see with the eyes of

others, this might not so often occur; for it need not
be remarked, that few things, if any, ever retain their
proper forms in the atmosphere of self-love; a fact that
will account for many obliquities besides the one in
question. To this we may add, that the existence of
a compulsory power in either Good or Evil could not,
in respect to man, consist with his free agency, — with-
out which there could be no conscience; nor does it
follow, that, because men, with the free power of choice,
yet so often choose wrong, there is any natural indis-
tinctness in the absolute character of Evil, which, as
before hinted, is sufficiently apparent to them when re-
ferring to others; in such cases the obliquitous choice
only shows, that, with the full force of right perception,
their interposing passions or interests have also the
power of giving their own color to every object hav-
ing the least relation to themselves.

Admitting this personal modification, we may then
safely repeat our position, — that to hate Good or to
love Evil, solely for their own sakes. is only possible
with the irredeemably wicked, in other words, with
devils.

We now proceed to the latter clause of our general
proposition. And here it may be asked, on what
ground we assume one intuitive universal Principle as
the true source of all those emotions which have just
been discussed. To this we reply, On the ground of
their common agreement. As we shall here use the
words *effect* and *emotion* as convertible terms, we wish
it to be understood, that, when we apply the epithet
common or *same* to *effect*, we do so only in relation to
kind, and for the sake of brevity, instead of saying the
same *class* of effects; implying also in the word *kind*
the existence of many degrees, but no other difference.

4 *

For instance, if a beautiful flower and a noble act shall be found to excite a kindred emotion, however slight from the one or deep from the other, they come in effect under the same category. And this we are forced to admit, however heterogeneous, since a common ground is necessarily predicated of a common result. How else, for instance, can we account for a scene in nature, a bird, an animal, a human form, affecting us each in a similar way? There is certainly no similitude in the objects that compose a landscape, and the form of an animal and man; they have no resemblance either in shape, or texture, or color, in roughness, smoothness, or any other known quality; while their several effects are so near akin, that we do not stop to measure even the wide degrees by which they are marked, but class them in a breath by some common term. It is very plain that this singular property of assimilating to one what is so widely unlike cannot proceed from any similar conformation, or quality, or attribute of mere being, that is, of any thing essential to distinctive existence. There must needs, then, be some common ground for their common effect. For if they agree not in themselves one with the other, it follows of necessity that the ground of their agreement must be in relation to something within our own minds, since only *there* is this common effect known as a fact.

We are now brought to the important question, *Where* and *what* is this reconciling ground? Certainly not in sensation, for that could only reflect their distinctive differences. Neither can it be in the reflective faculties, since the effect in question, being co-instantaneous, is wholly independent of any process of reasoning; for we do not feel it because we understand,

but only because we are conscious of its presence. Nay, it is because we neither do nor can understand it, being therefore a matter aloof from all the powers of reasoning, that its character is such as has been asserted, and, as such, universal.

Where, then, shall we search for this mysterious ground but in the mind, since only there, as before observed, is this common effect known as a fact? and where in the mind but in some inherent Principle, which is both intuitive and universal, since, in a greater or less degree, all men feel it *without knowing why?*

But since an inward Principle can, of necessity, have only a potential existence, until called into action by some outward object, it is also clear that any similar effect, which shall then be recognized through it, from any number of differing and distinct objects, can only arise from some mutual relation between a *something* in the objects and in the Principle supposed, as their joint result and proper product.

And, since it would appear that we cannot avoid the admission of some such Principle, having a reciprocal relation to certain outward objects, to account for these kindred emotions from so many distinct and heterogeneous sources, it remains only that we give it a name; which has already been anticipated in the term Harmony.

The next question here is, In what consists this *peculiar relation?* We have seen that it cannot be in any thing that is essential to any condition of mere being or existence; it must therefore consist in some *undiscoverable* condition indifferently applicable to the Physical, Intellectual, and Moral, yet only applicable in each to certain kinds.

And this is all that we do or *can* know of it. But

of this we may be as certain as that we live and breathe.

It is true that, for particular purposes, we may analyze certain combinations of sounds and colors and forms, so as to ascertain their relative quantities or collocation; and these facts (of which we shall hereafter have occasion to speak) may be of importance both in Art and Science. Still, when thus obtained, they will be no more than mere facts, on which we can predicate nothing but that, when they are imitated, — that is, when similar combinations of quantities, &c., are repeated in a work of art, — they will produce the same effect. But *why* they should is a mystery which the reflective faculties do not solve; and never can, because it refers to a living Power that is above the understanding. In the human figure, for instance, we can give no reason why eight heads to the stature please us better than six, or why three or twelve heads seem to us monstrous. If we say, in the latter case, *because* the head of the one is too small and of the other too large, we give no *reason;* we only state the *fact* of their disagreeable effect on us. And, if we make the proportion of eight heads our rule, it is because of the fact of its being more pleasing to us than any other; and, from the same feeling, we prefer those statures which approach it the nearest. Suppose we analyze a certain combination of sounds and colors, so as to ascertain the exact relative quantities of the one and the collocation of the other, and then compare them. What possible resemblance can the understanding perceive between these sounds and colors? And yet a something within us responds to both in a similar emotion. And so with a thousand things, nay, with myriads of objects that have no other affinity but

with that mysterious harmony which began with our being, which slept with our infancy, and which their presence only seems to have *awakened.* If we cannot go back to our own childhood, we may see its illustration in those about us who are now emerging into that unsophisticated state. Look at them in the fields, among the birds and flowers; their happy faces speak the harmony within them: the divine instrument, which these have touched, gives them a joy which, perhaps, only childhood in its first fresh consciousness can know. Yet what do they understand of musical quantities, or of the theory of colors?

And so with respect to Truth and Goodness; whose preëxisting Ideas, being in the living constituents of an immortal spirit, need but the slightest breath of some outward condition of the true and good, — a simple problem, or a kind act, — to awake them, as it were, from their unconscious sleep, and start them for eternity.

We may venture to assert, that no philosopher, however ingenious, could communicate to a child the abstract idea of Right, had the latter nothing beyond or above the understanding. He might, indeed, be taught, like the inferior animals, — a dog, for instance, — that, if he took certain forbidden things, he would be punished, and thus do right through fear. Still he would desire the forbidden thing, though belonging to another; nor could he conceive why he should not appropriate to himself, and thus allay his appetite, what was held by another, could he do so undetected; nor attain to any higher notion of right than that of the strongest. But the child has something higher than the mere power of apprehending consequences. The simplest exposition, whether of right or wrong, even by an ignorant nurse,

is instantly responded to by something *within him*, which, thus awakened, becomes to him a living voice ever after; and the good and the true must thenceforth answer its call, even though succeeding years would fain overlay them with the suffocating crowds of evil and falsehood.

We do not say that these eternal Ideas of Beauty, Truth, and Goodness will, strictly speaking, always act. Though indestructible, they may be banished for a time by the perverted Will, and mockeries of the brain, like the fume-born phantoms from the witches' caldron in Macbeth, take their places, and assume their functions. We have examples of this in every age, and perhaps in none more startling than in the present. But we mean only that they cannot be *forgotten:* nay, they are but too often recalled with unwelcome distinctness. Could we read the annals which must needs be scored on every heart,— could we look upon those of the aged reprobate, — who will doubt that their darkest passages are those made visible by the distant gleams from these angelic Forms, that, like the Three which stood before the tent of Abraham, once looked upon his youth?

And we doubt not that the truest witness to the common source of these inborn Ideas would readily be acknowledged by all, could they return to it now with their matured power of introspection, which is, at least, one of the few advantages of advancing years. But, though we cannot bring back youth, we may still recover much of its purer revelations of our nature from what has been left in the memory. From the dim present, then, we would appeal to that fresher time, ere the young spirit had shrunk from the overbearing pride of the understanding, and confidently ask, if the emotions we then felt from the Beautiful, the True,

and the Good, did not seem in some way to refer to a common origin. And we would also ask, if it was then frequent that the influence from one was *singly* felt,—if it did not rather bring with it, however remotely, a sense of something, though widely differing, yet still akin to it. When we have basked in the beauty of a summer sunset, was there nothing in the sky that spoke to the soul of Truth and Goodness ? And when the opening intellect first received the truth of the great law of gravitation, or felt itself mounting through the profound of space, to travel with the planets in their unerring rounds, did never then the kindred Ideas of Goodness and Beauty chime in, as it were, with the fabled music, — not fabled to the soul, — which led you on like one entranced ?

And again, when, in the passive quiet of your moral nature, so predisposed in youth to all things genial, you have looked abroad on this marvellous, ever teeming Earth, — ever teeming alike for mind and body, — and have felt upon you flow, as from ten thousand springs of Goodness, Truth, and Beauty, ten thousand streams of innocent enjoyment; did you not then *almost hear* them shout in confluence, and almost *see* them gushing upwards, as if they would prove their unity, in one harmonious fountain ?

But, though the preceding be admitted as all true in respect to certain " gifted" individuals, it may yet be denied that it is equally true with respect to all, in other words, that the Principle assumed is an inherent constituent of the human being. To this we reply, that universality does not necessarily imply equality.

The universality of a Principle does not imply *everywhere* equal energy or activity, or even the same mode of manifestation, any more than do the essential Fac-

ulties of the Understanding. Of this we have an anal-
ogous illustration in the faculty of Memory; which is
almost indefinitely differenced in different men, both in
degree and mode. In some, its greatest power is
shown in the retention of thoughts, but not of words,
that is, not of the original words in which they were pre-
sented. Others possess it in a very remarkable degree
as to forms, places, &c., and but imperfectly for other
things; others, again, never forget names, dates, or fig-
ures, yet cannot repeat a conversation the day after it
took place; while some few have the doubtful happi-
ness of forgetting nothing. We might go on with a
long list of the various modes and degrees in which
this faculty, so essential to the human being, is every-
where manifested. But this is sufficient for our pur-
pose. In like manner is the Principle of Harmony
manifested; in one person as it relates to Form, in
another to Sound; so, too, may it vary as to the degrees
of truth and goodness. We say degrees; for we may
well doubt whether, even in the faculty of memory, its
apparent absence as to any one essential object is any
thing more than a feeble degree of activity: and the
doubt is strengthened by the fact, that in many seem-
ingly hopeless cases it has been actually, as it were,
brought into birth. And we are still indisposed to ad-
mit its entire absence in any one particular for which it
was bestowed on man. An imperfect developement,
especially as relating to the intellectual and moral, we
know to depend, in no slight measure, on the *will* of
the subject. Nay, (with the exception of idiots,) it may
safely be affirmed, that no individual ever existed who
could not perceive the difference between what is true
and false, and right and wrong. We here, of course,
except those who have so ingeniously *unmade* them-

selves, in order to reconstruct their " humanity " after a better fashion. As to the " *why* " of these differences, we know nothing; it is one of those unfathomable mysteries which to the finite mind must ever be hidden.

Though it has been our purpose, throughout this discourse, to direct our inquiries mainly to the essential Elements of the subject, it may not be amiss here to take a brief notice of their collateral product in those mixed modes from which we derive so large a portion of our mental gratification : we allude to the various combinations of the several Ideas, which have just been examined, with each other as well as with their opposites. To this prolific source may be traced much of that many-colored interest which we take in their various forms as presented by the imagination, — in every thing, indeed, which is true, or even partially true, to the great Principle of Harmony, both in nature and in art. It is to these mixed modes more especially, that we owe all that mysterious interest which gives the illusion of life to a work of fiction, and fills us with delight or melts with woe, whether in the happiness or the suffering of some imagined being, uniting goodness with beauty, or virtue with plainness, or uncommon purity and intellect even with deformity; for even that may be so overpowered in the prominent harmony of superior intellect and moral worth, as to be virtually neutralized, at least, to become unobtrusive as a discordant force. Besides, it cannot be expected that *complete* harmony is ever to be realized in our imperfect state ; we should else, perhaps, with such expectation, have no pleasures of the kind we speak of: nor is this necessary, the imagination being always ready to supply deficiencies, whenever the approximation is sufficiently near to call

5

it forth. Nay, if the interest felt be nothing more than
mere curiosity, we still refer to this presiding Principle;
which is no less essential to a simple combination of
events, than to the higher demands of Form or Char-
acter. But its presence must be felt, however slightly.
Of this we have the evidence in many cases, and, per-
haps, most conclusive where the partial harmony is felt
to verge on a powerful discord; or where the effort to
unite them produces that singular alternation of what
is both revolting and pleasing: as in the startling union
of evil passions with some noble quality, or with a
master intellect. And here we have a solution of that
paradoxical feeling of interest and abhorrence, which
we experience in such a character as King Richard.

And may it not be that we are permitted this in-
terest for a deeper purpose than we are wont to sup-
pose ; because Sin is best seen in the light of Virtue, —
and then most fearfully when she holds the torch to
herself? Be this as it may, with pure, unintellectual,
brutal evil it is very different. We cannot look upon
it undismayed: we take no interest in it, nor can we.
In Richard there is scarce a glimmer of his better na-
ture; yet we do not despise him, for his intellect and
courage command our respect. But the fiend Iago,
— who ever followed him through the weaving of
his spider-like web, without perpetual recurrence to its
venomous source, — his devilish heart? Even the in-
tellect he shows seems actually animalized, and we
shudder at its subtlety, as at the cunning of a reptile.
Whatever interest may have been imputed to him
should be placed to the account of his hapless victim;
to the first striving with distrust of a generous nature;
to the vague sense of misery, then its gradual develope-
ment, then the final overthrow of absolute faith; and,

last of all, to the throes of agony of the noble Moor, as he writhes and gasps in his accursed toils.

To these mixed modes may be added another branch, which we shall term the class of Imputed Attributes. In this class are concerned all those natural objects with which we connect (not by individual association, but by a general law of the mind) certain moral or intellectual attributes; which are not, indeed, supposed to exist in the objects themselves, but which, by some unknown affinity, they awaken or occasion in us, and which we, in our turn, impute to them. However this be, there are multitudes of objects in the inanimate world, which we cannot contemplate without associating with them many of the characteristics which we ascribe to the human being; and the ideas so awakened we involuntarily express by the ascription of such significant epithets as *stately, majestic, grand,* and so on. It is so with us, when we call some tall forest stately, or qualify as majestic some broad and slowly-winding river, or some vast, yet unbroken waterfall, or some solitary, gigantic pine, seeming to disdain the earth, and to hold of right its eternal communion with air; or when to the smooth and far-reaching expanse of our inland waters, with their bordering and receding mountains, as they seem to march from the shores, in the pomp of their dark draperies of wood and mist, we apply the terms *grand* and *magnificent:* and so onward to an endless succession of objects, imputing, as it were, our own nature, and lending our sympathies, till the headlong rush of some mighty cataract suddenly thunders upon us. But how is it then? In the twinkling of an eye, the outflowing sympathies ebb back upon the heart; the whole mind seems severed from earth, and the awful feeling to suspend the

breath;—there is nothing human to which we can liken it. And here begins another kind of emotion, which we call Sublime.

We are not aware that this particular class of objects has hitherto been noticed, at least as holding a distinct position. And, if we may be allowed to supply the omission, we should assign to it the intermediate place between the Beautiful and the Sublime. Indeed, there seems to be no other station so peculiarly proper; inasmuch as they would thus form, in a consecutive series, a regular ascent from the sensible material to the invisible spiritual: hence naturally uniting into one harmonious whole every possible emotion of our higher nature.

In the preceding discussion, we have considered the outward world only in its immediate relation to Man, and the Human Being as the predetermined centre to which it was designed to converge. As the subject, however, of what are called the sublime emotions, he holds a different position; for the centre here is not himself, nor, indeed, can he approach it within conceivable distance: yet still he is drawn to it, though baffled for ever. Now the question is, Where, and in what bias, is this mysterious attraction? It must needs be in something having a clear affinity with us, or we could not feel it. But the attraction is also both pure and pleasurable; and it has just been shown, that we have in ourselves but one principle by which to recognize any corresponding emotion, — namely, the principle of Harmony. May we not then infer a similar Principle without us, an Infinite Harmony, to which our own is attracted? and may we not further, — if we may so speak without irreverence, — suppose our own to have emanated thence when " man became

a living soul"? And though this relation may not be consciously acknowledged in every instance, or even in one, by the mass of men, does it therefore follow that it does not exist? How many things act upon us of which we have no knowledge? If we find, as in the case of the Beautiful, the same, or a similar, effect to follow from a great variety of objects which have no resemblance or agreement with one another, is it not a necessary inference, that for their common effect they must all refer to something without and distinct from themselves? Now in the case of the Sublime, the something referred to is not in man: for the emotion excited has an outward tendency; the mind cannot contain it; and the effort to follow it towards its mysterious object, if long continued, becomes, in the excess of interest, positively painful.

Could any finite object account for this? But, supposing the Infinite, we have an adequate cause. If these emotions, then, from whatever object or circumstance, be to prompt the mind beyond its prescribed limits, whether carrying it back to the primitive past, the incomprehensible *beginning*, or sending it into the future, to the unknown *end*, the ever-present Idea of the mighty Author of all these mysteries must still be implied, though we think not of it. It is this Idea, or rather its influence, whether we be conscious of it or not, which we hold to be the source of every sublime emotion. To make our meaning plainer, we should say, that that which has the power of possessing the mind, to the exclusion, for the time, of all other thought, and which presents no *comprehensible* sense of a whole, though still impressing us with a full apprehension of such as a reality, — in other words, which cannot be circumscribed by the forms of the un-

5 *

derstanding while it strains them to the utmost, — that
we should term a sublime object. But whether this
effect be occasioned directly by the object itself, or be
indirectly suggested by its relations to some other
object, its unknown cause, it matters not; since the
apparent power of calling forth the emotion, by whatever
means, is, *quoad* ourselves, its sublime condition.
Hence, if a minute insect, an ant, for instance, through
its marvellous instinct, lift the mind of the amazed
spectator to the still more inscrutable Creator, it must
possess, as to *him*, the same power. This is, indeed, an
extreme case, and may be objected to as depending on
the individual mind; on a mind prepared by cultivation
and previous reflection for the effect in question.
But to this it may be replied, that some degree of cultivation,
or, more properly speaking, of developement
by the exercise of its reflective faculties, is obviously
essential ere the mind can attain to mature growth, —
we might almost say to its natural state, since nothing
can be said to have attained its true nature until
all its capacities are at least called into birth. No
one, for example, would refer to the savages of Australia
for a true specimen of what was proper or natural
to the human mind; we should rather seek it, if
such were the alternative, in a civilized child of five years
old. Be this as it may, it will not be denied that ignorance,
brutality, and many other deteriorating causes,
do practically incapacitate thousands for even an approximation,
not only to this, but to many of the inferior
emotions, the character of which is purely mental.
And this, we think, is quite sufficient to neutralize the
objection, if not, indeed, to justify the application of the
term to all cases where the *immediate* effect, whether directly
or indirectly, is such as has been described. But,

to reduce this to a common-sense view, it is only say-
ing, — what no one will deny, — that a man of edu-
cation and refinement has not only more, but higher,
pleasures of the mind than a mere clown.

But though the position here advanced must ne-
cessarily exclude many objects which have hitherto,
though, as we think, improperly, been classed with the
sublime, it will still leave enough, and more than
enough, for the utmost exercise of our limited powers;
inasmuch as, in addition to the multitude of objects in
the material world, not only the actions, passions, and
thoughts of men, but whatever concerns the human
being, that in any way — by a hint merely — leads
the mind, though indirectly, to the Infinite attributes, —
all come of right within the ground assumed.

It will be borne in mind, that the conscious presence
of the Infinite Idea is not only *not* insisted on, but ex-
pressly admitted to be, in most cases, unthought of; it
is also admitted, that a sublime effect is often power-
fully felt in many instances where this Idea could not
truly be predicated of the apparent object. In such
cases, however, some kind of resemblance, or, at least,
a seeming analogy to an infinite attribute, is neverthe-
less essential. It must *appear* to us, for the time, either
limitless, indefinite, or in some other way beyond the
grasp of the mind: and, whatever an object may *seem*
to be, it must needs *in effect* be to *us* even that which
it seems. Nor does this transfer the emotion to a dif-
ferent source; for the Infinite Idea, or something anal-
ogous, being thus imputed, is in reality its true cause.

It is still the unattainable, the *ever-stimulating*, yet
ever-eluding, in the character of the sublime object, that
gives to it both its term and its effect. And whence
the conception of this mysterious character, but from its

mysterious prototype, the Idea of the Infinite? Neither does it matter, as we have said, whether actual or supposed; for what the imagination cannot master will master the imagination. Take, for instance, but a single *passion*, and clothe it with this character; in the same instant it becomes sublime. So, too, with a single thought. In the Mosaic words so often quoted, " Let there be light, and there was light," we have the sublime of thought, of mere naked thought ; but what could more awe the mind with the power of God? Of like nature is the conjecture of Newton, when he imagined stars so distant from the sun that their coeval light has not yet reached us. Let us endeavour for one moment to conceive of this ; does not the soul seem to dilate within us, and the body to shrink as to a grain of dust? " Woe is me! unclean, unclean!" said the holy Prophet, when the Infinite Holiness stood before him. Could a more terrible distance be measured, than by these fearful words, between God and man?

If it be objected to this view, that many cases occur, having the same conditions with those assumed in our general proposition, which are yet exclusively painful, unmitigated even by a transient moment of pleasure, — in Despair, for instance, — as who can limit it? — to this we reply, that no emotion having its sole, or circle of existence in the individual mind itself, can be to that mind other than a *subject*. A man in despair, or under any mode of extreme suffering of like nature, may, indeed, if all interfering sympathy have been removed by time or after-description, be to *another* a sublime object, — at least in one of those suggestive forms just noticed; but not to *himself*. The source of the sublime — as all along implied — is essentially *ab extra*. The human mind is not its centre, nor can it be realized except by a contemplative act.

Besides, as a mental pleasure, — indeed the highest known, — to be recognized as such, it must needs be accompanied by the same *relative character* by which is tested every other pleasure coming under that denomination; namely, by the entire absence of *self*, that is, by the same freedom from all personal consideration which has been shown to characterize the true effect of the Three leading Ideas already considered. But if to this also it be further objected, that in certain particular cases, as of personal danger, — from which the sublime emotion has often been experienced, — some personal consideration must necessarily be involved, as without a sense of security we could not enjoy it; we answer, that, if it be meant only that the mind should be in such a state as to enable us to receive an unembarrassed impression, it seems to us superfluous, — an obvious truism placed in opposition to an absurd impossibility. We needed not to be told, that no pleasurable emotion is likely to occur while we are unmanned by fear. The same might be said, also, in respect to the Beautiful: for who was ever alive to it under a paroxysm of terror, or pain of any kind? A terrified person is in any thing but a fit state for such emotion. He may indeed *afterwards*, when his fear is passed off, contemplate the circumstance that occasioned it with a different feeling; but the object of his dismay is *then* projected, as it were, completely from himself; and he feels the sublimity in a contemplative state: he can feel it in no other. Nor is that state incompatible with a consciousness of peril, though it can never be with personal terror. And, if it is meant that we should have a positive, present conviction that we are in no danger, this we must deny, as we find it contradicted in innumerable instances. So far, indeed, is a sense

of security from being essential to the condition of a
sublime emotion, that the sense of danger, on the con-
trary, is one of its most exciting accompaniments.
There is a fascination in danger which some persons
neither can nor would resist; which seems, as it were,
to disenthral them of self;—as if the mysterious In-
finite were actually drawing them on by an invisible
power.

Was it mere scientific curiosity that cost the elder
Pliny his life? Might it not have been rather this sub-
lime fascination? But we have repeated examples of
it in our own time. Many who will read this may
have been in a storm at sea. Did they never feel its
sublimity while they knew their danger? We will
answer for ourselves; for we have been in one, when
the dismasted vessels that surrounded us permitted no
mistake as to our peril; it was strongly felt, but still
stronger was the sublime emotion in the awful scene.
The crater of Vesuvius is even now, perhaps for the
thousandth time, reflecting from its lake of fire some
ghastly face, with indrawn breath and hair bristling,
bent, as by fate, over its sulphurous brink.

Let us turn to Mont Blanc, that mighty pyramid of
ice, in whose shadow might repose all the tombs of the
Pharaohs. It rises before the traveller like the accumu-
lating mausoleum of Europe: perhaps he looks upon
it as his own before his natural time; yet he cannot
away from it. A terrible charm hurries him over fright-
ful chasms, whose blue depths seem like those of the
ocean; he cuts his way up a polished precipice, shining
like steel, — as elusive to the touch; he creeps slowly
and warily around and beneath huge cliffs of snow;
now he looks up, and sees their brows fretted by the
percolating waters like a Gothic ceiling, and he fears

even to whisper, lest an audible breath should awaken the avalanche: and thus he climbs and climbs, till the dizzy summit fills up his measure of fearful ecstasy.

Now, though cases may occur where the emotion in question is attended with a sense of security, as in the reading or hearing the description of an earthquake, such as that of 1768 in Lisbon, while we are safely housed and by a comfortable fire, it does not therefore follow, that this consciousness of safety is its essential condition. It is merely an accidental circumstance. It cannot, therefore, apply, either as a rule or an objection. Besides, even if supported by fact, we might well dismiss it on the ground of irrelevancy, since a sense of personal safety cannot be placed in opposition to and as inconsistent with a disinterested or unselfish state; which is that claimed for the emotion as its true condition. If there be not, then, a sounder objection, we may safely admit the characteristic in question; for the reception of which we have, on the other hand, the weight of experience, — at least negatively, since, strictly speaking, we cannot experience the absence of any thing.

But though, according to our theory, there are many things now called sublime that would properly come under a different classification, such as many objects of Art, many sentiments, and many actions, which are strictly human, as well in their *end* as in their origin; it is not to be inferred that the exclusion of any work of man is *because* of *its apparent origin*, but of its *end*, the end only being the determining point, as referring to its *Idea*. Now, if the Idea referred to be of the Infinite, which is *out* of his nature, it cannot strictly be said to originate with man, — that is, absolutely; but it is rather, as it were, a reflected form of it from

the Maker of his mind. If we are led to such an Idea,
then, by any work of imagination, a poem, a picture, a
statue, or a building, it is as truly sublime as any natu-
ral object. This, it appears to us, is the sole mystery,
without which neither sound, nor color, nor form, nor
magnitude, is a true correlative to the unseen cause.
And here, as with Beauty, though the test of that be
within us, is the *modus operandi* equally baffling to the
scrutiny of the understanding. We feel ourselves, as
it were, lifted from the earth, and look upon the out-
ward objects that have so affected us, yet learn not
how; and the mystery deepens as we compare them
with other objects from which have followed the same
effects, and find no resemblance. For instance; the roar
of the ocean, and the intricate unity of a Gothic cathe-
dral, whose beginning and end are alike intangible,
while its climbing tower seems visibly even to rise to
the Idea which it strives to embody, — these have noth-
ing in common, — hardly two things could be named
that are more unlike; yet in relation to man they have
but one end: for who can hear the ocean when breath-
ing in wrath, and limit it in his mind, though he think
not of Him who gives it voice? or ascend that spire
without feeling his faculties vanish, as it were with its
vanishing point, into the abyss of space? If there be
a difference in the effect from these and other objects,
it is only in the intensity, the degree of impetus given;
as between that from the sudden explosion of a volcano
and from the slow and heavy movement of a rising
thunder-cloud; its character and its office are the same,
— in its awful harmony to connect the created with its
Infinite Cause.

But let us compare this effect with that from Beauty.
Would the Parthenon, for instance, with its beauti-

ful forms, — made still more beautiful under its native sky, — seeming almost endued with the breath of life, as if its conscious purple were a living suffusion brought forth in sympathy by the enamoured blushes of a Grecian sunset; — would this beautiful object even then elevate the soul above its own roof? No: we should be filled with a pure delight, — but with no longing to rise still higher. It would satisfy us; which the sublime does not; for the feeling is too vast to be circumscribed by human content.

On the supernatural it is needless to enlarge; for, in whatever form the beings of the invisible world are supposed to visit us, they are immediately connected in the mind with the unknown Infinite; whether the faith be in the heart or in the imagination; whether they bubble up from the earth, like the Witches in Macbeth, taking shape at will, or self-dissolving into air, and no less marvellous, foreknowing thoughts ere formed in man; or like the Ghost in Hamlet, an unsubstantial shadow, having the functions of life, motion, will, and speech; a fearful mystery invests them with a spell not to be withstood; the bewildered imagination follows like a child, leaving the finite world for one unknown, till it aches in darkness, trackless, endless.

Perhaps, as being nearest in station to the unsearchable Author of all things, the highest example of this would be found in the Angelic Nature. If it be objected, that the poets have not always so represented it, it rests with them to show cause why they have not. Milton, no doubt, could have assigned a sufficient reason in *the time chosen for his poem*, — that of the creation of the first man, when his intercourse with the highest order of created beings was not only essential to the plan of the poem, but according with the express

6

will of the Creator: hence, he might have considered
it no violation of the *then* relation between man and
angels to assign even the epithet *affable* to the arch-
angel Raphael; for man was then sinless, and in all
points save knowledge a fit object of regard, and cer-
tainly a fit pupil to his heavenly instructor. But, sup-
pose the poet, throughout his work, (as in the process of
his story he was forced to do near the end,) — suppose
he had chosen, assuming the philosopher, to assign to
Adam the *altered relation of one of his fallen posterity*,
how could he have endured a holy spiritual presence?
To be consistent, Adam must have been dumb with
awe, incapable of holding converse such as is describ-
ed. Between sinless man and his sinful progeny, the
distance is immeasurable. And so, too, must be the ef-
fect on the latter, in such a presence; and for this conclu-
sion we have the authority of Scripture, in the dismay
of the soldiers at the Saviour's sepulchre, on which
more directly. If there be no like effect attending the
other angelic visits recorded in Scripture, such as those
to Lot and Abraham, the reason is obvious in the
special mission to those individuals, who were doubtless
divinely prepared for their reception; for it is reasonable
to suppose the mission had else been useless. But
with the Roman soldiers, where there was no such
qualifying circumstance, the case was different; indeed,
it was in striking contrast with that of the two Marys,
who, though struck with awe, yet being led there, as
witnesses, by the Spirit, were not so overpowered.

And here, as the Idea of Angels is universally asso-
ciated with every perfection of *form*, may naturally oc-
cur the question so often agitated, — namely, whether
Beauty and Sublimity are, under any circumstances,
compatible. To us it seems of easy solution. For

we see no reason why Beauty, as the condition of a subordinated object or component part, may not incidentally enter into the Sublime, as well as a thousand other conditions of opposite characters, which pertain to the multifarious assimilants that often form its other components.

When Beauty is not made *essential*, but enters as a mere contingent, its admission or rejection is a matter of indifference. In an angel, for instance, beauty is the condition of his mere form; but the angel has also an intellectual and moral or spiritual nature, which is essentially paramount: the former being but the condition, so to speak, of his visibility, the latter, his very life, — an Essence next to the inconceivable Giver of life.

Could we stand in the presence of one of these holy beings, (if to stand were possible,) what of the Sublime in this lower world would so shake us? Though his beauty were such as never mortal dreamed of, it would be as nothing, — swallowed up as darkness, — in the awful, spiritual brightness of the messenger of God. Even as the soldiers in Scripture, at the sepulchre of the Saviour, we should fall before him, — we should " become," like them, " as dead men."

But though Milton does not unveil the " face like lightning "; and though the angel Raphael is made to hold converse with man, and the " severe in youthful beauty " gives even the individual impress to Zephon, and Michael and Abdiel are set apart in their prowess; there is not one he names that does not breathe of Heaven, that is not encompassed with the glory of the Infinite. And why the reader is not overwhelmed in their supposed presence is because he is a beholder *through* Adam, — through him also a listener; but when-

ever he is made, by the poet's spell, to forget Adam,
and to see, as it were in his own person, the embattled
hosts * * * * *

If we dwell upon Form *alone*, though it should be of
surpassing beauty, the idea would not rise above that
of man, for this is conceivable of man: but the mo-
ment the angelic nature is touched, we have the higher
ideas of supernal intelligence and perfect holiness, to
which all the charms and graces of mere form immedi-
ately become subordinate, and, though the beauty re-
main, its agency is comparatively negative under the
overpowering transcendence of a celestial spirit.

As we have already seen that the Beautiful is limit-
ed to no particular form, but possesses its power in
some mysterious *condition*, which is applicable to many
distinct objects; in like manner does the Sublime in-
clude within its sphere, and subdue to its condition, an
indefinite variety of objects, with their distinctive condi-
tions; and among them we find that of the Beautiful,
as well as, to a *certain degree*, its reverse, so that, though
we may truly recognize their coëxistence in the same
object, it is not possible that their effect upon us should
be otherwise than unequal, and that the higher law
should not subordinate the lower. We do not deny
that the Beautiful may, so to speak, mitigate the awful
intensity of the Sublime; but it cannot change its char-
acter, much less impart its own; the one will still be
awful, the other, of itself, never.

When at Rome, we once asked a foreigner, who
seemed to be talking somewhat vaguely on the subject,
what he understood by the Sublime. His answer was,
" Le plus beau"; making it only a matter of degree.
Now let us only imagine (if we can) a beautiful earth-
quake, or a beautiful hurricane. And yet the foreign-

er is not alone in this. D'Azzara, the biographer of Mengs, speaking of Beauty, talks of "this sublime quality," and in another place, for certain reasons assigned, he says, "The grand style is beautiful." Nay, many writers, otherwise of high authority, seem to have taken the same view; while others who could have had no such notion, having used the words Beauty and the Beautiful in an allegorical or metaphorical sense, have sometimes been misinterpreted literally. Hence Winckelmann reproaches Michael Angelo for his continual talk about Beauty, when he showed nothing of it in his works. But it is very evident that the *Beltà* and *Bellezza* of Michael Angelo were never used by him in a literal sense, nor intended to be so understood by others: he adopted the terms solely to express abstract Perfection, which he allegorized as the mistress of his mind, to whose exclusive worship his whole life was devoted. Whether it was the most appropriate term he could have chosen, we shall not inquire. It is certain, however, that the literal adoption of it by subsequent writers has been the cause of much confusion, as well as vagueness.

For ourselves, we are quite at a loss to imagine how a notion so obviously groundless has ever had a single supporter; for, if a distinct effect implies a distinct cause, we do not see why distinct terms should not be employed to express the difference, or how the legitimate term for one can in any way be applied to signify a particular degree of the other. Like the two Dromios, they sometimes require a conjurer to tell which is which. If only Perfection, which is a generic term implying the summit of all things, be meant, there is surely nothing to be gained (if we except *intended* obscurity) by substituting a specific term which is limited

6 *

to a few. We speak not here of allegorical or met-
aphorical propriety, which is not now the question,
but of the literal and didactic; and we may add, that
we have never known but one result from this arbitrary
union, — which is, to procreate words.

In further illustration of our position, it may be
well here to notice one mistaken source of the Sublime,
which seems to have been sometimes resorted to, both in
poems and pictures; namely, in the sympathy excited
by excruciating bodily suffering. Suppose a man on
the rack to be placed before us, — perhaps some miser-
able victim of the Inquisition; the cracking of his joints
is made frightfully audible; his calamitous "Ah!" goes
to our marrow; then the cruel precision of the mechan-
ical familiar, as he lays bare to the sight his whole
anatomy of horrors. And suppose, too, the executioner
compelled to his task, — consequently an irresponsible
agent, whom we cannot curse; and, finally, that these
two objects compose the whole scene. What could
we feel but an agony even like that of the sufferer, the
only difference being that one is physical, the other
mental? And this is all that mere sympathy has any
power to effect; it has led us to its extreme point, —
our flesh creeps, and we turn away with almost bodily
sickness. But let another actor be added to the drama
in the presiding Inquisitor, the cool methodizer of this
process of torture; in an instant the scene is changed,
and, strange to say, our feelings become less painful, —
nay, we feel a momentary interest, — from an instant
revulsion of our moral nature: we are lost in wonder
at the excess of human wickedness, and the hateful
wonder, as if partaking of the infinite, now distends
the faculties to their utmost tension; for who can set
bounds to passion when it seizes the whole soul? It is

as the soul itself, without form or limit. We may not think even of the after judgment; we become ourselves *justice*, and we award a hatred commensurate with the sin, so indefinite and monstrous that we stand aghast at our own judgment.

Why this extreme tension of the mind, when thus outwardly occasioned, should create in us an interest, we know not; but such is the fact, and we are not only content to endure it for a time, but even crave it, and give to the feeling the epithet *sublime*.

We do not deny that much bodily suffering may be admitted with effect as a subordinate agent, when, as in the example last added, it is made to serve as a necessary expositor of moral deformity. Then, indeed, in the hands of a great artist, it becomes one of the most powerful auxiliaries to a sublime end. All that we contend for is that sympathy alone is insufficient as a cause of sublimity.

There are yet other sources of the false sublime, (if we may so call it,) which are sometimes resorted to also by poets and painters; such as the horrible, the loathsome, the hideous, and the monstrous : these form the impassable boundaries to the true Sublime. Indeed, there appears to be in almost every emotion a certain point beyond which we cannot pass without recoiling, — as if we instinctively shrunk from what is forbidden to our nature.

It would seem, then, that, in relation to man, Beauty is the extreme point, or last summit, of the natural world, since it is in that that we recognize the highest emotion of which we are susceptible from the purely physical. If we ascend thence into the moral, we shall find its influence diminish in the same ratio with our upward progress. In the continuous chain of creation of which it

forms a part, the link above it where the moral modifi-
cation begins seems scarcely changed, yet the difference,
though slight, demands another name, and the nomen-
clator within us calls it Elegance ; in the next connect-
ing link, the moral adjunct becomes more predominant,
and we call it Majesty ; in the next, the physical becomes
still fainter, and we call the union Grandeur ; in the next,
it seems almost to vanish, and a new form rises before
us, so mysterious, so undefined and elusive to the senses,
that we turn, as if for its more distinct image, within
ourselves, and there, with wonder, amazement, awe, we
see it filling, distending, stretching every faculty, till,
like the Giant of Otranto, it seems almost to burst the
imagination : under this strange confluence of opposite
emotions, this terrible pleasure, we call the awful form
Sublimity. This was the still, small voice that shook
the Prophet on Horeb ; — though small to his ear, it was
more than his imagination could contain; he could not
hear it again and live.

It is not to be supposed that we have enumerated all
the forms of gradation between the Beautiful and the
Sublime; such was not our purpose; it is sufficient to
have noted the most prominent, leaving the intermedi-
ate modifications to be supplied (as they can readily
be) by the reader. If we descend from the Beautiful,
we shall pass in like manner through an equal varie-
ty of forms gradually modified by the grosser material
influences, as the Handsome, the Pretty, the Comely,
the Plain, &c., till we fall to the Ugly.

There ends the chain of pleasurable excitement ; but
not the chain of Forms ; which, taking now as if a lit-
eral curve, again bends upward, till, meeting the de-
scending extreme of the moral, it seems to complete
the mighty circle. And in this dark segment will be

found the startling union of deepening discords, — still deepening, as it rises from the Ugly to the Loathsome, the Horrible, the Frightful,* the Appalling.

As we follow the chain through this last region of disease, misery, and sin, of embodied Discord, and feel, as we must, in the mutilated affinities of its revolting forms, their fearful relation to this fair, harmonious creation, — how does the awful fact, in these its breathing fragments, speak to us of a fallen world!

As the living centre of this stupendous circle stands the Soul of Man; the *conscious Reality*, to which the vast inclosure is but the symbol. How vast, then, his being! If space could measure it, the remotest star would fall within its limits. Well, then, may he tremble to essay it even in thought; for where must it carry him, — that winged messenger, fleeter than light? Where but to the confines of the Infinite ; even to the presence of the unutterable *Life*, on which nothing finite can look and live?

Finally, we shall conclude our Discourse with a few words on the master Principle, which we have supposed to be, by the will of the Creator, the realizing life to all things fair and true and good : and more especially would we revert to its spiritual purity, emphatically manifested through all its manifold operations, — so impossible of alliance with any thing sordid, or false, or wicked, — so unapprehensible, even, except for its own most sinless sake. Indeed, we cannot look upon it as other than the universal and eternal witness of God's goodness and love, to draw man to himself, and to testify to the meanest, most obliquitous mind, — at least once in life, be it though in childhood, — that there *is* such a thing as *good without self*.

* The Frightful is not the Terrible, though often confounded with it.

It will be remembered, that, in all the various examples adduced, in which we have endeavoured to illustrate the operation of Harmony, there was but one character to all its effects, whatever the difference in the objects that occasioned them; that it was ever untinged with any personal taint: and we concluded thence its supernal source. We may now advance another evidence still more conclusive of its spiritual origin, namely, in the fact, that it cannot be realized in the Human Being *quoad* himself. With the fullest consciousness of the possession of this principle, and with the power to realize it in other objects, he has still no power in relation to himself, — that is, to become the object to himself.

Now, as the condition of Harmony, so far as we can know it through its effect, is that of *impletion*, where nothing can be added or taken away, it is evident that such a condition can never be realized by the mind in itself. And yet the desire to this end is as evidently implied in that incessant, yet unsatisfying activity, which, under all circumstances, is an imperative, universal law of our nature.

It might seem needless to enlarge on what must be generally felt as an obvious truth; still, it may not be amiss to offer a few remarks, by way of bringing it, though a truism, more distinctly before us. In all ages the majority of mankind have been more or less compelled to some kind of exertion for their mere subsistence. Like all compulsion, this has no doubt been considered a hardship. Yet we never find, when by their own industry, or any fortunate circumstance, they have been relieved from this exigency, that any one individual has been contented with doing nothing. Some, indeed, before their liberation, have conceived of idleness

as a kind of synonyme with happiness ; but a short
experience has never failed to prove it no less remote
from that desirable state. The most offensive employ-
ments, for the want of a better, have often been resum-
ed, to relieve the mind from the intolerable load of *noth-
ing*, — the heaviest of all weights, — as it needs must
be to an immortal spirit: for the mind cannot stop, ex-
cept it be in a mad-house ; there, indeed, it may rest,
or rather stagnate, on one thought, — its little circle,
perhaps of misery. From the very moment of con-
sciousness, the active Principle begins to busy itself
with the things about it : it shows itself in the infant,
stretching its little hands towards the candle ; in the
schoolboy, filling up, if alone, his play-hour with the
mimic toils of after age ; and so on, through every
stage and condition of life ; from the wealthy spend-
thrift, beggaring himself at the gaming-table for em-
ployment, to the poor prisoner in the Bastile, who, for
the want of something to occupy his thoughts, overcame
the antipathy of his nature, and found his companion in
a spider. Nay, were there need, we might draw out the
catalogue till it darkened with suicide. But enough has
been said to show, that, aside from guilt, a more terrible
fiend has hardly been imagined than the little word
Nothing, when embodied and realized as the master of
the mind. And well for the world that it is so ; since
to this wise law of our nature, to say nothing of con-
veniences, we owe the endless sources of innocent en-
joyment with which the industry and ingenuity of man
have supplied us.

But the wisdom of the law in question is not merely
that it is a preventive to the mind preying on itself ;
we see in it a higher purpose, — no less than what in-
volves the developement of the human being ; and, if we

look to its final bearing, it is of the deepest import. It might seem at first a paradox, that, the natural condition of the mind being averse to inactivity, it should still have so strong a desire for rest; but a little reflection will show that this involves no real contradiction. The mind only mistakes the *name* of its object, neither rest nor action being its real aim; for in a state of rest it desires action, and in a state of action, rest. Now all action supposes a purpose, which purpose can consist of but one of two things; either the attainment of some immediate object as its completion, or the causing of one or more future acts, that shall follow as a consequence. But whether the action terminates in an immediate object, or serves as the procreating cause of an indefinite series of acts, it must have some ultimate object in which it ends, — or is to end. Even supposing such a series of acts to be continued through a whole life, and yet remain incomplete, it would not alter the case. It is well known that many such series have employed the minds of mathematicians and astronomers to their last hour; nay, that those acts have been taken up by others, and continued through successive generations : still, whether the point be arrived at or no, there must have been an end in contemplation.

Now no one can believe that, in similar cases, any man would voluntarily devote all his days to the adding link after link to an endless chain, for the mere pleasure of labor. It is true he may be aware of the wholesomeness of such labor as one of the means of cheerfulness; but, if he have no further aim, his being aware of this result makes an equable flow of spirits a positive object. Without *hope*, uncompelled labor is an impossibility; and hope implies an object. Nor would the veriest idler, who passes a whole day in

whittling a stick, if he could be brought to look into himself, deny it. So far from having no object, he would and must acknowledge that he was in fact hoping to relieve himself of an oppressive portion of time by whittling away its minutes and hours. Here we have an extreme instance of that which constitutes the real business of life, from the most idle to the most industrious; namely, to attain to a *satisfying state*.

But no one will assert that such a state was ever a consequence of the attainment of any object, however exalted. And why? Because the motive of action is left behind, and we have nothing before us.

Something to desire, something to look forward to, we *must* have, or we perish, — even of suicidal rest. If we find it not here in the world about us, it must be sought for in another; to which, as we conceive, that secret ruler of the soul, the inscrutable, ever-present spirit of Harmony, for ever points. Nor is it essential that the thought of harmony should even cross the mind; for a want may be felt without any distinct consciousness of the form of that which is desired. And, for the most part, it is only in this negative way that its influence is acknowledged. But this is sufficient to account for the universal longing, whether definite or indefinite, and the consequent universal disappointment.

We have said that man cannot to himself become the object of Harmony, — that is, find its proper correlative in himself; and we have seen that, in his present state, the position is true. How is it, then, in the world of spirit? Who can answer? And yet, perhaps, — if without irreverence we might hazard the conjecture, — as a finite creature, having no centre in himself on which to revolve, may it not be that his true correlative

7

will there be revealed (if, indeed, it be not before) to the
disembodied man, in the Being that made him? And
may it not also follow, that the Principle we speak of
will cease to be potential, and flow out, as it were, and
harmonize with the eternal form of Hope, — even that
Hope whose living end is in the unapproachable
Infinite?

Let us suppose this form of hope to be taken away
from an immortal being who has no self-satisfying
power within him, what would be his condition? A
conscious, interminable vacuum, were such a thing
possible, would but faintly image it. Hope, then,
though in its nature unrealizable, is not a mere *notion;*
for so long as it continues hope, it is to the mind an
object and an object *to be* realized; so, where its form
is eternal, it cannot but be to it an ever-during object.
Hence we may conceive of a never-ending approxima-
tion to what can never be realized.

From this it would appear, that, while we cannot
to ourselves become the object of Harmony, it is
nevertheless certain, from the universal desire *so* to
realize it, that we cannot suppress the continual
impulse of this paramount Principle; which, there-
fore, as it seems to us, must have a double purpose;
first, by its outward manifestation, which we all recog-
nize, to confirm its reality, and secondly, to convince
the mind that its true object is not merely out of, but
above, itself, — and only to be found in the Infinite
Creator.

ART.

IN treating on Art, which, in its highest sense, and more especially in relation to Painting and Sculpture, is the subject proposed for our present examination, the first question that occurs is, In what consists its peculiar character? or rather, What are the characteristics that distinguish it from Nature, which it professes to imitate?

To this we reply, that Art is characterized, —

First, by Originality.

Secondly, by what we shall call Human or Poetic Truth; which is the verifying principle by which we recognize the first.

Thirdly, by Invention; the product of the Imagination, as grounded on the first, and verified by the second. And,

Fourthly, by Unity, the synthesis of all.

As the first step to the right understanding of any discourse is a clear apprehension of the terms used, we add, that by Originality we mean any thing (admitted by the mind as *true*) which is peculiar to the Author, and which distinguishes his production from that of all others; by Human or Poetic Truth, that which may be said to exist exclusively in and for the mind, and as contradistinguished from the truth of things in the

natural or external world; by Invention, any unprac-
tised mode of presenting a subject, whether by the com-
bination of entire objects already known, or by the
union and modification of known but fragmentary parts
into new and consistent forms; and, lastly, by Unity,
such an agreement and interdependence of all the
parts, as shall constitute a whole.

It will be our attempt to show, that, by the presence
or absence of any one of these characteristics, we shall
be able to affirm or deny in respect to the pretension of
any object as a work of Art; and also that we shall
find within ourselves the corresponding law, or by
whatever word we choose to designate it, by which
each will be recognized; that is, in the degree propor-
tioned to the developement, or active force, of the law
so judging.

Supposing the reader to have gone along with us in
what has been said of the *Universal*, in our Prelim-
inary Discourse, and as assenting to the position, that
any faculty, law, or principle, which can be shown to
be *essential* to *any one* mind, must necessarily be also
predicated of every other sound mind, even where the
particular faculty or law is so feebly developed as
apparently to amount to its absence, in which case it
is inferred potentially, — we shall now assume, on the
same grounds, that the originating *cause*, notwithstand-
ing its apparent absence in the majority of men, is an
essential reality in the condition of the Human Being;
its potential existence in all being of necessity affirm-
ed from its existence in one.

Assuming, then, its reality, — or rather leaving it to
be evidenced from its known effects, — we proceed to
inquire *in what* consists this originating power.

And, first, as to its most simple form. If it be true,

(as we hope to set forth more at large in a future dis-
course,) that no two minds were ever found to be
identical, there must then in every individual mind be
something which is not in any other. And, if this un-
known something is also found to give its peculiar hue,
so to speak, to every impression from outward objects,
it seems but a natural inference, that, whatever it be, it
must possess a pervading force over the entire mind, —
at least, in relation to what is external. But, though
this may truly be affirmed of man generally, from its
evidence in any one person, we shall be far from the
fact, should we therefore affirm, that, otherwise than
potentially, the power of outwardly manifesting it is
also universal. We know that it is not, — and our daily
experience proves that the power of reproducing or
giving out the individualized impressions is widely
different in different men. With some it is so feeble
as apparently never to act; and, so far as our subject
is concerned, it may practically be said not to exist; of
which we have abundant examples in other mental
phenomena, where an imperfect activity often renders
the existence of some essential faculty a virtual nullity.
When it acts in the higher degrees, so as to make an-
other see or feel *as* the Individual saw or felt, — this,
in relation to Art, is what we mean, in its strictest
sense, by Originality. He, therefore, who possesses the
power of presenting to another the *precise* images or
emotions as they existed in himself, presents that
which can be found nowhere else, and was first found
by and within himself; and, however light or trifling,
where these are true as to his own mind, their author is
so far an originator.

But let us take an example, and suppose two *por-
traits;* simple heads, without accessories, that is, with

7 *

blank backgrounds, such as we often see, where no attempt is made at composition; and both by artists of equal talent, employing the same materials, and conducting their work according to the same technical process. We will also suppose ourselves acquainted with the person represented, with whom to compare them. Who, that has ever made a similar comparison, will expect to find them identical? On the contrary, though in all respects equal, in execution, likeness, &c., we shall still perceive a certain *exclusive something* that will instantly distinguish the one from the other, and both from the original. And yet they shall both seem to us true. But they will be true to us also in a double sense; namely, as to the living original and as to the individuality of the different painters. Where such is the result, both artists must originate, inasmuch as they both outwardly realize the individual image of their distinctive minds.

Nor can the truth they present be ascribed to the technic process, which we have supposed the same with each; as, on such a supposition, with their equal skill, the result must have been identical. No; by whatever it is that one man's mental impression, or his mode of thought, is made to differ from another's, it is that something, which our imaginary artists have here transferred to their pencil, that makes them different, yet both original.

Now, whether the medium through which the impressions, conceptions, or emotions of the mind are thus externally realized be that of colors, words, or any thing else, this mysterious though certain principle is, as we believe, the true and only source of all originality.

In the power of assimilating what is foreign, or ex-

ternal, to our own particular nature consists the individualizing law, and in the power of reproducing what is thus modified consists the originating cause.

Let us turn now to an opposite example, — to a mere mechanical copy of some natural object, where the marks in question are wholly wanting. Will any one be truly affected by it? We think not; we do not say that he will not praise it, — this he may do from various motives; but his *feeling* — if we may so name the index of the law within — will not be called forth to any spontaneous correspondence with the object before him.

But why talk of feeling, says the pseudo-connoisseur, where we should only, or at least first, bring knowledge? This is the common cant of those who become critics for the sake of distinction. Let the Artist avoid them, if he would not disfranchise himself in the suppression of that uncompromising *test* within him, which is the only sure guide to the truth without.

It is a poor ambition to desire the office of a judge merely for the sake of passing sentence. But such an ambition is not likely to possess a person of true sensibility. There are some, however, in whom there is no deficiency of sensibility, yet who, either from self-distrust, or from some mistaken notion of Art, are easily persuaded to give up a right feeling, in exchange for what they may suppose to be knowledge, — the barren knowledge of faults; as if there could be a human production without them! Nevertheless, there is little to be apprehended from any conventional theory, by one who is forewarned of its mere negative power, — that it can, at best, only suppress feeling; for no one ever was, or ever can be, argued into a real liking for what he has once felt to be false. But, where the feeling is genuine, and

not the mere reflex of a popular notion, so far as it goes it must be true. Let no one, therefore, distrust it, to take counsel of his head, when he finds himself standing before a work of Art. Does he feel its truth? is the only question, — if, indeed, the impertinence of the understanding should then propound one; which we think it will not, where the feeling is powerful. To such a one, the characteristic of Art upon which we are now discoursing will force its way with the power of light; nor will he ever be in danger of mistaking a mechanical copy for a living imitation.

But we sometimes hear of " faithful transcripts," nay, of fac-similes. If by these be implied neither more nor less than exists in their originals, they must still, in that case, find their true place in the dead category of Copy. Yet we need not be detained by any inquiry concerning the merits of a fac-simile, since we firmly deny that a fac-simile, in the true sense of the term, is a thing possible.

That an absolute identity between any natural object and its represented image is a thing impossible, will hardly be questioned by any one who thinks, and will give the subject a moment's reflection; and the difficulty lies in the nature of things, the one being the work of the Creator, and the other of the creature. We shall therefore assume as a fact, the eternal and insuperable difference between Art and Nature. That our pleasure from Art is nevertheless similar, not to say equal, to that which we derive from Nature, is also a fact established by experience; to account for which we are necessarily led to the admission of another fact, namely, that there exists in Art a *peculiar something* which we receive as equivalent to the admitted difference. Now, whether we call this equivalent, individu-

alized truth, or human or poetic truth, it matters not; we know by its *effects*, that some such principle does exist, and that it acts upon us, and in a way corresponding to the operation of that which we call Truth and Life in the natural world. Of the various laws growing out of this principle, which take the name of Rules when applied to Art, we shall have occasion to speak in a future discourse. At present we shall confine ourselves to the inquiry, how far the difference alluded to may be safely allowed in any work professing to be an imitation of Nature.

The fact, that truth may subsist with a very considerable admixture of falsehood, is too well known to require an argument. However reprehensible such an admixture may be in morals, it becomes in Art, from the limited nature of our powers, a matter of necessity.

For the same reason, even the realizing of a thought, or that which is properly and exclusively human, must ever be imperfect. If Truth, then, form but the greater proportion, it is quite as much as we may reasonably look for in a work of Art. But why, it may be asked, where the false predominates, do we still derive pleasure? Simply because of the Truth that remains. If it be further demanded, What is the minimum of truth in order to a pleasurable effect? we reply, So much only as will cause us to feel that the truth *exists*. It is this feeling alone that determines, not only the true, but the degrees of truth, and consequently the degrees of pleasure.

Where no such feeling is awakened, and supposing no deficiency in the recipient, he may safely, from its absence, pronounce the work false; nor could any ingenious theory of the understanding convince him to the contrary. He may, indeed, as some are wont to

do, make a random guess, and *call* the work true; but
he can never so *feel* it by any effort of reasoning. But
may not men differ as to their impressions of truth?
Certainly as to the degrees of it, and in this according
to their sensibility, in which we know that men are not
equal. By sensibility here we mean the power or ca-
pacity of receiving impressions. All men, indeed, with
equal organs, may be said in a certain sense to see
alike. But will the same natural object, conveyed
through these organs, leave the same impression?
The fact is otherwise. What, then, causes the differ-
ence, if it be not (as before observed) a peculiar some-
thing in the individual mind, that modifies the image?
If so, there must of necessity be in every true work of
Art — if we may venture the expression — another, or
distinctive, truth. To recognize this, therefore, — as we
have elsewhere endeavoured to show, — supposes in the
recipient something akin to it. And, though it be in
reality but a *sign* of life, it is still a sign of which we
no sooner receive the impress, than, by a law of our
mind, we feel it to be acting upon our thoughts and
sympathies, without our knowing how or wherefore.
Admitting, therefore, the corresponding instinct, or
whatever else it may be called, to vary in men, —
which there is no reason to doubt, — the solution of
their unequal impression appears at once. Hence it
would be no extravagant metaphor, should we affirm
that some persons see more with their minds than
others with their eyes. Nay, it must be obvious to all
who are conversant with Art, that much, if not the
greater part, in its higher branches is especially ad-
dressed to this mental vision. And it is very certain,
if there were no truth beyond the reach of the senses,
that little would remain to us of what we now consider
our highest and most refined pleasure.

But it must not be inferred that originality consists in any contradiction to Nature; for, were this allowed and carried out, it would bring us to the conclusion, that, the greater the contradiction, the higher the Art. We insist only on the modification of the natural by the personal; for Nature is, and ever must be, at least the sensuous ground of all Art: and where the outward and inward are so united that we cannot separate them, there shall we find the perfection of Art. So complete a union has, perhaps, never been accomplished, and *may* be impossible ; it is certain, however, that no approach to excellence can ever be made, if the *idea* of such a union be not constantly looked to by the artist as his ultimate aim. Nor can the idea be admitted without supposing a *third* as the product of the two, — which we call Art; between which and Nature, in its strictest sense, there must ever be a difference ; indeed, a *difference with resemblance* is that which constitutes its essential condition.

It has doubtless been observed, that, in this inquiry concerning the nature and operation of the first characteristic, the presence of the second, or verifying principle, has been all along implied; nor could it be otherwise, because of their mutual dependence. Still more will its active agency be supposed in our examination of the third, namely, Invention. But before we proceed to that, the paramount index of the highest art, it may not be amiss to obtain, if possible, some distinct apprehension of what we have termed Poetic Truth ; to which, it will be remembered, was also prefixed the epithet Human, our object therein being to prepare the mind, by a single word, for its peculiar sphere ; and we think it applicable also for a more important reason, namely, that this kind of Truth is the *true ground of the*

poetical, — for in what consists the poetry of the natural world, if not in the sentiment and reacting life it receives from the human fancy and affections? And, until it can be shown that sentiment and fancy are also shared by the brute creation, this seeming effluence from the beautiful in nature must rightfully revert to man. What, for instance, can we suppose to be the effect of the purple haze of a summer sunset on the cows and sheep, or even on the more delicate inhabitants of the air? From what we know of their habits, we cannot suppose more than the mere physical enjoyment of its genial temperature. But how is it with the poet, whom we shall suppose an object in the same scene, stretched on the same bank with the ruminating cattle, and basking in the same light that flickers from the skimming birds. Does he feel nothing more than the genial warmth? Ask him, and he perhaps will say, — " This is my soul's hour; this purpled air the heart's atmosphere, melting by its breath the sealed fountains of love, which the cold commonplace of the world had frozen: I feel them gushing forth on every thing around me; and how worthy of love now appear to me these innocent animals, nay, these whispering leaves, that seem to kiss the passing air, and blush the while at their own fondness! Surely they are happy, and grateful too that they are so ; for hark! how the little birds send up their song of praise! and see how the waving trees and waving grass, in mute accordance, keep time with the hymn!"

This is but one of the thousand forms in which the human spirit is wont to effuse itself on the things without, making to the mind a new and fairer world, — even the shadowing of that which its immortal craving will sometimes dream of in the unknown future. Nay,

there is scarcely an object so familiar or humble, that its magical touch cannot invest it with some poetic charm. Let us take an extreme instance,—a pig in his sty. The painter, Morland, was able to convert even this disgusting object into a source of pleasure, — and a pleasure as real as any that is known to the palate.

Leaving this to have the weight it may be found to deserve, we turn to the original question; namely, What do we mean by Human or Poetic Truth ?

When, in respect to certain objects, the effects are found to be uniformly of the same kind, not only upon ourselves, but also upon others, we may reasonably infer that the efficient cause is of one nature, and that its uniformity is a necessary result. And, when we also find that these effects, though differing in degree, are yet uniform in their character, while they seem to proceed from objects which in themselves are indefinitely variant, both in kind and degree, we are still more forcibly drawn to the conclusion, that the *cause* is not only *one*, but not inherent in the object.* The question now arises, What, then, is that which seems to us so like an *alter et idem*, — which appears to act upon, and is recognized by us, through an animal, a bird, a tree, and a thousand different, nay, opposing objects, in the same way, and to the same end? The inference follows of necessity, that the mysterious cause must be in some general law, which is absolute and *imperative* in relation to every such object under certain conditions. And we receive the solution as true, — because we cannot help it. The reality, then, of such a law becomes a fixture in the mind.

But we do not stop here: we would know some-

* See Introductory Discourse.

8

thing concerning the conditions supposed. And in order to this, we go back to the effect. And the answer is returned in the form of a question, — May it not be something *from ourselves*, which is reflected back by the object, — something with which, as it were, we imbue the object, making it correspond to a *reality* within us? Now we recognize the reality within; we recognize it also in the object, — and the affirming light flashes upon us, not in the form of *deduction*, but of inherent Truth, which we cannot get rid of; and we *call* it Truth, — for it will take no other name.

It now remains to discover, so to speak, its location. In what part, then, of man may this self-evidenced, yet elusive, Truth or power be said to reside? It cannot be in the senses; for the senses can impart no more than they receive. Is it, then, in the mind? Here we are compelled to ask, What is understood by the mind? Do we mean the understanding? We can trace no relation between the Truth we would class and the reflective faculties. Or in the moral principle? Surely not; for we can predicate neither good nor evil by the Truth in question. Finally, do we find it identified with the truth of the Spirit? But what is the truth of the Spirit but the Spirit itself, — the conscious *I?* which is never even thought of in connection with it. In what form, then, shall we recognize it? In its own, — the form of Life, — the life of the Human Being; that self-projecting, realizing power, which is ever present, ever acting and giving judgment on the instant on all things corresponding with its inscrutable self. We now assign it a distinctive epithet, and call it Human.

It is a common saying, that there is more in a name than we are apt to imagine. And the saying is not without reason; for when the name happens to be the

true one, being proved in its application, it becomes no
unimportant indicator as to the particular offices for
which the thing named was designed. So we find it
with respect to the Truth of which we speak ; its dis-
tinctive epithet marking out to us, as its sphere of
action, the mysterious intercourse between man and
man ; whether the medium consist in words or colors,
in thought or form, or in any thing else on which the
human agent may impress, be it in a sign only, his
own marvellous life. As to the process or *modus
operandi*, it were a vain endeavour to seek it out : that
divine secret must ever to man be an humbling dark-
ness. It is enough for him to know that there is that
within him which is ever answering to that without,
as life to life, — which must be life, and which must
be true.

We proceed now to the third characteristic. It has
already been stated, in the general definition, what
we would be understood to mean by the term Inven-
tion, in its particular relation to Art ; namely, any un-
practised mode of presenting a subject, whether by the
combination of forms already known, or by the union
and modification of known but fragmentary parts into a
new and consistent whole : in both cases tested by the
two preceding characteristics.

We shall consider first that division of the subject
which stands first in order, — the Invention which con-
sists in the new combination of known forms. This
may be said to be governed by its exclusive relation
either to *what is*, or *has been*, or, when limited by the
probable, to what strictly may be. It may therefore be
distinguished by the term Natural. But though we so
name it, inasmuch as all its forms have their proto-
types in the Actual, it must still be remembered that

these existing forms do substantially constitute no
more than mere *parts* to be combined into a *whole*, for
which Nature has provided no original. For examples
in this, the most comprehensive class, we need not re-
fer to any particular school; they are to be found in
all and in every gallery: from the histories of Raf-
faelle, the landscapes of Claude and Poussin and others,
to the familiar scenes of Jan Steen, Ostade, and Brower.
In each of these an adherence to the actual, if not
strictly observed, is at least supposed in all its parts;
not so in the whole, as that relates to the probable; by
which we mean such a result as *would be* true, were
the same combination to occur in nature. Nor must
we be understood to mean, by adherence to the actual,
that one part is to be taken for an exact portrait; we
mean only such an imitation as precludes an intention-
al deviation from already existing and known forms.

It must be very obvious, that, in classing together
any of the productions of the artists above named, it
cannot be intended to reduce them to a level; such an
attempt (did our argument require it) must instantly
revolt the common sense and feeling of every one at
all acquainted with Art. And therefore, perhaps, it
may be thought that their striking difference, both in
kind and degree, might justly call for some further
division. But admitting, as all must, a wide, nay,
almost impassable, interval between the familiar sub-
jects of the lower Dutch and Flemish painters, and the
higher intellectual works of the great Italian masters,
we see no reason why they may not be left to draw
their own line of demarcation as to their respective
provinces, even as is every day done by actual objects;
which are all equally natural, though widely differ-
enced as well in kind as in quality. It is no degradation

to the greatest genius to say of him and of the most unlettered boor, that they are both men.

Besides, as a more minute division would be wholly irrelevant to the present purpose, we shall defer the examination of their individual differences to another occasion. In order, however, more distinctly to exhibit their common ground of Invention, we will briefly examine a picture by Ostade, and then compare it with one by Raffaelle, than whom no two artists could well be imagined having less in common.

The interior of a Dutch cottage forms the scene of Ostade's work, presenting something between a kitchen and a stable. Its principal object is the carcass of a hog, newly washed and hung up to dry; subordinate to which is a woman nursing an infant; the accessories, various garments, pots, kettles, and other culinary utensils.

The bare enumeration of these coarse materials would naturally predispose the mind of one, unacquainted with the Dutch school, to expect any thing but pleasure; indifference, not to say disgust, would seem to be the only possible impression from a picture composed of such ingredients. And such, indeed, would be their effect under the hand of any but a real Artist. Let us look into the picture and follow Ostade's *mind*, as it leaves its impress on the several objects. Observe how he spreads his principal light, from the suspended carcass to the surrounding objects, moulding it, so to speak, into agreeable shapes, here by extending it to a bit of drapery, there to an earthen pot; then connecting it, by the flash from a brass kettle, with his second light, the woman and child; and again turning the eye into the dark recesses through a labyrinth of broken chairs, old bas-

8 *

kets, roosting fowls, and bits of straw, till a glimpse of sunshine, from a half-open window, gleams on the eye, as it were, like an echo, and sending it back to the principal object, which now seems to act on the mind as the luminous source of all these diverging lights. But the magical whole is not yet completed; the mystery of color has been called in to the aid of light, and so subtly blends that we can hardly separate them; at least, until their united effect has first been felt, and after we have begun the process of cold analysis. Yet even then we cannot long proceed before we find the charm returning; as we pass from the blaze of light on the carcass, where all the tints of the prism seem to be faintly subdued, we are met on its borders by the dark harslet, glowing like rubies; then we repose awhile on the white cap and kerchief of the nursing mother; then we are roused again by the flickering strife of the antagonist colors on a blue jacket and red petticoat; then the strife is softened by the low yellow of a straw-bottomed chair; and thus with alternating excitement and repose do we travel through the picture, till the scientific explorer loses the analyst in the unresisting passiveness of a poetic dream. Now all this will no doubt appear to many, if not absurd, at least exaggerated: but not so to those who have ever felt the sorcery of color. They, we are sure, will be the last to question the character of the feeling because of the ingredients which worked the spell, and, if true to themselves, they must call it poetry. Nor will they consider it any disparagement to the all-accomplished Raffaelle to say of Ostade that he also was an Artist.

We turn now to a work of the great Italian, — the Death of Ananias. The scene is laid in a plain apart-

ment, which is wholly devoid of ornament, as became the hall of audience of the primitive Christians. The Apostles (then eleven in number) have assembled to transact the temporal business of the Church, and are standing together on a slightly elevated platform, about which, in various attitudes, some standing, others kneeling, is gathered a promiscuous assemblage of their new converts, male and female. This quiet assembly (for we still feel its quietness in the midst of the awful judgment) is suddenly roused by the sudden fall of one of their brethren; some of them turn and see him struggling in the agonies of death. A moment before he was in the vigor of life, — as his muscular limbs still bear evidence; but he had uttered a falsehood, and an instant after his frame is convulsed from head to foot. Nor do we doubt for a moment as to the awful cause: it is almost expressed in voice by those nearest to him, and, though varied by their different temperaments, by terror, astonishment, and submissive faith, this voice has yet but one meaning, — " Ananias has lied to the Holy Ghost." The terrible words, as if audible to the mind, now direct us to him who pronounced his doom, and the singly-raised finger of the Apostle marks him the judge; yet not of himself, — for neither his attitude, air, nor expression has any thing in unison with the impetuous Peter, — he is now the simple, passive, yet awful instrument of the Almighty: while another on the right, with equal calmness, though with more severity, by his elevated arm, as beckoning to judgment, anticipates the fate of the entering Sapphira. Yet all is not done; lest a question remain, the Apostle on the left confirms the judgment. No one can mistake what passes within him; like one transfixed in adoration, his

uplifted eyes seem to ray out his soul, as if in recog-
nition of the divine tribunal. But the overpowering
thought of Omnipotence is now tempered by the hu-
man sympathy of his companion, whose open hands,
connecting the past with the present, seem almost to
articulate, "Alas, my brother!" By this exquisite turn,
we are next brought to John, the gentle almoner of the
Church, who is dealing out their portions to the needy
brethren. And here, as most remote from the judged
Ananias, whose suffering seems not yet to have reached
it, we find a spot of repose, — not to pass by, but to
linger upon, till we feel its quiet influence diffusing it-
self over the whole mind; nay, till, connecting it with
the beloved Disciple, we find it leading us back through
the exciting scene, modifying even our deepest emotions
with a kindred tranquillity.

This is Invention; we have not moved a step
through the picture but at the will of the Artist. He
invented the chain which we have followed, link by link,
through every emotion, assimilating many into one; and
this is the secret by which he prepared us, without excit-
ing horror, to contemplate the struggle of mortal agony.

This too is Art; and the highest art, when thus the
awful power, without losing its character, is tempered,
as it were, to our mysterious desires. In the work of
Ostade, we see the same inventive power, no less ef-
fective, though acting through the medium of the hum-
blest materials.

We have now exhibited two pictures, and by two
painters who may be said to stand at opposite poles.
And yet, widely apart as are their apparent stations,
they are nevertheless tenants of the same ground,
namely, actual nature; the only difference being, that
one is the sovereign of the purely physical, the other of

the moral and intellectual, while their common medium is the catholic ground of the imagination.

We do not fear either skeptical demur or direct contradiction, when we assert that the imagination is as much the medium of the homely Ostade, as of the refined Raffaelle. For what is that, which has just wrapped us as in a spell when we entered his humble cottage, — which, as we wandered through it, invested the coarsest object with a strange charm? Was it the *truth* of these objects that we there acknowledged? In part, certainly, but not simply the truth that belongs to their originals; it was the truth of his own individual mind superadded to that of nature, nay, clothed upon besides by his imagination, imbuing it with all the poetic hues which float in the opposite regions of night and day, and which only a poet can mingle and make visible in one pervading atmosphere. To all this our own minds, our own imaginations, respond, and we pronounce it true to both. We have no other rule, and well may the artists of every age and country thank the great Lawgiver that there *is no other.* The despised *feeling* which the schools have scouted is yet the mother of that science of which they vainly boast. But of this we may have more to say in another place.

We shall now ascend from the *probable* to the *possible*, to that branch of Invention whose proper office is from the known but fragmentary to realize the unknown; in other words, to embody the possible, having its sphere of action in the world of Ideas. To this class, therefore, may properly be assigned the term *Ideal.*

And here, as being its most important scene, it will be necessary to take a more particular view of the verifying principle, the agent, so to speak, that gives reality to the inward, when outwardly manifested.

Now, whether we call this Human or Poetic Truth, or *inward life*, it matters not; we know by *its effects*, (as we have already said, and we now repeat,) that some such principle does exist, and that it acts upon us, and in a way analogous to the operation of that which we call truth and life in the world about us. And that the cause of this analogy is a real affinity between the two powers seems to us confirmed, not only *positively* by this acknowledged fact, but also *negatively* by the absence of the effect above mentioned in all those productions of the mind which we pronounce unnatural. It is therefore in effect, or *quoad* ourselves, both truth and life, addressed, if we may use the expression, to that inscrutable *instinct* of the imagination which conducts us to the knowledge of all invisible realities.

A distinct apprehension of the reality and of the office of this important principle, we cannot but think, will enable us to ascertain with some degree of precision, at least so far as relates to art, the true limits of the Possible, — the sphere, as premised, of Ideal Invention.

As to what some have called our *creative* powers, we take it for granted that no correct thinker has ever applied such expressions literally. Strictly speaking, we can *make* nothing: we can only construct. But how vast a theatre is here laid open to the constructive powers of the finite creature; where the physical eye is permitted to travel for millions and millions of miles, while that of the mind may, swifter than light, follow out the journey, from star to star, till it falls back on itself with the humbling conviction that the measureless journey is then but begun! It is needless to dwell on the immeasurable mass of materials which a world like this may supply to the Artist.

The very thought of its vastness darkens into wonder. Yet how much deeper the wonder, when the created mind looks into itself, and contemplates the power of impressing its thoughts on all things visible; nay, of giving the likeness of life to things inanimate; and, still more marvellous, by the mere combination of words or colors, of evolving into shape its own Idea, till some unknown form, having no type in the actual, is made to seem to us an organized being. When such is the result of any unknown combination, then it is that we achieve the Possible. And here the Realizing Principle may strictly be said to prove itself.

That such an effect should follow a cause which we know to be purely imaginary, supposes, as we have said, something in ourselves which holds, of necessity, a predetermined relation to every object either outwardly existing or projected from the mind, which we thus recognize as true. If so, then the Possible and the Ideal are convertible terms; having their existence, *ab initio*, in the nature of the mind. The soundness of this inference is also supported negatively, as just observed, by the opposite result, as in the case of those fantastic combinations, which we sometimes meet with both in Poetry and Painting, and which we do not hesitate to pronounce unnatural, that is, false.

And here we would not be understood as implying the preëxistence of all possible forms, as so many *patterns*, but only of that constructive Power which imparts its own Truth to the unseen *real*, and, under certain conditions, reflects the image or semblance of its truth on all things imagined; and which must be assumed in order to account for the phenomena presented in the frequent coincident effect between the real and the feigned. Nor does the absence of conscious-

ness in particular individuals, as to this Power in them-
selves, fairly affect its universality, at least potentially:
since by the same rule there would be equal ground for
denying the existence of any faculty of the mind which
is of slow or gradual developement; all that we may
reasonably infer in such cases is, that the whole mind
is not yet revealed to itself. In some of the greatest
artists, the inventive powers have been of late develope-
ment; as in Claude, and the sculptor Falconet. And
can any one believe that, while the latter was hewing
his master's marble, and the former making pastry,
either of them was conscious of the sublime Ideas
which afterwards took form for the admiration of the
world? When Raffaelle, then a youth, was selected to
execute the noble works which now live on the walls of
the Vatican, " he had done little or nothing," says Rey-
nolds, " to justify so high a trust." Nor could he have
been certain, from what he knew of himself, that
he was equal to the task. He could only hope to
succeed; and his hope was no doubt founded on his
experience of the progressive developement of his mind
in former efforts; rationally concluding, that the origi-
nally seeming blank from which had arisen so many
admirable forms was still teeming with others, that
only wanted the occasion, or excitement, to come forth
at his bidding.

To return to that which, as the interpreting medium
of his thoughts and conceptions, connects the artist with
his fellow-men, we remark, that only on the ground
of some self-realizing power, like what we have termed
Poetic Truth, could what we call the Ideal ever be in-
telligible.

That some such power is inherent and fundamental
in our nature, though differenced in individuals by

more or less activity, seems more especially confirmed in this latter branch of the subject, where the phenomena presented are exclusively of the Possible. Indeed, we cannot conceive how without it there could ever be such a thing as true Art; for what might be received as such in one age might also be overruled in the next: as we know to be the case with most things depending on opinion. But, happily for Art, if once established on this immutable base, there it must rest: and rest unchanged, amidst the endless fluctuations of manners, habits, and opinions; for its truth of a thousand years is as the truth of yesterday. Hence the beings described by Homer, Shakspeare, and Milton are as true to us now, as the recent characters of Scott. Nor is it the least characteristic of this important Truth, that the only thing needed for its full reception is simply its presence, — being its own evidence.

How otherwise could such a being as Caliban ever be true to us? We have never seen his race; nay, we knew not that such a creature *could* exist, until he started upon us from the mind of Shakspeare. Yet who ever stopped to ask if he were a real being? His existence to the mind is instantly felt; — not as a matter of faith, but of fact, and a fact, too, which the imagination cannot get rid of if it would, but which must ever remain there, verifying itself, from the first to the last moment of consciousness. From whatever point we view this singular creature, his reality is felt. His very language, his habits, his feelings, whenever they recur to us, are all issues from a living thing, acting upon us, nay, forcing the mind, in some instances, even to speculate on his nature, till it finds itself classing him in the chain of being as the intermediate link between man and the brute. And this we do, not by an ingenious

9

effort, but almost by involuntary induction ; for we per-
ceive speech and intellect, and yet without a soul.
What but an intellectual brute could have uttered the
imprecations of Caliban ? They would not be natural
in man, whether savage or civilized. Hear him, in his
wrath against Prospero and Miranda : —

> " A wicked dew as e'er my mother brushed
> With raven's feather from unwholesome fen,
> Light on you both ! "

The wild malignity of this curse, fierce as it is, yet
wants the moral venom, the devilish leaven, of a con-
senting spirit : it is all but human.

 To this we may add a similar example, from our
own art, in the Puck, or Robin Goodfellow, of Sir
Joshua Reynolds. Who can look at this exquisite lit-
tle creature, seated on its toadstool cushion, and not
acknowledge its prerogative of life, — that mysterious
influence which in spite of the stubborn understanding
masters the mind, — sending it back to days long past,
when care was but a dream, and its most serious busi-
ness a childish frolic ? But we no longer think of child-
hood as the past, still less as an abstraction ; we see it
embodied before us, in all its mirth and fun and glee ;
and the grave man becomes again a child, to feel as a
child, and to follow the little enchanter through all his
wiles and never-ending labyrinth of pranks. What can
be real, if that is not which so takes us out of our
present selves, that the weight of years falls from
us as a garment, — that the freshness of life seems
to begin anew, and the heart and the fancy, resum-
ing their first joyous consciousness, to launch again
into this moving world, as on a sunny sea, whose
pliant waves yield to the touch, yet, sparkling and
buoyant, carry them onward in their merry gambols ?

Where all the purposes of reality are answered, if there be no philosophy in admitting, we see no wisdom in disputing it.

Of the immutable nature of this peculiar Truth, we have a like instance in the Farnese Hercules; the work of the Grecian sculptor Glycon, — we had almost said his immortal offspring. Since the time of its birth, cities and empires, even whole nations, have disappeared, giving place to others, more or less barbarous or civilized; yet these are as nothing to the countless revolutions which have marked the interval in the manners, habits, and opinions of men. Is it reasonable, then, to suppose that any thing not immutable in its nature could possibly have withstood such continual fluctuation? But how have all these changes affected this *visible image of Truth?* In no wise; not a jot; and because what is *true* is independent of opinion: it is the same to us now as it was to the men of the dust of antiquity. The unlearned spectator of the present day may not, indeed, see in it the Demigod of Greece; but he can never mistake it for a mere exaggeration of the human form; though of mortal mould, he cannot doubt its possession of more than mortal powers; he feels its *essential life,* for he feels before it as in the stirring presence of a superior being.

Perhaps the attempt to give form and substance to a pure Idea was never so perfectly accomplished as in this wonderful figure. Who has ever seen the ocean in repose, in its awful sleep, that smooths it like glass, yet cannot level its unfathomed swell? So seems to us the repose of this tremendous personification of strength: the laboring eye heaves on its slumbering sea of muscles, and trembles like a skiff as it passes over them: but the silent intimations of the spirit be-

neath at length become audible; the startled imagina-
tion hears it in its rage, sees it in motion, and sees its
resistless might in the passive wrecks that follow the up-
roar. And this from a piece of marble, cold, immovable,
lifeless! Surely there is that in man, which the senses
cannot reach, nor the plumb of the understanding
sound.

Let us turn now to the Apollo called Belvedere. In
this supernal being, the human form seems to have been
assumed as if to make visible the harmonious conflu-
ence of the pure ideas of grace, fleetness, and majesty;
nor do we think it too fanciful to add celestial splen-
dor; for such, in effect, are the thoughts which crowd,
or rather rush, into the mind on first beholding it.
Who that saw it in what may be called the place of
its glory, the Gallery of Napoleon, ever thought of it
as a man, much less as a statue; but did not feel rath-
er as if the vision before him were of another world, —
of one who had just lighted on the earth, and with a
step so ethereal, that the next instant he would vault into
the air? If I may be permitted to recall the impression
which it made on myself, I know not that I could bet-
ter describe it than as a sudden intellectual flash, filling
the whole mind with light, — and light in motion. It
seemed to the mind what the first sight of the sun is
to the senses, as it emerges from the ocean; when from
a point of light the whole orb at once appears to bound
from the waters, and to dart its rays, as by a visible ex-
plosion, through the profound of space. But, as the
deified Sun, how completely is the conception verified
in the thoughts that follow the effulgent original and
its marble counterpart! Perennial youth, perennial
brightness, follow them both. Who can imagine the
old age of the sun? As soon may we think of an old

Apollo. Now all this may be ascribed to the imagination of the beholder. Granted, — yet will it not thus be explained away. For that is the very faculty addressed by every work of Genius, — whose nature is *suggestive;* and only when it excites to or awakens congenial thoughts and emotions, filling the imagination with corresponding images, does it attain its proper end. The false and the commonplace can never do this.

It were easy to multiply similar examples; the bare mention of a single name in modern art might conjure up a host, — the name of Michael Angelo, the mighty sovereign of the Ideal, than whom no one ever trod so near, yet so securely, the dizzy brink of the Impossible.

Of Unity, the fourth and last characteristic, we shall say but little; for we know in truth little or nothing of the law which governs it: indeed, all that we know but amounts to this, — that, wherever existing, it presents to the mind the Idea of a Whole, — which is itself a mystery. For what answer can we give to the question, What is a Whole? If we reply, That which has neither more nor less than it ought to have, we do not advance a step towards a definite notion; for the *rule* (if there be one) is yet undiscovered, by which to measure either the too much or the too little. Nevertheless, incomprehensible as it certainly is, it is what the mind will not dispense with in a work of Art; nay, it will not concede even a right to the name to any production where this is wanting. Nor is it a sound objection, that we also receive pleasure from many things which seem to us fragmentary; for instance, from actual views in Nature, — as we shall hope to show in another place. It is sufficient at present, that, in relation to Art, the law of the imagination demands a whole; in order to which

9 *

not a single part must be felt to be wanting; all must
be there, however imperfectly rendered; nay, such is
the craving of this active faculty, that, be they but mere
hints, it will often fill them out to the desired end; the
only condition being, that the part hinted be founded in
truth. It is well known to artists, that a sketch, con-
sisting of little more than hints, will frequently produce
the desired effect, and by the same means, — the hints
being true so far as expressed, and without an hiatus.
But let the artist attempt to *finish* his sketch, that
is, to fill out the parts, and suppose him deficient in the
necessary skill, the consequence must be, that the true
hints, becoming transformed to elaborate falsehoods,
will be all at variance, while the revolted imagination
turns away with disgust. Nor is this a thing of rare
occurrence: indeed, he is a most fortunate artist, who
has never had to deplore a well-hinted whole thus
reduced to fragments.

These are facts; from which we may learn, that with
less than a whole, either already wrought, or so indicat-
ed that the excited imagination can of itself complete
it, no genuine response will ever be given to any pro-
duction of man. And we learn from it also this two-
fold truth; first, that the Idea of a Whole contains in
itself a preëxisting law; and, secondly, that Art, the
peculiar product of the Imagination, is one of its true
and predetermined ends.

As to its practical application, it were fruitless to
speculate. It applies itself, even as truth, both in ac-
tion and reaction, verifying itself: and our minds sub-
mit, as if it had said, There is nothing wanting; so,
in the converse, its dictum is absolute when it announ-
ces a deficiency.

To return to the objection, that we often receive

pleasure from many things in Nature which seem to us fragmentary, we observe, that nothing in Nature can be fragmentary, except in the seeming, and then, too, to the understanding only, — to the feelings never; for a grain of sand, no less than a planet, being an essential part of that mighty whole which we call the universe, cannot be separated from the Idea of the world without a positive act of the reflective faculties, an act of volition; but until then even a grain of sand cannot cease to imply it. To the mere understanding, indeed, even the greatest extent of actual objects which the finite creature can possibly imagine must ever fall short of the vast works of the Creator. Yet we nevertheless can, and do, apprehend the existence of the universe. Now we would ask here, whether the influence of a *real*, — and the epithet here is not unimportant, — whether the influence of a real Whole is at no time felt without an act of consciousness, that is, without thinking of a whole. Is this impossible? Is it altogether out of experience? We have already shown (as we think) that no *unmodified copy* of actual objects, whether single or multifarious, ever satisfies the imagination, — which imperatively demands a something more, or at least different. And yet we often find that the very objects from which these copies are made *do* satisfy us. How and why is this? A question more easily put than answered. We may suggest, however, what appears to us a clew, that in abler hands may possibly lead to its solution; namely, the fact, that, among the innumerable emotions of a pleasurable kind derived from the actual, there is not one, perhaps, which is strictly confined to the objects before us, and which we do not, either directly or indirectly, refer to something beyond and not present. Now have we at all times a distinct

consciousness of the things referred to? Are they not rather more often vague, and only indicated in some *undefined* feeling? Nay, is its source more intelligible where the feeling is more definite, when taking the form of a sense of harmony, as from something that diffuses, yet deepens, unbroken in its progress through endless variations, the melody as it were of the pleasurable object? Who has never felt, under certain circumstances, an expansion of the heart, an elevation of mind, nay, a striving of the whole being to pass its limited bounds, for which he could find no adequate solution in the objects around him, — the apparent cause? Or who can account for every mood that thralls him, — at times like one entranced in a dream by airs from Paradise, — at other times steeped in darkness, when the spirit of discord seems to marshal his every thought, one against another?

Whether it be that the Living Principle, which permeates all things throughout the physical world, cannot be touched in a single point without conducting to its centre, its source, and confluence, thus giving by a part, though obscurely and indefinitely, a sense of the whole, — we know not. But this we may venture to assert, and on no improbable ground, — that a ray of light is not more continuously linked in its luminous particles than our moral being with the whole moral universe. If this be so, may it not give us, in a faint shadowing at least, some intimation of the many real, though unknown relations, which everywhere surround and bear upon us? In the deeper emotions, we have, sometimes, what seems to us a fearful proof of it. But let us look at it negatively; and suppose a case where this chain is broken, — of a human being who is thus cut off from all possible sympathies, and shut up, as it were, in the

hopeless solitude of his own mind. What is this horrible avulsion, this impenetrable self-imprisonment, but the appalling state of *despair?* And what if we should see it realized in some forsaken outcast, and hear his forlorn cry, "Alone! alone!" while to his living spirit that single word is all that is left him to fill the blank of space? In such a state, the very proudest autocrat would yearn for the sympathy of the veriest wretch.

It would seem, then, since this living cement which is diffused through nature, binding all things in one, so that no part can be contemplated that does not, of necessity, even though unconsciously to us, act on the mind with reference to the whole,— since this, as we find, cannot be transferred to any copy of the actual, it must needs follow, if we would imitate Nature in its true effects, that recourse must be had to another, though similar principle, which shall so pervade our production as to satisfy the mind with an efficient equivalent. Now, in order to this there are two conditions required: first, the personal modification, (already discussed) of every separate part, — which may be considered as its proper life; and, secondly, the uniting of the parts by such an interdependence that they shall appear to us as essential, one to another, and all to each. When this is done, the result is a whole. But how do we obtain this mutual dependence? We refer the questioner to the law of Harmony, — that mysterious power, which is only apprehended by its imperative effect.

But, be the above as it may, we know it to be a fact, that, whilst nothing in Nature ever affects us as fragmentary, no unmodified copy of her by man is ever felt by us as otherwise.

We have thus — and, we trust, on no fanciful ground
— endeavoured to establish the real and distinctive
character of Art. And, if our argument be admitted,
it will be found to have brought us to the following
conclusions : — first, that the true ground of all original-
ity lies in the *individualizing law*, that is, in that mod-
ifying power, which causes the difference between man
and man as to their mental impressions; secondly,
that only in a *true* reproduction consists its evidence ;
thirdly, that in the involuntary response from other
minds lies the truth of the evidence; fourthly, that
in order to this response there must therefore exist
some universal kindred principle, which is essential to
the human mind, though widely differenced in the de-
gree of its activity in different individuals ; and finally,
that this principle, which we have here denominated
Human or Poetic Truth, being independent both of
the will and of the reflective faculties, is in its nature
imperative, to affirm or deny, in relation to every pro-
duction pretending to Art, from the simple imitation
of the actual to the probable, and from the probable
to the possible ; — in one word, that the several charac-
teristics, Originality, Poetic Truth, Invention, each im-
ply a something not inherent in the objects imitated,
but which must emanate alone from the mind of the
Artist.

And here it may be well to notice an apparent ob-
jection, that will probably occur to many, especially
among painters. How, then, they may ask, if the
principle in question be universal and imperative, do
we account for the mistakes which even great Artists
have sometimes made as to the realizing of their con-
ceptions ? We hope to show, that, so far from oppos-
ing, the very fact on which the objection is grounded

will be found, on the contrary, to confirm our doctrine. Were such mistakes uniformly permanent, they might, perhaps, have a rational weight; but that this is not the case is clearly evident from the additional fact of the change in the Artist's judgment, which almost invariably follows any considerable interval of time. Nay, should a case occur where a similar mistake is never rectified, — which is hardly probable, — we might well consider it as one of those exceptions that prove the rule, — of which we have abundant examples in other relations, where a true principle is so feebly developed as to be virtually excluded from the sphere of consciousness, or, at least, where its imperfect activity is for all practical purposes a mere nullity. But, without supposing any mental weakness, the case may be resolved by the no less formidable obstacle of a too inveterate memory : and there have been such, — where a thought or an image once impressed is never erased. In Art it is certainly an advantage to be able sometimes to forget. Nor is this a new notion ; for Horace, it seems, must have had the same, or he would hardly have recommended so long a time as nine years for the revision of a poem. That Titian also was not unaware of the advantage of forgetting is recorded by Boschini, who relates, that, during the progress of a work, he was in the habit of occasionally turning it to the wall, until it had somewhat faded from his memory, so that, on resuming his labor, he might see with fresh eyes ; when (to use his expression) he would criticize the picture with as much severity as his worst enemy. If, instead of the picture on the canvas, Boschini had referred to that in his mind, as what Titian sought to forget, he would have been, as we think, more correct. This practice is not uncommon with

Artists, though few, perhaps, are aware of its real object.

It has doubtless the appearance of a singular anomaly in the judgment, that it should not always be as correct in relation to our own works as to those of another. Yet nothing is more common than perfect truth in the one case, and complete delusion in the other. Our surprise, however, would be sensibly diminished, if we considered that the reasoning or reflective faculties have nothing to do with either case. It is the Principle of which we have been speaking, the life, or truth within, answering to the life, or rather its sign, before us, that here sits in judgment. Still the question remains unanswered; and again we are asked, Why is it that our own works do not always respond with equal veracity? Simply because we do not always *see* them, — that is, as they are, — but, looking as it were *through them*, see only their originals in the mind; the mind here acting, instead of being acted upon. And thus it is, that an Artist may suppose his conception realized, while that which gave life to it in his mind is outwardly wanting. But let time erase, as we know it often does, the mental image, and its embodied representative will then appear to its author as it is, — true or false. There is one case, however, where the effect cannot deceive; namely, where it comes upon us as from a foreign source; where our own seems no longer ours. This, indeed, is rare; and powerful must be the pictured Truth, that, as soon as embodied, shall thus displace its own original.

Nor does it in any wise affect the essential nature of the Principle in question, or that of the other Characteristics, that the effect which follows is not always of a pleasurable kind; it may even be disagreeable. What

we contend for is simply its *reality;* the character of the perception, like that of every other truth, depending on the individual character of the percipient. The common truth of existence in a living person, for instance, may be to us either a matter of interest or indifference, nay, even of disgust. So also may it be with what is true in Art. Temperament, ignorance, cultivation, vulgarity, and refinement have all, in a greater or less degree, an influence in our impressions; so that any reality may be to us either an offence or a pleasure, yet still a reality. In Art, as in Nature, the True is imperative, and must be *felt,* even where a timid, a proud, or a selfish motive refuses to acknowledge it.

These last remarks very naturally lead us to another subject, and one of no minor importance; we mean, the education of an Artist; on this, however, we shall at present add but a few words. We use the word *education* in its widest sense, as involving not only the growth and expansion of the intellect, but a corresponding developement of the moral being; for the wisdom of the intellect is of little worth, if it be not in harmony with the higher spiritual truth. Nor will a moderate, incidental cultivation suffice to him who would become a great Artist. He must sound no less than the full depths of his being ere he is fitted for his calling; a calling in its very condition lofty, demanding an agent by whom, from the actual, living world, is to be wrought an imagined consistent world of Art, — not fantastic, or objectless, but having a purpose, and that purpose, in all its figments, a distinct relation to man's nature, and all that pertains to it, from the humblest emotion to the highest aspiration; the circle that bounds it being that only which bounds his spirit, — even the confines of that higher world, where ideal

10

glimpses of angelic forms are sometimes permitted to
his sublimated vision. Art may, in truth, be called the
human world; for it is so far the work of man, that
his beneficent Creator has especially endowed him
with the powers to construct it; and, if so, surely not
for his mere amusement, but as a part (small though it
be) of that mighty plan which the Infinite Wisdom
has ordained for the evolution of the human spirit;
whereby is intended, not alone the enlargement of his
sphere of pleasure, but of his higher capacities of ado-
ration; — as if, in the gift, he had said unto man,
Thou shalt know me by the powers I have given thee.
The calling of an Artist, then, is one of no common
responsibility; and it well becomes him to consider at
the threshold, whether he shall assume it for high and
noble purposes, or for the low and licentious.

FORM.

THE subject proposed for the following discourse is the Human Form; a subject, perhaps, of all others connected with Art, the most obscured by vague theories. It is one, at least, of such acknowledged difficulty as to constrain the writer to confess, that he enters upon it with more distrust than hope of success. Should he succeed, however, in disencumbering this perplexed theme of some of its useless dogmas, it will be quite as much as he has allowed himself to expect.

The object, therefore, of the present attempt will be to show, first, that the notion of one or more standard Forms, which shall in all cases serve as exemplars, is essentially false, and of impracticable application for any true purpose of Art; secondly, that the only approach to Science, which the subject admits, is in a few general rules relating to Stature, and these, too, serving rather as convenient *expedients* than exact guides, inasmuch as, in most cases, they allow of indefinite variations; and, thirdly, that the only efficient Rule must be found in the Artist's mind, — in those intuitive Powers, which are above, and beyond, both the senses and the understanding; which, nevertheless, are so far from precluding knowledge, as, on

the contrary, to require, as their effective condition, the widest intimacy with the things external, — without which their very existence must remain unknown to the Artist himself.

Supposing, then, certain standard Forms to have been admitted, it may not be amiss to take a brief view of the nature of the Being to whom they are intended to be applied; and to consider them more especially as auxiliaries to the Artist.

In the first place, we observe, that the purpose of Art is not to represent any given number of men, but the Human Race; and so that the representation shall affect us, not indeed as living to the senses, but as true to the mind. In order to this, there must be *all* in the imitation (though it be but hinted) which the mind will recognize as true to the human being: hence the first business of the Artist is to become acquainted with his subject in all its properties. He then naturally inquires, what is its general characteristic; and his own consciousness informs him, that, besides an animal nature, there is also a moral intelligence, and that they together form the man. This important truism (we say important, for it seems to have been not seldom overlooked) makes the foundation of all his future observations; nor can he advance a step without continual reference to this double nature. We find him accordingly in the daily habit of mentally distinguishing this person from that, as a moral being, and of assigning to each a separate character; and this not voluntarily, but simply because he cannot avoid it. Yet, by what does he presume to judge of strangers? He will probably answer, By their general exterior. And what is the inference? There can be but one; namely, that there must be — at least to him — some

efficient correspondence between the physical and the moral. This is so plain, that the wonder is, how it ever came to be doubted. Nor is it directly denied, except by those who from habitual disgust reject the guess-work of the various pretenders to scientific systems; yet even these, no less than others, do practically admit it in their common intercourse with the world. And it cannot be otherwise; for what the Creator has joined must have some affinity, although the palpable signs may elude our cognizance. And that they do elude it, except perhaps in a very slight degree, is actually the case, as is well proved by the signal failure of all attempts to reduce them to a science; for neither diagram nor axiom has ever yet corrected an instinctive impression. But man does not live by science; he feels, acts, and judges right in a thousand things without the consciousness of any rule by which he so feels, acts, or judges. And, happily for him, he has a surer guide than human science in that unknown Power within him, — without which he had been without knowledge. But of this we shall have occasion to speak again in another part of our discourse.

Though the medium through which the soul acts be, as we have said, elusive to the senses, — in so far as to be irreducible to any distinct form, — it is not therefore the less real, as every one may verify by his own experience; and, though seemingly invisible, it must nevertheless, constituted as we are, act through the physical, and a physical medium expressly constructed for its peculiar action; nay, it does this continually, without our confounding for a moment the soul with its instrument. Who can look into the human eye, and doubt of an influence not of the body? The form and

10 *

color leave but a momentary impression, or, if we re-
member them, it is only as we remember the glass
through which we have read the dark problems of the
sky. But in this mysterious organ we see not even the
signs of its mystery. We see, in truth, nothing; for
what is there has neither form, nor symbol, nor any
thing reducible to a sensuous distinctness; and yet who
can look into it, and not be conscious of a real though
invisible presence? In the eye of a brute, we see only
a part of the animal; it gives us little beyond the
palpable outward; at most, it is but the focal point of
its fierce, or gentle, affectionate, or timorous character,
—the character of the species. But in man, neither
gentleness nor fierceness can be more than as relative
conditions,— the outward moods of his unseen spirit;
while the spirit itself, that daily and hourly sends forth
its good and evil, to take shape from the body, still sits
in darkness. Yet have we that which can surely reach
it; even our own spirit. By this it is that we can
enter into another's soul, sound its very depths, and
bring up his dark thoughts, nay, place them before
him till he starts at himself; and more, — it is by this
we *know* that even the tangible, audible, visible world
is not more real than a spiritual intercourse. And
yet without the physical organ who can hold it? We
can never indeed understand, but we may not doubt,
that which has its power of proof in a single act of
consciousnesss. Nay, we may add that we cannot
even conceive of a soul without a correlative form, —
though it be in the abstract; and *vice versâ.*

For, among the many impossibilities, it is not the
least to look upon a living human form as a thing;
in its pictured copies, as already shown in a former
discourse, it may be a thing, and a beautiful thing;

but the moment we conceive of it as living, if it show
not a soul, we give it one by a moral necessity; and
according to the outward will be the spirit with which
we endow it. No poetic being, supposed of our spe-
cies, ever lived to the imagination without some in-
dication of the moral; it is the breath of its life:
and this is also true in the converse; if there be but
a hint of it, it will instantly clothe itself in a hu-
man shape; for the mind cannot separate them. In
the whole range of the poetic creations of the great
master of truth, — we need hardly say Shakspeare,
— not an instance can be found where this condition of
life is ever wanting; his men and women all have
souls. So, too, when he peoples the air, though he de-
scribe no form, he never leaves these creatures of the
brain without a shape, for he will sometimes, by a sin-
gle touch of the moral, enable us to supply one. Of
this we have a striking instance in one of his most un-
substantial creations, the "delicate Ariel." Not an al-
lusion to its shape or figure is made throughout the
play; yet we assign it a form on its very first entrance,
as soon as Prospero speaks of its refusing to comply
with the "abhorred commands" of the witch, Sycorax.
And again, in the fifth act, when Ariel, after recounting
the sufferings of the wretched usurper and his follow-
ers, gently adds, —

> " Your charm so strongly works them,
> That, if you now beheld them, your affections
> Would become tender."

On which Prospero remarks, —

> "Hast thou, which art but air, a touch, a feeling
> Of their afflictions?"

Now, whether Shakspeare intended it or not, it is not
possible after this for the reader to think of Ariel but in

a human form; for slight as these hints are, if they do not indicate the moral affections, they at least imply something akin to them, which in a manner compels us to invest the gentle Spirit with a general likeness to our own physical exterior, though, perhaps, as indistinct as the emotion that called for it.

We have thus considered the human being in his complex condition, of body and spirit, or physical and moral; showing the impossibility of even thinking of him in the one, to the exclusion of the other. We may, indeed, successively think first of the form, and then of the moral character, as we may think of any one part of either analytically; but we cannot think of the *human being* except as a *whole.* It follows, therefore, as a consequence, that no imitation of man can be true which is not addressed to us in this double condition. And here it may be observed, that in Art there is this additional requirement, that there be no discrepancy between the form and the character intended, — or rather, that the form *must* express the character, or it expresses nothing: a necessity which is far from being general in actual nature. But of this hereafter.

Let us now endeavour to form some general notion of Man in his various aspects, as presented by the myriads which people the earth. But whose imagination is equal to the task, — to the setting in array before it the countless multitudes, each individual in his proper form, his proper character? Were this possible, we should stand amazed at the interminable differences, the hideous variety; and that, too, no less in the moral, than in the physical; nay, so opposite and appalling in the former as hardly to be figured by a chain of animals, taking for the extremes the fierce and filthy hyena and the inoffensive lamb. This is man in the concrete, —

to which, according to some, is to be applied the *abstract Ideal!*

Now let us attempt to conceive of a being that shall represent all the diversities of mind, affections, and dispositions, that fleck this heterogeneous mass of humanity, and then to conceive of a Form that shall be in such perfect affinity with it as to indicate them all. The bare statement of the proposition shows its absurdity. Yet this must be the office of a Standard Form; and this it must do, or it will be a falsehood. Nor should we find it easier with any given number, with twenty, fifty, nay, an hundred (so called) generic forms. We do not hesitate to affirm, that, were it possible, it would be quite as easy with one as with a thousand.

But to this it may be replied, that the Standard Form was never intended to represent the vicious or degraded, but man in his most perfect developement of mind, affections, and body. This is certainly narrowing its office, and, unfortunately, to the representing of but *one* man; consequently, of no possible use beyond to the Painter or Sculptor of Humanity, since every repetition of this perfect form would be as the reflection of one multiplied by mirrors. But such repetitions, it may be further answered, were never contemplated, that Form being given only as an exemplar of the highest, to serve as a guide in our approach to excellence; as we could not else know to a certainty to what degree of elevation our conceptions might rise. Still, in that case its use would be limited to a single object, that is, to itself, its own perfectness; it would not aid the Artist in the intermediate ascent to it, — unless it contained within itself all the gradations of human character; which no one will pretend.

But let us see how far it is possible to *realize* the Idea of a *perfect* Human Form.

We have already seen that the mere physical structure is not man, but only a part; the Idea of man including also an internal moral being. The external, then, in an *actually disjoined* state, cannot, strictly speaking, be the human' form, but only a diagram of it. It is, in fact, but a partial condition, becoming human only when united with the internal moral; which, in proof of the union, it must of necessity indicate. If we would have a true Idea of it, therefore, it must be as a whole; consequently, the perfect physical exterior must have, as an essential part, the perfect moral. Now come two important questions. First, In what consists Moral Perfection? We use the word *moral* here (from a want in our language) in its most comprehensive sense, as including the spiritual and the intellectual. With respect to that part of our moral being which pertains to the affections, in all their high relations to God and man, we have, it is true, a sure and holy guide. In a Christian land, the humblest individual may answer as readily as the most profound scholar, and express its perfection in the single word, Holiness. But what will be the reply in regard to the Intellect? For what is a perfect Intellect? Is it the Dialectic, the Speculative, or the Imaginative? Or, rather, would it not include them all?

We proceed next to the Physical. What, then, constitutes its Perfection? Here, it might seem, there can be no difficulty, and the reply will probably be in naming all the excellent qualities in our animal nature, such as strength, agility, fleetness, with every other that can be thought of. The bare enumeration of these few qualities may serve to show the nature of the task; yet a physically perfect form requires them all; none must be omitted; it would else be imperfect; nay, they must

not only be there, but all be developed in their highest degrees. We might here exclaim with Hamlet, though in a very different sense,

" A combination and a form indeed ! "

And yet there is no other way to express physical perfection. But can it be so expressed? The reader must reply for himself. We will, however, suppose it possible; still the task is incomplete without the adjustment of these to the perfect Moral, in the highest known degrees of its several elements. To those who can imagine *such* a form as shall be the sure exponent of *such* a moral being, — and such it must be, or it will be nothing, — we leave the task of constructing this universal exemplar for multitudinous man. We may add, however, one remark; that, supposing it possible thus to concentrate, and with equal prominence, all the qualities of the species into one individual, it can only be done by supplanting Providence, in other words, by virtually overruling the great principle of subordination so visibly impressed on all created life. For although, as we have elsewhere observed, there can be no sound mind (and the like may be affirmed of the whole man), which is deficient in any one essential, it does not therefore follow, that each of these essentials may not be almost indefinitely differenced in the degrees of their developement without impairing the human integrity. And such is the fact in actual nature; nor does this in any wise affect the individual unity, — as will be noticed hereafter.

We will now briefly examine the pretensions of what are called the Generic Forms. And here we are met by another important characteristic of the human being, namely, his essential individuality.

It is true that the human family, so called, is divided

into many distinct races, having each its peculiar con-
formation, color, and so forth, which together constitute
essential differences; but it is to be remembered that
these essentials are all physical; and *so far* they are
properly generic, as implying a difference in kind. But,
though a striking difference is also observable in their
moral being, it is by no means of the same nature with
that which marks their physical condition, the differ-
ence in the moral being only of degree; for, however
fierce, brutal, stupid, or cunning, or gentle, generous, or
heroic, the same characteristics may each be paralleled
among ourselves; nay, we could hardly name a vice, a
passion, or a virtue, in Asia, Africa, or America, that
has not its echo in civilized Europe. And what is the
inference? That climate and circumstance, if such
are the causes of the physical variety, have no con-
trolling power, except in degree, over the Moral. Does
not this undeniable fact, then, bring us to the fair con-
clusion, that the moral being has no genera? To affirm
otherwise would be virtually to deny its responsible
condition; since the law of its genus must be para-
mount to all other laws, — to education, government,
religion. Nor can the result be evaded, except by the
absurd supposition of generic responsibilities! To us,
therefore, it seems conclusive that a moral being, as a
free agent, cannot be subject to a generic law; nor
could he now be — what every man feels himself to be,
in spite of his theory — the fearful architect of his own
destiny. In one sense, indeed, we may admit a human
genus, — such as every man must be in his individual
entireness.

Man has been called a microcosm, or little world.
And such, however mean and contemptible to others,
is man to himself; nay, such he must ever be, whether

he wills it or not. He may hate, he may despise, yet he cannot but cling to that without which he is not; he is the centre and the circle, be it of pleasure or of pain; nor can he be other. Touch him with misery, and he becomes paramount to the whole world, — to a thousand worlds; for the beauty and the glory of the universe are as nothing to him who is all darkness. Then it is that he will *feel*, should he have before doubted, that he is not a mere part, a fraction, of his kind, but indeed a world; and though little in one sense, yet a world of awful magnitude in its capacity of suffering. In one word, Man is a whole, *an Individual*.

If the preceding argument be admitted, it will be found to have relieved the student of two delusive dogmas, — and the more delusive, as carrying with them a plausible show of science.

As to the flowery declamations about Beauty, they would not here be noticed, were they not occasionally met with in works of high merit, and not unfrequently mixed up with philosophic truth. If they have any definite meaning, it amounts to this, — that the Beautiful is the summit of every possible excellence! The extravagance, not to say absurdity, of such a proposition, confounding, as it does, all received distinctions, both in the moral and the natural world, needs no comment. It is hardly to be believed, however, that the writers in question could have deliberately intended this. It is more probable, that, in so expressing themselves, they were only giving vent to an enthusiastic feeling, which we all know is generally most vague when associated with admiration; it is not therefore strange that the ardent expression of it should partake of its vagueness. Among the few critical works of authority in which the word is so used, we may men-

11

tion the (in many respects admirable) Discourses of
Sir Joshua Reynolds, where we find the following
sentence: — " The *beauty* of the Hercules is one, of the
Gladiator another, of the Apollo another; which, of
course, would present three different Ideas of Beauty."
If this had been said of various animals, differing in
kind, the term so applied might, perhaps, have been
appropriate. But the same term is here applied to ob-
jects of the same kind, differing not essentially even in
age; we say *age*, inasmuch as in the three great di-
visions, or periods. of human life, namely, childhood,
youth, and maturity, the characteristic conditions of
each are so *essentially* distinct, as virtually to separate
them into positive kinds.

But it is no less idle than invidious to employ our
time in overturning the errors of others; if we estab-
lish Truth, they will fall of themselves. There cannot
be two right sides to any question; and, if we are right,
what is opposed to us must of necessity he wrong.
Whether we are so or not must be determined by those
who admit or reject what has already been advanced
on the subject of Beauty, in the first Discourse. It
will be remembered, that, in the course of our argument
there, we were brought to the conclusion, that Beauty
was the Idea of a certain physical *condition*, both gen-
eral and ultimate; general, as presiding over objects of
many kinds, and ultimate, as being the *perfection* of
that peculiar condition in each, and therefore not appli-
cable to, or representing, its degrees in any ; which, as
approximations only to the one supreme Idea, should
truly be distinguished by other terms. Accordingly,
we cannot, strictly speaking, say of two persons of
the same age and sex, differing from each other, that
they are equally beautiful. We hear this, indeed, al-

most daily; it is nevertheless not the true expression of the actual impression made on the speaker, though he may not take the trouble to examine and compare them. But let him do so, and we doubt not that he would find the one to rise (in however slight a degree) above the other; and, if he did not assign a different term to the lower, it would be only because he was not in the habit of marking, or did not think it worth his while to note, such nice distinctions.

If there is a *first* and a *last* to any thing, the intermediates can be neither one nor the other; and, if we so name them, we speak falsely. It is no less so with Beauty, which, being at the head, or first in a series, admits no transference of its title. We mean, if speaking strictly; which, however, we freely acknowledge, no one can; but that is owing to the insufficiency of language, which in no dialect could supply a hundredth part of the terms needed to mark every minute shade of difference. Perhaps no subject requiring a wider nomenclature has one so contracted; and the consequence is, that no subject is more obscured by vague expressions. But it is the business of the Artist, if he cannot form to himself the corresponding terms, to be prepared at least to perceive and to note these various shades. We do not say, that an actual acquaintance with all the nice distinctions is an essential requisite, but only that it will not be altogether useless to be aware of their existence; at any rate, it may serve to shield him from the annoyance of false criticism, when censured for wanting beauty where its presence would have been an impertinence.

Before we quit the subject, it may not be amiss to observe, that, in the preceding remarks, our object has been not so much to insist on correct speaking as correct

thinking. The poverty of language, as already admitted, has made the former impossible; but, though constrained in this, as in many other cases where a subordinate is put for its principal, to apply the term Beautiful to its various degrees, yet a right apprehension of what Beauty *is* may certainly prevent its misapplication as to other objects having no relation to it. Nor is this a small matter where the avoiding of confusion is an object desirable; and there is clearly some difference between an approach to precision and utter vagueness.

We have now to consider how far the Correspondence between the outward form and the inward being, which is assumed by the Artist, is supported by fact.

In a fair statement, then, of facts, it cannot be denied that with the mass of men the outward intimation of character is certainly very faint, with many obscure, and with some ambiguous, while with others it has often seemed to express the very reverse of the truth. Perhaps a stronger instance of the latter could hardly occur than that cited in a former discourse in illustration of the physical relation of Beauty; where it was shown that the first and natural impression from a beautiful form was not only displaced, but completely reversed, by the revolting discovery of a moral discrepancy. But while we admit, on the threshold, that the Correspondence in question cannot be sustained as universally obvious, it is, nevertheless, not apprehended that this admission can affect our argument, which, though in part grounded on special cases of actual coincidence, is yet supported by other evidences, which lead us to regard all such discrepancies rather as exceptions, and as so many deviations from the original law of our nature, nay, which lead us also rationally

to infer at least a future, potential correspondence in every individual. To the past, indeed, we cannot appeal; neither can the past be cited against us, since little is known of the early history of our race but a chronicle of their actions; of their outward appearance scarcely any thing, certainly not enough to warrant a decision one way or the other. Should we assume, then, the Correspondence as a primeval law, who shall gainsay it? It is not, however, so asserted. We may nevertheless hold it as a matter of *faith;* and simply as such it is here submitted. But faith of any kind must have some ground to rest on, either real or supposed, either that of authority or of inference. Our ground of faith, then, in the present instance, is in the universal desire amongst men to *realize* the Correspondence. Nothing is more common than, on hearing or reading of any remarkable character, to find this instinctive craving, if we may so term it, instantly awakened, and actively employed in picturing to the imagination some corresponding form; nor is any disappointment more general, than that which follows the detection of a discrepancy on actual acquaintance. Indeed, we can hardly deem it rash, should we rest the validity of this universal desire on the common experience of any individual, taken at random, — provided only that he has a particle of imagination. Nor is its action dependent on our caprice or will. Ask any person of ordinary cultivation, not to say refinement, how it is with him, when his imagination has not been forestalled by some definite fact; whether he has never found himself *involuntarily* associating the good with the beautiful, the energetic with the strong, the dignified with the ample, or the majestic with the lofty; the refined with the delicate, the modest with the come-

11 *

ly ; the base with the ugly, the brutal with the mis-
shapen, the fierce with the coarse and muscular, and so
on ; there being scarcely a shade of character to which
the imagination does not affix some corresponding
form.

In a still more striking form may we find the evi-
dence of the law supposed, if we turn to the young,
and especially to those of a poetic temperament, — to
the sanguine, the open, and confiding, the creatures of
impulse, who reason best when trusting only to the
spontaneous suggestions of feeling. What is more
common than implicit faith in their youthful day-
dreams, — a faith that lives, though dream after dream
vanish into common air when the sorcerer Fact touches
their eyes ? And whence this pertinacious faith that
will not die, but from a spring of life, that neither cus-
tom nor the dry understanding can destroy ? Look
at the same Youth at a more advanced age, when the
refining intellect has mixed with his affections, adding
thought and sentiment to every thing attractive, con-
verting all things fair to things also of good report.
Let us turn, at the same time, to one still more ad-
vanced, — even so far as to have entered into the con-
ventional valley of dry bones, — one whom the world
is preparing, by its daily practical lessons, to enlighten
with unbelief. If we see them together, perhaps we
shall hear the senior scoff at his younger companion as
a poetic dreamer, as a hunter after phantoms that
never were, nor could be, in nature : then may follow a
homily on the virtues of experience, as the only securi-
ty against disappointment. But there are some hearts
that never suffer the mind to grow old. And such we
may suppose that of the dreamer. If he is one, too,
who is accustomed to look into himself, — not as a

reasoner, — but with an abiding faith in his nature, — we shall, perhaps, hear him reply, — Experience, it is true, has often brought me disappointment; yet I cannot distrust those dreams, as you call them, bitterly as I have felt their passing off; for I feel the truth of the source whence they come. They could not have been so responded to by my living nature, were they but phantoms; they could not have taken such forms of truth, but from a possible ground.

By the word *poetic* here, we do not mean the visionary or fanciful, — for there may be much fancy where there is no poetic feeling, — but that sensibility to *harmony* which marks the temperament of the Artist, and which is often most active in his earlier years. And we refer to such natures, not only as being more peculiarly alive to all existing affinities, but as never satisfied with those merely which fall within their experience; ever striving, on the contrary, as if impelled by instinct, to supply the deficiency wherever it is felt. From such minds proceed what are called romantic imaginings, but what we would call — without intending a paradox — the romance of Truth. For it is impossible that the mind should ever have this perpetual craving for the False.

But the desire in question is not confined to any particular age or temperament, though it is, doubtless, more ardent in some than in others. Perhaps it is only denied to the habitually vicious. For who, not hardened by vice, has ever looked upon a sleeping child in its first bloom of beauty, and seen its pure, fresh hues, its ever varying, yet according lines, moulding and suffusing, in their playful harmony, its delicate features, — who, not callous, has ever looked upon this exquisite creature, (so like what a poet might fancy of

visible music, or embodied odors,) and has not felt
himself carried, as it were, out of this present world,
in quest of its moral counterpart? It seems to us
perfect; we desire no change,—not a line or a hue
but as it is; and yet we have a paradoxical feeling of a
want,—for it is all *physical;* and we supply that want
by endowing the child with some angelic attribute.
Why do we this? To make it a *whole*,—not to the
eye, but to the mind.

Nor is this general disposition to find a coincidence
between a fair exterior and moral excellence altogether
unsupported by facts of, at least, a partial realization.
For, though a perfect correspondence cannot be look-
ed for in a state where all else is imperfect, he is
most unfortunate who has never met with many, and
very near, approximations to the desired union. But
we have a still stronger assurance of their predeter-
mined affinity in the peculiar activity of this desire
where there is no such approximation. For example,
when we meet with an instance of the higher virtues
in an unattractive form, how natural the wish that that
form were beautiful! So, too, on beholding a beautiful
person, how common the wish that the mind it clothed
were also good! What are these wishes but uncon-
scious retrospects to our primitive nature? And why
have we them, if they be not the workings of that
universal law, which gathers to itself all scattered af-
finities, bodying them forth in the never-ending forms
of harmony,—in the flower, in the tree, in the bird, and
the animal,—if they be not the evidence of its continu-
ous, though fruitless, effort to evolve too in *man* its last
consummate work, by the perfect confluence of the
body and the spirit? In this universal yearning (for it
seems to us no less) to connect the physical with its

appropriate moral, — to say nothing of the mysterious intuition that points to the appropriate, — is there not something like a clew to what was originally natural? And, again, in the never-ceasing strivings of the two great elements of our being, each to supply the deficiencies of the other, have we not also an intimation of something that *once was*, that is now lost, and would be recovered? Surely there must be more in this than a mere concernment of Art; — if, indeed, there be not in Art more of the prophetic than we are now aware of. To us it seems that this irrepressible desire to find the good in the beautiful, and the beautiful in the good, implies an end, both beyond and above the trifling present; pointing to deep and dark questions, — to no less than where the mysteries which surround us will meet their solution. One great mystery we see in part resolving itself here. We see the deformities of the body sometimes giving place to its glorious tenant. Some of us may have witnessed this, and felt the spiritual presence gaining daily upon us, till the outward shape seemed lost in its brightness, leaving no trace in the memory.

Whether the position we have endeavoured to establish be disputed or not, the absolute correspondence between the Moral and the Physical is, at any rate, the essential ground of the Plastic arts; which could not else exist, since through *Form alone* they have to convey, not only thought and emotion, but distinct and permanent character. For our own part, we cannot but consider their success in this as having settled the question.

From the view here presented, what is the inference in relation to Art? That Man, as a compound being, cannot be represented without an indication as well of

Mind as of body; that, by a natural law which we cannot resist, we do continually require that they be to us as mutual exponents, the one of the other; and, finally, that, as a responsible being, and therefore a free agent, he cannot be truly represented, either to the memory or to the imagination, but as an Individual.

It would seem, also, from the indefinite varieties in men, though occasioned only by the mere difference of degrees in their common faculties and powers, that the coincidence of an equal developement of all was never intended in nature; but that some one or more of them, becoming dominant, should distinguish the individual. It follows, therefore, if this be the case, that only through the phase of such predominance can the human being ever be contemplated. To the Artist, then, it becomes the only safe ground; the starting-point from whence to ascend to a true Ideal, — which is no other than a partial individual truth made whole in the mind: and thus, instead of one Ideal, and that baseless, he may have a thousand, — nay, as many as there are marked or apprehensible *individuals*.

But we must not be understood as confining Art to actual portraits. Within such limits there could not be Art, — certainly not Art in its highest sense ; we should have in its place what would be little better than a doubtful empiricism; since the most elevated subject, in the ablest hands, would depend, of necessity, on the chance success of a search after models. And, supposing that we bring together only the rarest forms, still those forms, simply as circumscribed portraits, and therefore insulated parts, would instantly close every avenue to the imagination; for such is the law of the imagination, that it cannot admit, or, in other words, recognize as a whole, that which remains unmodified

by some imaginative power, which alone can give unity to separate and distinct objects. Yet, as it regards man, all true Art does, and must, find its proper object in the *Individual*: as without individuality there could not be character, nor without character, the human being.

But here it may be asked, In what manner, if we resort not to actual portrait, is the Individual Man to be expressed? We answer, By carrying out the natural individual predominant *fragment*, which is visible to us in actual Form, to its full, consistent developement. The Individual is thus idealized, when, in the complete accordance of all its parts, it is presented to the mind as a *whole*.

When we apply the term *fragment* to a human being, we do not mean in relation to his species, (in regard to which we have already shown him to be a distinct whole,) but in relation to the Idea, to which his predominant characteristic suggests itself but as a partial manifestation, and made partial because counteracted by some inadequate exponent, or else modified by other, though minor, characteristics.

How this is effected must be left to the Artist himself. It is impossible to prescribe a rule that would be to much purpose for any one who stands in need of such instruction; if his own mind does not suggest the mode, it would not even be intelligible. Perhaps our meaning, however, may be made more obvious, if we illustrate it by example. We would refer, then, to the restoration of a statue, (a thing often done with success,) where, from a single fragment, the unknown Form has been completely restored, and so remoulded, that the parts added are in perfect unity with the suggestive fragment. Now the parts wanting having never been

seen, this cannot be called a mere act of the memory. Nevertheless, it is not from nothing that man can produce even the *semblance* of any thing. The materials of the Artist are the work of Him who created the Artist himself; but over these, which his senses and mind are given him to observe and collect, he has a *delegated power*, for the purpose of combining and modifying, as unlimited as mysterious. It is by the agency of this intuitive and assimilating Power, elsewhere spoken of, that he is able to separate the essential from the accidental, to proceed also from a part to the whole; thus educing, as it were, an Ideal nature from the germs of the Actual.

Nor does the necessity of referring to Nature preclude the Imaginative, or any other class of Art that rests its truth in the desires of the mind. In an especial manner must the personification of Sentiment, of the Abstract, which owe their interest to the common desire of rendering permanent, by embodying, that which has given us pleasure, take its starting-point from the Actual; from something which, by universal association or particular expression, shall recall the Sentiment, Thought, or Time, and serve as their exponents; there being scarcely an object in Nature which the spirit of man has not, as it were, impressed with sympathy, and linked with his being. Of this, perhaps, we could not have a more striking example than in the Aurora of Michael Angelo; which, if not universal, is not so only because the faculty addressed is by no means common. For, as the peculiar characteristic of the Imaginative is its suggestive power, the effect of this figure must of necessity differ in different minds. As in many other cases, there must needs be at least some degree of sympathy with the mind that imagined it, in order to any

impression; and the degree in which that is made will always be in proportion to the congeniality between the agent and the recipient. Should it appear, then, to any one as a thing of no meaning, it is not therefore conclusive that the Artist has failed. For, if there be but one in a thousand to whose mind it recalls the deep stillness of Night, gradually broken by the awakening stir of Day, with its myriad forms of life emerging into motion, while their lengthened shadows, undistinguished from their objects, seem to people the earth with gigantic beings; then the dim, gray monotony of color transforming them to stone, yet leaving them in motion, till the whole scene becomes awful and mysterious as with moving statues; — if there be but one in ten thousand who shall have thus imagined, as he stands before this embodied Dawn, then is it, for every purpose of feeling through the excited imagination, as true and real as if instinct with life, and possessing the mind by its living will. Nor is the number so rare of those who have thus felt the suggestive sorcery of this sublime Statue. But the mind so influenced must be one to respond to sublime emotions, since such was the emotion which inspired the Artist. If susceptible only to the gay and beautiful, it will not answer. For this is not the Aurora of golden purple, of laughing flowers and jewelled dew-drops; but the dark Enchantress, enthroned on rocks, or craggy mountains, and whose proper empire is the shadowy confines of light and darkness.

How all this is done, we shall not attempt to explain. Perhaps the Artist himself could not answer; as to the *quo modo* in every particular, we doubt if it were possible to satisfy another. He may tell us, indeed, that having imagined certain appearances and effects peculiar to the Time, he endeavoured to imbue, as it were,

12

some *human form* with the sentiment they awakened, so that the embodied sentiment should associate itself in the spectator's mind with similar images; and further endeavoured, that the *form* selected should, by its air, attitude, and gigantic proportions, also excite the ideas of vastness, solemnity, and repose; adding to this that indefinite expression, which, while it is felt to act, still leaves no trace of its indistinct action. So far, it is true, he may retrace the process; but of the *informing life* that quickened his fiction, thus presenting the presiding Spirit of that ominous Time, he knows nothing but that he felt it, and imparted it to the insensible marble.

And now the question will naturally occur, Is all that has been done by the learned in Art, to establish certain canons of Proportion, utterly useless? By no means. If rightly applied, and properly considered, — as it seems to us they must have been by the great artists of Antiquity, — as *expedient fictions*, they undoubtedly deserve at least a careful examination. And, inasmuch as they are the result of a comparison of the finest actual forms through successive ages, and as they indicate the general limits which Nature has been observed to assign to her noblest works, they are so far to be valued. But it must not be forgotten, that, while a race, or class, may be generally marked by a certain average height and breadth, or curve and angle, still is every class and race composed of *Individuals*, who must needs, as such, differ from each other; and though the difference be slight, yet is it " the little more, or the little less," which often separates the great from the mean, the wise from the foolish, in human character; — nay, the widest chasms are sometimes made by a few lines : so that, in every individual case, the limits in question are rather to be departed from, than strictly adhered to.

The canon of the Schools is easily mastered by every student who has only memory; yet of the hundreds who apply it, how few do so to any purpose! Some ten or twenty, perhaps, call up life from the quarry, and flesh and blood from the canvas; the rest conjure in vain with their canon; they call up nothing but the dead measures. Whence the difference? The answer is obvious, — In the different minds they each carry to their labors.

But let us trace, with the Artist, the beginning and progress of a successful work; a picture, for instance. His method of proceeding may enable us to ascertain how far he is assisted by the science, so called, of which we are speaking. He adjusts the height and breadth of his figures according to the canon, either by the division of heads or faces, as most convenient. By these means, he gets the general divisions in the easiest and most expeditious way. But could he not obtain them without such aid? He would answer, Yes, by the eye alone; but it would be a waste of time were he so to proceed, since he would have to do, and undo, perhaps twenty times, before he could erect this simple scaffolding; whereas, by applying these rules, whose general truth is already admitted, he accomplishes his object in a few minutes. Here we admit the use of the canon, and admire the facility with which it enables his hand, almost without the aid of a thought, thus to lay out his work. But here ends the science; and here begins what may seem to many the work of mutilation: a leg, an arm, a trunk, is increased, or diminished; line after line is erased, or retrenched, or extended, again and again, till not a trace remains of the original draught. If he is asked now by what he is guided in these innumerable changes, he can only answer, By the feeling

within me. Nor can he better tell *how* he knows when he has *hit the mark.* The same feeling responds to its truth; and he repeats his attempts until that is satisfied.

It would appear, then, that in the Mind alone is to be found the true or ultimate Rule, — if, indeed, that can be called a rule which changes its measure with every change of character. It is therefore all-important that every aid be sought which may in any way contribute to the due developement of the mental powers; and no one will doubt the efficiency here of a good general education. As to the course of study, that must be left in a great measure to be determined by the student; it will be best indicated by his own natural wants. We may observe, however, that no species of knowledge can ever be *oppressive* to real genius, whose peculiar privilege is that of subordinating all things to the paramount desire. But it is not likely that a mind so endowed will be long diverted by any studies that do not either strengthen its powers by exercise, or have a direct bearing on some particular need.

If the student be a painter, or a sculptor, he will not need to be told that a knowledge of the human being, in all his complicated springs of action, is not more essential to the poet than to him. Nor will a true Artist require to be reminded, that, though *himself* must be his ultimate dictator and judge, the allegiance of the world is not to be commanded either by a dreamer or a dogmatist. And nothing, perhaps, would be more likely to secure him from either character, than the habit of keeping his eyes open, — nay, his very heart; nor need he fear to open it to the whole world, since nothing not kindred will enter there to abide; for

> " Evil into the mind
> May come and go, so unapproved, and leave
> No spot or blame behind."

And he may also be sure that a pure heart will shed a refining light on his intellect, which it may not receive from any other source.

It cannot be supposed that an Artist, so disciplined, will overlook the works of his predecessors, — especially those exquisite remains of Antiquity which time has spared to us. But to his own discretion must be left the separating of the factitious from the true, — a task of some moment; for it cannot be denied that a mere antiquarian respect for whatever is ancient has preserved, with the good, much that is worthless. Indeed, it is to little purpose that the finest forms are set before us, if we *feel* not their truth. And here it may be well to remark, that an injudicious *word* has often given a wrong direction to the student, from which he has found it difficult to recover when his maturer mind has perceived the error. It is a common thing to hear such and such statues, or pictures, recommended as *models*. If the advice is followed, — as it too often is *literally*, — the consequence must be an offensive mannerism; for, if repeating himself makes an artist a mannerist, he is still more likely to become one if he repeat another. There is but one model that will not lead him astray, — which is Nature: we do not mean what is merely obvious to the senses, but whatever is so acknowledged by the mind. So far, then, as the ancient statues are found to represent her, — and the student's own feeling must be the judge of that, — they are undoubtedly both true and important objects of study, as presenting not only a wider, but a higher view of Nature, than might else be commanded, were they buried with their authors; since, with the finest forms of the fairest portion of the earth, we have also in them the realized Ideas of some of the greatest minds.

12 *

In like manner may we extend our sphere of knowledge by the study of all those productions of later ages which have stood this test. There is no school from which something may not be learned. But chiefly to the Italian should the student be directed, who would enlarge his views on the present subject, and especially to the works of Raffaelle and Michael Angelo; in whose highest efforts we have, so to speak, certain revelations of Nature which could only have been made by her privileged seers. And we refer to them more particularly, as to the two great sovereigns of the two distinct empires of Truth, — the Actual and the Imaginative; in which their claims are acknowledged by *that* within us, of which we know nothing but that it *must* respond to all things true. We refer to them, also, as important examples in their mode of study; in which it is evident that, whatever the source of instruction, it was never considered as a law of servitude, but rather as the means of giving visible shape to their own conceptions.

From the celebrated antique fragment, called the Torso, Michael Angelo is said to have constructed his forms. If this be true, — and we have no reason to doubt it, — it could nevertheless have been to him little more than a hint. But that is enough to a man of genius, who stands in need, no less than others, of a point to start from. There was something in this fragment which he seems to have felt, as if of a kindred nature to the unembodied creatures in his own mind; and he pondered over it until he mastered the spell of its author. He then turned to his own, to the germs of life that still awaited birth, to knit their joints, to attach the tendons, to mould the muscles, — finally, to sway the limbs by a mighty will. Then emerged into being that

gigantic race of the Sistina, — giants in mind no less than in body, that appear to have descended as from another planet. His Prophets and Sibyls seem to carry in their persons the commanding evidence of their mission. They neither look nor move like beings to be affected by the ordinary concerns of life ; but as if they could only be moved by the vast of human events, the fall of empires, the extinction of nations ; as if the awful secrets of the future had overwhelmed in them all present sympathies. As we have stood before these lofty apparitions of the painter's mind, it has seemed to us impossible that the most vulgar spectator could have remained there irreverent.

With many critics it seems to have been doubted whether much that we now admire in Raffaelle would ever have been but for his great contemporary. Be this as it may, it is a fact of history, that, after seeing the works of Michael Angelo, both his form and his style assumed a breadth and grandeur which they possessed not before. And yet these great artists had little, if any thing, in common ; a sufficient proof that an original mind may owe, and even freely acknowledge, its impetus to another without any self-sacrifice.

As Michael Angelo adopted from others only what accorded with his own peculiar genius, so did Raffaelle ; and, wherever collected, the materials of both could not but enter their respective minds as their natural aliment.

The genius of Michael Angelo was essentially *Imaginative*. It seems rarely to have been excited by the objects with which we are daily familiar ; and when he did treat them, it was rather as things past, as they appear to us through the atmosphere of the hallowing memory. We have a striking instance of this in his statue

of Lorenzo de' Medici; where, retaining of the original
only enough to mark the individual, and investing the
rest with an air of grandeur that should accord with
his actions, he has left to his country, not a mere ef-
figy of the person, but an embodiment of the mind;
a portrait for posterity, in which the unborn might rec-
ognize Lorenzo the Magnificent.

But the mind of Raffaelle was an ever-flowing foun-
tain of human sympathies; and in all that concerns
man, in his vast varieties and complicated relations,
from the highest forms of majesty to the humblest con-
dition of humanity, even to the maimed and mis-
shapen, he may well be called a master. His Apostles,
his philosophers, and most ordinary subordinates, are all
to us as living beings; nor do we feel any doubt that
they all had mothers, and brothers, and kindred. In the
assemblage of the Apostles (already referred to) at the
Death of Ananias, we look upon men whom the effu-
sion of the Spirit has equally sublimated above every
unholy thought; a common power seems to have in-
vested them all with a preternatural majesty. Yet not
an iota of the *individual* is lost in any one; the gentle
bearing and amenity of John still follow him in his office
of almoner; nor in Peter does the deep repose of the erect
attitude of the Apostle, as he deals the death-stroke to
the offender by a simple bend of his finger, subdue the
energetic, sanguine temperament of the Disciple.

If any man may be said to have reigned over the
hearts of his fellows, it was Raffaelle Sanzio. Not
that he knew better what was in the hearts and minds
of men than many others, but that he better under-
stood their relations to the external. In this the great-
est names in Art fall before him; in this he has no rival;
and, however derived, or in whatever degree improved by

study, in him it seems to have risen to intuition. We
know not how he touches and enthralls us; as if he
had wrought with the simplicity of Nature, we see no
effort; and we yield as to a living influence, sure, yet
inscrutable.

It is not to be supposed that these two celebrat-
ed Artists were at all times successful. Like other
men, they had their moments of weakness, when they
fell into manner, and gave us diagrams, instead of
life. Perhaps no one, however, had fewer lapses of this
nature than Raffaelle; and yet they are to be found in
some of his best works. We shall notice now only
one instance, — the figure of St. Catherine in the ad-
mirable picture of the Madonna di Sisto; in which we
see an evident rescript from the Antique, with all the
received lines of beauty, as laid down by the analyst,
— apparently faultless, yet without a single inflection
which the mind can recognize as allied to our sympa-
thies; and we turn from it coldly, as from the work of
an artificer, not of an Artist. But not so can we turn
from the intense life, that seems almost to breathe upon
us from the celestial group of the Virgin and her Child,
and from the Angels below: in these we have the evi-
dence of the divine afflatus, — of inspired Art.

In the works of Michael Angelo it were easy to
point out numerous examples of a similar failure,
though from a different cause; not from mechanically
following the Antique, but rather from erecting into a
model the exaggerated *shadow* of his own practice; from
repeating lines and masses that might have impressed
us with grandeur but for the utter absence of the inform-
ing soul. And that such is the character — or rather
want of character — of many of the figures in his
Last Judgment cannot be gainsaid by his warmest ad-

mirers, — among whom there is no one more sincere
than the present writer. But the failures of great men
are our most profitable lessons, — provided only, that
we have hearts and heads to respond to their success.

In conclusion. We have now arrived at what ap-
pears to us the turning-point, that, by a natural reflux,
must carry us back to our original Position; in other
words, it seems to us clear, that the result of the argu-
ment is that which was anticipated in our main Propo-
sition; namely, that no given number of Standard
Forms can with certainty apply to the Human Being;
that all Rules therefore, thence derived, can only be con-
sidered as *Expedient Fictions*, and consequently subject
to be *overruled* by the Artist, — in whose mind alone
is the ultimate Rule; and, finally, that without an inti-
mate acquaintance with Nature, in all its varieties of
the moral, intellectual, and physical, the highest pow-
ers are wanting in their necessary condition of action,
and are therefore incapable of supplying the Rule.

COMPOSITION.

THE term Composition, in its general sense, signifies the union of things that were originally separate: in the art of Painting it implies, in addition to this, such an arrangement and reciprocal relation of these materials, as shall constitute them so many essential parts of a whole.

In a true Composition of Art will be found the following characteristics: — First, Unity of Purpose, as expressing the general sentiment or intention of the Artist. Secondly, Variety of Parts, as expressed in the diversity of shape, quantity, and line. Thirdly, Continuity, as expressed by the connection of parts with each other, and their relation to the whole. Fourthly, Harmony of Parts.

As these characteristics, like every thing which the mind can recognize as true, all have their origin in its natural desires, they may also be termed Principles; and as such we shall consider them. In order, however, to satisfy ourselves that they are truly such, and not arbitrary assumptions, or the traditional dogmas of Practice, it may be well to inquire whence is their authority; for, though the ultimate cause of pleasure and pain may ever remain to us a mystery, yet it is not so

with their intermediate causes, or the steps that lead
to them.

With respect to Unity of Purpose, it is sufficient to
observe, that, where the attention is at the same time
claimed by two objects, having each a different end,
they must of necessity break in upon that free state re-
quired of the mind in order to receive a full impression
from either. It is needless to add, that such conflict-
ing claims cannot, under any circumstances, be ren-
dered agreeable. And yet this most obvious require-
ment of the mind has sometimes been violated by great
Artists, — though not of authority in this particular, as
we shall endeavour to show in another place.

We proceed, meanwhile, to the second principle,
namely, Variety; by which is to be understood *differ-
ence*, yet with *relation* to a *common end*.

Of a ruling Principle, or Law, we can only get a no-
tion by observing the effects of certain things in rela-
tion to the mind; the uniformity of which leads us to
infer something which is unchangeable and permanent.
It is in this way that, either directly or indirectly, we
learn the existence of certain laws that invariably con-
trol us. Thus, indirectly, from our disgust at monoto-
ny, we infer the necessity of variety. But variety, when
carried to excess, results in weariness. Some limitation,
therefore, seems no less needed. It is, however, obvi-
ous, that all attempts to fix the limit to Variety, that
shall apply as a universal rule, must be nugatory, inas-
much as the *degree* must depend on the *kind*, and the
kind on the subject treated. For instance, if the subject
be of a gay and light character, and the emotions in-
tended to be excited of a similar nature, the variety
may be carried to a far greater extent than in one of a
graver character. In the celebrated Marriage at Cana,

by Paul Veronese, we see it carried, perhaps, to its utmost limits; and to such an extent, that an hour's travel will hardly conduct us through all its parts; yet we feel no weariness throughout this journey, nay, we are quite unconscious of the time it has taken. It is no disparagement of this remarkable picture, if we consider the subject, not according to the title it bears, but as what the Artist has actually made it, — that is, as a Venetian entertainment; and also the effect intended, which was to delight by the exhibition of a gorgeous *pageant*. And in this he has succeeded to a degree unexampled; for literally the eye may be said to *dance* through the picture, scarcely lighting on one part before it is drawn to another, and another, and another, as by a kind of witchery; while the subtile interlocking of each successive novelty leaves it no choice, but, seducing it onward, still keeps it in motion, till the giddy sense seems to call on the Imagination to join in the revel; and every poetic temperament answers to the call, bringing visions of its own, that mingle with the painted crowd, exchanging forms, and giving them voice, like the creatures of a dream.

To those who have never seen this picture, our account of its effect may perhaps appear incredible when they are told, that it not only has no story, but not a single expression to which you can attach a sentiment. It is nevertheless for this very reason that we here cite it, as a triumphant verification of those immutable laws of the mind to which the principles of Composition are supposed to appeal; where the simple technic exhibition, or illustration of *Principles*, without story, or thought, or a single definite expression, has still the power to possess and to fill us with a thousand delightful emotions.

13

And here we cannot refrain from a passing remark on certain criticisms, which have obtained, as we think, an undeserved currency. To assert that such a work is solely addressed to the senses (meaning thereby that its only end is in mere pleasurable sensation) is to give the lie to our convictions; inasmuch as we find it appealing to one of the mightiest ministers of the Imagination, — the great Law of Harmony, — which cannot be *touched* without awakening by its vibrations, so to speak, the untold myriads of sleeping forms that lie within its circle, that start up in tribes, and each in accordance with the congenial instrument that summons them to action. He who can thus, as it were, embody an abstraction is no mere pander to the senses. And who that has a modicum of the imaginative would assert of one of Haydn's Sonatas, that its effect on him was no other than sensuous? Or who would ask for the *story* in one of our gorgeous autumnal sunsets?

In subjects of a grave or elevated kind, the Variety will be found to diminish in the same degree in which they approach the Sublime. In the raising of Lazarus, by Lievens, we have an example of the smallest possible number of parts which the nature of such a subject would admit. And, though a different conception might authorize a much greater number, yet we do not feel in this any deficiency; indeed, it may be doubted if the addition of even one more part would not be felt as obtrusive.

By the term *parts* we are not to be understood as including the minutiæ of dress or ornament, or even the several members of a group, which come more properly under the head of detail; we apply the term only to those prominent divisions which constitute the essential features of a composition. Of these the Sublime

admits the fewest. Nor is the limitation arbitrary. By whatever causes the stronger passions or higher faculties of the mind become pleasurably excited, if they be pushed as it were beyond their supposed limits, till a sense of the indefinite seems almost to partake of the infinite, to these causes we affix the epithet *Sublime*. It is needless to inquire if such an effect can be produced by any thing short of the vast and overpowering, much less by the gradual approach or successive accumulation of any number of separate forces. Every one can answer from his own experience. We may also add, that the pleasure which belongs to the deeper emotions always trenches on pain; and the sense of pain leads to reaction; so that, singly roused, they will rise but to fall, like men at a breach, — leaving a conquest, not over the living, but the dead. The effect of the Sublime must therefore be sudden, and to be sudden, simple, scarce seen till felt; coming like a blast, bending and levelling every thing before it, till it passes into space. So comes this marvellous emotion; and so vanishes, — to where no straining of our mortal faculties will ever carry them.

To prevent misapprehension, we may here observe, that, though the parts be few, it does not necessarily follow that they should always consist of simple or single objects. This narrow inference has often led to the error of mistaking mere space for grandeur, especially with those who have wrought rather from theory than from the true possession of their subjects. Hence, by the mechanical arrangement of certain large and sweeping masses of light and shadow, we are sometimes surprised into a momentary expectation of a sublime impression, when a nearer approach gives us only the notion of a vast blank. And the

error lies in the misconception of a mass. For a mass is not a *thing*, but the condition of *things;* into which, should the subject require it, a legion, a host, may be compressed, an army with banners, — yet so that they break not the unity of their Part, that technic form to which they are subordinate.

The difference between a Part and a Mass is, that a Mass may include, *per se*, many Parts, yet, in relation to a Whole, is no more than a single component. Perhaps the same distinction may be more simply expressed, if we define it as only a larger division, including several *parts*, which may be said to be analogous to what is termed the detail of a *Part*. Look at the ocean in a storm, — at that single wave. How it grows before us, building up its waters as with conscious life, till its huge head overlooks the mast! A million of lines intersect its surface, a myriad of bubbles fleck it with light; yet its terrible unity remains unbroken. Not a bubble or a line gives a thought of minuteness; they flash and flit, ere the eye can count them, leaving only their aggregate, in the indefinite sense of multitudinous motion : take them away, and you take from the *mass* the very sign of its power, that fearful impetus which makes it what it is, — a moving mountain of water.

We have thus endeavoured, in the opposite characters of the Sublime and the Gay or Magnificent, to exhibit the two extremes of Variety; of the intermediate degrees it is unnecessary to speak, since in these two is included all that is applicable to the rest.

Though it is of vital importance to every composition that there be variety of Lines, little can be said on the subject in addition to what has been advanced in relation to parts, that is, to shape and quantity; both

having a common origin. By a line in Composition is meant something very different from the geometrical definition. Originally, it was no doubt used as a metaphor; but the needs of Art have long since converted this, and many other words of like application, (as *tone*, &c.,) into technical terms. *Line* thus signifies the course or medium through which the eye is led from one part of the picture to another. The indication of this course is various and multiform, appertaining equally to shape, to color, and to light and dark; in a word, to whatever attracts and keeps the eye in motion. For the regulation of these lines there is no rule absolute, except that they vary and unite; nor is the last strictly necessary, it being sufficient if they so terminate that the transition from one to another is made naturally, and without effort, by the imagination. Nor can any laws be laid down as to their peculiar character: this must depend on the nature of the subject.

In the wild and stormy scenes of Salvator Rosa, they break upon us as with the angular flash of lightning; the eye is dashed up one precipice only to be dashed down another; then, suddenly hurried to the sky, it shoots up, almost in a direct line, to some sharp-edged rock; whence pitched, as it were, into a sea of clouds, bellying with circles, it partakes their motion, and seems to reel, to roll, and to plunge with them into the depths of air.

If we pass from Salvator to Claude, we shall find a system of lines totally different. Our first impression from Claude is that of perfect *unity*, and this we have even before we are conscious of a single image; as if, circumscribing his scenes by a magic circle, he had imposed his own mood on all who entered it. The *spell* then opens ere it seems to have begun, acting upon us

13 *

with a vague sense of limitless expanse, yet so contin-
uous, so gentle, so imperceptible in its remotest grada-
tions, as scarcely to be felt, till, combining with unity,
we find the feeling embodied in the complete image of
intellectual repose, — fulness and rest. The mind thus
disposed, the charmed eye glides into the scene : a soft,
undulating light leads it on, from bank to bank, from
shrub to shrub ; now leaping and sparkling over pebbly
brooks and sunny sands; now fainter and fainter, dying
away down shady slopes, then seemingly quenched in
some secluded dell; yet only for a moment, — for a
dimmer ray again carries it onward, gently winding
among the boles of trees and rambling vines, that,
skirting the ascent, seem to hem in the twilight; then
emerging into day, it flashes in sheets over towers and
towns, and woods and streams, when it finally dips into
an ocean, so far off, so twin-like with the sky, that the
doubtful horizon, unmarked by a line, leaves no point
of rest : and now, as in a flickering arch, the fascinated
eye seems to sail upward like a bird, wheeling its flight
through a mottled labyrinth of clouds, on to the zenith ;
whence, gently inflected by some shadowy mass, it
slants again downward to a mass still deeper, and still
to another, and another, until it falls into the darkness
of some massive tree, — focused like midnight in the
brightest noon : there stops the eye, instinctively clos-
ing, and giving place to the Soul, there to repose and
to dream her dreams of romance and love.

From these two examples of their general effect,
some notion may be gathered of the different systems
of the two Artists; and though no mention has been
made of the particular lines employed, their distinctive
character may readily be inferred from the kind of mo-
tion given to the eye in the descriptions we have at-

tempted. In the rapid, abrupt, contrasted, whirling movement in the one, we have an exposition of an irregular combination of curves and angles; while the simple combination of the parabola and the serpentine will account for all the imperceptible transitions in the other.

It would be easy to accumulate examples from other Artists who differ in the economy of line not only from these but from each other; as Raffaelle, Michael Angelo, Correggio, Titian, Poussin, — in a word, every painter deserving the name of master: for lines here may be called the tracks of thought, in which we follow the author's mind through his imaginary creations. They hold, indeed, the same relation to Painting that versification does to Poetry, an element of style; for what is meant by a line in Painting is analogous to that which in the sister art distinguishes the abrupt gait of Crabbe from the sauntering walk of Cowley, and the "long, majestic march" of Dryden from the surging sweep of Milton.

Of Continuity little needs be said, since its uses are implied in the explanation of Line; indeed, all that can be added will be expressed in its essential relation to a *whole*, in which alone it differs from a mere line. For, though a line (as just explained) supposes a continuous course, yet a line, *per se*, does not necessarily imply any relation to other lines. It will still be a line, though standing alone; but the principle of continuity may be called the unifying spirit of every line. It is therefore that we have distinguished it as a separate principle.

In fact, if we judge from feeling, the only true test, it is no paradox to say that the excess of variety must inevitably end in monotony; for, as soon as the sense of fatigue begins, every new variety but adds to the

pain, till the succeeding impressions are at last resolved into continuous pain. But, supposing a limit to variety, where the mind may be pleasurably excited, the very sense of pleasure, when it reaches the extreme point, will create the desire of renewing it, and naturally carry it back to the point of starting; thus superinducing, with the renewed enjoyment, the fulness of pleasure, in the sense of a whole.

It is by this summing up, as it were, of the memory, through recurrence, not that we perceive, — which is instantaneous, — but that we enjoy any thing as a whole. If we have not observed it in others, some of us, perhaps, may remember it in ourselves, when we have stood before some fine picture, though with a sense of pleasure, yet for many minutes in a manner abstracted, — silently passing through all its harmonious transitions without the movement of a muscle, and hardly conscious of action, till we have suddenly found ourselves returning on our steps. Then it was, — as if we had no eyes till then, — that the magic Whole poured in upon us, and vouched for its truth in an outbreak of rapture.

The fourth and last division of our subject is the Harmony of Parts; or the essential agreement of one part with another, and of each with the whole. In addition to our first general definition, we may further observe, that by a Whole in Painting is signified the complete expression, by means of form, color, light, and shadow, of one thought, or series of thoughts, having for their end some particular truth, or sentiment, or action, or mood of mind. We say *thought*, because no images, however put together, can ever be separated by the mind from other and extraneous images, so as to comprise a positive whole, unless they be limited by some intellectual boundary. A picture wanting this may

have fine parts, but is not a Composition, which implies parts united to each other, and also suited to some specific purpose, otherwise they cannot be known as united. Since Harmony, therefore, cannot be conceived of without reference to a whole, so neither can a whole be imagined without fitness of parts. To give this fitness, then, is the ultimate task and test of genius: it is, in fact, calling form and life out of what before was but a chaos of materials, and making them the subject and exponents of the will. As the master-principle, also, it is the disposer, regulator, and modifier of shape, line, and quantity, adding, diminishing, changing, shaping, till it becomes clear and intelligible, and it finally manifests itself in pleasurable identity with the harmony within us.

To reduce the operation of this principle to precise rules is, perhaps, without the province of human power: we might else expect to see poets and painters made by recipe. As in many other operations of the mind, we must here be content to note a few of the more tangible facts, if we may be allowed the phrase, which have occasionally been gathered by observation during the process. The first fact presented is, that equal quantities, when coming together, produce monotony, and, if at all admissible, are only so when absolutely needed, at a proper distance, to echo back or recall the theme, which would otherwise be lost in the excess of variety. We speak of quantity here as of a mass, not of the minutiæ; for *the essential components* of a part may often be *equal quantities,* (as in a piece of architecture, of armour, &c.,) which are analogous to poetic feet, for instance, a spondee. The same effect we find from parallel lines and repetition of shapes. Hence we obtain the law of a limited variety. The next is, that

the quantities must be so disposed as to balance each
other; otherwise, if all or too many of the larger be on
one side, they will endanger the imaginary circle, or other
figure, by which every composition is supposed to be
bounded, making it appear "lop-sided," or to be falling
either in upon the smaller quantities, or out of the pic-
ture: from which we infer the necessity of balance. If,
without others to counteract and restrain them, the parts
converge, the eye, being forced to the centre, becomes
stationary; in like manner, if all diverge, it is forced
to fly off in tangents: as if the great laws of Attrac-
tion and Repulsion were here also essential, and illus-
trated in miniature. If we add to these Breadth, I be-
lieve we shall have enumerated all the leading phenom-
ena of Harmony, which experience has enabled us to
establish as rules. By *breadth* is meant such a mass-
ing of the quantities, whether by color, light, or shadow,
as shall enable the eye to pass without obstruction, and
by easy transitions, from one to another, so that it shall
appear to take in the whole at a glance. This may be
likened to both the exordium and peroration of a dis-
course, including as well the last as the first general
idea. It is, in other words, a simple, connected, and
concise exposition and summary of what the artist
intends.

We have thus endeavoured to arrange and to give a
logical permanency to the several principles of Composi-
tion. It is not to be supposed, however, that in these
we have every principle that might be named; but they
are all, as we conceive, that are of universal application.
Of other minor, or rather personal ones, since they
pertain to the individual, the number can only be lim-
ited by the variety of the human intellect, to which
these may be considered as so many simple elementary

guides; not to create genius, but to enable it to under-
stand itself, and by a distinct knowledge of its own
operations to correct its mistakes, — in a word, to estab-
lish the landmarks between the flats of commonplace
and the barrens of extravagance. And, though the per-
sonal or individual principles referred to may not with
propriety be cited as examples in a general treatise like
the present, they are not only not to be overlooked, but
are to be regarded by the student as legitimate ob-
jects of study. To the truism, that we can only judge
of other minds by a knowledge of our own, we may
add its converse as especially true. In that mysterious
tract of the intellect, which we call the Imagination,
there would seem to lie hid thousands of unknown
forms, of which we are often for years unconscious, un-
til they start up awakened by the footsteps of a stran-
ger. Hence it is that the greatest geniuses, as present-
ing a wider field for excitement, are generally found
to be the widest likers; not so much from affinity, or
because they possess the precise kinds of excellence
which they admire, but often from the *differences* which
these very excellences in others, as the exciting cause,
awaken in themselves. Such men may be said to be
endowed with a double vision, an inward and an out-
ward; the inward seeing not unfrequently the reverse
of what is seen by the outward. It was this which
caused Annibal Caracci to remark, on seeing for the
first time a picture by Caravaggio, that he thought a
style totally opposite might be made very captivating;
and the hint, it is said, sunk deep into and was not lost
on Guido, who soon after realized what his master had
thus imagined. Perhaps no one ever caught more from
others than Raffaelle. I do not allude to his " borrow-
ing," so ingeniously, not soundly, defended by Sir

Joshua, but rather to his excitability, (if I may here apply a modern term,) — that inflammable temperament, which took fire, as it were, from the very friction of the atmosphere. For there was scarce an excellence, within his knowledge, of his predecessors or contemporaries, which did not in a greater or less degree contribute to the developement of his powers; not as presenting models of imitation, but as shedding new light on his own mind, and opening to view its hidden treasures. Such to him were the forms of the Antique, of Leonardo da Vinci, and of Michael Angelo, and the breadth and color of Fra Bartolomeo, — lights that first made him acquainted with himself, not lights that he followed; for he was a follower of none. To how many others he was indebted for his impulses cannot now be known; but the new impetus he was known to have received from every new excellence has led many to believe, that, had he lived to see the works of Titian, he would have added to his grace, character, and form, and with equal originality, the splendor of color. " The design of Michael Angelo and the color of Titian," was the inscription of Tintoretto over the door of his painting-room. Whether he intended to designate these two artists as his future models matters not; but that he did not follow them is evidenced in his works. Nor, indeed, could he: the temptation to *follow*, which his youthful admiration had excited, was met by an interdiction not easily withstood, — the decree of his own genius. And yet the decree had probably never been heard but for these very masters. Their presence stirred him; and, when he thought of serving, his teeming mind poured out its abundance, making *him* a master to future generations. To the forms of Michael Angelo he was certainly indebted for the elevation of his own; there,

however, the inspiration ended. With Titian he was nearly allied in genius; yet he thought rather with than after him, — at times even beyond him. Titian, indeed, may be said to have first opened his eyes to the mysteries of nature; but they were no sooner opened, than he rushed into them with a rapidity and daring unwont to the more cautious spirit of his master; and, though irregular, eccentric, and often inferior, yet sometimes he made his way to poetical regions, of whose celestial hues even Titian himself had never dreamt.

We might go on thus with every great name in Art. But these examples are enough to show how much even the most original minds, not only may, but *must*, owe to others; for the social law of our nature applies no less to the intellect than to the affections. When applied to genius, it may be called the social inspiration, the simple statement of which seems to us of itself a solution of the oft-repeated question, " Why is it that genius always appears in clusters ? " To Nature, indeed, we must all at last recur, as to the only true and permanent foundation of real excellence. But Nature is open to all men alike, in her beauty, her majesty, her grandeur, and her sublimity. Yet who will assert that all men see, or, if they see, are impressed by these her attributes alike ? Nay, so great is the difference, that one might almost suppose them inhabitants of different worlds. Of Claude, for instance, it is hardly a metaphor to say that he lived in two worlds during his natural life; for Claude the pastry-cook could never have seen the same world that was made visible to Claude the painter. It was human sympathy, acting through human works, that gave birth to his intellect at the age of forty. There is something, perhaps, ludicrous in the thought of an infant of forty. Yet the

14

fact is a solemn one, that thousands die whose minds
have never been born.

We could not, perhaps, instance a stronger confuta-
tion of the vulgar error which opposes learning to
genius, than the simple history of this remarkable
man. In all that respects the mind, he was literally a
child, till accident or necessity carried him to Rome;
for, when the office of color-grinder, added to that of
cook, by awakening his curiosity, first excited a love for
the Art, his progress through its rudiments seems to
have been scarcely less slow and painful than that of a
child through the horrors of the alphabet. It was the
struggle of one who was learning to think; but, the
rudiments being mastered, he found himself suddenly
possessed, not as yet of thought, but of new forms of
language; then came thoughts, pouring from his mind,
and filling them as moulds, without which they had
never, perhaps, had either shape or consciousness.

Now what was this new language but the product of
other minds, — of successive minds, amending, enlarg-
ing, elaborating, through successive ages, till, fitted to all
its wants, it became true to the Ideal, and the vernac-
ular tongue of genius through all time? The first in-
ventor of verse was but the prophetic herald of Homer,
Shakspeare, and Milton. And what was Rome then
but the great University of Art, where all this accumu-
lated learning was treasured?

Much has been said of self-taught geniuses, as op-
posed to those who have been instructed by others: but
the distinction, it appears to us, is without a difference;
for it matters not whether we learn in a school or by
ourselves, — we cannot learn any thing without in some
way recurring to other minds. Let us imagine a poet
who had never read, never heard, never conversed with

another. Now if he will not be taught in any thing by another, he must strictly preserve this independent negation. Truly the verses of such a poet would be a miracle. Of similar self-taught painters we have abundant examples in our aborigines, — but nowhere else.

But, while we maintain, as a positive law of our nature, the necessity of mental intercourse with our fellow-creatures, in order to the full developement of the *individual*, we are far from implying that any thing which is actually taken from others can by any process become our own, that is, original. We may reverse, transpose, diminish, or add to it, and so skilfully that no seam or mutilation shall be detected; and yet we shall not make it appear original, — in other words, *true*, the offspring of *one* mind. A borrowed thought will always be borrowed; as it will be felt as such in its *effect*, even while we are ourselves unconscious of the fact: for it will want that *effect of life*, which only the first mind can give it.*

* There is one species of imitation, however, which, as having been practised by some of the most original minds, and also sanctioned by the ablest writers, demands at least a little consideration; namely, the adoption of an attitude, provided it be employed to convey a different thought. So far, indeed, as the imitation has been confined to a suggestion, and the attitude adopted has been modified by the new subject, to which it was transferred, by a distinct change of character and expression, though with but little variation in the disposition of limbs, we may not dissent; such imitations being virtually little more than hints, since they end in thoughts either totally different from, or more complete than, the first. This we do not condemn, for every Poet, as well as Artist, knows that a thought so modified is of right his own. It is the transplanting of a tree, not the borrowing of a seed, against which we contend. But when writers justify the appropriation of entire figures, without any such change, we do not agree with them; and cannot but think that the examples they have quoted, as in the Sacrifice at Lystra, by Raffaelle, and the Baptism, by Poussin, will fully support our position. The antique *basso rilievo* which Raffaelle has introduced in the former, being certainly imitated both as to lines and grouping, is so distinct, both in character and form, from the surrounding figures, as to ren-

Of the multifarious retailers of the second-hand in style, the class is so numerous as to make a selection difficult: they meet us at every step in the history of the Art. One instance, however, may suffice, and we select Vernet, as uniting in himself a singular and striking example of the *false* and the *true ;* and also as the least invidious instance, inasmuch as we may prove our position by opposing him to himself.

der them a distinct people, and their very air reminds us of another age. We cannot but believe we should have had a very different group, and far superior in expression, had he given us a conception of his own. It would at least have been in accordance with the rest, animated with the superstitious enthusiasm of the surrounding crowd ; and especially as sacrificing Priests would they have been amazed and awe-stricken in the living presence of a god, instead of personating, as in the present group, the cold officials of the Temple, going through a stated task at the shrine of their idol. In the figure by Poussin, which he borrowed from Michael Angelo, the discrepancy is still greater. The original figure, which was in the Cartoon at Pisa, (now known only by a print,) is that of a warrior who has been suddenly roused from the act of bathing by the sound of a trumpet; he has just leaped upon the bank, and, in his haste to obey its summons, thrusts his foot through his garment. Nothing could be more appropriate than the violence of this action; it is in unison with the hurry and bustle of the occasion. And this is the figure which Poussin (without the slightest change, if we recollect aright) has transferred to the still and solemn scene in which John baptizes the Saviour. No one can look at this figure without suspecting the plagiarism. Similar instances may be found in his other works ; as in the Plague of the Philistines, where the Alcibiades of Raffaelle is coolly sauntering among the dead and dying, and with as little relation to the infected multitude as if he were still with Socrates in the School of Athens. In the same picture may be found also one of the Apostles from the Cartoon of the Draught of Fishes : and we may naturally ask what business he has there. And yet such appropriations have been made to appear no thefts, simply because no attempt seems to have been made at concealment! But theft, we must be allowed to think, is still theft, whether committed in the dark, or in the face of day. And the example is a dangerous one, inasmuch as it comes from men who were not constrained to resort to such shifts by any poverty of invention.

Akin to this is another and larger kind of borrowing, which, though it cannot strictly be called copying, yet so evidently betrays a foreign origin, as to produce the same effect. We allude to the adoption of the peculiar lines, handling, and disposition of masses, &c., of any particular master.

In the landscapes of Vernet, (when not mere views,) we see the imitator of Salvator, or rather copyist of his lines; and these we have in all their angular nakedness, where rocks, trees, and mountains are so jagged, contorted, and tumbled about, that nothing but an explosion could account for their assemblage. They have not the relation which we sometimes find even in a random collocation, as in the accidental pictures of a discolored wall; for the careful hand of the contriver is traced through all this disorder; nay, the very execution, the conventional dash of pencil, betrays what a lawyer would call the *malice prepense* of the Artist in their strange disfigurement. To many this may appear like hypercriticism; but we sincerely believe that no one, even among his admirers, has ever been deceived into a real sympathy with such technical flourishes: they are felt as factitious; as mere diagrams of composition deduced from pictures.

Now let us look at one of his Storms at Sea, when he wrought from his own mind. A dark leaden atmosphere prepares us for something fearful: suddenly a scene of tumult, fierce, wild, disastrous, bursts upon us; and we feel the shock drive, as it were, every other thought from the mind: the terrible vision now seizes the imagination, filling it with sound and motion: we see the clouds fly, the furious waves one upon another dashing in conflict, and rolling, as if in wrath, towards the devoted ship: the wind blows from the canvas; we hear it roar through her shrouds; her masts bend like twigs, and her last forlorn hope, the close-reefed foresail, streams like a tattered flag: a terrible fascination still constrains us to look, and a dim, rocky shore looms on her lee: then comes the dreadful cry of "Breakers ahead!" the crew stand appalled, and the

14*

master's trumpet is soundless at his lips. This is the
uproar of nature, and we *feel* it to be *true;* for here every
line, every touch, has a meaning. The ragged clouds,
the huddled waves, the prostrate ship, though forced by
contrast into the sharpest angles, all agree, opposed as
they seem, — evolving harmony out of apparent dis-
cord. And this is Genius, which no criticism can ever
disprove.

But all great names, it is said, must have their shad-
ows. In our Art they have many shadows, or rather I
should say, reflections; which are more or less distinct
according to their proximity to the living originals, and,
like the images in opposite mirrors, becoming them-
selves reflected and re-reflected with a kind of battle-
door alternation, grow dimmer and dimmer till they
vanish from mere distance.

Thus have the great schools of Italy, Flanders, and
Holland lived and walked after death, till even their
ghosts have become familiar to us.

We would not, however, be understood as asserting
that we receive pleasure only from original works : this
would be contradicting the general experience. We
admit, on the contrary, that there are hundreds, nay,
thousands, of pictures having no pretensions to origi-
nality of any kind, which still afford pleasure; as, indeed,
do many things out of the Art, which we know to be
second-hand, or imperfect, and even trifling. Thus grace
of manner, for instance, though wholly unaided by a
single definite quality, will often delight us, and a ready
elocution, with scarce a particle of sense, make com-
monplace agreeable; and it seems to be, that the pain
of mental inertness renders action so desirable, that the
mind instinctively surrounds itself with myriads of ob-
jects, having little to recommend them but the property
of keeping it from stagnating. And we are far from

denying a certain value to any of these, provided they be innocent : there are times when even the wisest man will find commonplace wholesome. All we have attempted to show is, that the effect of an original work, as opposed to an imitation, is marked by a difference, not of degree merely, but of kind ; and that this difference cannot fail to be felt, not, indeed, by every one, but by any competent judge, that is, any one in whom is developed, by natural exercise, that internal sense by which the spirit of life is discerned.

<div align="center">*　*　*　*　*</div>

Every original work becomes such from the infusion, so to speak, of the mind of the Author; and of this the fresh materials of nature alone seem susceptible. The imitated works of man cannot be endued with a second life, that is, with a second mind : they are to the imitator as air already breathed.

<div align="center">*　*　*　*　*</div>

What has been said in relation to Form — that the works of our predecessors, so far as they are recognized as true, are to be considered as an extension of Nature, and therefore proper objects of study — is equally applicable to Composition. But it is not to be understood that this extended Nature (if we may so term it) is in any instance to be imitated as a *whole*, which would be bringing our minds into bondage to another ; since, as already shown in the second Discourse, every original work is of necessity impressed with the mind of its author. If it be asked, then, what is the advantage of such study, we shall endeavour to show, that it is not merely, as some have supposed, in enriching the mind with materials, but rather in widening our view of excellence, and, by consequent excitement, expanding our own powers of observation, reflection, and performance. By increasing the power of performance, we

mean enlarging our knowledge of the technical pro-
cess, or the medium through which thought is express-
ed; a most important species of knowledge, which,
if to be otherwise attained, is at least most readily
learned from those who have left us the result of
their experience. This technical process, which has
been well called the language of the Art, includes, of
course, all that pertains to Composition, which, as the
general medium, also contains most of the elements of
this peculiar tongue.

From the gradual progress of the various arts of civ-
ilization, it would seem that only under the action of
some great *social* law can man arrive at the full devel-
opement of his powers. In our Art especially is this
true; for the experience of one man must necessarily
be limited, particularly if compared with the endless
varieties of form and effect which diversify the face of
Nature; and the finest of these, too, in their very nature
transient, or of rare occurrence, and only known to oc-
cur to those who are prepared to seize them in their
rapid transit; so that in one short life, and with but
one set of senses, the greatest genius can learn but lit-
tle. The Artist, therefore, must needs owe much to the
living, and more to the dead, who are virtually his com-
panions, inasmuch as through their works they still live
to our sympathies. Besides, in our great predecessors
we may be said to possess a multiplied life, if life be
measured by the number of acts, — which, in this case,
we may all appropriate to ourselves, as it were by a
glance. For the dead in Art may well be likened to
the hardy pioneers of our own country, who have suc-
cessively cleared before us the swamps and forests that
would have obstructed our progress, and opened to us
lands which the efforts of no individual, however per-
severing, would enable him to reach.

APHORISMS.

SENTENCES

WRITTEN BY MR. ALLSTON ON THE WALLS OF HIS STUDIO.

1. " No genuine work of Art ever was, or ever can be, produced but for its own sake; if the painter does not conceive to please himself, he will not finish to please the world."— FUSELI.

2. If an Artist love his Art for its own sake, he will delight in excellence wherever he meets it, as well in the work of another as in his own. This is the test of a true love.

3. Nor is this genuine love compatible with a craving for distinction; where the latter predominates, it is sure to betray itself before contemporary excellence, either by silence, or (as a bribe to the conscience) by a modicum of praise.

The enthusiasm of a mind so influenced is confined to itself.

4. Distinction is the consequence, never the object, of a great mind.

5. The love of gain never made a Painter; but it has marred many.

6. The most common disguise of Envy is in the praise of what is subordinate.

7. Selfishness in Art, as in other things, is sensibility kept at home.

8. The Devil's heartiest laugh is at a detracting witticism. Hence the phrase " devilish good " has sometimes a literal meaning.

9. The most intangible, and therefore the worst, kind of lie is a half truth. This is the peculiar device of a *conscientious* detractor.

10. Reverence is an ennobling sentiment; it is felt to be degrading only by the vulgar mind, which would escape the sense of its own littleness by elevating itself into an antagonist of what is above it. He that has no pleasure in looking up is not fit so much as to look down. Of such minds are mannerists in Art; in the world, tyrants of all sorts.

11. No right judgment can ever be formed on any subject having a moral or intellectual bearing without benevolence; for so strong is man's natural self-bias, that, without this restraining principle, he insensibly becomes a competitor in all such cases presented to his mind; and, when the comparison is thus made personal, unless the odds be immeasurably against him, his decision will rarely be impartial. In other words, no one can see any thing as it really is through the misty spectacles

of self-love. We must wish well to another in order to do him justice. Now the virtue in this good-will is not to blind us to his faults, but to our own rival and interposing merits.

12. In the same degree that we overrate ourselves, we shall underrate others; for injustice allowed at home is not likely to be corrected abroad. Never, therefore, expect justice from a vain man; if he has the negative magnanimity not to disparage you, it is the most you can expect.

13. The Phrenologists are right in placing the organ of self-love in the back of the head, it being there where a vain man carries his intellectual light; the consequence of which is, that every man he approaches is obscured by his own shadow.

14. Nothing is rarer than a solitary lie; for lies breed like Surinam toads; you cannot tell one but out it comes with a hundred young ones on its back.

15. If the whole world should agree to speak nothing but truth, what an abridgment it would make of speech! And what an unravelling there would be of the invisible webs which men, like so many spiders, now weave about each other! But the contest between Truth and Falsehood is now pretty well balanced. Were it not so, and had the latter the mastery, even language would soon become extinct, from its very uselessness. The present superfluity of words is the result of the warfare.

16. A witch's skiff cannot more easily sail in the teeth of the wind, than the human *eye* lie against fact;

15

but the truth will oftener quiver through lips with a lie upon them.

17. An open brow with a clenched hand shows any thing but an open purpose.

18. It is a hard matter for a man to lie *all over*, Nature having provided king's evidence in almost every member. The hand will sometimes act as a vane to show which way the wind blows, when every feature is set the other way ; the knees smite together, and sound the alarm of fear, under a fierce countenance; and the legs shake with anger, when all above is calm.

19. Nature observes a variety even in her correspondences; insomuch that in parts which seem but repetitions there will be found a difference. For instance, in the human countenance, the two sides of which are never identical. Whenever she deviates into monotony, the deviation is always marked as an exception by some striking deficiency ; as in idiots, who are the only persons that laugh equally on both sides of the mouth.
The insipidity of many of the antique Statues may be traced to the false assumption of identity in the corresponding parts. No work wrought by *feeling* (which, after all, is the ultimate rule of Genius) was ever marked by this monotony.

20. He is but half an orator who turns his hearers into spectators. The best gestures (*quoad* the speaker) are those which he cannot help. An unconscious thump of the fist or jerk of the elbow is more to the purpose, (whatever that may be,) than the most graceful *cut-and-dried* action. It matters not whether the orator

personates a trip-hammer or a wind-mill; if his mill
but move with the grist, or his hammer knead the iron
beneath it, he will not fail of his effect. An impertinent
gesture is more likely to knock down the orator than
his opponent.

21. The only true independence is in humility; for
the humble man exacts nothing, and cannot be morti-
fied, — expects nothing, and cannot be disappointed.
Humility is also a healing virtue; it will cicatrize a
thousand wounds, which pride would keep for ever
open. But humility is not the virtue of a fool; since
it is not consequent upon any comparison between
ourselves and others, but between what we are and
what we ought to be, — which no man ever was.

22. The greatest of all fools is the proud fool, — who
is at the mercy of every fool he meets.

23. There is an essential meanness in the wish *to
get the better* of any one. The only competition worthy
of a wise man is with himself.

24. He that argues for victory is but a gambler in
words, seeking to enrich himself by another's loss.

25. Some men make their ignorance the measure of
excellence; these are, of course, very fastidious critics;
for, knowing little, they can find but little to like.

26. The Painter who seeks popularity in Art closes
the door upon his own genius.

27. Popular excellence in one age is but the *mechanism*
of what was good in the preceding; in Art, the *technic*.

28. Make no man your idol, for the best man must have faults; and his faults will insensibly become yours, in addition to your own. This is as true in Art as in morals.

29. A man of genius should not aim at praise, except in the form of *sympathy;* this assures him of his success, since it meets the feeling which possessed himself.

30. Originality in Art is the individualizing the Universal; in other words, the impregnating some general truth with the individual mind.

31. The painter who is content with the praise of the world in respect to what does not satisfy himself, is not an artist, but an artisan; for though his reward be only praise, his pay is that of a mechanic, — for his time, and not for his art.

32. *Reputation* is but a synonyme of *popularity;* dependent on suffrage, to be increased or diminished at the will of the voters. It is the creature, so to speak, of its particular age, or rather of a particular state of society; consequently, dying with that which sustained it. Hence we can scarcely go over a page of history, that we do not, as in a church-yard, tread upon some buried reputation. But fame cannot be voted down, having its immediate foundation in the essential. It is the eternal shadow of excellence, from which it can never be separated; nor is it ever made visible but in the light of an intellect kindred with that of its author. It is that light which projects the shadow which is seen of the multitude, to be wondered at and reverenced, even while so little comprehended as to be often confounded with the substance, — the substance being

admitted from the shadow, as a matter of faith. It is the economy of Providence to provide such lights: like rising and setting stars, they follow each other through successive ages: and thus the monumental form of Genius stands for ever relieved against its own imperishable shadow.

33. All excellence of every kind is but variety of truth. If we wish, then, for something beyond the true, we wish for that which is false. According to this test, how little truth is there in Art! Little indeed! but how much is that little to him who feels it!

34. Fame does not depend on the *will* of any man, but Reputation may be given or taken away. Fame is the sympathy of kindred intellects, and sympathy is not a subject of *willing;* while Reputation, having its source in the popular voice, is a sentence which may either be uttered or suppressed at pleasure. Reputation, being essentially contemporaneous, is always at the mercy of the envious and the ignorant; but Fame, whose very birth is *posthumous*, and which is only known *to exist by the echo of its footsteps through congenial minds*, can neither be increased nor diminished by any degree of will.

35. What *light* is in the natural world, such is *fame* in the intellectual; both requiring an *atmosphere* in order to become perceptible. Hence the fame of Michael Angelo is, to some minds, a nonentity; even as the sun itself would be invisible *in vacuo.*

36. Fame has no necessary conjunction with Praise: it may exist without the breath of a word; it is a *recog-*

15 *

nition of excellence, which *must be felt*, but need not be *spoken*. Even the envious must feel it, — feel it, and hate it, in silence.

37. I cannot believe that any man who deserved fame ever labored for it; that is, *directly*. For, as fame is but the contingent of excellence, it would be like an attempt to project a shadow, before its substance was obtained. Many, however, have so fancied. " I write, I paint, for fame," has often been repeated: it should have been, " I write, I paint, for reputation." All anxiety, therefore, about Fame should be placed to the account of Reputation.

38. A man may be pretty sure that he has not attained *excellence*, when it is not all in all to him. Nay, I may add, that, if he looks beyond it, he has not reached it. This is not the less true for being good *Irish*.

39. An original mind is rarely understood, until it has been *reflected* from some half-dozen congenial with it, so averse are men to admitting the *true* in an unusual form; whilst any novelty, however fantastic, however false, is greedily swallowed. Nor is this to be wondered at; for all truth demands a response, and few people care to *think*, yet they must have something to supply the place of thought. Every mind would appear original, if every man had the power of *projecting* his own into the mind of others.

40. All effort at originality must end either in the quaint or the monstrous. For no man knows himself as an original; he can only believe it on the report of others to whom *he is made known*, as he is by the projecting power before spoken of.

41. There is one thing which no man, however generously disposed, can *give*, but which every one, however poor, is bound to *pay*. This is Praise. He cannot give it, because it is not his own, — since what is dependent for its very existence on something in another can never become to him a *possession;* nor can he justly withhold it, when the presence of merit claims it as a *consequence.* As praise, then, cannot be made a *gift*, so, neither, when not his due, can any man receive it : he may think he does, but he receives only *words ;* for *desert* being the essential condition of praise, there can be no reality in the one without the other. This is no fanciful statement; for, though praise may be withheld by the ignorant or envious, it cannot be but that, in the course of time, an existing merit will, on *some one*, produce its effects; inasmuch as the existence of any cause without its effect is an impossibility. A fearful truth lies at the bottom of this, an *irreversible justice* for the weal or woe of him who confirms or violates it.

[From the back of a pencil sketch.]

LET no man trust to the gentleness, the generosity, or seeming goodness of his heart, in the hope that they alone can safely bear him through the temptations of this world. This is a state of probation, and a perilous passage to the true beginning of life, where even the best natures need continually to be reminded of their weakness, and to find their only security in steadily referring all their thoughts, acts, affections, to the ultimate end of their being: yet where, imperfect as we are, there is no obstacle too mighty, no temptation

too strong, to the truly humble in heart, who, distrusting themselves, seek to be sustained only by that holy Being who is life and power, and who, in his love and mercy, has promised to give to those that ask. — Such were my reflections, to which I was giving way on reading this melancholy story.

If he is satisfied with them, he may rest assured that he is neither fitted for this world nor the next. Even in this, there are wrongs and sorrows which no human remedy can reach ; — no, tears cannot restore what is lost.

[Written in a book of sketches, with a pencil.]

A REAL debt of gratitude — that is, founded on a disinterested act of kindness — cannot be cancelled by any subsequent unkindness on the part of our benefactor. If the favor be of a pecuniary nature, we may, indeed, by returning an equal or greater sum, balance the moneyed part; but we cannot *liquidate* the *kind motive* by the setting off against it any number of unkind ones. For an after injury can no more *undo* a previous kindness, than we can *prevent* in the future what has happened in the past. So neither can a good act undo an ill one: a fearful truth! For good and evil have a moral *life*, which nothing in time can extinguish; the instant they *exist*, they start for Eternity. How, then, can a man who has *once* sinned, and who has not of *himself* cleansed his soul, be fit for heaven where no sin can enter? I seek not to enter into the mystery of the *atonement*, " which even the angels sought to comprehend and could not"; but I feel its truth in an unutterable conviction, and that, without it, all flesh must perish. Equally deep, too, and unalienable, is my conviction that " the fruit of sin is misery." A second birth to the

soul is therefore a necessity which sin *forces* upon us.
Ay, — but not against the desperate *will* that rejects it.

This conclusion was not anticipated when I wrote
the first sentence of the preceding paragraph. But it
does not surprise me. For it is but a recurrence of what
I have repeatedly experienced; namely, that I never light-
ed on *any truth* which I *inwardly felt* as such, however
apparently remote from our religious being, (as, for in-
stance, in the philosophy of my art,) that, by following
it out, did not find its illustration and confirmation in
some great doctrine of the Bible, — the only true phi-
losophy, the sole fountain of light, where the dark ques-
tions of the understanding which have so long stood,
like chaotic spectres, between the fallen soul and its
reason, at once lose their darkness and their terror.

THE HYPOCHONDRIAC.

THE HYPOCHONDRIAC.*

He would not taste, but swallowed life at once ;
And scarce had reached his prime ere he had bolted,
With all its garnish, mixed of sweet and sour,
Full fourscore years. For he, in truth, did wot not
What most he craved, and so devoured all ;
Then, with his gases, followed Indigestion,
Making it food for night-mares and their foals.
Bridgen.†

It was the opinion of an ancient philosopher, that we
can have no want for which Nature does not provide an
appropriate gratification. As it regards our physical
wants, this appears to be true. But there are moral
cravings which extend beyond the world we live in ; and,
were we in a heathen age, would serve us with an un-
answerable argument for the immortality of the soul.
That these cravings are felt by all, there can be no
doubt ; yet that all feel them in the same degree would
be as absurd to suppose, as that every man possesses
equal sensibility or understanding. Boswell's desires,
from his own account, seem to have been limited to
reading Shakspeare in the other world, — whether with
or without his commentators, he has left us to guess ;

* First printed in 1821, in " The Idle Man," No. II. p. 38.

† A feigned name. — *Editor.*

16

and Newton probably pined for the sight of those distant
stars whose light has not yet reached us. What origi-
nally was the particular craving of my own mind I can-
not now recall; but that I had, even in my boyish days,
an insatiable desire after something which always eluded
me, I well remember. As I grew into manhood, my de-
sires became less definite; and by the time I had passed
through college, they seemed to have resolved them-
selves into a general passion for *doing*.

It is needless to enumerate the different subjects
which one after another engaged me. Mathematics,
metaphysics, natural and moral philosophy, were each
begun, and each in turn given up in a passion of love
and disgust.

It is the fate of all inordinate passions to meet their
extremes; so was it with mine. Could I have pursued
any of these studies with moderation, I might have been
to this day, perhaps, both learned and happy. But I
could be moderate in nothing. Not content with being
employed, I must always be *busy;* and business, as
every one knows, if long continued, must end in fatigue,
and fatigue in disgust, and disgust in change, if that be
practicable, — which unfortunately was my case.

The restlessness occasioned by these half-finished
studies brought on a severe fit of self-examination.
Why is it, I asked myself, that these learned works,
which have each furnished their authors with sufficient
excitement to effect their completion, should thus weary
me before I get midway into them? It is plain enough.
As a reader I am merely a recipient, but the composer
is an active agent; a vast difference! And now I can
account for the singular pleasure, which a certain bad
poet of my acquaintance always took in inflicting his
verses on every one who would listen to him; each pe-

rusal being but a sort of mental echo of the original bliss of composition. I will set about writing immediately.

Having, time out of mind, heard the epithet *great* coupled with Historians, it was that, I believe, inclined me to write a history. I chose my subject, and began collating, and transcribing, night and day, as if I had not another hour to live; and on I went with the industry of a steam-engine; when it one day occurred to me, that, though I had been laboring for months, I had not yet had occasion for one original thought. Pshaw! said I, 't is only making new clothes out of old ones. I will have nothing more to do with history.

As it is natural for a mind suddenly disgusted with mechanic toil to seek relief from its opposite, it can easily be imagined that my next resource was Poetry. Every one rhymes now-a-days, and so can I. Shall I write an Epic, or a Tragedy, or a Metrical Romance? Epics are out of fashion; even Homer and Virgil would hardly be read in our time, but that people are unwilling to admit their schooling to have been thrown away. As to Tragedy, I am a modern, and it is a settled thing that no modern *can* write a tragedy; so I must not attempt that. Then for Metrical Romances, — why, they are now manufactured; and, as the Edinburgh Review says, may be " imported" by us " in bales." I will bind myself to no particular class, but give free play to my imagination. With this resolution I went to bed, as one going to be inspired. The morning came; I ate my breakfast, threw up the window, and placed myself in my elbow-chair before it. An hour passed, and nothing occurred to me. But this I ascribed to a fit of laughter that seized me, at seeing a duck made drunk by eating rum-cherries. I turned my back on the

window. Another hour followed, then another, and another: I was still as far from poetry as ever; every object about me seemed bent against my abstraction; the card-racks fascinating me like serpents, and compelling me to read, as if I would get them by heart, " Dr. Joblin," " Mr. Cumberback," " Mr. Milton Bull," &c. &c. I took up my pen, drew a sheet of paper from my writing-desk, and fixed my eyes upon that; — 't was all in vain; I saw nothing on it but the watermark, *D. Ames.* I laid down the pen, closed my eyes, and threw my head back in the chair. " Are you waiting to be shaved, Sir ? " said a familiar voice. I started up, and overturned my servant. " No, blockhead! " — " I am waiting to be inspired "; — but this I added mentally. What is the cause of my difficulty ? said I. Something within me seemed to reply, in the words of Lear, " Nothing comes of nothing." Then I must seek a subject. I ran over a dozen in a few minutes, chose one after another, and, though twenty thoughts very readily occurred on each, I was fain to reject them all; some for wanting pith, some for belonging to prose, and others for having been worn out in the service of other poets. In a word, my eyes began to open on the truth, and I felt convinced that *that* only was poetry which a man writes because he cannot help writing; the irrepressible effluence of his secret being on every thing in sympathy with it, — a kind of *flowering* of the soul amid the warmth and the light of nature. I am no poet, I exclaimed, and I will not disfigure Mr. Ames with commonplace verses.

I know not how I should have borne this second disappointment, had not the title of a new Novel, which then came into my head, suggested a trial in that branch of letters. I will write a Novel. Having come to this determination, the next thing was to collect materials.

They must be sought after, said I, for my late experiment has satisfied me that I might wait for ever in my elbow-chair, and they would never come to me; they must be toiled for, — not in books, if I would not deal in second-hand, — but in the world, that inexhaustible storehouse of all kinds of originals. I then turned over in my mind the various characters I had met with in life; amongst these a few only seemed fitted for any story, and those rather as accessories; such as a politician who hated popularity, a sentimental grave-digger, and a metaphysical rope-dancer; but for a hero, the grand nucleus of my fable, I was sorely at a loss. This, however, did not discourage me. I knew he might be found in the world, if I would only take the trouble to look for him. For this purpose I jumped into the first stage-coach that passed my door; it was immaterial whither bound, my object being men, not places. My first day's journey offered nothing better than a sailor who rebuked a member of Congress for swearing. But at the third stage, on the second day, as we were changing horses, I had the good fortune to light on a face which gave promise of all I wanted. It was so remarkable that I could not take my eyes from it; the forehead might have been called handsome but for a pair of enormous eyebrows, that seemed to project from it like the quarter-galleries of a ship, and beneath these were a couple of small, restless, gray eyes, which, glancing in every direction from under their shaggy brows, sparkled like the intermittent light of fire-flies; in the nose there was nothing remarkable, except that it was crested by a huge wart with a small grove of black hairs; but the mouth made ample amends, being altogether indescribable, for it was so variable in its expression, that I could not tell whether it had most of the sardonic, the

16 *

benevolent, or the sanguinary, appearing to exhibit them all in succession with equal vividness. My attention, however, was mainly fixed by the sanguinary; it came across me like an east wind, and I felt a cold sweat damping my linen; and when this was suddenly succeeded by the benevolent, I was sure I had got at the secret of his character, — no less than that of a murderer haunted by remorse. Delighted with this discovery, I made up my mind to follow the owner of the face wherever he went, till I should learn his history. I accordingly made an end of my journey for the present, upon learning that the stranger was to pass some time in the place where we stopped. For three days I made minute inquiries; but all I could gather was, that he had been a great traveller, though of what country no one could tell me. On the fourth day, finding him on the move, I took passage in the same coach. Now, said I, is my time of harvest. But I was mistaken; for, in spite of all the lures which I threw out to draw him into a communicative humor, I could get nothing from him but monosyllables. So far from abating my ardor, this reserve only the more whetted my curiosity. At last we stopped at a pleasant village in New Jersey. Here he seemed a little better known; the innkeeper inquiring after his health, and the hostler asking if the balls he had supplied him with fitted the barrels of his pistols. The latter inquiry I thought was accompanied by a significant glance, that indicated a knowledge on the hostler's part of more than met the ear; I determined therefore to sound him. After a few general remarks, that had nothing to do with any thing, by way of introduction, I began by hinting some random surmises as to the use to which the stranger might have put the pistols he spoke of; inquired whether he was in the habit

of loading them at night; whether he slept with them under his pillow; if he was in the practice of burning a light while he slept; and if he did not sometimes awake the family by groans, or by walking with agitated steps in his chamber. But it was all in vain, the man protesting that he never knew any thing ill of him. Perhaps, thought I, the hostler having overheard his midnight wanderings, and detected his crime, is paid for keeping the secret. I pumped the landlord, and the landlady, and the barmaid, and the chambermaid, and the waiters, and the cook, and every thing that could speak in the house; still to no purpose, each ending his reply with, " Lord, Sir, he 's as honest a gentleman, for aught I know, as any in the world "; then would come a question, — " But perhaps *you* know something of him yourself ? " Whether my answer, though given in the negative, was uttered in such a tone as to imply an affirmative, thereby exciting suspicion, I cannot tell; but it is certain that I soon after perceived a visible change towards him in the deportment of the whole household. When he spoke to the waiters, their jaws fell, their fingers spread, their eyes rolled, with every symptom of involuntary action; and once, when he asked the landlady to take a glass of wine with him, I saw her, under pretence of looking out of the window, throw it into the street; in short, the very scullion fled at his approach, and a chambermaid dared not enter his room unless under guard of a large mastiff. That these circumstances were not unobserved by him will appear by what follows.

Though I had come no nearer to facts, this general suspicion, added to the remarkable circumstance that no one had ever heard his name (being known only as *the gentleman*), gave every day new life to my hopes. He

is the very man, said I; and I began to revel in all the
luxury of detection, when, as I was one night undress-
ing for bed, my attention was caught by the following
letter on my table.

"SIR,

"If you are the gentleman you would be thought, you
will not refuse satisfaction for the diabolical calumnies
you have so unprovokedly circulated against an inno-
cent man.

"Your obedient servant,

"TIMOLEON BUB.

"P. S. I shall expect you at five o'clock to-morrow
morning, at the three elms, by the river-side."

This invitation, as may be well imagined, discom-
posed me not a little. Who Mr. Bub was, or in what
way I had injured him, puzzled me exceedingly. Per-
haps, thought I, he has mistaken me for another person;
if so, my appearing on the ground will soon set matters
right. With this persuasion I went to bed, somewhat
calmer than I should otherwise have been; nay, I was
even composed enough to divert myself with the folly
of one bearing so vulgar an appellation taking it into
his head to play the *man of honor*, and could not help
a waggish feeling of curiosity to see if his name and
person were in keeping.

I woke myself in the morning with a loud laugh, for
I had dreamt of meeting, in the redoubtable Mr. Bub, a
little pot-bellied man, with a round face, a red snub-
nose, and a pair of gooseberry wall-eyes. My fit of
pleasantry was far from passed off when I came in sight
of the fatal elms. I saw my antagonist pacing the

ground with considerable violence. Ah! said I, he is trying to escape from his unheroic name! and I laughed again at the conceit; but, as I drew a little nearer, there appeared a majestic altitude in his figure very unlike what I had seen in my dream, and my laugh began to stiffen into a kind of rigid grin. There now came upon me something very like a misgiving that the affair might turn out to be no joke. I felt an unaccountable wish that this Mr. Bub had never been born; still I advanced: but if an aërolite had fallen at my feet, I could not have been more startled, than when I found in the person of my challenger — the mysterious stranger. The consequences of my curiosity immediately rushed upon me, and I was no longer at a loss in what way I had injured him. All my merriment seemed to curdle within me; and I felt like a dog that had got his head into a jug, and suddenly finds he cannot extricate it. " Well met, Sir," said the stranger; "now take your ground, and abide the consequences of your infernal insinuations." " Upon my word," replied I, — " upon my honor, Sir," — and there I stuck, for in truth I knew not what it was I was going to say; when the stranger's second, advancing, exclaimed, in a voice which I immediately recognized, " Why, zounds! Rainbow, are *you* the man?" " Is it you, Harman?" " What!" continued he, " my old classmate Rainbow turned slanderer? Impossible! Indeed, Mr. Bub, there must be some mistake here." " None, Sir," said the stranger; " I have it on the authority of my respectable landlord, that, ever since this gentleman's arrival, he has been incessant in his attempts to blacken my character with every person at the inn." " Nay, my friend" —— But I put an end to Harman's further defence of me, by taking him aside, and frankly confessing the whole truth. It was with

some difficulty I could get through the explanation, being frequently interrupted with bursts of laughter from my auditor; which, indeed, I now began to think very natural. In a word, to cut the story short, my friend having repeated the conference verbatim to Mr. Bub, he was good-natured enough to join in the mirth, saying, with one of his best sardonics, he " had always had a misgiving that his unlucky ugly face would one day or other be the death of somebody." Well, we passed the day together, and having cracked a social bottle after dinner, parted, I believe, as heartily friends as we should have been (which is saying a great deal) had he indeed proved the favorite villain in my Novel. But, alas! with the loss of my villain, away went the Novel.

Here again I was at a stand; and in vain did I torture my brains for another pursuit. But why should I seek one? In fortune I have a competence, — why not be as independent in mind? There are thousands in the world whose sole object in life is to attain the means of living without toil; and what is any literary pursuit but a series of mental labor, ay, and oftentimes more wearying to the spirits than that of the body. Upon the whole, I came to the conclusion, that it was a very foolish thing to do any thing. So I seriously set about trying to do nothing.

Well, what with whistling, hammering down all the nails in the house that had started, paring my nails, pulling my fire to pieces and rebuilding it, changing my clothes to full dress though I dined alone, trying to make out the figure of a Cupid on my discolored ceiling, and thinking of a lady I had not thought of for ten years before, I got along the first week tolerably well. But by the middle of the second week, — 't was horrible! the hours seemed to roll over me like mill-stones. When

I awoke in the morning I felt like an Indian devotee, the day coming upon me like the great temple of Juggernaut; cracking of my bones beginning after breakfast; and if I had any respite, it was seldom for more than half an hour, when a newspaper seemed to stop the wheels; — then away they went, crack, crack, noon and afternoon, till I found myself by night reduced to a perfect jelly, — good for nothing but to be ladled into bed, with a greater horror than ever at the thought of sunrise.

This will never do, said I; a toad in the heart of a tree lives a more comfortable life than a nothing-doing man; and I began to perceive a very deep meaning in the truism of " something being better than nothing." But is a precise object always necessary to the mind? No: if it be but occupied, no matter with what. That may easily be done. I have already tried the sciences, and made abortive attempts in literature, but I have never yet tried what is called general reading; — that, thank Heaven, is a resource inexhaustible. I will henceforth read only for amusement. My first experiment in this way was on Voyages and Travels, with occasional dippings into Shipwrecks, Murders, and Ghost-stories. It succeeded beyond my hopes; month after month passing away like days, and as for days, — I almost fancied that I could see the sun move. How comfortable, thought I, thus to travel over the world in my closet! how delightful to double Cape Horn and cross the African Desert in my rocking-chair, — to traverse Caffraria and the Mogul's dominions in the same pleasant vehicle! This is living to some purpose; one day dining on barbecued pigs in Otaheite; the next in danger of perishing amidst the snows of Terra del Fuego; then to have a lion cross my path in the heart of Africa; to run for my

life from a wounded rhinoceros, and sit, by mistake, on a sleeping boa-constrictor; — this, this, said I, is life! Even the dangers of the sea were but healthful stimulants. If I met with a tornado, it was only an agreeable variety; water-spouts and ice-islands gave me no manner of alarm; and I have seldom been more composed than when catching a whale. In short, the ease with which I thus circumnavigated the globe, and conversed with all its varieties of inhabitants, expanded my benevolence; I found every place, and everybody in it, even to the Hottentots, vastly agreeable. But, alas! I was doomed to discover that this could not last for ever. Though I was still curious, there were no longer curiosities; for the world is limited, and new countries, and new people, like every thing else, wax stale on acquaintance; even ghosts and hurricanes become at last familiar; and books grow old, like those who read them.

I was now at what sailors call a dead lift; being too old to build castles for the future, and too dissatisfied with the life I had led to look back on the past. In this state of mind, I bought me a snuffbox; for, as I could not honestly recommend my disjointed self to any decent woman, it seemed a kind of duty in me to contract such habits as would effectually prevent my taking in the lady I had once thought of. I set to, snuffing away till I made my nose sore, and lost my appetite. I then threw my snuffbox into the fire, and took to cigars. This change appeared to revive me. For a short time I thought myself in Elysium, and wondered I had never tried them before. Thou fragrant weed! O, that I were a Dutch poet, I exclaimed, that I might render due honor to thy unspeakable virtues! Ineffable tobacco! Every puff seemed like oil poured upon troubled waters, and I felt an inexpressible calmness stealing over my

frame; in truth, it seemed like a benevolent spirit recon-
ciling my soul to my body. But moderation, as I have
before said, was never one of my virtues. I walked my
room, pouring out volumes like a moving glass-house.
My apartment was soon filled with smoke; I looked in
the glass and hardly knew myself, my eyes peering at
me, through the curling atmosphere, like those of a poo-
dle. I then retired to the opposite end, and surveyed
the furniture; nothing retained its original form or po-
sition; — the tables and chairs seemed to loom from the
floor, and my grandfather's picture to thrust forward its
nose like a French-horn, while that of my grandmother,
who was reckoned a beauty in her day, looked, in her
hoop, like her husband's wig-block stuck on a tub.
Whether this was a signal for the fiends within me to
begin their operations, I know not: but from that day I
began to be what is called nervous. The uninterrupted
health I had hitherto enjoyed now seemed the greatest
curse that could have befallen me. I had never had the
usual itinerant distempers; it was very unlikely that I
should always escape them; and the dread of their com-
ing upon me in my advanced age made me perfectly
miserable. I scarcely dared to stir abroad; had sand-
bags put to my doors to keep out the measles; forbade
my neighbours' children playing in my yard to avoid
the whooping-cough; and, to prevent infection from the
small-pox, I ordered all my male servants' heads to be
shaved, made the coachman and footman wear tow
wigs, and had them both regularly smoked whenever
they returned from the neighbouring town, before they
were allowed to enter my presence. Nor were these all
my miseries; in fact, they were but a sort of running
base to a thousand other strange and frightful fancies;
the mere skeleton to a whole body-corporate of horrors.

17

I became dreamy, was haunted by what I had read, frequently finding a Hottentot, or a boa-constrictor, in my bed. Sometimes I fancied myself buried in one of the pyramids of Egypt, breaking my shins against the bones of a sacred cow. Then I thought myself a kangaroo, unable to move because somebody had cut off my tail.

In this miserable state I one evening rushed out of my house. I know not how far, or how long, I had been from home, when, hearing a well-known voice, I suddenly stopped. It seemed to belong to a face that I knew; yet how I should know it somewhat puzzled me, being then fully persuaded that I was a Chinese Josh. My friend (as I afterwards learned he was) invited me to go to his club. This, thought I, is one of my worshippers, and they have a right to carry me wherever they please; accordingly I suffered myself to be led.

I soon found myself in an American tavern, and in the midst of a dozen grave gentlemen who were emptying a large bowl of punch. They each saluted me, some calling me by name, others saying they were happy to make my acquaintance; but what appeared quite unaccountable was my not only understanding their language, but knowing it to be English. A kind of reaction now began to take place in my brain. Perhaps, said I, I am not a Josh. I was urged to pledge my friend in a glass of punch; I did so; my friend's friend, and his friend, and all the rest, in succession, begged to have the same honor; I complied, again and again, till at last, the punch having fairly turned my head topsy-turvy, righted my understanding; and I found myself *myself*.

This happy change gave a pleasant fillip to my spir-

its. I returned home, found no monster in my bed, and
slept quietly till near noon the next day. I arose with
a slight headache and a great admiration of punch; re-
solving, if I did not catch the measles from my late ad-
venture, to make a second visit to the club. No symp-
toms appearing, I went again; and my reception was
such as led to a third, and a fourth, and a fifth visit,
when I became a regular member. I believe my induce-
ment to this was a certain unintelligible something in
three or four of my new associates, which at once grati-
fied and kept alive my curiosity, in their letting out just
enough of themselves while I was with them to excite
me when alone to speculate on what was kept back.
I wondered I had never met with such characters in
books; and the kind of interest they awakened began
gradually to widen to others. Henceforth I will live in
the world, said I; 't is my only remedy. A man's own
affairs are soon conned; he gets them by heart till they
haunt him when he would be rid of them; but those of
another can be known only in part, while that which
remains unrevealed is a never-ending stimulus to curi-
osity. The only natural mode, therefore, of preventing
the mind preying on itself, — the only rational, because
the only interminable employment, — is to be busy
about other people's business.

 The variety of objects which this new course of life
each day presented, brought me at length to a state of
sanity; at least, I was no longer disposed to conjure
up remote dangers to my door, or chew the cud on my
indigested past reading; though sometimes, I confess,
when I have been tempted to meddle with a very bad
character, I have invariably been threatened with a re-
lapse; which leads me to think the existence of some
secret affinity between rogues and boa-constrictors is not

unlikely. In a short time, however, I had every reason
to believe myself completely cured; for the days began
to appear of their natural length, and I no longer saw
every thing through a pair of blue spectacles, but found
nature diversified by a thousand beautiful colors, and
the people about me a thousand times more interesting
than hyenas or Hottentots. The world is now my only
study, and I trust I shall stick to it for the sake of my
health.

POEMS.

17 *

THE SYLPHS OF THE SEASONS,

A POET'S DREAM.

PREFATORY NOTE.

As it may be objected to the following poem, that some of the images there introduced are not wholly peculiar to the Season described, the author begs leave to state, that, both in their selection and disposition, he was guided by that, which, in his limited experience, was found to be the Season of their greatest impression ; and, though he has not always felt the necessity of pointing out the collateral causes by which the effect was increased, he yet flatters himself that, in general, they are sufficiently implied either by what follows or precedes them. Thus, for instance, the *running brook*, though by no means peculiar, is appropriated to Spring ; as affording by its motion and *seeming* exultation one of the most lively images of that spirit of renovation which animates the earth after its temporary suspension during the Winter. By the same rule is assigned to Summer the *placid lake*, &c., not because that image is never seen, or enjoyed, at any other season ; but on account of its affecting us more in Summer, than either in the Spring, or in

Autumn; the indolence and languor generally then experienced disposing us to dwell with particular delight on such an object of repose, not to mention the grateful idea of coolness derived from a knowledge of its temperature. Thus, also, the *evening cloud*, exhibiting a fleeting representation of successive objects, is, perhaps, justly appropriated to Autumn, as in that season the general decay of inanimate nature leads the mind to turn upon itself, and without effort to apply almost every image of sense, or vision of the imagination, to its own transitory state.

If the above be admitted, it is needless to add more; if it be not, it would be useless.

Long has it been my fate to hear
The slave of Mammon, with a sneer,
 My indolence reprove.
Ah, little knows he of the care,
The toil, the hardship, that I bear,
While lolling in my elbow-chair,
 And seeming scarce to move!

For, mounted on the Poet's steed,
I *there* my ceaseless journey speed
 O'er mountain, wood, and stream;
And oft within a little day
'Mid comets fierce 't is mine to stray,
And wander o'er the Milky-way,
 To catch a Poet's dream.

But, would the Man of Lucre know
What riches from my labors flow,
 A DREAM is my reply.
And who for wealth has ever pined,
That had a World within his mind,
Where every treasure he may find,
 And joys that never die?

One night, my task diurnal done,
(For I had travelled with the Sun
 O'er burning sands, o'er snows,)
Fatigued, I sought the couch of rest;
My wonted prayer to Heaven addressed;
But scarce had I my pillow pressed,
 When thus a vision rose.

Methought within a desert cave,
Cold, dark, and solemn as the grave,
 I suddenly awoke.
It seemed of sable Night the cell,
Where, save when from the ceiling fell
An oozing drop, her silent spell
 No sound had ever broke.

There motionless I stood alone,
Like some strange monument of stone
 Upon a barren wild;
Or like (so solid and profound
The darkness seemed that walled me round)
A man that's buried under ground,
 Where pyramids are piled.

Thus fixed, a dreadful hour I past;
And now I heard, as from a blast,
 A voice pronounce my name:
Nor long upon my ear it dwelt,
When round me 'gan the air to melt,
And motion once again I felt
 Quick circling o'er my frame.

Again it called; and then a ray,
That seemed a gushing fount of day,
 Across the cavern streamed.
Half struck with terror and delight,
I hailed the little, blessed light,
And followed till my aching sight
 An orb of darkness seemed.

Nor long I felt the blinding pain;
For soon upon a mountain plain
 I gazed with wonder new.
There high a castle reared its head;
And far below a region spread,
Where every Season seemed to shed
 Its own peculiar hue.

Now at the castle's massy gate,
Like one that's blindly urged by fate,
 A bugle-horn I blew.
The mountain-plain it shook around,
The vales returned a hollow sound,
And, moving with a sigh profound,
 The portals open flew.

Then entering, from a glittering hall
I heard a voice seraphic call,
 That bade me, " Ever reign ! "
" All hail ! " it said, in accent wild,
" For thou art Nature's chosen child,
Whom wealth nor blood has e'er defiled ;
 Hail, Lord of this Domain ! "

And now I paced a bright saloon,
That seemed illumined by the moon,
 So mellow was the light.
The walls with jetty darkness teemed,
While down them crystal columns streamed,
And each a mountain torrent seemed,
 High-flashing through the night.

Reared in the midst, a double throne
Like burnished cloud of evening shone ;
 While, grouped the base around,
Four Damsels stood of Faery race ;
Who, turning each with heavenly grace
Upon me her immortal face,
 Transfixed me to the ground.

And thus the foremost of the train : —
" Be thine the throne, and thine to reign
 O'er all the varying year !
But, ere thou rul'st, the Fates command,
That of our chosen rival band
A Sylph shall win thy heart and hand,
 Thy sovereignty to share.

" For we, the sisters of a birth,
Do rule by turns the subject earth,
　　　To serve ungrateful man;
But, since our varied toils impart
No joy to his capricious heart,
'T is now ordained that human art
　　　Shall rectify the plan."

Then spake the Sylph of Spring serene:—
" 'T is *I* thy joyous heart, I ween,
　　　With sympathy shall move;
For I with living melody
Of birds, in choral symphony,
First waked thy soul to poesy,
　　　To piety and love.

" When thou, at call of vernal breeze,
And beckoning bough of budding trees,
　　　Hast left thy sullen fire,
And stretched thee in some mossy dell,
And heard the browsing wether's bell,
Blithe echoes rousing from their cell
　　　To swell the tinkling choir:

" Or heard from branch of flowering thorn
The song of friendly cuckoo warn
　　　The tardy-moving swain;
Hast bid the purple swallow hail,
And seen him now through ether sail,
Now sweeping downward o'er the vale,
　　　And skimming now the plain;

" Then, catching with a sudden glance
The bright and silver-clear expanse
 Of some broad river's stream,
Beheld the boats adown it glide,
And motion wind again the tide,
Where, chained in ice by Winter's pride,
 Late rolled the heavy team:

" Or, lured by some fresh-scented gale,
That wooed the moorèd fisher's sail
 To tempt the mighty main,
Hast watched the dim, receding shore,
Now faintly seen the ocean o'er,
Like hanging cloud, and now no more
 To bound the sapphire plain;

" Then, wrapt in night, the scudding bark,
(That seemed, self-poised amid the dark,
 Through upper air to leap,)
Beheld, from thy most fearful height,
The rapid dolphin's azure light
Cleave, like a living meteor bright,
 The darkness of the deep: —

" 'T was mine the warm, awakening hand,
That made thy grateful heart expand,
 And feel the high control
Of Him, the mighty Power, that moves
Amid the waters and the groves,
And through his vast creation proves
 His omnipresent soul.

18

" Or, brooding o'er some forest rill,
Fringed with the early daffodil
　　And quivering maiden-hair,
When thou hast marked the dusky bed,
With leaves and water-rust o'erspread,
That seemed an amber light to shed
　　On all was shadowed there ;

"And thence, as by its murmur called,
The current traced to where it brawled
　　Beneath the noontide ray,
And there beheld the checkered shade
Of waves, in many a sinuous braid,
That o'er the sunny channel played,
　　With motion ever gay :

" 'T was I to these the magic gave,
That made thy heart, a willing slave,
　　To gentle Nature bend,
And taught thee how, with tree and flower,
And whispering gale, and dropping shower,
In converse sweet to pass the hour,
　　As with an early friend ;

" That 'mid the noontide, sunny haze
Did in thy languid bosom raise
　　The raptures of the boy,
When, waked as if to second birth,
Thy soul through every pore looked forth,
And gazed upon the beauteous Earth
　　With myriad eyes of joy ;

" That made thy heart, like His **above**,
To flow with universal love
 For every living thing.
And, O ! if I, with ray divine,
Thus tempering, did thy soul refine,
Then let thy gentle heart be mine,
 And bless the Sylph of Spring."

And next the Sylph of Summer fair,
The while her crispèd, golden hair
 Half veiled her sunny eyes : —
" Nor less may *I* thy homage claim,
At touch of whose exhaling flame
The fog of Spring, that chilled thy **frame**,
 In genial vapor flies.

" Oft by the heat of noon oppressed,
With flowing hair and open vest,
 Thy footsteps have I won
To mossy couch of welling grot,
Where thou hast blessed thy happy lot,
That thou in that delicious spot
 Mayst see, not feel, the sun :

" Thence tracing from the body's change,
In curious philosophic range,
 The motion of the mind ;
And how from thought to thought it flew,
Still hoping in each vision new
The faery land of bliss to view,
 But ne'er that land to find.

" And then, as grew thy languid mood,
To some embowering, silent wood
 I led thy careless way;
Where high, from tree to tree, in air
Thou saw'st the spider swing her snare,
So bright! — as if, entangled there,
 The sun had left a ray:

" Or lured thee to some beetling steep,
To mark the deep and quiet sleep
 That wrapt the tarn below;
And mountain blue and forest green
Inverted on its plane serene,
Dim gleaming through the filmy sheen
 That glazed the painted show;

" Perchance, to mark the fisher's skiff
Swift from beneath some shadowy cliff
 Dart, like a gust of wind;
And, as she skimmed the sunny lake,
In many a playful wreath her wake
Far trailing, like a silvery snake,
 With sinuous length behind.

" Not less, when hill and dale and heath
Still Evening wrapt in mimic death,
 Thy spirit true I proved:
Around thee, as the darkness stole,
Before thy wild, creative soul
I bade each faery vision roll,
 Thine infancy had loved.

" Then o'er the silent, sleeping land,
Thy fancy, like a magic wand,
 Forth called the Elfin race :
And now around the fountain's brim
In circling dance they gayly skim,
And now upon its surface swim,
 And water-spiders chase ;

" Each circumstance of sight or sound
Peopling the vacant air around
 With visionary life :
For, if amid a thicket stirred
Or flitting bat, or wakeful bird,
Then straight thy eager fancy heard
 The din of Faery strife ;

" Now, in the passing beetle's hum,
The Elfin army's goblin drum
 To pigmy battle sound ;
And now, where dripping dew-drops plash
On waving grass, their bucklers clash,
And now their quivering lances flash,
 Wide dealing death around :

" Or, if the moon's effulgent form
The passing clouds of sudden storm
 In quick succession veil,
Vast serpents now their shadows glide,
And, coursing now the mountain's side,
A band of giants huge they stride
 O'er hill, and wood, and dale.

18 *

" And still on many a service rare
Could I descant, if need there were,
 My firmer claim to bind;
But rest I most my high pretence
On that my genial influence,
Which made the body's indolence
 The vigor of the mind."

And now, in accents deep and low,
Like voice of fondly-cherished woe,
 The Sylph of Autumn sad:—
" Though *I* may not of raptures sing,
That graced the gentle song of Spring,
Like Summer, playful pleasures bring,
 Thy youthful heart to glad;

" Yet still may I in hope aspire
Thy heart to touch with chaster fire,
 And purifying love:
For I with vision high and holy,
And spell of quickening melancholy,
Thy soul from sublunary folly
 First raised to worlds above.

" What though be mine the treasures fair
Of purple grape, and yellow pear,
 And fruits of various hue,
And harvests rich of golden grain,
That dance in waves along the plain
To merry song of reaping swain,
 Beneath the welkin blue?

" With these I may not urge my suit,
Of Summer's patient toil the fruit,
 For mortal purpose given :
Nor may it fit my sober mood
To sing of sweetly murmuring flood,
Or dyes of many-colored wood,
 That mock the bow of heaven.

" But, know, 't was mine the secret power
That waked thee at the midnight hour
 In bleak November's reign :
'T was I the spell around thee cast,
When thou didst hear the hollow blast
In murmurs tell of pleasures past,
 That ne'er would come again :

" And led thee, when the storm was o'er,
To hear the sullen ocean roar,
 By dreadful calm oppressed ;
Which still, though not a breeze was there,
Its mountain-billows heaved in air,
As if a living thing it were,
 That strove in vain for rest.

" 'T was I, when thou, subdued by woe,
Didst watch the leaves descending slow,
 To each a moral gave ;
And, as they moved in mournful train,
With rustling sound, along the plain,
Taught them to sing a seraph's strain
 Of peace within the grave.

" And then, upraised thy streaming eye,
I met thee in the western sky
 In pomp of evening cloud,
That, while with varying form it rolled,
Some wizard's castle seemed of gold,
And now a crimsoned knight of old,
 Or king in purple proud.

" And last, as sunk the setting sun,
And Evening with her shadows dun
 The gorgeous pageant past,
'T was then of life a mimic show,
Of human grandeur here below,
Which thus beneath the fatal blow
 Of Death must fall at last.

" O, then with what aspiring gaze
Didst thou thy trancèd vision raise
 To yonder orbs on high,
And think how wondrous, how sublime,
'T were upwards to their spheres to climb,
And live beyond the reach of Time,
 Child of Eternity ! "

And last the Sylph of Winter spake,
The while her piercing voice did shake
 The castle-vaults below : —
" O youth, if thou, with soul refined,
Hast felt the triumph pure of mind,
And learnt a secret joy to find
 In deepest scenes of woe ;

" If e'er with fearful ear at eve
Hast heard the wailing tempests grieve
 Through chink of shattered wall,
The while it conjured o'er thy brain
Of wandering ghosts a mournful train,
That low in fitful sobs complain
 Of Death's untimely call;

" Or feeling, as the storm increased,
The love of terror nerve thy breast,
 Didst venture to the coast,
To see the mighty war-ship leap
From wave to wave upon the deep,
Like chamois goat from steep to steep,
 Till low in valley lost;

" Then, glancing to the angry sky,
Behold the clouds with fury fly
 The lurid moon athwart, —
Like armies huge in battle, throng,
And pour in volleying ranks along,
While piping winds in martial song
 To rushing war exhort:

" O, then to me thy heart be given,
To me, ordained by Him in heaven
 Thy nobler powers to wake.
And, O! if thou with poet's soul,
High brooding o'er the frozen pole,
Hast felt beneath my stern control
 The desert region quake;

" Or from old Hecla's cloudy height,
When o'er the dismal, half-year's night
 He pours his sulphurous breath,
Hast known my petrifying wind
Wild ocean's curling billows bind,
Like bending sheaves by harvest hind,
 Erect in icy death ;

" Or heard adown the mountain's steep
The northern blast with furious sweep
 Some cliff dissevered dash,
And seen it spring with dreadful bound,
From rock to rock, to gulf profound,
While echoes fierce from caves resound
 The never-ending crash :

" If thus with terror's mighty spell
Thy soul inspired was wont to swell,
 Thy heaving frame expand,
O, then to me thy heart incline ;
For know, the wondrous charm was mine,
That fear and joy did thus combine
 In magic union bland.

" Nor think confined my native sphere
To horrors gaunt, or ghastly fear,
 Or desolation wild ;
For I of pleasures fair could sing,
That steal from life its sharpest sting,
And man have made around it cling,
 Like mother to her child.

" When thou, beneath the clear blue sky,
So calm no cloud was seen to fly,
 Hast gazed on snowy plain,
Where Nature slept so pure and sweet,
She seemed a corse in winding-sheet,
Whose happy soul had gone to meet
 The blest Angelic train ;

" Or marked the sun's declining ray
In thousand varying colors play
 O'er ice-incrusted heath,
In gleams of orange now, and green,
And now in red and azure sheen,
Like hues on dying dolphin seen,
 Most lovely when in death ;

" Or seen at dawn of eastern light
The frosty toil of Fays by night
 On pane of casement clear,
Where bright the mimic glaciers shine,
And Alps, with many a mountain pine,
And armèd knights from Palestine
 In winding march appear :

" 'T was I on each enchanting scene
The charm bestowed, that banished spleen
 Thy bosom pure and light.
But still a *nobler* power I claim, —
That power allied to poet's fame,
Which language vain has dared to name, —
 The soul's creative might.

" Though Autumn grave, and Summer fair,
And joyous Spring, demand a share
 Of Fancy's hallowed power,
Yet these I hold of humbler kind,
To grosser means of earth confined,
Through mortal *sense* to reach the mind,
 By mountain, stream, or flower.

" But mine, of purer nature still,
Is that which to thy secret will
 Did minister unseen,
Unfelt, unheard, when every sense
Did sleep in drowsy indolence,
And silence deep and night intense
 Enshrouded every scene;

" That o'er thy teeming brain did raise
The spirits of departed days *
 Through all the varying year,
And images of things remote,
And sounds that long had ceased to float,
With every hue, and every note,
 As living now they were;

" And taught thee from the motley mass
Each harmonizing part to class
 (Like Nature's self employed);

 * In a late beautiful poem by Mr. Montgomery is the following line: —
" *The spirits of departed hours.*" The author, fearing that so singular a
coincidence of thought and language might subject him to the charge of
plagiarism, thinks it necessary to state that his poem was written long be-
fore he had the pleasure of reading Mr. Montgomery's.

And then, as worked thy wayward will,
From these, with rare combining skill,
With new-created worlds to fill
 Of space the mighty void.

" O, then to me thy heart incline ;
To me, whose plastic powers combine
 The harvest of the mind ;
To me whose magic coffers bear
The spoils of all the toiling year,
That still in mental vision wear
 A lustre more refined."

She ceased. And now, in doubtful mood,
All motionless and mute I stood,
 Like one by charm oppressed :
By turns from each to each I roved,
And each by turns again I loved ;
For ages ne'er could one have proved
 More lovely than the rest.

" O blessed band, of birth divine,
What mortal task is like to mine ? " —
 And further had I spoke,
When, lo! there poured a flood of light
So fiercely on my aching sight,
I fell beneath the vision bright,
 And with the pain awoke.

 19

THE TWO PAINTERS,

A TALE.

Say why in every work of man
Some imperfection mars the plan?
Why joined in every human art
A perfect and imperfect part?
Is it that life for art is short?
Or is it Nature's cruel sport?
Or would she thus a moral teach,
That man should see, but never reach,
The height of excellence, and show
The vanity of works below?
Or consequence of Pride, or Sloth?
Or rather the effect of both?
Whoe'er on life his eye has cast,
I fear, alas! will say the last.

 Once on a time in Charon's wherry
Two Painters met, on Styx's ferry.

" Good Sir," said one, with bow profound,
" I joy to meet thee under ground ;
And, though with zealous spite we strove
To blast each other's fame above,
Yet here, as neither bay nor laurel
Can tempt us to prolong our quarrel,
I hope the hand which I extend
Will meet the welcome of a friend."
" Sweet Sir," replied the other Shade,
While scorn on either nostril played,
" Thy proffered love were great and kind,
Could I in thee a *rival* find."
" A rival, Sir!" returned the first,
Ready with rising wind to burst,
" Thy meekness, sure, in this I see :
We are not rivals. I agree :
And therefore am I more inclined
To cherish one of humble mind,
Who apprehends that one above him
Can never condescend to love him."

Nor longer did their courteous guile,
Like serpent, twisting through a smile,
Each other sting in civil phrase,
And poison with envenomed praise ;
For now the fiend of anger rose,
Distending each death-withered nose,
And, rolling fierce, each glassy eye,
Like owlet's at the noonday sky,
Such flaming volleys poured of ire
As set old Charon's phlegm on fire.
" Peace ! peace !" the grisly boatman cried,
" You drown the roar of Styx's tide.

Unmannered ghosts! if such your strife,
 T were better you were still in life!
If passions such as these you show,
You 'll make another Earth below;
Which, sure, would be a viler birth,
Than if we made a Hell on Earth."
At which in loud defensive strain
'Gan speak the angry Shades again.
" I 'll hear no more!" cried he. " No more!"
In echoes hoarse, returned the shore.
" To Minos' court you soon shall hie,
(Chief Justice here); 't is he will try
Your jealous cause, and prove at once
That only dunce can hate a dunce."

Thus checked, in sullen mood they sped,
Nor more on either side was said;
Nor aught the dismal silence broke,
Save only when the boatman's stroke
Deep-whizzing through the wave was heard,
And now and then a spectre-bird,
Low-cowering, with a hungry scream,
For spectre-fishes in the stream.

Now midway passed, the creaking oar
Is heard upon the fronting shore;
Where, thronging round in many a band,
The curious ghosts beset the strand.
Now suddenly the boat they spy,
Like gull diminished in the sky;
And now, like cloud of dusky white,
Slow sailing o'er the deep of night,

The sheeted group within the bark
Is seen amid the billows dark.
Anon the keel, with grating sound,
They hear upon the pebbly ground,
And now, with kind, officious hand,
They help the ghostly crew to land.

 " What news?" they cried with one accord.
" I pray you," said a noble lord,
" Tell me if in the world above
I still retain the people's love;
Or whether they, like us below,
The motives of a Patriot know."
" And me inform," another said,
" What think they of a Buck that's dead?
Have they discerned, that, being dull,
I knocked my wit from watchman's skull?"
"And me," cried one, of knotty front,
With many a scar of pride upon 't,
" Resolve me if the world opine
Philosophers are still divine :
That, having hearts for friends too small,
Or, rather, having none at all,
Professed to love, with saving grace,
The *abstract* of the human race."
"And I," exclaimed a fourth, " would ask,
What think they of the Critic's task?
Perceive they now our shallow arts, —
That merely from the want of parts
To write ourselves, we gravely taught
How books by others should be wrought?"

19 *

Whom interrupting, then inquired
A fifth, in squalid garb attired,
" Do now the world with much regard
In memory hold the dirty Bard,
Who credit gained for genius rare
By shabby coat and uncombed hair ? "
" Or do they," said a Shade of prose,
With many a pimple's ghost on nose,
" The eccentric author still admire,
Who, wanting that same genius' fire,
Diving in cellars underground
In pipe the spark ethereal found, —
Which, fanned by many a ribald joke,
From brother tipplers puffed in smoke,
Such blaze diffused, with crackling loud,
As blinded all the staring crowd ? "
And last, with jealous-glancing eye,
That seemed in all around to pry,
A Painter's ghost in voice suppressed,
Thus questioning, the group addressed : —

" Sweet strangers, may I too demand,
How thrive the offspring of my hand ?
Whether, as when in life I flourished,
They still by puffs of fame are nourished ?
Or whether have the world discerned
The tricks by which my fame was earned ; —
That, lacking in my pencil skill,
I made my tongue its office fill ; —
That, marking (as for love of truth)
In others' works a limb uncouth,

Or face too young, or face too old,
Or color hot, or color cold,
Or hinting, (if to praise betrayed,)
' Though colored well, it yet might *fade*,'
And ' Though its grace I can't deny,
Yet pity 't is so hard and dry,'
I thus by implication showed
That mine were wrought in better mode ; —
And, talking thus superiors down,
Obliquely raised my own renown ?
In short, I simply this would ask, —
If Truth has stripped me of the mask,
And, chasing Fashion's mist away,
Exposed me to the eye of day, —
A Painter false, without a heart,
Who loved himself, and not his art." *

* The author would be sorry to have it supposed that he alludes
here to any individual ; for he can say with truth, that such a character
has never fallen under his observation : much less would he be thought to
reflect on the Artists, as a class of men to which such baseness may be
generally imputed. The case here is merely *supposed*, to show how easily
imbecility and selfishness may pervert this most innocent of all arts to the
vilest purposes. He may be allowed, also, to disclaim an opinion too gen-
erally prevalent ; namely, that envy and detraction are the natural off-
spring of the art. That Artists should possess a portion of these vices, in
common with Poets, Musicians, and other candidates for fame, is reasona-
bly to be expected ; but that they should exclusively monopolize them, or
even hold an undue proportion, it were ungenerous to suppose. The au-
thor has known Artists in various countries, and he can truly say, that, with
a very few exceptions, he has found them candid and liberal, prompt to
discover merit, and just in applauding it. If there have been exceptions,
he has also generally been able to trace their cause to the unpropitious co-
incidence of narrow circumstances, a defective education, and poverty of
intellect. Is it then surprising, that in the hands of such a triumvirate the
art should be degraded to an imposture, to the trick of a juggler ? But it

At which, with fixed and fishy gaze,
The Strangers both expressed amaze.
" Good Sir," said they, " 't is strange you dare
Such meanness of yourself declare."

" Were I on earth," replied the Shade,
" I never had the truth betrayed;
For there (and, I suspect, like you)
I ne'er had time myself to view.
Yet, knowing that 'bove all creation
I held myself in estimation,
I deemed that what I *loved* the *best*
Of every virtue was possessed.
But *here* in colors black and true
Men see themselves, who never knew
Their motives in the worldly strife,
Or real characters through life.
And here, alas! I scarce had been
A little day, when every sin
That slumbered in my living breast,
By Minos roused from torpid rest,
Like thousand adders, rushing out,
Entwined my shuddering limbs about.
O strangers, hear! — the truth I tell —
That fearful sight I saw was Hell.
And, O! with what unmeasured woe
Did bitterness upon me flow,
When, thundering through the hissing air,
I heard the sentence of Despair, —

surely would be a cause of wonder, if, with such leprous members, the
sound and respectable body of its professors should escape the suspicion
of partaking their contamination.

' Now, never hope from Hell to flee ;
Yourself is all the Hell you see ! ' "

 He ceased. But still with stubborn pride
The rival Shades each other eyed ;
When, bursting with terrific sound,
The voice of Minos shook the ground.
The startled ghosts on either side,
Like clouds before the wind, divide ;
And leaving far a passage free,
Each conning his defensive plea,
With many a crafty lure for grace,
The Painters onward hold their pace.
Anon before the Judgment-Seat,
With sneer confronting sneer they meet :
And now in deep and awful strain,
Piercing like fiery darts the brain,
Thus Minos spake : — " Though I am he
From whom no secret thought may flee ;
Who sees it ere the birth be known
To him that claims it for his own ;
Yet would I still with patience hear
What each may for himself declare,
That all in your defence may see
The justice pure of my decree.
But, hold ! — It ill beseems my place
To hear debate in such a case :
Be therefore thou, Da Vinci's shade,
Who when on earth to men displayed
The scattered powers of human kind
In thy capacious soul combined, —
Be thou the umpire of the strife,
And judge as thou wert still in life."

Thus bid, with grave, becoming air,
The appointed judge assumed the chair.
And now with modest-seeming air,
The rivals straight for speech prepare;
And thus, with hand upon his breast,
The Senior Ghost the Judge addressed: —
" The world (if aught the world I durst
In this believe) did call me first
Of those, who, by the magic play
Of harmonizing colors, sway
The gazer's sense with such surprise,
As makes him disbelieve his eyes.
'T is true that some, of vision dim,
Or squeamish taste, or pedant whim,
My works assailed with narrow spite;
And, passing o'er my color bright,
Reproached me for my want of grace,
And silks and velvets out of place,
And vulgar form, and lame design,
And want of character, — in fine,
For lack of worth of every kind
To charm or to enlarge the mind.
Now this, my Lord, as will appear,
Was nothing less than malice sheer,
To stab me, like assassins dark,
Because I did not hit a mark,
At which (as I have hope of fame)
I never once designed to aim.
For, seeing that the life of man
Was scarcely longer than a span,
And knowing that the Graphic Art
Ne'er mortal mastered but *in part*,

I wisely deemed 't were labor vain,
Should I attempt the *whole* to gain ;
And therefore, with ambition high,
Aspired to reach what pleased the **eye** ;
Which, truly, Sir, must be confessed
A part that far excels the rest :
For if, as all the world agree,
'Twixt Painting and fair Poesy
The difference in the mode be found,
Of color this, and that of sound,
'T is plain, o'er every other grace,
That color holds the highest place ;
As being that distinctive part,
Which bounds it from another art.
If, therefore, with reproof severe
I 've galled my pigmy Rival here,
'T was only, as your Lordship knows,
Because his foolish envy chose
To rank his classic forms of mud
Above my wholesome flesh and blood."

Thus ended parle the Senior Shade.
And now, as scorning to upbraid,
With curving, *parabolic* smile,
Contemptuous, eying him the while,
His Rival thus : — " 'T were vain, my Lord
To wound a gnat by spear or sword ; *
If, therefore, *I*, of greater might,
Would meet this *thing* in equal fight,
'T were fit that I in size should be
As mean, diminutive, as he ;

* " Who breaks a butterfly upon a wheel ? " — POPE.

Of course, disdaining to reply,
I pass the wretch unheeded by.
But, since your Lordship deigns to know
What I in my behalf may show,
With due submission, I proclaim,
That few on earth have borne a name
More envied or esteemed than mine,
For grace, expression, and design,
For manners true of every clime,
And composition's art sublime.
In academic lore profound,
I boldly took that lofty ground,
Which, as it raised me near the sky,
Was thence for vulgar eyes too high;
Or, if beheld, to them appeared
By clouds of gloomy darkness bleared.
Yet still that misty height I chose,
For well I knew the world had those
Whose sight, by learning cleared of rheum,
Could pierce with ease the thickest gloom.
Thus, perched sublime, 'mid clouds I wrought,
Nor heeded what the vulgar thought.
What, though with clamor coarse and rude
They jested on my colors crude;
Comparing, with malicious grin,
My drapery to bronze and tin,
My flesh to brick and earthen ware,
To wire of various kinds my hair;
Or (if a landscape bit they saw)
My trees to pitchforks crowned with straw,
My clouds to pewter plates of thin edge,
And fields to dish of eggs and spinage;

Yet this and many a grosser rub,
Like famed Diogenes in tub,
I bore with philosophic nerve,
Nay, gladly bore; for, here observe,
'T was that which gave to them offence
Did constitute my excellence. —
I see, my Lord, at this you stare:
Yet thus I'll prove it to a hair. —
As Mind and Body are distinct,
Though long in social union linked,
And as the only power they boast
Is merely at each other's cost;
If both should hold an equal station,
They'd both be kings without a nation:
If, therefore, one would paint the Mind
In partnership with Body joined,
And give to each an equal place,
With each an equal truth and grace,
'T is clear the picture could not fail
To be without or head or tail.
And therefore, as the Mind alone
I chose should fill my graphic throne,
To fix her power beyond dispute,
I trampled Body under foot:
That is, in more prosaic dress,
As I the passions would express,
And as they ne'er could be portrayed
Without the subject Body's aid,
I showed no more of that than merely
Sufficed to represent them clearly:
As thus, — by simple means and pure
Of light and shadow, and contour.
20

But, since what mortals call complexion
Has with the mind no more connection,
Than ethics with a country dance,
I left my coloring all to chance;
Which oft (as I may proudly state)
With Nature warred at such a rate,
As left no mortal hue or stain
Of base, corrupting flesh, to chain
The Soul to earth; but, free as light,
E'en let her soar till out of sight."

Thus spake the champion bold of Mind;
And thus the Colorist rejoined:—
" In truth, my Lord, I apprehend,
If I by *words* with him contend,
My case is gone; for he, by gift
Of what is called the *gab*, can shift
The right for wrong, with such a sleight,
That right seems wrong and wrong the right, —
Nay, by his twisting logic, make
A square the form of circle take.
I therefore, with submission meet,
In justice do your Grace entreat
To let awhile your judgment pause,
That *works*, not *words*, may plead our cause.
Let Mercury then to Earth repair,
The works of both survey with care,
And hither bring the best of each,
And save us further waste of speech."

" Such fair demand," the Judge replied,
" Could not with justice be denied. —

Good Mercury, hence!" "I fly, my **Lord**,"
The Courier said. And, at the word,
High-bounding, wings his airy flight
So swift, his form eludes the sight;
Nor aught is seen his course to mark,
Save when athwart the region dark
His brazen helm is spied afar,
Bright-trailing like a falling star.

And now for minutes ten there stole
A silence deep o'er every soul, —
When, lo! again before them stands
The Courier's self with empty hands.
" Why, how is this ?" exclaimed the twain ;
" Where are the *pictures*, Sir ? Explain!"
" Good Sirs," replied the God of Post,
" I scarce had reached the other coast,
When Charon told me, one he ferried
Informed him they were dead and buried ;
Then bade me hither haste and say,
Their ghosts were now upon the way."
In mute amaze the Painters stood.
But soon upon the Stygian flood,
Behold! the spectre-pictures float,
Like rafts, behind the towing boat ;
Now reached the shore, in close array,
Like armies drilled in Homer's day,
When marching on to meet the foe,
By bucklers hid from top to toe,
They move along the dusky fields,
A grisly troop of painted shields ;
And now, arrived, in order fair,
A gallery huge they hang in air.

The ghostly crowd with gay surprise
Began to rub their stony eyes:
Such pleasant lounge, they all averred,
None saw since he had been interred;
And thus, like connoisseurs on Earth,
Began to weigh the pictures' worth.
But first (as deemed of higher kind)
Examined they the works of *Mind*.
* " Pray what is this ? " demanded one.
" That, Sir, is Phœbus, *alias* Sun:
A classic work you can't deny ;
The car and horses in the sky,
The clouds on which they hold their **way**,
Proclaim him all the God of Day."
" Nay, learned Sir, his dirty plight
More fit beseems the God of Night.
Besides, I cannot well divine
How mud like this can ever shine."
" Then look at that a little higher."
" I see 't is Orpheus, by his lyre.
The beasts that listening stand around,
Do well declare the force of sound :
But why the fiction thus reverse,
And make the power of song a curse ?
The ancient Orpheus softened rocks,
Yours changes living things to blocks."
" Well, this you 'll sure acknowledge fine, —
Parnassus' top, with all the Nine.
Ah, *there* is beauty, soul, and fire,
And all that human wit inspire ! "

* The author, having no revenge to gratify, and consequently no pleasure in giving pain, has purposely excluded the works of all living Artists from this Gallery.

" Good Sir, you 're right; for, being stone,
They 're each to blunted wits a hone."
" And what is that ? " inquired another.
" That, Sir, is Cupid and his Mother."
" What, Venus ? Sure it cannot be :
That skin begrimed ne'er felt the sea ;
That Cupid, too, ne'er knew the sky,
For lead, I 'm sure, could never fly."
" I 'll hear no more," the Painter said,
" Your souls are, like your bodies, dead ! "

 With secret triumph now elate,
His grinning Rival 'gan to prate.
" O, fie ! my friends ; upon my word,
You 're too severe ; he should be *heard*, —
For *Mind* can ne'er to glory reach
Without the usual aid of *speech*.
If thus, howe'er, you seal his doom,
What hope have I unknown to Rome ?
But since the *truth* be your dominion,
I beg to hear your just opinion.
This picture, then, — which some have thought
By far the best I ever wrought, —
Observe it well with critic ken ;
'T is Daniel in the Lions' Den."
" 'T is flesh itself ! " exclaimed a critic ;
" But why make Daniel paralytic ?
His limbs and features are distorted,
And then his legs are badly sorted.
'T is true, a miracle you 've hit,
But not as told in Holy Writ ;
For there the miracle was braving,
With *bones unbroke*, the Lions' craving ;

20 *

But yours, (what ne'er could man befall,)
That he should *live with none at all.*"
" And pray," inquired another spectre,
" What Mufti 's that at pious lecture ? "
" That 's Socrates, condemned to die ;
He next, in sable, standing by,
Is Galen,* come to save his friend,
If possible, from such an end ;
The other figures, grouped around,
His Scholars, wrapt in woe profound."
" And am I like to this portrayed ? "
Exclaimed the Sage's smiling Shade.
" Good Sir, I never knew before
That I a Turkish turban wore,
Or mantle hemmed with golden stitches,
Much less a pair of satin breeches ;
But, as for him in sable clad,
Though wondrous kind, 't was rather mad
To visit one like me forlorn,
So long before himself was born."
" And what 's the next ? " inquired a third ;
" A jolly blade, upon my word ! "
" 'T is Alexander, Philip's son,
Lamenting o'er his battles won ;
That, now his mighty toils are o'er,
The world has naught to conquer more."
At which, forth stalking from the host,
Before them stood the Hero's Ghost.
" Was that," said he, " my earthly form,
The Genius of the battle-storm ?

* To those who are conversant with the works of the Old Masters, this
piece of anachronism will hardly appear exaggerated.

From top to toe the figure 's Dutch!
Alas, my friend, had I been such,
Had I that fat and meaty skull,
Those bloated cheeks, and eyes so dull,
That drivelling mouth, and bottle nose,
Those shambling legs, and gouty toes, —
Thus formed to snore throughout the day,
And eat and drink the night away, —
I ne'er had felt the feverish flame
That caused my bloody thirst for fame,
Nor madly claimed immortal birth,
Because the vilest brute on earth :
And, O! I 'd not been doomed to hear,
Still whizzing in my blistered ear,
The curses deep, in damning peals,
That rose from 'neath my chariot-wheels,
When I along the embattled plain
With furious triumph crushed the slain :
I should not thus be doomed to see,
In every shape of agony,
The victims of my cruel wrath,
For ever dying, strew my path ;
The grinding teeth, the lips awry,
The inflated nose, the starting eye,
The mangled bodies writhing round,
Like serpents, on the bloody ground ;
I should not thus for ever seem
A charnel-house, and scent the steam
Of black, fermenting, putrid gore,
Rank oozing through each burning pore ;
Behold, as on a dungeon wall,
The worms upon my body crawl,

The which, if I would brush away,
Around my clammy fingers play,
And, twining fast with many a coil,
In loathsome sport my labor foil."

" Enough!" the frighted Painter cried,
And hung his head in fallen pride.

Not so the other. He, of stuff
More stubborn, ne'er would cry, Enough ;
But, like a soundly cudgelled oak,
More sturdy grew at every stroke.
And thus again his ready tongue
With fluent logic would have rung : —
" My Lord, I 'll prove, or I 'm a liar "
Whom interrupting then with ire,
Thus checked the Judge : — "O, proud, yet mean !
And canst thou hope from me to screen
Thy foolish heart, and o'er it spread
A veil to cheat the omniscient dead ?
And canst thou hope, as once on Earth,
Applause to gain by specious worth, —
Like those that still by sneer and taunt
Would prove pernicious what they want, —
And claim the mastership of Art,
Because thou only know'st a *part ?*

" Hadst thou from Nature, not the Schools
Distorted by pedantic rules,
With patience wrought, such logic vain
Had ne'er perverted thus thy brain :
For genius never gave delight
By means of what offends the sight :

Nor hadst thou deemed, with folly mad,
Thou couldst to Nature's beauties *add*,
By *taking from her that which gives*
The best assurance that she lives;
By imperfection give attraction,
And multiply them by subtraction.

" Did Raffael thus, whose honored ghost
Is now Elysium's fairest boast?
Far different he. Though weak and lame
In parts that gave to others fame,
Yet sought not *he* by such defect
To swindle praise for *wise neglect*
Of *vulgar* charms, that only *blind*
The dazzled eye to those of Mind.
By Heaven impressed with genius' seal,
An eye to see, and heart to feel,
His soul through boundless Nature roved,
And seeing felt, and feeling loved.
But weak the power of mind at will
To give the hand the painter's skill;
For mortal works, maturing slow,
From patient care and labor flow:
And, hence restrained, his youthful hand
Obeyed a master's dull command;
But soon with health his sickly style
From Leonardo learned to smile;
And now from Buonarroti caught
A nobler Form; and now it sought
Of Color fair the magic spell,
And traced her to the Friar's * cell.

* Fra Bartolomeo.

No foolish pride, no narrow rule,
Enslaved his soul; from every School,
Whatever fair, whatever grand,
His pencil, like a potent wand,
Transfusing, bade his canvas grace.
Progressive thus, with giant pace,
And energy no toil could tame,
He climbed the rugged mount of Fame:
And soon had reached the summit bold,
When Death, who there delights to hold
His fatal watch, with envious blow
Quick hurled him to the shades below."

Thus checked the Judge the champion vain
Of *Classic Form;* and thus, in strain
By anger half and pity moved,
The ghostly Colorist reproved: —
" And what didst *thou* aspire to gain,
Who daredst the will of Jove arraign,
That bounded thus within a span
The little life of little man,
With shallow art deriving thence
Excuses for thy indolence?
'T is cant and hypocritic stuff!
The life of man is long enough:
For, did he but the half improve,
He would not quarrel thus with Jove.

" But most I marvel (if it be
That aught may wondrous seem to me)
That Jove's high gift, your noble Art,
Bestowed to raise man's grovelling heart,

Refining with ethereal ray
Each gross and selfish thought away,
Should pander turn of paltry pelf,
Imprisoning each within himself;
Or, like a gorgeous serpent, be
Your splendid source of misery,
And, crushing with his burnished folds,
Still narrower make your narrow souls.

" But words can ne'er reform produce
In Ignorance and Pride obtuse.
Then know, ye vain and foolish pair!
Your doom is fixed a yoke to bear
Like beasts on Earth; and, thus in tether,
Five centuries to paint together.
If thus, by mutual labors joined,
Your jarring souls should be combined,
The faults of each the other mending,
The powers of both harmonious blending,
Great Jove, perhaps, in gracious vein,
May send your souls on Earth again;
Yet there One only Painter be;
For thus the eternal Fates decree:
' One leg alone shall never run,
Nor two Half-Painters make but One.' "

ECCENTRICITY.

" Projecêre animas." — Virg.

Alas, my friend! what hope have I of fame,
Who am, as Nature made me, still the same?
And thou, poor suitor to a bankrupt Muse,
How mad thy toil, how arrogant thy views!
What though endued with Genius' power to move
The magic chords of sympathy and love,
The painter's eye, the poet's fervid heart,
The tongue of eloquence, the vital art
Of bold Prometheus, kindling at command
With breathing life the labors of his hand;
Yet shall the world thy daring, high pretence
With scorn deride, for thou — hast common sense.

But dost thou, reckless of stern honor's laws,
Intemperate hunger for the world's applause?
Bid Nature hence; her fresh, embowering woods,
Her lawns and fields, and rocks, and rushing floods,
And limpid lakes, and health-exhaling soil,
Elastic gales, and all the glorious toil
Of Heaven's own hand, with courtly shame discard,
And Fame shall triumph in her city bard.

Then, pent secure in some commodious lane,
Where stagnant Darkness holds her morbid **reign**,
Perchance snug-roosted o'er some brazier's den,
Or stall of nymphs, by courtesy *not* men,
Whose gentle trade to skin the living eel,
The while they curse it that it dares to feel; *
Whilst ribald jokes and repartees proclaim
Their happy triumph o'er the sense of shame;
The city Muse invoke, that imp of mind
By smoke engendered on an eastern wind;
Then, half awake, thy patent-thinking pen
The paper give, and blot the souls of men.

The time has been when Nature's simple face
Perennial youth possessed, and winning grace;
But who shall dare, in this refining age,
With Nature's praise to soil his snowy page?
What polished lover, unappalled by sneers,
Dare court a beldame of six thousand years,
When every clown, with microscopic eyes,
The gaping furrows on her forehead spies? —
" Good Sir, your pardon. In her naked state,
Her withered form we cannot choose but hate;
But fashion's art the waste of time repairs,
Each wrinkle fills, and dyes her silver hairs;
Thus wrought anew, our gentle bosoms glow;
We cannot choose but love what 's *comme il faut.*"

Alas, poor Cowper! could thy chastened eye
(Awhile forgetful of thy joys on high)

* See Boswell's Life of Johnson.

Revisit earth, what indignation strange
Would sting thee to behold the courtly change!
Here " velvet " lawns, there " plushy " woods that lave
Their " silken " tresses in the " glassy " wave;
Here " 'broidered" meads, there flowery " carpets"
 spread,
And " downy " banks to " pillow " Nature's head.
How wouldst thou start to find thy native soil,
Like birthday belle, by gross mechanic toil
Tricked out to charm with meretricious air,
As though all France and Manchester were there!
But this were luxury, were bliss refined,
To view the altered region of the mind;
Where whim and mystery, like wizards, rule,
And conjure wisdom from the seeming fool, —
Where learned heads, like old cremonas, boast
Their merit soundest that are cracked the most, —
While Genius' self, infected with the joke,
His person decks with Folly's motley cloak.

 Behold, loud-rattling like a thousand drums,
Eccentric Hal, the child of Nature, comes!
Of Nature once, — but *now* he acts a part,
And Hal is now the full-grown boy of art.
In youth's pure spring his high, impetuous soul
Nor custom owned, nor fashion's vile control.
By Truth impelled where beckoning Nature led,
Through life he moved with firm, elastic tread ;
But soon the world, with wonder-teeming eyes,
His manners mark, and goggle with surprise.
" He 's wondrous strange!" exclaims each gaping clod;
" A wondrous genius, for he 's wondrous odd!"

Where'er he goes, there goes before his — fame,
And courts and taverns echo round his name;
Till, fairly knocked by admiration down,
The petted monster cracks his wondrous crown.
No longer now to simple Nature true,
He studies only to be oddly new;
Whate'er he does, whate'er he deigns to say,
Must all be said and done the oddest way;
Nay, e'en in dress eccentric as in thought,
His wardrobe seems by Lapland witches wrought,
Himself by goblins in a whirlwind dressed,
With rags of clouds from Hecla's stormy crest.

" Has truth no charms?" When first beheld, I grant,
But, wanting novelty, has every want:
For pleasure's thrill the sickly palate flies,
Save haply pungent with a rare surprise.
The humble toad that leaps her nightly round,
The harmless tenant of the garden ground,
Is loathed, abhorred, nay, all the reptile race
Together joined were never half so base;
Yet snugly find her in some quarry pent,
Through ages doomed to one tremendous Lent,
Surviving still, as if in Nature's spite,
Without or nourishment, or air, or light,
What raptures then the astonished gazer seize!
What lovely creature like a toad can please!

Hence many an oaf, by Nature doomed to shine
The unknown father of an unknown line,
If haply shipwrecked on some desert shore
Of Folly's seas, by man untrod before,

Which, bleak and barren, to the starving mind
Yields naught but fog, or damp, unwholesome wind,
With loud applause the wondering world shall hail,
And Fame embalm him in the marvellous tale.

With chest erect, and bright, uplifted eye,
On tiptoe raised, like one prepared to fly,
Yon wight behold, whose sole aspiring hope
Eccentric soars to catch the hangman's rope.
In order ranged, with date of place and time,
Each owner's name, his parentage and crime,
High on his walls, inscribed to glorious shame,
Unnumbered halters gibbet him to fame.

Who next appears thus stalking by his side?
Why that is one who 'd sooner die than — ride!
No inch of ground can maps unheard of show
Untraced by him, unknown to every toe;
As if intent this punning age to suit,
The globe's circumference measuring by the foot.

Nor less renowned whom stars inveterate doom
To smiles eternal, or eternal gloom;
For what 's a *character* save one confined
To some unchanging sameness of the mind, —
To some strange, fixed monotony of mien,
Or dress for ever brown, for ever green ?

A sample comes. Observe his sombre face,
Twin-born with Death, without his brother's grace!
No joy in mirth his soul perverted knows,
Whose only joy to tell of others' woes.

A fractured limb, a conflagrating fire,
A name or fortune lost, his tongue inspire :
From house to house where'er misfortunes press,
Like Fate, he roams, and revels in distress ;
In every ear with dismal boding moans, —
A walking register of sighs and groans!

High towering next, as he'd eclipse the moon,
With pride upblown, behold yon live balloon.
All trades above, all sciences and arts,
To fame he climbs through very scorn of parts ;
With solemn emptiness distends his state,
And, great in nothing, soars above the great;
Nay, stranger still, through apathy of blood,
By candor numbered with the chaste and good,
With wife, and child, domestic, stranger, friend,
Alike he lives, as though his being's end
Were o'er his house like formal guest to roam,
And walk abroad to leave himself at home.

" But who is he, that sweet, obliging youth ? "
He looks the picture of ingenuous truth.
O, that 's his antipode, of courteous race,
The man of bows and ever-smiling face.
Why Nature made him, or for what designed,
Never he knew, nor ever sought to find,
Till cunning came, blest harbinger of ease !
And kindly whispered, " Thou wert born to please."
Roused by the news, behold him now expand,
Like beaten gold, and glitter o'er the land.
Well stored with nods and sly, approving winks,
Now first with this and now with that he thinks ;
21 *

Howe'er opposing, still assents to each,
And claps a dovetail to each booby's speech.
At random thus for all, for none he lives,
Profusely lavish though he nothing gives;
The world he roves as living but to show
A friendless man without a single foe;
From bad to good, to bad from good to run,
And find a character by seeking none.

Who covets fame should ne'er be over nice, —
Some slight distortion pays the market price.
If haply lamed by some propitious chance,
Instruct in attitude, or teach to dance;
Be still extravagant in deed, or word;
If new, enough, — no matter how absurd.

" Then what is Genius? " Nay, if rightly used,
Some gift of Nature happily abused.
Nor wrongly deem, by this eccentric rule,
That Nature favors whom she makes a fool.
Her scorn and favor we alike despise;
Not Nature's follies, but our own, we prize.

" Or what is wit? " A meteor bright and rare,
That comes and goes we know not whence or where;
A brilliant nothing out of something wrought,
A mental vacuum by condensing thought.

Behold Tortoso. There's a man of wit;
To all things fitted, though for nothing fit;
Scourge of the world, yet crouching for a name,
And honor bartering for the breath of fame;

Born to command, and yet an arrant slave;
Through too much honesty a seeming knave;
At all things grasping, though on nothing bent,
And ease pursuing e'en with discontent;
Through nature, arts, and sciences he flies,
And gathers truth to manufacture lies.

Nor only Wits for tortured talents claim
Of sovereign mobs the glorious meed of fame;
E'en Sages too, of grave and reverend air,
Ycleped *Philosophers*, must have their share;
Who, deeper still in conjuration skilled,
A mighty something out of nothing build.

"Then wherefore read? Why cram the youthful
head
With all the learned lumber of the dead,
Who, seeking wisdom, followed Nature's laws,
Nor dared effects admit without a cause?"
Why? — Ask the sophist of our modern school;
To foil the workman we must know the tool;
And, that possessed, how swiftly is defaced
The noblest, rarest monument of taste!
So neatly, too, the mutilations stand
Like native errors of the artist's hand;
Nay, what is more, the very tool betrayed
To seem the product of the work it made.

"O monstrous slander on the human race!"
Then read conviction in Ortuno's case.
By Nature fashioned in her happiest mood,
With learning, fancy, keenest wit endued,

To what high purpose, what exalted end,
These lofty gifts did great Ortuno bend?
With grateful triumph did Ortuno raise
The mighty trophies to their Author's praise,
With skill deducing from the harmonious whole
Immortal proofs of One Creative Soul?
Ah, no! infatuate with the dazzling light,
In them he saw their own creative might;
Nay, madly deemed, if such their wondrous skill,
The phantom of a God 't was theirs to *will*.

But granting that he *is*, he bids you show
By what you prove it, or by what you know.
O reasoning worm! who questions thus of Him
That lives in all, and moves in very limb;
Must with himself in very strangeness dwell;
Has never heard the voice of Conscience tell
Of right and wrong, and speak in louder tone
Than tropic thunder of that Holy One,
Whose pure, eternal justice shall requite
The deed of wrong, and justify the right.

Can such blaspheme and breathe the vital air?
Let mad philosophy their names declare.
Yet some there are, less daring in their aim,
With humbler cunning butcher sense for fame;
Who, doubting still, with many a fearful pause,
The existence grant of one almighty cause;
But, halting there, in bolder tone deny
The life hereafter, when the man shall die,
Nor mark the monstrous folly of their gain, —
That God all-wise should fashion *them* in vain.

'T were labor lost in this material age,
When schoolboys trample on the Inspired Page, —
When cobblers prove by syllogistic pun
The sole they mend and that of man are one, —
'T were waste of time to check the Muse's speed,
For all the *whys* and *wherefores* of their creed;
To show how proved the juices are the same
That feed the body, and the mental frame.

But who, half skeptic, half afraid of wrong,
Shall walk our streets, and mark the passing throng, —
The brawny oaf in mould Herculean cast,
The pigmy statesman trembling in his blast,
The cumbrous citizen of portly paunch,
Unwont to soar beyond the smoking haunch,
The meagre bard behind the moving tun,
His shadow seeming lengthened by the sun, —
Who forms scarce visible shall thus descry,
Like flitting clouds athwart the mental sky,
From giant bodies then bare gleams of mind,
Like mountain watch-lights blinking to the wind, —
Nor blush to find his unperverted eye
Flash on his heart, and give his tongue the lie?

'T is passing strange! yet, born as if to show
Man to himself his most malignant foe,
There are (so desperate is the madness grown)
Who 'd rather live a *lie* than live unknown;
Whose very tongues, with force of Holy Writ,
Their doctrines damn with self-recoiling wit.

Behold yon dwarf, of visage pale and wan, —
A sketch of life, a remnant of a man!

Whose livid lips, as now he moulds a grin,
Like charnel-doors disclose the waste within;
Whose stiffened joints within their sockets grind,
Like gibbets creaking to the passing wind;
Whose shrivelled skin with such adhesion clings
His bones around in hard, compacted rings,
If veins there were, no blood beneath could force,
Unless by miracle, its trickling course;—
Yet even *he* within that sapless frame
A mind sustained that climbed the steeps of fame.
Such is the form by mystic Heaven designed
The earthly mansion of the rarest mind.
But mark his gratitude. This soul sublime,
This soul lord paramount o'er space and time,
This soul of fire, with impious madness sought
Itself to prove of mortal matter wrought;
Nay, bred, engendered, on the grub-worm plan,
From that vile clay which made his outward man,
That shadowy form which, darkening into birth,
But seemed a sign to mark a soul on earth.

But who shall cast an introverted eye
Upon himself, that will not there descry
A conscious life that shall, nor cannot die?
E'en at our birth, when first the infant mould
Gives it a mansion and an earthly hold,
The exulting Spirit feels the heavenly fire
That lights her tenement will ne'er expire;
And when, in after years, disease and age,
Our fellow-bodies sweeping from life's stage,
Obtrude the thought of death, e'en then we seem,
As in the revelation of a dream,

To hear a voice, more audible than speech,
Warn of a part which death can never reach.
Survey the tribes of savage men that roam
Like wandering herds, each wilderness their home; —
Nay, even there the immortal spirit stands
Firm on the verge of death, and looks to brighter lands.

Shall human wisdom, then, with beetle sight,
Because obstructed in its blundering flight,
Despise the deep conviction of our birth,
And limit life to this degraded earth?

O, far from me be that insatiate pride,
Which, turning on itself, drinks up the tide
Of natural light, till one eternal gloom,
Like walls of adamant, inclose the tomb.
Tremendous thought! that this transcendent **Power,**
Felled with the body in one fatal hour,
With all its faculties, should pass like air
For ages without end as though it never were!

Say, whence, obedient to their destined end,
The various tribes of living nature tend?
Why beast, and bird, and all the countless race
Of earth and waters, each his proper place
Instinctive knows, and through the endless chain
Of being moves in one harmonious strain;
While man alone, with strange perversion, draws
Rebellious fame from Nature's broken laws?
Methinks I hear, in that still voice that stole,
On Horeb's mount, o'er rapt Elijah's soul,

With stern reproof indignant Heaven reply:
"'T is overweening Pride, that blinds the eye
Of reasoning man, and o'er his darkened life
Confusion spreads, and misery and strife."

With wonder filled and self-reflecting praise,
The slave of Pride his mighty powers surveys;
On Reason's sun (by bounteous Nature given,
To guide the soul upon her way to heaven)
Adoring gazes, till the dazzling light
To darkness sears his vain, presumptuous sight;
Then bold, though blind, through error's night he runs,
In fancy lighted by a thousand suns;
For bloody laurels now the warrior plays,
Now libels nature for the poet's bays,
Now darkness drinks from metaphysic springs,
Or follows fate on astrologic wings:
'Mid toils at length the world's loud wonder won,
With Persian piety, to Reason's sun
Profound he bows, and, idolist of fame,
Forgets the God who lighted first the flame.

All-potent Reason! what thy wondrous light?
A shooting star athwart a polar night;
A bubble's gleam amid the boundless main;
A sparkling sand on waste Arabia's plain; —
E'en such, vain Power, thy limited control,
E'en such thou art to man's mysterious soul!

Presumptuous man! wouldst thou aspiring reach
True wisdom's height, let conscious weakness teach

Thy feeble soul her poor, dependent state,
Nor madly war with Nature to be great.

Come then, Humility, thou surest guide!
On earth again with frenzied men reside;
Tear the dark film of vanity and lies,
And inward turn their renovated eyes;
In aspect true let each himself behold,
By self deformed in pride's portentous mould.
And if thy voice, on Bethlehem's holy plain
Once heard, can reach their flinty hearts again,
Teach them, as fearful of a serpent's gaze,
Teach them to shun the gloating eye of praise;
The slightest swervings from their nature's plan
Make them a lie, and poison all the man,
Till black corruption spread the soul throughout,
Whence thick and fierce, like fabled mandrakes, **sprout**
The seeds of vice with more than tropic force,
Exhausting in the growth their very vital source.

Nor wrongly deem the cynic Muse aspires
With monkish tears to quench our nobler fires.
Let honest pride our humble hearts inflame,
First to deserve, ere yet we look to, fame;
Not fame miscalled, the mob's applauding stare, —
This monsters have, proportioned as they 're rare;
But that sweet praise, the tribute of the good,
For wisdom gained, through love of truth pursued.
Coeval with our birth, this pure desire
Was given to lift our grovelling natures higher,
Till that high praise, by genuine merit wrung
For men's slow justice, shall employ the **tongue**
22

Of yon Supernal Court, from whom may flow
Or bliss eternal or eternal woe.
And, since in all this hope exalting lives,
Let virtuous toil improve what Nature gives:
Each in his sphere some glorious palm may gain,
For Heaven all-wise created naught in vain.

 O task sublime, to till the human soil
Where fruits immortal crown the laborer's toil!
Where deathless flowers, in everlasting bloom,
May gales from heaven with odorous sweets perfume,
Whose fragrance still, when man's last work is done,
And hoary Time his final course has run,
Through ages back, with freshening power shall last,
Mark his long track, and linger where he passed!

THE PAINT-KING.

Fair Ellen was long the delight of the young,
　　No damsel could with her compare ;
Her charms were the theme of the heart and the tongue,
And bards without number in ecstasies sung
　　The beauties of Ellen the fair.

Yet cold was the maid; and though legions advanced,
　　All drilled by Ovidean art,
And languished and ogled, protested and danced,
Like shadows they came, and like shadows they glanced
　　From the hard, polished ice of her heart.

Yet still did the heart of fair Ellen implore
　　A something that could not be found;
Like a sailor she seemed on a desolate shore,
With nor house, nor a tree, nor a sound but the roar
　　Of breakers high-dashing around.

From object to object still, still would she veer,
 Though nothing, alas! could she find ;
Like the moon, without atmosphere, brilliant and clear,
Yet doomed, like the moon, with no being to cheer
 The bright barren waste of her mind.

But, rather than sit like a statue so still
 When the rain made her mansion a *pound*,
Up and down would she go, like the sails of a mill,
And pat every stair, like a woodpecker's bill,
 From the tiles of the roof to the ground.

One morn, as the maid from her casement inclined,
 Passed a youth, with a frame in his hand.
The casement she closed, — not the eye of her mind;
For, do all she could, no, she could not be blind;
 Still before her she saw the youth stand.

" Ah, what can he do ? " said the languishing maid;
 " Ah, what with that frame can he do ? "
And she knelt to the Goddess of Secrets and prayed,
When the youth passed again, and again he displayed
 The frame and a picture to view.

" O beautiful picture ! " the fair Ellen cried,
 " I must see thee again or I die."
Then under her white chin her bonnet she tied,
And after the youth and the picture she hied,
 When the youth, looking back, met her eye.

" Fair damsel," said he, (and he chuckled the while,)
 " This picture I see you admire :
Then take it, I pray you ; perhaps 't will beguile
Some moments of sorrow, (nay, pardon my smile,)
 Or, at least, keep you home by the fire."

Then Ellen the gift with delight and surprise
 From the cunning young stripling received.
But she knew not the poison that entered her eyes,
When, sparkling with rapture, they gazed on the
 prize ; —
 Thus, alas, are fair maidens deceived!

'T was a youth o'er the form of a statue inclined,
 And the sculptor he seemed of the stone ;
Yet he languished as though for its beauty he pined,
And gazed as the eyes of the statue so blind
 Reflected the beams of his own.

'T was the tale of the sculptor Pygmalion of old ;
 Fair Ellen remembered and sighed :
" Ah, couldst thou but lift from that marble so cold,
Thine eyes too imploring, thy arms should enfold
 And press me this day as thy bride."

She said : when, behold, from the canvas arose
 The youth, and he stepped from the frame ;
With a furious transport his arms did inclose
The love-plighted Ellen ; and, clasping, he froze
 The blood of the maid with his flame!
 22 *

She turned, and beheld on each shoulder a wing.
 "O Heaven!" cried she, "who art thou?"
From the roof to the ground did his fierce answer ring,
As, frowning, he thundered, "I am the PAINT-KING!
 And mine, lovely maid, thou art now!"

Then high from the ground did the grim monster lift
 The loud-screaming maid like a blast;
And he sped through the air like a meteor swift,
While the clouds, wandering by him, did fearfully drift
 To the right and the left as he passed.

Now suddenly sloping his hurricane flight,
 With an eddying whirl he descends;
The air all below him becomes black as night,
And the ground where he treads, as if moved with
 affright,
 Like the surge of the Caspian bends.

"I am here!" said the fiend, and he thundering knocked
 At the gates of a mountainous cave;
The gates open flew, as by magic unlocked,
While the peaks of the mount, reeling to and fro, rocked
 Like an island of ice on the wave.

"O, mercy!" cried Ellen, and swooned in his arms;
 But the Paint-King, he scoffed at her pain.
"Prithee, love," said the monster, "what mean· these
 alarms?"
She hears not, see sees not, the terrible charms
 That wake her to horror again.

She opens her lids, but no longer her eyes
 Behold the fair youth she would woo;
Now appears the PAINT-KING in his natural guise;
His face, like a palette of villanous dyes,
 Black and white, red and yellow, and blue.

On the skull of a Titan, that Heaven defied,
 Sat the fiend, like the grim Giant Gog,
While aloft to his mouth a huge pipe he applied,
Twice as big as the Eddystone Lighthouse, descried
 As it looms through an easterly fog.

And anon, as he puffed the vast volumes, were seen,
 In horrid festoons on the wall,
Legs and arms, heads and bodies, emerging between,
Like the drawing-room grim of the Scotch Sawney
 Beane,
 By the Devil dressed out for a ball.

" Ah me!" cried the damsel, and fell at his feet.
 " Must I hang on these walls to be dried?"
" O, no!" said the fiend, while he sprung from his seat;
" A far nobler fortune thy person shall meet;
 Into paint will I grind thee, my bride!"

Then, seizing the maid by her dark auburn hair,
 An oil-jug he plunged her within.
Seven days, seven nights, with the shrieks of despair,
Did Ellen in torment convulse the dun air,
 All covered with oil to the chin.

On the morn of the eighth on a huge, sable stone
 Then Ellen, all reeking, he laid;
With a rock for his muller he crushed every bone,
But, though ground to jelly, still, still did she groan;
 For life had forsook not the maid.

Now, reaching his palette, with masterly care
 Each tint on its surface he spread;
The blue of her eyes, and the brown of her hair,
And the pearl and the white of her forehead so fair,
 And her lips' and her cheeks' rosy-red.

Then, stamping his foot, did the monster exclaim,
 " Now I brave, cruel Fairy, thy scorn!"
When lo! from a chasm wide-yawning there came
A light, tiny chariot of rose-colored flame,
 By a team of ten glowworms upborne.

Enthroned in the midst on an emerald bright,
 Fair Geraldine sat without peer;
Her robe was a gleam of the first blush of light,
And her mantle the fleece of a noon-cloud white,
 And a beam of the moon was her spear.

In an accent that stole on the still, charmèd air
 Like the first gentle language of Eve,
Thus spake from her chariot the Fairy so fair: —
" I come at thy call, — but, O Paint-King, beware,
 Beware if again you deceive!"

" 'T is true," said the monster, "thou queen of my heart,
 Thy portrait I oft have essayed;
Yet ne'er to the canvas could I with my art
The least of thy wonderful beauties impart;
 And my failure with scorn you repaid.

" Now I swear by the light of the Comet-King's tail,"
 And he towered with pride as he spoke,
" If again with these magical colors I fail,
The crater of Etna shall hence be my jail,
 And my food shall be sulphur and smoke.

" But if I succeed, then, O fair Geraldine!
 Thy promise with justice I claim,
And thou, queen of Fairies, shalt ever be mine,
The bride of my bed; and thy portrait divine
 Shall fill all the earth with my fame."

He spake; when, behold, the fair Geraldine's form
 On the canvas enchantingly glowed;
His touches, — they flew like the leaves in a storm;
And the pure, pearly white and the carnation warm
 Contending in harmony flowed.

And now did the portrait a twin-sister seem
 To the figure of Geraldine fair:
With the same sweet expression did faithfully teem
Each muscle, each feature; in short, not a gleam
 Was lost of her beautiful hair.

'T was the Fairy herself! but, alas, her blue eyes
　　Still a pupil did ruefully lack;
And who shall describe the terrific surprise
That seized the Paint-King when, behold, he descries
　　Not a speck on his palette of black!

" I am lost!" said the fiend, and he shook like a leaf;
　　When, casting his eyes to the ground,
He saw the lost pupils of Ellen, with grief,
In the jaws of a mouse, and the sly little thief
　　Whisk away from his sight with a bound.

" I am lost!" said the Fiend, and he fell like a stone;
　　Then rising the Fairy in ire
With a touch of her finger she loosened her zone,
(While the limbs on the wall gave a terrible groan,)
　　And she swelled to a column of fire.

Her spear now a thunderbolt flashed in the air,
　　And sulphur the vault filled around:
She smote the grim monster; and now by the hair
High-lifting, she hurled him in speechless despair
　　Down the depths of the chasm profound.

Then over the picture thrice waving her spear,
　　" Come forth!" said the good Geraldine;
When, behold, from the canvas descending, appear
Fair Ellen, in person more lovely than e'er,
　　With grace more than ever divine!

MYRTILLA.

ADDRESSED TO A LADY, WHO LAMENTED THAT SHE HAD NEVER BEEN
IN LOVE.

" Al nuovo giorno
Pietosa man mi sollevò." — METASTASIO.

" Ah me! how sad," Myrtilla cried,
 " To waste alone my years!"
While o'er a streamlet's flowery side
She pensive hung, and watched the tide
 That dimpled with her tears.

" The world, though oft to merit blind,
 Alas! I cannot blame;
For they have oft the knee inclined,
And poured the sigh, — but, like the wind
 Of winter, cold it came.

" Ah no! neglect I cannot rue."
 Then o'er the limpid stream
She cast her eyes of ether blue;
Her watery eyes looked up to view
 Their lovelier parents' beam.

And ever as the sad lament
 Would thus her lips divide,
Her lips, like sister roses bent
By passing gales, elastic sent
 Their blushes from the tide.

While mournful o'er her pictured face
 Did then her glances steal,
She seemed, she thought, a marble Grace,
To enslave with love the human race,
 But ne'er that love to feel.

" Ah, what avail those eyes replete
 With charms without a name!
Alas! no kindred rays they meet,
To kindle by collision sweet
 Of mutual love the flame!

" O, 't is the worst of cruel things,
 This solitary state!
Yon bird that trims his purple wings,
As on the bending bough he swings,
 Prepares to join his mate.

" The little glowworm sheds her light, —
 Nor sheds her light in vain, —
That still her tiny lover's sight
Amid the darkness of the night
 May trace her o'er the plain.

" All living nature seems to move
 By sympathy divine, —
The sea, the earth, the air above;
As if one universal love
 Did all their hearts entwine!

" My heart alone of all my kind
 No love can ever warm:
That only can resemblance find
With waste Arabia, where the wind
 Ne'er breathes on human form;

" A blank, embodied space, that knows
 No changes in its reign,
Save when the fierce tornado throws
Its barren sands, like drifted snows,
 In ridges o'er the plain."

Thus plained the maid; and now her eyes
 Slow lifting from the tide,
Their liquid orbs with sweet surprise
A youth beheld in ecstasies,
 Mute standing by her side.

" Forbear, O lovely maid, forbear!"
 The youth enamoured cried,
" Nor with Arabia's waste compare
The heart of one so young and fair,
 To every charm allied.

23

" Or, if Arabia, — rather say,
　　Where some delicious spring
Remurmurs to the leaves that play
'Mid palm and date and floweret gay
　　On zephyr's frolic wing.

" And now, methinks, I cannot deem
　　The picture else but true ;
For I a wandering traveller seem
O'er life's drear waste, without a gleam
　　Of hope, — if not in *you*."

Thus spake the youth ; and then his tongue
　　Such converse sweet distilled,
It seemed, as on his words she hung,
As though a heavenly spirit sung,
　　And all her soul he filled.

He told her of his cruel fate,
　　Condemned alone to rove
From infancy to man's estate,
Though courted by the fair and great,
　　Yet never once to love.

And then from many a poet's page
　　The blest reverse he proved, —
How sweet to pass life's pilgrimage,
From purple youth to sere old age,
　　Aye loving and beloved !

Here ceased the youth; but still his words
 Did o'er her fancy play;
They seemed the matin-song of birds,
Or like the distant low of herds
 That welcomes in the day.

The sympathetic chord she feels
 Soft thrilling in her soul;
And, as the sweet vibration steals
Through every vein, in tender peals
 She seems to hear it roll.

Her altered heart, of late so drear,
 Then seemed a faery land,
Where Nymphs and rosy Loves appear
On margin green of fountain clear,
 And frolic hand in hand.

But who shall paint her crimson blush,
 Nor think his hand of stone,
As now the secret with a flush
Did o'er her aching senses rush, —
 Her heart was not her own!

The happy Lindor, with a look
 That every hope confessed,
Her glowing hand exulting took,
And pressed it, as she fearful shook,
 In silence to his breast.

Myrtilla felt the spreading flame,
 Yet knew not how to chide;
So sweet it mantled o'er her frame,
That, with a smile of pride and shame,
 She owned herself his bride.

No longer, then, ye fair, complain,
 And call the Fates unkind;
The high, the low, the meek, the vain,
Shall each a sympathetic swain,
 Another *self*, shall find.

TO A LADY,

O, CENSURE not the Poet's art,
Nor think it chills the feeling heart
 To love the gentle Muses.
Can that which in a stone or flower,
As if by transmigrating power,
 His generous soul infuses; —

Can that for social joys impair
The heart that like the liberal air
 All Nature's self embraces;
That in the cold Norwegian main,
Or 'mid the tropic hurricane,
 Her varied beauty traces;

That in her meanest work can find
A fitness and a grace combined
 In blest, harmonious union;

23 *

That even with the cricket holds,
As if by sympathy of souls,
 Mysterious communion;—

Can that with sordid selfishness
His wide-expanded heart impress,
 Whose consciousness is loving,—
Who, giving life to all he spies,
His joyous being multiplies,
 In youthfulness improving?

O Lady, then, fair queen of earth,
Thou loveliest of mortal birth,
 Spurn not thy truest lover;
Nor censure *him* whose keener sense
Can feel thy magic influence
 Where naught the world discover;—

Whose eye on that bewitching face
Can every source unnumbered trace
 Of germinating blisses;
See Sylphids o'er thy forehead weave
The lily-fibred film, and leave
 It fixed with honeyed kisses;

While some within thy liquid eyes,
Like minnows of a thousand dyes
 Through lucid waters glancing,
In busy motion to and fro,
The gems of diamond-beetles sow,
 Their lustre thus enhancing;

Here some, their little vases filled
With blushes for thy cheek distilled
 From roses newly blowing,
Each tiny thirsting pore supply,
And some in q᠁ ᠁k succession by
 The down of peaches strowing;

There others who from hanging bell
Of cowslip caught the dew that fell
 While yet the day was breaking,
And o'er thy pouting lips diffuse
The tincture, — still its glowing hues
 Of purple morn partaking;

Here some, that in the petals pressed
Of humid honeysuckles rest,
 From nightly fog defended,
Flutter their fragrant wings between,
Like humming-birds that scarce are seen,
 They seem with air so blended;

While some, in equal clusters knit,
On either side in circles flit,
 Like bees in April swarming,
Their tiny weight each other lend,
And force the yielding cheek to bend,
 Thy laughing dimples forming.

Nor, Lady, think the Poet's eye
Can only outward charms espy,
 Thy form alone adoring. —

Ah, Lady, no; though fair they be,
Yet he a fairer sight may see,
 Thy lovely *soul* exploring:

And, while from part to part it flies
The gentle Spirit he descries,
 Through every line pursuing;
And feels upon his nature shower
That pure, that humanizing power,
 Which raises by subduing.

SONNET

ON A FALLING GROUP IN THE LAST JUDGMENT OF MICHAEL ANGELO,
IN THE CAPPELLA SISTINA.

How vast, how dread, o'erwhelming, is the thought
Of space interminable! to the soul
A circling weight that crushes into naught
Her mighty faculties! a wondrous whole,
Without or parts, beginning, or an end!
How fearful, then, on desperate wings to send
The fancy e'en amid the waste profound!
Yet, born as if all daring to astound,
Thy giant hand, O Angelo, hath hurled
E'en human forms, with all their mortal weight,
Down the dread void, — fall endless as their fate!
Already now they seem from world to world
For ages thrown; yet doomed, another past,
Another still to reach, nor e'er to reach the last!

SONNET

ON THE GROUP OF THE THREE ANGELS BEFORE THE TENT OF ABRA-
HAM, BY RAFFAELLE, IN THE VATICAN.

O, NOW I feel as though another sense,
From heaven descending, had informed my soul;
I feel the pleasurable, full control
Of Grace, harmonious, boundless, and intense.
In thee, celestial Group, embodied lives
The subtile mystery, that speaking gives
Itself resolved; the essences combined
Of Motion ceaseless, Unity complete.
Borne like a leaf by some soft eddying wind,
Mine eyes, impelled as by enchantment sweet,
From part to part with circling motion rove,
Yet seem unconscious of the power to move;
From line to line through endless changes run,
O'er countless shapes, yet seem to gaze on One.

SONNET

ON SEEING THE PICTURE OF ÆOLUS BY PELLIGRINO TIBALDI, IN THE
INSTITUTE AT BOLOGNA.

FULL well, Tibaldi, did thy kindred mind
The mighty spell of Buonarroti own.
Like one who, reading magic words, receives
The gift of intercourse with worlds unknown,
'T was thine, deciphering Nature's mystic leaves,
To hold strange converse with the viewless wind;
To see the Spirits, in embodied forms,
Of gales and whirlwinds, hurricanes and storms.
For, lo! obedient to thy bidding, teems
Fierce into shape their stern, relentless Lord:
His form of motion ever-restless seems;
Or, if to rest inclined his turbid soul,
On Hecla's top to stretch, and give the word
To subject Winds that sweep the desert pole.

SONNET

ON REMBRANDT; OCCASIONED BY HIS PICTURE OF JACOB'S DREAM.

As in that twilight, superstitious age
When all beyond the narrow grasp of mind
Seemed fraught with meanings of supernal kind,
When e'en the learned, philosophic sage,
Wont with the stars through boundless space to range,
Listened with reverence to the changeling's tale; —
E'en so, thou strangest of all beings strange!
E'en so thy visionary scenes I hail;
That, like the rambling of an idiot's speech,
No image giving of a thing on earth,
Nor thought significant in Reason's reach,
Yet in their random shadowings give birth
To thoughts and things from other worlds that come,
And fill the soul, and strike the reason dumb.

SONNET

ON THE LUXEMBOURG GALLERY.

———————

THERE is a charm no vulgar mind can reach,
No critic thwart, no mighty master teach;
A charm how mingled of the good and ill!
Yet still so mingled that the mystic whole
Shall captive hold the struggling gazer's will,
Till vanquished reason own its full control.
And such, O Rubens, thy mysterious art,
The charm that vexes, yet enslaves the heart!
Thy lawless style, from timid systems free,
Impetuous rolling like a troubled sea,
High o'er the rocks of reason's lofty verge
Impending hangs; yet, ere the foaming surge
Breaks o'er the bound, the refluent ebb of taste
Back from the shore impels the watery waste.

24

SONNET

TO MY VENERABLE FRIEND, THE PRESIDENT OF THE ROYAL ACADEMY.

FROM one unused in pomp of words to raise
A courtly monument of empty praise,
Where self, transpiring through the flimsy pile,
Betrays the builder's ostentatious guile,
Accept, O West, these unaffected lays,
Which genius claims and grateful justice pays.
Still green in age, thy vigorous powers impart
The youthful freshness of a blameless heart:
For thine, unaided by another's pain,
The wiles of envy, or the sordid train
Of selfishness, has been the manly race
Of one who felt the purifying grace
Of honest fame; nor found the effort vain
E'en for itself to love thy soul-ennobling art.

THE MAD LOVER

STAY, gentle stranger, softly tread!
　O, trouble not this hallowed heap!
Vile Envy says my Julia 's dead;
　But Envy thus will never sleep.

Ye creeping Zephyrs, hist you, pray,
　Nor press so hard yon withered leaves;
For Julia sleeps beneath this clay, —
　Nay, feel it, how her bosom heaves!

O, she was purer than the stream
　That saw the first-created morn;
Her words were like a sick man's dream
　That nerves with health a heart forlorn.

And who their lot would hapless deem,
　Those lovely, speaking lips to view, —
That light between, like rays that beam
　Through sister clouds of rosy hue?

Yet these were to her fairer soul
 But as yon opening clouds on high
To glorious worlds that o'er them roll,
 The portals to a brighter sky.

And shall the glutton worm defile
 This spotless tenement of love,
That like a playful infant's smile
 Seemed born of purest light above?

And yet I saw the sable pall
 Dark-trailing o'er the broken ground, —
The earth did on her coffin fall, —
 I heard the heavy, hollow sound.

Avaunt, thou Fiend! nor tempt my brain
 With thoughts of madness brought from hell!
No woe like this of all her train
 Has Memory in her blackest cell.

'T is all a tale of fiendish art, —
 Thou com'st, my love, to prove it so!
I 'll press thy hand upon my heart, —
 It chills me like a hand of snow!

Thine eyes are glazed, thy cheeks are pale,
 Thy lips are livid, and thy breath
Too truly tells the dreadful tale, —
 Thou comest from the house of death!

O, speak, beloved! lest I rave;
 The fatal truth I 'll bravely meet,
And I will follow to the grave,
 And wrap me in thy winding-sheet.

24 *

FIRST LOVE.

A BALLAD.*

Ah me! how hard the task to bear,
 The weight of ills we know!
But harder still to dry the tear
 That mourns a nameless woe.

If by the side of Lucy's wheel
 I sit to see her spin,
My head around begins to reel,
 My heart to beat within.

Or when on harvest holiday
 I lead the dance along,
If Lucy chance to cross my way,
 So sure she leads me wrong.

* This and the two following ballads were written at a very early age,
and have already appeared in some of the periodical works of their day.

If I attempt the pipe to play,
 And catch my Lucy's eye,
The trembling music dies away,
 And melts into a sigh.

Where'er I go, where'er I turn,
 If Lucy there be found,
I seem to shiver, yet I burn, —
 My head goes swimming round.

I cannot bear to see her smile,
 Unless she smile on me;
And if she frown, I sigh the while,
 But know not whence it be.

Ah, what have I to Lucy done
 To cause me so much stir?
From rising to the setting sun
 I sigh and think of her.

In vain I strive to join the throng
 In social mirth and ease;
Now lonely woods I stray among,
 For only woods can please.

Ah me! this restless heart I fear
 Will never be at rest,
Till Lucy cease to live, or tear
 Her image from my breast.

THE COMPLAINT.

"O, HAD I Colin's winning ease,"
 Said Lindor with a sigh,
"So carelessly ordained to please,
 I'd every care defy.

"If Colin but for Daphne's hair
 A simple garland weave,
He gives it with so sweet an air
 He seems a crown to give.

"But, though I cull the fairest flower
 That decks the breast of spring,
And posies from the woodland bower
 For Daphne's bosom bring,

"When I attempt to give the fair,
 With many a speech in store,
My half-formed words dissolve in air,
 I blush, and dare no more.

" And shall I, then, expect a smile
 From Daphne on my love,
When every word and look the while
 My clownish weakness prove?

" Oft at the close of summer day,
 When Daphne wandered by,
I 've left my little flock astray,
 And followed with a sigh.

" Yet, fearing to approach too near,
 I lingered far behind;
And, lest my step should reach her ear,
 I shook at every wind.

" How happy, then, must Colin be,
 Who never knew this fear, —
Whose sweet address at liberty
 Commands the fair one's ear!

" A smile, a tear, a word, a sigh,
 Stand ready at his call;
In me unknown they live and die,
 Who have and feel them all."

Ah, simple swain, how little knows
 The love-sick mind to scan
Those gifts which real love bestows
 To mark the favored man!

Secure, let fluent parrots feign
 The music of the dove;
'T is only in the eye may reign
 The eloquence of love.

WILL, THE MANIAC.

A BALLAD.

Hark! what wild sound is on the breeze?
 'T is Will, at evening fall
Who sings to yonder waving trees,
 That shade his prison-wall.

Poor Will was once the gayest swain
 At village dance was seen;
No freer heart of wicked stain
 E'er tripped the moonlight green.

His flock was all his humble pride,
 A finer ne'er was shorn;
And only when a lambkin died
 Had Will a cause to mourn.

But now poor William's brain is turned,
 He knows no more his flock;
For when I asked " if them he mourned,"
 He mocked the village cock.

No, William does not mourn his fold,
 Though tenantless and drear ;
Some say, a love he never told
 Did crush his heart with fear.

And she, 't is said, for whom he pined
 Was heiress of the land,
A lovely lady, pure of mind,
 Of open heart and hand.

And others tell, as *how* he strove
 To win the noble fair,
Who, scornful, jeered his simple love,
 And left him to despair.

Will wandered then amid the rocks
 Through all the livelong day,
And oft would creep where bursting shocks
 Had rent the earth away.

He loved to delve the darksome dell,
 Where never pierced a ray,
There to the wailing night-bird tell,
 " How love was turned to clay."

And oft upon yon craggy mount,
 Where threatening cliffs hang high,
Have I observed him stop to count
 With fixless stare the sky ;

Then to himself, in murmurs low,
 Repeating, as he wound
Along the mountain's woody brow,
 Till lost was every sound.

But soon he went so wild astray,
 His kindred ached to see;
And now, secluded from the day,
 In yonder cell is he.

25

AMERICA TO GREAT BRITAIN.*

ALL hail! thou noble land,
 Our Fathers' native soil!
O, stretch thy mighty hand,
 Gigantic grown by toil,
O'er the vast Atlantic wave to our shore!
 For thou with magic might
 Canst reach to where the light
 Of Phœbus travels bright
 The world o'er!

The Genius of our clime,
 From his pine-embattled steep,
Shall hail the guest sublime;
 While the Tritons of the deep

* Written in America, in the year 1810, and in 1817 inserted by Coleridge in the first edition of his "Sibylline Leaves," with the following note: — "This poem, written by an American gentleman, a valued and dear friend, I communicate to the reader for its moral, no less than its poetic spirit." — *Editor.*

With their conchs the kindred league shall proclaim.
 Then let the world combine, —
 O'er the main our naval line
 Like the milky-way shall shine
 Bright in fame!

 Though ages long have past
 Since our Fathers left their home,
 Their pilot in the blast,
 O'er untravelled seas to roam,
Yet lives the blood of England in our veins!
 And shall we not proclaim
 That blood of honest fame
 Which no tyranny can tame
 By its chains?

 While the language free and bold
 Which the Bard of Avon sung,
 In which our Milton told
 How the vault of heaven rung
When Satan, blasted, fell with his host; —
 While this, with reverence meet,
 Ten thousand echoes greet,
 From rock to rock repeat
 Round our coast; —

 While the manners, while the arts,
 That mould a nation's soul,
 Still cling around our hearts, —
 Between let Ocean roll,

Our joint communion breaking with the Sun:
 Yet still from either beach
 The voice of blood shall reach,
 More audible than speech,
 " We are One." *

 * *Note by the Author.* — This alludes merely to the moral union of the two countries. The author would not have it supposed that the tribute of respect, offered in these stanzas to the land of his ancestors, would be paid by him, if at the expense of the independence of that which gave him birth.

WRITTEN IN SPRING.*

THIS gentle breath which eddies round my cheek,—
 This respiration of the waking spring,—
How eloquently sweet it seems to speak
 Of hope and joy to every living thing!
To every?—No, it speaks not thus to all
 Alike of hope; where misery gnaws the heart,
Her gentle breathings on the senses fall
 Like hateful thoughts that make the memory start.
The soul grows selfish where enjoyment flies,
 And, loathing, curses what it cannot taste;
This glorious sun, and yon blue, blessed skies,
 And this green earth, but tell him of the past;
The frightful past, that other name for death,
 That, when recalled, like mocking spectres come,—
In forms of life, without the living breath,
 Like things that speak, yet organless and dumb!
For all that seems in this fair world to live,
 To live to man, must catch the quickening ray

* First printed in 1821, in "The Idle Man." No. I , p. 54.

25 *

From man's free soul; and they but freely give
 Back unto him the life he gave; for they
Are dead to him who lives not unto them.
 But unto him, whose happy soul reposes
In love's sweet dream, how exquisite a gem
 Seems every dewdrop on these budding roses!
The humblest plant that sprouts beneath his feet,
 The ragged brier, nay, e'en the common grass,
Within that soul a kindred image meet,
 As if reflected from an answering glass.
And how they seem by sympathy to lend
 Their youthful freshness to each rising thought,
As if the mind had just begun to send
 Her faculties abroad, uncurbed, untaught,
From all in nature beautiful and fair
 To build her splendid fabrics, while the heart,
Itself deluding, seems by magic rare
 To give a substance to each airy part.
Sweet age of first impressions! free and light!
 When all the senses, like triumphal ports,
Did let into the soul, by day, by night,
 The gorgeous pageants pouring from the courts
Of Nature's vast dominions! — substance then
 To the heart's faith; but, now that youth's bright dawn
No longer shines, they flit like shadowy men
 That walk on ceilings; for the light is gone!
Yet no, — not gone; for unto him that loves,
 The heart is youthful and the faith is strong;
And be it love, or be it youth, that moves
 The soul to joy, that light will live as long.
And, O, how blest this kind reacting law,
 That the young heart, with Nature's beauties glowing,

Should need, in all it felt, in all it saw,
 Another heart to share its overflowing;
While he that feels the pure expansive power
 Of joyous love, must pour his feelings forth
On every tree, and herb, and fragrant flower,
 And all that grows upon the beauteous earth.

THE ANGEL AND THE NIGHTINGALE.

"To him that hath shall be given."

PART I.

In days long past, within a lonely wood,
Far from the sound of levelling axe, there stood
A stately Oak, that seemed itself a grove;
And near it grew, entwining shade with shade,
A slender Ash, that with his branches played,
Though oft at noon, all-motionless with love,
'T would lean upon his breast, as 't were a gentle maid.

And swift beneath a little brook there ran,
Like some wild creature from the face of man,
So swiftly did it run with smothered voice;
Nor ever was it heard, save only where
Some thwarting pebble sent upon the air
Its tiny moan; or when 't was wont rejoice
For wandering root o'erleaped, that checked its scared
career.

But near these loving trees no other grew;
For, made as if for love, kind Nature threw
Around them far a zone of soft, white sand,
Whose very touch nor plant nor hardy brier
Might e'er abide, so scorching was the fire
That lurked within; yet round this charmèd band
Still many a tree and shrub would press, in strange desire.

In sooth it was a rare and lovely sight,
This quiet sylvan moon, so meekly bright;
For such might seem to musing bard the scene;
A spot where Peace, with all her gentle train
Of blending sympathies, might ever reign:
And cold were he on whom its dreamy sheen
Within that dark green wood shall ever fall in vain.

Nor unbeloved was this secluded place
By some of better world and higher race.
And here, 't was said, a heavenly Stranger came,
If haply he might find some heart content
With Nature's will; that would not murmur vent
For boon withheld of beauty or of fame,
Or pine for aught of good to other creatures sent.

Beneath that stately Oak this Stranger kept
His daily watch, and there, too, had he slept,
The Ash had fanned the nightly mist away.
But not, as we, do Spirits need that charm,
That sweet self-losing, that doth oft disarm
The robber grief, bid misery gaunt be gay,
And hate, that cold heart-worm, make powerless to
 harm.

Such self-oblivion would not him beseem,
Of whose least passing thought no youthful dream
Of man's Elysium might an image give.
The Good and Beautiful in him were joined;
Their conscious union made his happy mind;
And, ever as they moved, fair forms would live,
And sweet according sounds through all his being wind.

'T was on a soft June evening, — when the sun
Was just below the wood, and, one by one,
Seemed through the trees to call his wandering rays, —
That two young Birds, within a hazel-bush,
This converse held. Said one, a lively Thrush, —
" I hardly may deserve this strain of praise;
Such praise, were I a maid, would surely make me blush;

" 'T is verily too high," — and here she ducked
Her pretty head beneath a wing, and clucked
Like to a timid hen, — " too high indeed
From one of lineage so renowned in song;
Though thou, I must confess, dost scarce belong
To that proud race, that rarely deign to heed
Aught but their own vain throats, though ne'er so sweet
 or strong."

" Nay," said a gentle voice, whose gurgling tone
None but the Nightingale might ever own,
" My praise is just: nor can I well divine
Why my own native gift should make me blind
To other gifts, though differing wide in kind.
'T were to be poor indeed, if but in mine
My solitary heart may pleasure never find.

" And much I marvel if, in truth, there be
A heart so stricken with its own. For me, —
O, what a prison-house such narrow doom!
I know not why, — but peace within me dwells
Whene'er I hear yon distant chiming bells,
That have no life ; nor comes there aught of gloom,
If heard the runnel's song, within the darkest dells.

" But when from living creatures warm with blood,
When from the countless tribes that haunt this wood,
The morning song of waking joy goes up,
O, how doth leap my pulse, my spirits bound!
The many-mingled notes one only sound
Send to my heart, — as gathered in a drop, —
From swift, high-soaring larks' to sparrows' on the
 ground."

" I 'll seek no more," the Stranger said in thought;
" In this sweet Bird is all that I have sought."
And then — so willed he in his heavenly mind —
The little, wondering Bird before him flew,
And, fluttering round and round, her wonder grew
To see his wings, now floating on the wind,
And now to air exhaled and mingled with its blue.

And then she marvelled at his waving locks,
That gleamed like sunshine over running brooks.
But, when upon her turned his lustrous eyes,
With silent awe she seemed transfixed to stand,
The while she felt her little breast expand
As if with something that would reach the skies, —
So full they were of love, so beautifully bland.

" Sweet Bird of eve, thy fate is now with me,
And thou my chosen Bird henceforth shalt be;
And I will bless thee. But I may not say
Why thus I choose thee; for a virtue eyed
Too often in the heart may turn to pride,
And then with cold self-love that heart betray
To hard, contracting thoughts, that curse where they
 abide."

So spake the guardian Angel; then aloft
His wings, now visible, with heaving soft,
That made mysterious music, fanned the air,
And now the clouds, self-parting, downward sent
A rosy dew, that all the earth besprent;
While, upward as he passed, the stars did wear
A thousand gorgeous hues that from his glory went.

" No, never," said the Bird, " may thought of pride
This glorious Being from my fate divide;
But rather let my heart still humbler be,
That one so high should deign a thought bestow
On one so poor: and this alone to know,
Betide what may, were bliss enough for me.
O, how with such a boon can mix a passion low!"

And now, as one by crowding joys oppressed,
The happy Bird in silence sought her nest,
That lay embosomed in the spreading Oak.
Then, O, how sweetly closed — like closing flowers
That fold their petals from the nightly showers —
Her senses all! Nor aught their slumber broke
Till came the sun betimes to wake the morning hours.

PART II.

In childhood's dawn what bliss it is to live,
To breathe, to move, and to the senses give
Their first fresh travel o'er this glorious Earth!
Yet still of earth we seem, and all we see
But kindred things in other shapes to be;
Nor knows the soul her own distinctive birth
Till some deep inward joy from sense hath made her
 free.

And, when in after years she feels the press
From things without, — and not as once to bless,
But forming bondage, while the quick, sore sense
Of freedom still survives, — O, then, how sweet
Again within one pure heart-joy to greet,
And feel it cause our very bonds dispense
Harmonious thoughts, that make the Soul and world to
 meet!

E'en such the charm the Angel's parting word
Left in the bosom of our gentle Bird.
And, though too blest her morn of life had been
To know of clouding grief one fleeting shade,
Yet, O, in what surpassing light arrayed
Seemed nature now! 'T was but the light within
That ever from the heart on all around her played.
 26

She loved the world so lovely she had made,
And well the grateful world the gift repaid:
Its all was hers; for e'en the tiny moan
That came so faintly from the brook beneath
Now seemed her breast to heave, and forth to breathe,
And blend in deeper sadness with her own.
No, never round the heart did sadder murmur wreathe.

So time went on, and tributary strains
From hill and dale, and from the breezy plains,
Came pouring all, to lose themselves in her.
Then, lost in ecstasy, how all night long
Her own sweet tribe would sit to hear her song!
Sure ne'er was known such soul-dissolving stir
In soft Italia's courts, her melting race among.

Then went her fame abroad; and from the sea,
And from the far-off isles, wherever tree
Gave shelter to the wing, — from every clime
Endeared to bird, or where the spicy grove
Embalms the gale, or where, the clouds above,
The mountain pine stands sentry over time, —
The wingèd pilgrims came, — for fashion, or for love.

And now the wondering moon would see her light
Flash on the eagle in his downward flight,
Bending his conquered majesty to Song;
And then afar along the snowy host
Of albatross, from off the stormy coast
Of dreary Horn, that veered the clouds among,
Like to a gallant fleet by ocean-tempest tost;

And then it seemed, in one vast, jaggèd sheet,
Some rising thunder-cloud's broad breast to meet,
Upheaving heavily above the sea ;
But soon the seeming tempest nearer drew ;
And then it broke : then how his files to view
The Western chieftain wheeled, — how loftily ! —
The mighty wingèd prince, the condor of Peru.

But who describe the ever-growing throng,
Of warring note and plume, that poured along
The tracts of air ; or how the welkin rung,
As onward, like the crackling rush of flame,
With flap, and whiz, and whirr of wings, they came ?
But hushed again was all ; nor wing nor tongue
Stirred in the charmèd air that breathed the Bird of
 fame.

Nor easy were the task in words to paint
The congregated mass, of forms so quaint,
So wild and fierce and beautiful, that now,
Together mixed, o'erspread the enchanted wood.
Suffice to say, that gentler crowd ne'er stood
In princely hall, where all is smile and bow.
In sooth, our polished birds were quite as true and good.

As if of ancient feud each breast bereft,
Or haply each at home its feud had left,
A high-bred sympathy here seemed to wend
Its oily way, and, like a summer stream,
Made all that on it looked more lovely seem.
So all were pleased, as gently each did bend
To see so smooth and bright his mirrored image beam.

Then side by side were seen the tiny form
Of wizard petrel, brewer of the storm,
And giant ostrich from Zahara's plain;
Next the fierce hawk, the robber of the skies,
With gentle dove, of soft, beseeching eyes;
And there, from Belgian fen, the bowing crane,
And dainty Eastern queen, the bird of Paradise.

Yet one there was that seemed with none to pair,
But rather like a flower that grew in air,
Which ever and anon, as there it stood,
Would ope its petal to the passing gale,
And then, with fitful gleam, its hues exhale, —
The little humming-bird. So Fortune wooed
Seems to the dreaming Bard; so bright, — so dim, — so
 frail!

'T was passing faith, I ween, such sight to see, —
These strange and motley tribes as one agree;
But one the power that hither bade them hie, —
The magic power of Song: though some would fain
The motive deem but hope of fame to gain
For taste refined; — and what beneath the sky
Could harden e'er the heart to self-applauding strain?

Ah, darling self! what transformations come
Aye at thy bidding, — eloquent or dumb,
Or loose or pure, as might beseem the time!
E'en as with man, in purple or in cowl,
So with the feathered race: hence many an owl
Hath doffed his mousing mien for look sublime,
And ruffian vulture smoothed to peace his bloody scowl.

PART III.

Who reaches fame attains that dizzy height
Where seldom foot is sure, or sure the sight:
So runs the adage. Yet we deem not so.
Who reach it worthily still higher aim,
And, looking upward, steadfast stand the same.
But woe to him, self-pleased, who looks below,
To measure in his pride the fearful way he came!

And what is genius but the gift to see
Supernal Excellence, that aye doth flee
The grasp of man, yet ever still in view
To lead him on, revealing as it flies
Ideal forms, at every step that rise
And crowd his path with beauty ever new?
O, who of self could think with these before his eyes?

No, — rather would he deem a thing of clay
Were thus too blest to dream itself away.
So felt our favored Bird, so passed her days,
Nor e'en did fame one anxious thought awake;
She prized it never for its own vain sake;
Yet well she loved at that pure fount of praise,
A sympathizing heart, her nature's thirst to slake.

26 *

And, truth to say, her gentle spirit rose
And grew in strength from each applauded close.
Ah no! not hers the art, — if such there be, —
Herself unmoved, another's breast to sway:
And well she proved that truth will truth repay,
As now to hers, as 't were a mighty sea,
A thousand heaving hearts sent up their joyous spray.

Now from his throne of light the Angel bent
Towards Earth his ear, if unaware were blent
In these applauded strains one gush of pride.
And then he smiled, as angels on a child
Are wont to smile; upon her heart he smiled;
For, no, not one small spot was there descried,
Left by the breath of praise, — so treacherously mild.

Well pleased he saw, unsoiled of earthly stain,
His high creative gift still pure remain,
E'en as he gave it from the world above;
For he had marked her in her glory's blaze,
And seen the grateful Bird to heaven upraise
Her glittering eyes, in meek, adoring love:
And well in them he read, " No, never mine the
 praise."

" Thus far, sweet Bird, thy life of joy is pure.
'T is now thy lot to suffer and endure;
For now await thee other scenes, to try
And prove thee true. But Love the change ordains,
That Love that never sleeps where Evil reigns,
Bending his hateful rule to purpose high,
Till, sin by sin consumed, the good alone remains."

So, musing, spake in thought her Angel friend.
And now again to Earth our course we bend.
But here, alas! in silent pain awhile
Our tale would pause; for sad it were to trace
The fall of greatness in our human race,
But sadder here, where no ambitious guile,
Or thought of glory won by others' loss, had place.

'T were but to tell how troop by troop fell off
Of courtly friends, with loud and open scoff,
Or secret sneer, the vice of meaner heart;
The envious these. But most, they knew not why,
Went as they came, or else to roll the eye
As others did, or play the patron's part,
And buy at second hand cheap immortality.

Yet some there were, — a scattered, kindly few,
Who felt, and loved, the beautiful and true, —
Awhile did linger in the saddened wood,
Where now nor song, nor other sound, was heard,
Save when the night-hawk thro' the darkness whirred.
At length 'gan these to pine for present good,
And left, as in the past, our solitary Bird.

But whence the change? Some unknown **Power**,
 't is said,
And strong as dark, had on her fortunes laid
His fatal ban, that daily seemed to drain
The fountain of her song, till all was still; —
E'en as the sandy grave of some small rill,
Erewhile a mighty stream, that, towards the main
From mountain torrents sent, would fain its course fulfil.

And soon her fame a cold tradition proved
Of barren words; if ever tongue it moved
Of some kind friend, yet colder grew the heart
That strove in vain its raptures to recall
As when it warmed beneath the magic thrall
Of living sound; 't was but of some vague art
A vaguer chronicle: and so alike to all.

Alas! to think that from the mind should pass,
E'en as an image from the insensate glass,
This all-subduing mystery of Sound,
That with a breath can from our stubborn clay
Set free the Soul, and launch her forth to stray,
With wandering stars, through yon blue depths pro-
 found,
Where blessed spirits bask in empyrean day!

'T is even so; the shadow of a dream
Were sooner held, — doth more substantial seem
Than this celestial trance; as if 't were given,
Not to the Memory in her hoarding pride,
But to the Soul, that, while to earth allied,
Free of its thraldom, she might know of heaven.
Ah, how may trance like this with erring flesh abide?

But did not she, the gentle Bird, repine,
Her glory gone? O, no! " It was not mine,"
Her wise and grateful heart again would say;
" For, were it else, 't were what I might reclaim.
The gift is gone, yet leaves me still the same;
Nay, richer still; and who shall take away
The memory of love, — the love with which it came?"

Thus to herself, in murmurs sweet and low,
Spake the meek-natured Bird, as to and fro
She swung upon the slender, topmost spray
Of that lithe Ash that leaned her nest beside;
While oft the moon, who ne'er did sorrow chide,
In soothing mirth would with her shadow play,
And chase it o'er the sand, or in the forest hide.

The little brook, too, like a lowly friend,
On stilly nights would sometimes humbly send
Its loving plaint: and strange to her it seemed
There came no sadness now in that low wail;
In sooth 't was like some gently-moving tale
Of checkered life, where joy through sadness gleamed,
So tempered each by each that neither might prevail.

And wherefore is it so, that grief to grief
No pang should add, but rather bring relief?
Yet so it is. And, O, how blest to feel
The pure and mystic bond, thus shadowed forth,
That binds us to our kind, — that from our birth
Makes self a prison-house in woe or weal,
And self-sufficing hearts as alien to the Earth!

But chiefly is it blest where virtue dwells,
In kind and gentle hearts; and then it wells,
As 't were a fountain, forth on all around,
So that the woods and fields, and all therein
That breathe or bloom, do seem as if akin,
And man to all one common life had bound.
So to our gentle Bird all nature's self had been.

And now did Nature in return bestow
That healing sympathy which never woe,
So it be innocent, may seek in vain.
" O, never could I in a world so fair,
So full of love, though losing all, despair;
For thou, sweet, loving world, wouldst still remain."
The guardian Angel heard, and blessed again his care.

Still was her humble spirit yet unproved
Of one sore test, which few have stood unmoved, —
That stinging pity which a rival's breath
Drops on the wounded heart. But soon it came.
And now began the Thrush to talk of fame;
Then of its loss, — " how bitter, — worse than death, —
To one who held so late a more than royal name.

" Alas, my friend, as I recall the time
When to our humble plain that name sublime
Drew from each distant land the wondering throng
That hung upon thy breath, and see thee here,
Alone, despised, in this thy hapless sphere
Of fleeting sway, I fain could wish thy song
No praise had ever won, — or praise at least sincere."

So spake the Thrush: but harmless fell the shaft
As shot in air. Yet when did lack in craft
The spirit of revenge? — if haply, too,
Of that rank, morbid growth which jealous minds
Breed as by instinct, where fit weapon finds
Each self-made wrong, as they together grew?
The smooth, dissembling Thrush had these of many
 kinds.

And soon she changed, and spake in blither mood, —
" How pleasant it would be in this lone wood
To hear the converse of some cheerful friends :
And many such she knew, whose chat would cheer
Her dearest friend, — might she invite them here.
 And, troth, she would." So straight aloft she bends
Her charitable flight, and soon is lost in air.

Nor strange the enmity in one so late
A seeming friend. 'T was but the common hate
Which cold, vain hearts deem solace in their need ;
These covet fame as if a thing of will,
By suffrage won ; so count it grievous ill
 If luckier rivals win the voted meed.
Then what but sweet revenge the craving heart can fill ?

Nor aught with such avails a rival's fall, —
Save that he feel it ; then, perchance, the gall
May cease to flow. But, let him brook it well, —
His sad reverse, — as did our gentle Bird,
Without complaining look or fretful word ;
 Then how afresh this bitter spring of hell,
With hotter-reeking hate, to fiercer flow is stirred !

PART IV.

'T was now the hour, — that boding hour of life,
When half-awakened forms of care or strife
Mix with the broken dream, — that shadowy hour,
That like a spectre stands 'twixt night and day,
For good or ill, and with his finger gray
Points to the daily doom no mortal power,
For virtue or for vice, can either change or stay.

And never came that hour more winning mild
To mar the fancies of a sleeping child,
Than now it came to our sweet Philomel.
She looked abroad upon the hueless wood,
Then on the sandy plain, where lately stood
That breathing multitude no tongue could tell;
All, all was still and blank, yet all to her was good.

For e'en the stillness seemed as if a part
Of that pure peace that wrapt her gentle heart.
Then how like thoughts, or rather like the cloud
Of formless feeling growing into thought,
The dusky mass, as now she sees it wrought
Slow into shapes, that all around her crowd,
As each their hue of life from day's first herald caught, —

The purple rack, that from the eastern sky
Tells to the waking earth that day is nigh.
So mused she undepressed in this lone scene.
But now the sun is up; and soon a train,
Led by the wily Thrush, athwart the plain
Is seen to bend. More gorgeous sight, I ween,
Ne'er made the ethereal bow when bent through morn-
 ing rain!

The tenants of the wood what this might mean
Quick gathered round to learn; for they had seen
The stranger band afar, like some gray mist,
Loosed from a mountain peak, wreathing its way
Slow up the west; and there anon to play
As with the sun; now, dark, his light resist,
And now, in flickering flakes, fling far each shivered ray.

These were the creatures of that regal clime
Where reigns the imperial Sun; whose soil sublime
Teems through its glowing depths e'en with his light,
There ripening into gems; the while he dyes,
With his own orient hues, the earth and skies,
But most the feathered race, — that so their flight
Might bring his glory back in radiant sacrifice.

"Behold my promised friends; far travellers they, —
E'en from the new-found world, — who fain would pay
Their passing homage to a Bird so famed."
So spake the insidious Thrush: and then around
Her snaky eyes she cast, as one who found
Full sure revenge. "Nay, wherefore shrink, ashamed
Thy meaner form to show? for what is form to *sound?*"

 27

The taunting words came dead upon the ear
Of her they would have smote; the cruel sneer
Touched not a heart so flooded o'er with love,—
That pure, supernal love which now gushed forth: —
" O blessed creatures! whence your glorious birth ?
From what bright region of the world above?
Sure never things so fair first breathed upon the Earth ! "

So deep, yet passionless, that wondrous love
Which Beauty wakes! Pure Instinct from above!
That, 'mid the selfish needs, and pains, and fears,
That waste the heart, still fresh dost ever live!
O, who can doubt the promise thou dost give
Of higher destiny, — when toiling years
And pain and sin shall flee, and only love survive ?

Scarce had she spoke, when o'er the wondering crowd,
Grazing the dark tree-tops, there stood a cloud
Of dazzling white ; while 'gainst the deep blue sky
Aloft it rose, as 't were some feudal pile,
Where tourneys, held for gentle ladies' smile,
Brought from each polished land her chivalry,
From proud Granada's realm to Britain's gallant isle.

But how unlike to them the radiant throng
That from these cloudy towers poured down their
 song,
Breathing of Heaven in each hallowed word!
" All hail! " they sang, — " all hail, sweet Nightingale!
Who enviest not, who hatest not, all hail!
Who sufferest all, yet lovest all, sweet Bird!
Thy glory here begun shall never, never fail ! "

But, lo! a sudden darkness, deep as night,
Fell on the thick, hot air. With strange affright
The wingèd crowd against each other dashed :
All but our gentle Bird; she fearless stood,
And saw the towery cloud, now changed to blood,
Boil as in wrath; and now with fire it flashed,
And forth the thunder rolled, and shook the appallèd wood.

Then straight again the quiet sylvan scene
Lay bright and basking in the morning sheen ; —
So like a dream had this wild vision fled!
Nor left it aught its fearful truth to note,
Save on the sandy plain one small, dark spot,
Where lay the envious Thrush, — black, stiff, and dead.
Alas, too well deserved her miserable lot!

A cold, brief look was all the useless dead
Had from her parting friends, who forthwith sped
Each to his tropic home. But what befell
Our gentle Bird? Some say her glorious strain
Within that dreadful cloud was heard again,
Deepening the thunder; then afar to swell
'Mid soft, symphonious sounds, like murmurs from the
 main.

Howe'er it was, one faith had all possessed, —
Her spirit then was numbered with the blest.
And still there are who hold a faith as strong,
Though years have passed, far, far upon the drift
Of ebbless time, that some have now the gift
On a still, starlight night to hear her song, —
As 't were their blameless hearts still nearer heaven to lift.

GLORIA MUNDI.

I LOOKED upon the fields so beautifully green,
I looked upon the hills and vale between,
By shade and sunshine flecked with day and night;
 And then I heard the mountain breezes tread
 Their wooded sides, like leafy steps that led
 Down to the broad and blue bright river's bed,
Dwindling in distance to a line of light.
I gazed, and gazed, — till all my senses caught
The earthy charm. Then waked the fevered thought:
" Drink, O my spirit, of thy cup of bliss,
That ne'er can fail thee in a world like this!"

The charm is gone! Ah, wherefore was it sent,
To leave this vague and haunting discontent?
I saw it rise, like moving meadow mists,
 Before my path, as 't were a thing of sight;
 E'en as that vapory sea, drinking the light
 Fresh from the sun, and showering rubies bright
Where'er it breaks, and purple amethysts.

Ay, so it seemed. And then I saw it paled,
Till, like that mimic sea, 't was all exhaled.
Then from her plumbless depth, — to mock the whole, —
Dark in her mystery, came forth the Soul.

And *now*, — O, what to me this marvellous Earth
But one vast show of misery and mirth,
In fearful alternation wheeled through space;
 Where life is death; where the dead dust doth **grow**,
 And push to air, and drink the dew, and blow
 In fragrant flowers, that in their turn re-sow
Their parent soil for some new living race;
Where crumbled sepulchres uprise in thrones,
And gorgeous palaces from dead men's bones;
Where, like the worm, the proudest lips are **fed**,
The delicate, the dainty, on the dead.

Ah, glorious vanity! Ah, worse than vain
To him who counts its whole possession gain,
Or fondly seeks on Earth one point of rest, —
 E'en though it be the imperial house of Fame,
 That still 'mid falling empires stands the same:
 Alas! that house of breath but stays his *name*, —
His restless spirit passes like a guest.
No, — there 's a spark that in the dullest lives;
That *once to all* its light spiritual gives,
Revealing to the soul a void so vast
Not all in time may fill, — not all the past!

And yet there are, who, ever doubting, deem
This inward light the fiction of a dream,
Contemptuous turning to the reasoning day:
27 *

While some with outward things e'en hope to close
The too-obtruding gulf, and buy repose
From ear and eye; or with fantastic shows
In pride of intellect around it play.
Vain toil of unbelief! For who may flee
This fearful warrant of his destiny,
That tracks the royal skeptic to his throne,
Marking his fealty to a world unknown?

O, rather let me, in the void I feel,
With no misgiving seek my lasting weal:
Things blank and imageless in human speech
 Have oft a truth imperative in might;
 And *so* that stream, unnamed, unknown of sight,
 Unheard of ear, that thence doth day and night
Flow on the Soul; and she doth feel it reach
Her deepest seat of life, and knows her home
Is whence that dim, mysterious stream doth come;
Where all without is peace, all peace within, —
A home closed only to the rebel, Sin.

Then be not in me quenched that inward ray,
Shed on my spirit when this moving clay
First took the wondrous gift, its life. O, never
 May things of sense beguile me to the brink
 Of that dark fount of Pride, of which to drink
 Is but to swallow madness, — when to think
Will only be to doubt, till darkness ever
Wall up the soul. But let Humility,
Born of the obedient will, my guide still be
Through this fair world, — though changing, yet how
 fair! —
Till all shall be to me as things that *were.*

THE ATONEMENT.

HOPELESS, alas, of sinful man the lot,
(And who can say of sin, he knows it not?)
If that the thoughts that herald forth the Will
In all their myriad hues may never die!
'T is even so, — with all their good and ill;
For what but they the *Ever-conscious I?*

Then what compunctious, agonizing grief?
Alas! it gives not to the Soul relief,
That in herself no *past* can know; that never
From the "*eternal Now*" one thought can sever.
Ah, no! — no partial suicide may drink
Her least of life whose tenure is to *think.*
What though, as dead, through threescore years and ten
Some evil thought should sleep? there 's no *amen.*
Fresh as new-born that unremembered thought
Again must wake, — nay, even on the brink
Of some far-distant grave, and there its link
Join to the living chain of self, self-wrought,

Which binds the Soul, — her fetter and her life:
Her life the consciousness of fruitless strife.

Ay, such, O Man, thy wretched lot had been
Had He forbade not, — He who knew no sin;
Who to his own, the creatures he had made,
Veiling his empyrean glory, came,
E'en in *their* form; who, not alone in name,
But palpable in flesh, as man, obeyed
The human law; a veritable man;
A second Adam, who again began
The human will, that, to our nature joined,
The obedience of that will should fulness find
In His, the Infinite, uncraving Mind.
O blessed truth! in my soul's need I feel
In thee alone my ever-during weal.
Yet who may hope to reach, or, reached, abide,
Unquenched of life, this awful mystery; —
The sweat of blood, the nameless agony,
That wrought the final doom of Sin and Death,
When tumbled from his throne the Prince of Earth; —
That gave again to Man a sinless birth,
That breathed into his clay a sinless breath?

No, not to me, of mortal mould, is given
To scan the mystery which no eye in heaven,
Attempered to all deepest things, may read.
Yet who shall make me doubt the truth I *need?*
Then down, my Soul! from the four farthest towers
Of the four warring winds, call in thy powers,
Vagrant o'er earth, with all their reasoning pride,
And here beneath the Cross their madness hide;

Down to its kindred dust here cast thy store
Of learned ignorance, to rise no more:
For what may all avail thee, if to thee,
When all of sense like passing air shall flee, —
If to thy dull, sealed ear, come not the cry,
"Where now, O Death, thy sting, O Grave, thy vic-
 tory?"

TO MY SISTER.

LINES SUGGESTED BY THE RECOLLECTION OF A LITTLE BIRD, CARVED
BY THE WRITER, WHEN SIX YEARS OLD, OUT OF A GREEN STALK OF
THE INDIAN CORN, AS A PARTING GIFT TO HIS SISTER.

———————

'T is sad to think, of all the crowded Past,
How small a remnant in the memory lives!
A shadowy mass of shapes at random cast
Wide on a broken sea the image gives
 Of most that we recall.
 Yet, haply, not to all
That once have lived doth wayward Memory close
Her book of life, — or, rather, book of love ;
For there, as quickened by some breath above,
The pure affections must for aye repose.

And how the rudest toys by childhood wrought, —
The symbols of its love, — there live and grow
To classic forms, on which no after thought,
No learned toil, can with its skill bestow
 A truer touch of Art,
 To fix them in the heart!

Then not in vain the gift of little worth,
Thus shadowing to the soul the blessed truth,
That all things pure must needs immortal youth
Hold as their heritage, though born of Earth.

And so, my Sister, doth that childish toy,
Which love for thee had shaped, still with me live ;
The life imparted by the loving Boy
Is truer life than now his Art can give :
 I see its emerald wing,
 Nay, almost hear it sing!
And oft that little vegetable bird
Shall flit between us when we part again;
Its bright, perennial form shall skim the main,
A silent sign, — nor need an uttered word.

SONNET.

THE FRENCH REVOLUTION.

———

The Earth has had her visitation. Like to this
She hath not known, save when the mounting waters
Made of her orb one universal ocean.
For now the Tree that grew in Paradise,
The deadly Tree that first gave Evil motion,
And sent its poison through Earth's sons and daugh-
 ters,
Had struck again its root in every land;
And now its fruit was ripe, — about to fall, —
And now a mighty Kingdom raised the hand,
To pluck and eat. Then from his throne stepped
 forth
The King of Hell, and stood upon the Earth:
But not, as once, upon the Earth to crawl.
A Nation's congregated form he took,
Till, drunk with sin and blood, Earth to her centre shook.

SONNET.

THOUGHT.

WHAT master-voice shall from the dim profound
Of Thought evoke its fearful, mighty Powers? —
Those dread enchanters, whose terrific call
May never be gainsaid; whose wondrous thrall
Alone the Infinite, the Uncreate, may bound;
In whose dark presence e'en the Reason cowers,
Lost in their mystery, e'en while her slaves,
Doing her proud behests. Ay, who to sense
Shall bring them forth? — those subtile Powers that wear
 wear
No shape their own, yet to the mind dispense
All shapes that be. Or who in deepest graves
Seal down the crime which they shall not uptear? —
Those fierce avengers, whom the murdered dead
Shall hear, and follow to the murderer's bed.

28

SONNET.

A SMILE.

A SMILE! — Alas, how oft the lips that bear
This floweret of the soul but give to air,
Like flowering graves, the growth of buried care!
Then drear indeed that miserable heart
Where this last human boon is aye denied!
If such there be, it claims in man no part,
Whose deepest grief has yet a mirthful bride.
For whose so many as the sad man's face?
His joy, though brief, is yet reprieve from woe;
The waters of his life in darkness flow;
Yet, when the accidents of time displace
The cares that vault their channel, and let in
A gleam of day, with what a joyous din
The stream jets out to catch the sunny grace!

SONNET.

ART.

———————

O Art, high gift of Heaven! how oft defamed
When seeming praised! To most a craft that fits,
By dead, prescriptive Rule, the scattered bits
Of gathered knowledge; even so misnamed
By some who would invoke thee; but not so
By him, — the noble Tuscan,* — who gave birth
To forms unseen of man, unknown to Earth,
Now living habitants; he felt the glow
Of thy revealing touch, that brought to view
The invisible Idea; and he knew,
E'en by his inward sense, its form was true:
'T was life to life responding, — highest truth!
So, through Elisha's faith, the Hebrew Youth
Beheld the thin blue air to fiery chariots grow.

* Michael Angelo.

THE CALYCANTHUS.*

INSCRIBED TO MY MOTHER.

A LITTLE Conjurer before me stood.
Upon his head he wore a purple hood;
 And yet no mystic word or sign
 Gave tokens of his wizard power.
 He seemed a modest, pretty Flower, —
 Such as might grace a Poet's line,
Or Painter love in golden locks to wreathe;
Nor seemed he other till my throbbing heart
Felt in his odorous breath his mighty art:
 Such breath can only magic breathe!

Scarce was my spirit of the truth aware
When straight it cleaved a thousand miles of air.
 I trod, methought, my native land;
 Where many a long-forgotten pleasure,

* Written on seeing this favorite flower of my childhood after an interval of many years.

Like many a spendthrift's early treasure,
Lay buried 'neath Time's dropping sand;
That ever-dropping sand that never drifts;
'Though whirlwinds sweep it, still unmoved that piles
Its grain on grain; still climbing up to miles, —
To where not Himalaya lifts.

But Time, with all his load, was then as naught;
The wizard Flower had in my vision wrought
The gift to see through mountain years.
O, then how swift upon me thronging
Came every childish hope and longing,
And causeless smiles, and sunny tears
That fell as if in mockery of grief,
Making their rosy journeys from the eye
In laughing dimples for a while to lie,
Then yield a life as bright as brief!

Again the tiny Artist toiled apart
Beneath that fervid sun, — nor dreamt of Art.
The gay Pomegranate dropped anew, —
As if to tempt his mimic powers, —
Her gold and crimson solid flowers,
That soon to fairy vases grew;
The giant Pine looked down upon the boat
Carved from his bark, and seemed in murmurs hoarse,
But gentle as the Child, to bless its course,
When that the little craft should float.

And then how *long*, how *full of time*, did seem
A single day in this my dreamed-o'er dream!

28 *

For all I saw the teeming mind
Had gifted with some wondrous story;
The aged Oak, whose moss-beard hoary
Waved to the fitful evening wind,
Was but the spirit of some Ogre, bound
In other shape, and doomed, for cruel thirst
Of infant's blood, to quit his form accursed, —
Then rooted to enchanted ground.

Deep mystery! that the Soul, as not content
To see, to hear, should thus her own moods vent, —
Living as 't were in all that lives!
E'en as the ever-changing Ocean,
Whether in calmed rest or motion,
Its own transforming image gives;
Sending its terrors into hearts of stone
Till human wailing swells the dooming roar;
Or, smoothly sleeping near some fearful shore,
Dyes rocks in beauty not their own.

Ah, never will return those loving days,
So loath to part, — those fond, reluctant rays
That seemed to haunt the summer's eve.
And, O, what charm of magic numbers
Can give me back the gentle slumbers
Those weary, happy days did leave,
When by my bed I saw my Mother kneel,
And with her blessing took her nightly kiss?
Whatever Time destroys, he cannot this, —
E'en now that hallowed kiss I feel.

ROSALIE.

" O, POUR upon my soul again
 That sad, unearthly strain,
That seems from other worlds to plain;
Thus falling, falling from afar,
As if some melancholy star
Had mingled with her light her sighs,
 And dropped them from the skies!

" No, — never came from aught below
 This melody of woe,
That makes my heart to overflow,
As from a thousand gushing springs,
Unknown before; that with it brings
This nameless light, — if light it be, —
 That veils the world I see.

" For all I see around me wears
 The hue of other spheres;
And something blent of smiles and tears
Comes from the very air I breathe.
O, nothing, sure, the stars beneath
Can mould a sadness like to this, —
 So like angelic bliss."

So, at that dreamy hour of day
 When the last lingering ray
Stops on the highest cloud to play, —
So thought the gentle Rosalie,
As on her maiden reverie
First fell the strain of him who stole
 In music to her soul.

THE SPANISH MAID.

Five weary months sweet Inez numbered
From that unfading, bitter day
When last she heard the trumpet bray
That called her Isidore away, —
That never to her heart has slumbered.

She hears it now, and sees, far bending
Along the mountain's misty side,
His plumèd troop, that, waving wide,
Seems like a rippling, feathery tide,
Now bright, now with the dim shore blending.

She hears the cannon's deadly rattle, —
And fancy hurries on to strife,
And hears the drum and screaming fife
Mix with the last sad cry of life.
O, should he, — should he fall in battle!

Yet still his name would live in story,
　　And every gallant bard in Spain
　　Would fight his battles o'er again.
　　And would she not for such a strain
Resign him to his country's glory?

Thus Inez thought, and plucked the flower
　　That grew upon the very bank
　　Where first her ear bewildered drank
　　The plighted vow, — where last she sank
In that too bitter parting hour.

But now the sun is westward sinking;
　　And soon, amid the purple haze
　　That showers from his slanting rays,
　　A thousand Loves there meet her gaze,
To change her high, heroic thinking.

Then hope, with all its crowding fancies,
　　Before her flits and fills the air;
　　And, decked in Victory's glorious gear,
　　In vision Isidore is there.
Then how her heart 'mid sadness dances!

Yet little thought she, thus forestalling
　　The coming joy, that in that hour
　　The Future, like the colored shower
　　That seems to arch the ocean o'er,
Was in the living Present falling.

The foe is slain. His sable charger,
 All flecked with foam, comes bounding on.
 The wild Morena rings anon;
 And on its brow the gallant Don
And gallant steed grow larger, larger;

 And now he nears the mountain-hollow;
 The flowery bank and little lake
 Now on his startled vision break, —
 And Inez there. — He's not awake!
Yet how he'll love this dream to-morrow!

But no, — he surely is not dreaming.
 Another minute makes it clear.
 A scream, a rush, a burning tear
 From Inez' cheek, dispel the fear
That bliss like his is only seeming.

THE TUSCAN GIRL.

How pleasant and how sad the turning tide
　Of human life, when side by side
　The child and youth begin to glide
　　Along the vale of years,
The pure twin-being for a little space,
With lightsome heart, and yet a graver face,
　　Too young for woe, though not for tears.

This turning tide is Ursulina's now,
　The time is marked upon her brow,
　Now every thought and feeling throw
　　Their shadows on her face ;
For so are every thought and feeling joined,
'T were hard to answer whether heart or mind
　　Of either were the native place.

The things that once she loved are still the same,
　Yet now there needs another name
　To give the feeling which they claim,
　　While she the feeling gives ;
She cannot call it gladness or delight ;
And yet there seems a richer, lovelier light
　　On e'en the humblest thing that lives.

She sees the mottled moth come twinkling by,
 And sees it sip the floweret nigh ;
 Yet not as once, with eager cry,
 She grasps the pretty thing ;
Her thoughts now mingle with its tranquil mood, —
So poised in air, as if on air it stood,
 To show its gold and purple wing.

She hears the bird without a wish to snare,
 But rather on the azure air
 To mount, and with it wander there
 To some untrodden land ;
As if it told her, in its happy song,
Of pleasure strange that never can belong
 To aught of sight or touch of hand.

Now the young soul her mighty power shall prove,
 And outward things around her move
 Pure ministers of purer love.
 And make the heart her home,
Or to the meaner senses sink a slave,
To do their bidding, though they madly crave
 Through hateful scenes of vice to roam.

But, Ursulina, thine the better choice ;
 Thine eyes so speak, as with a voice ;
 Thy heart may still in Earth rejoice
 And all its beauty love,
But no, not all this fair, enchanting Earth,
With all its spells, can give the rapture birth
 That waits thy conscious soul above.
 29

THE YOUNG TROUBADOUR.

THE House of Este's bannered pile
 Lay glittering in the morning sun,
 And many a warlike trophy, won
 From swarthy Moor and Arab dun,
Seemed grimly through the air to smile.

And all her knights from Palestine,
 As called in jubilant array
 From out their tombs, stood, fiercely gay,
 In mail and casque, to grace the day
That weds the heir of Este's line.

For all along the banquet-hall
 Was pedestalled, as if in life,
 The mail that each had worn in strife,
 To greet Count Julian's lovely wife,
Fair Isabel of Sinigal.

And many a noble, far and near,
 And pilgrims from the Holy Land,
 And all renowned for voice or hand
 In minstrelsy, in many a land,
From every courtly clime were there.

But one there was, a wandering Boy,
 A stranger to his native soil,
 Whom penury had doomed to moil,
 But grateful, in the Poet's toil,
Who could not pine for other joy.

With heart and head that seemed **as one**,
 His loved guitar his only store,
 From court to court he made his **tour**,
 A gentle, happy Troubadour,
Whose quiet spirit envied none.

And with the Bride the Troubadour,
 Now honored as her favored page,
 Had come his tiny skill to wage
 With other bards of riper age
In bridal song and festal lore.

Yet thought not he of rival art;
 He sang not for a sounding name;
 He loved the Muse because she came
 Unasked, and gave him more than fame, —
The pure, sweet music of the heart.

There stood within a lonely dell
 A broken fountain, called of yore
 The Lover's Fount, where, bending o'er,
 A marble Cupid once did pour
The sweetest drops that ever fell.

And all who drank of that pure stream,
 'T was said, would in its mirror see
 The gallant He, or lovely She,
 That, in their natal stars' decree,
Would bless them through life's troubled dream.

But long the stream had ceased to flow;
 Yet still the marble urchin stops,
 As if to watch the feigned drops,
 And mock the baffled lover's hopes
Who seeks in faith a bride below.

Beside this fountain's grassy brink,
 The little Bard now sought to train
 His wandering thoughts, and build a strain
 For knightly ears; but all in vain;
On knightly themes he could not think.

He sang of Este's martial lord;
 He numbered o'er each gallant deed,
 And made afresh the caitiffs bleed,
 That fell before his barbèd steed,
Or oped their cleft helms to his sword.

And yet his soul could not, as once,
 The madness catch, and outward glow,
 With flashing eye and knotted brow;
 A softer mood would o'er him grow,
Do all he could, — a little dunce!

And then he tried the tournament,
 And sang how Julian's mighty lance
 O'erthrew the chivalry of France;
 Then how he fell beneath a glance
From one bright eye, — which through him went.

Ah, *now* he touched the magic chord
 That waked his soul through all her springs;
 His true guitar itself now sings,
 As if alive its happy strings,
Mingling its life with every word.

Ah, *now he feels!* — for that bright eye
 Himself had felt in kindness beam,
 And now, his Lady fair the theme,
 His spirit trod, as in a dream,
The purple meadows of the sky.

For there alone her virtues took
 A bodied form, substantial, true,
 That to the inward senses grew,
 In angel shapes, distinct to view,
On which 't were bliss enough to look.

29 *

The trancèd Boy, now starting, stood,
 And gently breathed his last address:
 " O happy husband to possess
 A wife so formed to love, to bless,
A wife so beautiful, so good!"

THE BETROTHED.

" O, BLESS thee, happy, happy, revelling brook!
Whose merry voice within this lonely nook,
 In ceaseless gurgle, all day long
 Singeth the dancing leaves among; —
 I love, — O, how I love thy song!"
So from its joyous fount the almost bride,
Sweet Esther, poured her heart that brook beside.
The mystic word had passed its coral gate,
The little mystic *Yes* that sealed her fate :
 'T is now upon the outward air;
 Yet not, like other sounds, to share
 The common death; for, haply, there
The formless element that near it flew
Caught the warm breath, and into being grew.

Her page-like spirit now, that little word
Ever before her, like some fairy bird,
 Flits in her path ; to all around,
 To every form, to every sound,
 Imparting love; till e'en the ground,

The dull, dark ground beneath, the trees above,
And chiming breezes, all, breathe only love.
And with that little word there ever comes
A tune like that the homeward wild-bee hums,
 Shaping in sound her winter's store.
 The future now seems brimming o'er
 With nameless good; nor asks she more
Of jealous Time, than dimly thus to look
Into his bright, unlettered, future book.

One only form of all the crowded past
She could not, if she would, from memory cast, —
 Nay, from her sight; for wheresoe'er
 She turns or looks, afar or near,
 That haunting form is ever there.
Her own sweet Poet, too, no other gives, —
E'en on his unread page that image lives;
And, sooth to say, she loves that page the more, —
No, never had it touched her so before:
 She loves the woods, the earth, the sky;
 For all that in their empires lie
 But teem of him, — that dearer *I*,
On which she may not blush for aye to dwell, —
That other self she cannot love too well.

SONNET

ON THE STATUE OF AN ANGEL, BY BIENAIMÉ, IN THE POSSESSION OF
J. S. COPLEY GREENE, ESQ.

Ah, who can look on that celestial face,
And kindred for it claim with aught on earth?
If ever here more lovely form had birth, —
No, never that supernal purity, — that grace
So eloquent of unimpassioned love!
That, by a simple movement, thus imparts
Its own harmonious peace, the while our hearts
Rise, as by instinct, to the world above.
And yet we look on cold, unconscious stone.
But what is *that* which thus our spirits own
As Truth and Life? 'T is not material Art, —
But e'en the Sculptor's soul to sense unsealed.
O, never may he doubt, — its witness so revealed, —
There lives within him an immortal part!

SONNET

ON THE LATE S. T. COLERIDGE.

———————

And thou art gone, most loved, most honored friend!
No, never more thy gentle voice shall blend
With air of Earth its pure ideal tones,
Binding in one, as with harmonious zones,
The heart and intellect. And I no more
Shall with thee gaze on that unfathomed deep,
The Human Soul, — as when, pushed off the shore,
Thy mystic bark would through the darkness sweep,
Itself the while so bright! For oft we seemed
As on some starless sea, — all dark above,
All dark below, — yet, onward as we drove,
To plough up light that ever round us streamed.
But he who mourns is not as one bereft
Of all he loved: thy living Truths are left.

SONNET.

IMMORTALITY.

To think for aye; to breathe immortal breath;
And know nor hope, nor fear, of ending death;
To see the myriad worlds that round us roll
Wax old and perish, while the steadfast soul
Stands fresh and moveless in her sphere of thought;
O God, omnipotent! who in me wrought
This conscious world, whose ever-growing orb,
When the dead Past shall all in time absorb,
Will be but as begun, — O, of thine own,
Give of the holy light that veils thy throne,
That darkness be not mine, to take my place,
Beyond the reach of light, a blot in space!
So may this wondrous Life, from sin made free,
Reflect thy love for aye, and to thy glory be.

THE MARIGOLD.

INSCRIBED TO MISS M—— E—— D——.

EREWHILE it chanced two wandering Rays, —
 So then deposed a moon-struck Painter, —
Met on a cloud his upward gaze;
 One dazzling bright, the other fainter.
Then came a strain so small and wild,
'T was like the sobs of fairy child
Lost in a rose; and then it streamed
Like distant bells; then, — else he dreamed, —
It language took; and thus it seemed:

" Ho! brilliant Brother! tell me how" ——
 " Nay, radiant Sister, tell me rather
How one so well beloved as thou
 Could ever leave our royal Father?"
" He left me in the watery bow,
And sank so quick the sea below,
I lost my way, and bent my flight
To this high cloud, lest haply Night
Should quench on earth my feeble light."

" Dear, modest Topaz, say not so;
 Beside yon star thou seem'st another, —
And brighter of the two, I trow!"
 " But say, kind, dazzling Ruby Brother,
Why meet we in a place so drear?"
" O, how miscalled while thou art here,
Whose glory tracks thy very name!"
" Nay, truant flatterer, cease, for shame!"
" Then, gentle Sister, know, I came
To edge this curtain-cloud with flame;

" But scarce had I my task begun,
 When here I found a group of Azure
Changing my fringe to purple dun; —
 They said it was the Sun's good pleasure.
I knew 't was false, — the dastard Rays! —
And gave them battle. Soon my blaze
'Gan curl o'er each devoted head:
Anon they burnt to dusky red,
Then ashy gray, — and then they fled.

"And when I turned to join my Sire,
 His car was gone, nor 'bove the ocean
Was seen but one faint streak of fire,
 Left by its wheels' too rapid motion.
So here I sit, his mourning son,
Paled by the fray, though I had won!"
" Nay, still, bright Brother, droop not so,"
Sweet Topaz said; "for what below,
If we but join, can near us show?

" We 'll mingle rays, and down to Earth
 Descending with some gentle shower,
 30

There give the world another birth, —
　A bright and gorgeous sunny Flower;
So bright, that when the leaden cloud
Of darkling thunder seems to shroud
The land in night, our face so fair
Shall shine upon the murky air
As if a little sun were there!"

" Sweet Topaz, yes," the Ruby said;
　" From thee for worlds I would not vary,
So good and wise thy heart and head;
　And we will call the flower Mary;
For once I saw a maiden's eyes
So like the brightness that we prize,
Their light, I 'm sure, the name foretold, —
'T was hers, — but still our hue we 'll hold."
" We 'll call it, then, the Marigold."

" And this our *charm* no sullen knave," —
　So spake the blending Rays, together, —
" No spirit blue can ever brave
　With eastern wind or hazy weather;
For all who look upon us now
Shall feel this name — they know not how —
Linked with a past and pleasant thought;
Some gentle kindness, never bought, —
Some gift of heart, for memory wrought."

A FRAGMENT.

But most they wondered at the charm she gave
To common things, that seemed as from the grave
Of mouldering custom suddenly to rise
To fresh and fairer life ; a life so new,
And yet so real, — to the heart so true, —
They gazed upon the world as if a thousand ties,
Till now to all unknown, between them daily grew.

The life was hers, — from that mysterious cell
Whence sends the soul her self-diffusing spell,
Whose once embodied breath for ever *is :*
Though ruthless Time, with whom no creature strives,
At every step treads out a thousand lives,
Yet brings his wasting march no doom to this, —
Like heritage with air, that aye for all survives.

THE NIGHT-MARE.

ALMAHAYA.

Sister Spirit, tell me where
Left you her, — the Lady fair,
Whom the star that ruled her birth
Gave to thee to guard on earth?

ZELICAN.

I saw her but now, as I left my dell
To swing the tongue of yonder bell,
By me pass on the Twilight's steed, —
The pale gray steed, that loves to feed
On toadstools black, in swamps that grow,
And the feathers that fall from the moulting crow.

ALMAHAYA.

She went not alone so late, I trow?

ZELICAN.

Nay, not so; for by her side
A green-eyed Owl, as page, did ride.

ALMAHAYA.

And whither goes she, squired so?

ZELICAN.

To yon church-yard I saw her go.

ALMAHAYA.

But what, I pray thee, doth she there?

ZELICAN.

She goes to comb and curl her hair,
And scent it with the midnight dew
That drips from yonder mourning yew.

ALMAHAYA.

Look! — I see her through the gloom,
Making her toilet on a tomb.
I know her errand. Now 't is clear
She trims her smiles and trims her hair
Thus in the moonless, starless air,
To meet the Fiend that oft doth lie
By day concealed in a pigeon-pie.
I know the Fiend: I've seen his eyes
Gleaming through those fatal pies;
Those pies that each at night become
A new-made grave, — when, dark and dumb,
The Fiend steps out to the Lady fair,
To ride by her side through the startled air,
On his red-hoofed, blue-eyed, black night-mare.

ZELICAN.

Hush, good Sister! — hist, I pray!
Sure I heard his night-mare neigh.

ALMAHAYA.

O, haste thee, then, your charge to save! —
'T is the Fiend himself! In yonder grave
I see his head: and now he looms,
Like a column of smoke, above the tombs;
Now the blue eyes of his snorting mare
Like charnel-fires upon us glare;
She paws the ground; — but, hark! that groan!

ZELICAN.

'T is only a kick she gave to a bone:
I 've heard a skull thus near her moan.

ALMAHAYA.

But listen again!

ZELICAN.

'T is the laugh of despair;
For the Fiend is now with the Lady fair.
And see! they mount on the flashing air.

ALMAHAYA.

If I had flesh, 't would creep at this.
What 's that? Dost hear?

ZELICAN.

'T is the adder's hiss
In the jaws of a toad that squats by the yew:
I 've seen it so feed till it upward grew
To the size of a church.

ALMAHAYA.

It grows so now!
And the vane on the steeple now brushes its brow.
But, mercy upon us! — O, hear how it roars!
Like ten thousand thunders ——

ZELICAN.

The toad only snores,
After supping, good Sister.

ALMAHAYA.

But see that sight! —
Like a spark struck out from the solid night,
Down through the darkness comes a star.
Feel you not its fearful jar? —
'T is tumbling upon us! and with it the mare, —
But not her own rider, — 't is *thy* Lady fair,

Now clinging for life to her shaggy mane.
O, save her, dear Sister! — she touches again
The earth, and — O, horrible! — how the earth shakes!

ZELICAN.

Sweet Sister, no more. She is saved, — she awakes.

A FRAGMENT.

WISE is the face of Nature unto him
Whose heart, amid the business and the cares,
The cunning and bad passions, of the world,
Still keeps its freshness, and can look upon her
As when she breathed upon his schoolboy face
Her morning breath, from o'er the dewy beds
Of infant violets waking to the sun; —
When the young spirit, only recipient,
So drank in her beauties, that his heart
Would reel within him, joining jubilant
The dance of brooks and waving woods and flowers.

THE MAGIC SLIPPERS.

TO MRS. S——, ON HER PRESENTING THE WRITER A PAIR OF CRIMSON
SLIPPERS WROUGHT BY HERSELF.

I KNOW not if a dream it were,
Or daylight scene in sunny air;
 But once, methought, as stretched I lay
Beside a little forest Spring,
And musing on the cares that cling
To every heart, no earthly thing,
 It seemed, could chase my gloom away.

Above that little Spring there stood,
Like sentries to the sleeping wood,
 Two sister Pines, that night and day
Their vigil kept; and ever there
A soft, low murmur filled the air, —
As if a child his little prayer
 Were striving in a dream to say.

In sooth, it was a solemn sound;
So pure, so child-like, yet profound,
　　It seemed to hold me in a spell.
And then, methought, the murmur broke
Its even stream, and strangely took
The form of words, and bade me look
　　Within that little forest Well.

I looked, — and lo! a crimson flush,
Like to a gentle maiden's blush,
　　O'erspread the Spring; and then a sigh
Breathed from the Pines. A deeper hue, —
Which now to tiny vessels grew,
Riding at anchor o'er the blue
　　That dyed that dark, deep, nether sky.

But scarce could I the marvel note,
When straight within each magic boat
　　There stood two gallant Fairy Skippers;
And then anon they bore away,
Skimming the little azure bay
Swift to the bank where stretched I lay,
　　And took — the humble form of slippers!

And now, in sweetly soothing strain,
Thus came the Piny voice again: —
　　" O, deem not, man, the gift we send
Of little worth; that gift was wrought
Where kind affections hallow thought,
And give — what wealth has never bought —
　　In every gentle heart a friend."

I seized the gift with eager joy;
And then, — as if again a boy,
 A careless, happy boy once more, —
How pure, and beautiful, and kind
Seemed all I saw! The very wind
That kissed my cheek then seemed to bind
 My heart to all it travelled o'er.

A FRAGMENT.

Who knows himself must needs in prophecy
Too oft behold his own most sad reverse;
E'en like his noonday shadow, — once so true,
In form so fair, that the o'erpassing sun
Seemed, as in love, to robe it with the blue
Of his own heaven. Ah, then on that fair shade,
So pure and beautiful, 't were peace to look!
But *now*, how changed! distorted, black, and stretched
To strange, unnatural length by that same sun,
As towards the west he travels down to night,
Their common sepulchre. But where is *he*, —
Ah, where, — with such foreknowledge blessed, or cursed?

THE PARTING.

WRITTEN FOR MUSIC, AND INSCRIBED TO MISS R—— C—— D——.

Not " Farewell!" O, speak it never!
 Time and Distance in it find
Limit never, — flying ever, —
 Leaving darkened Hope behind.
Soon yon quiet vessel's motion,
Soon shall yonder rolling ocean,
Throw my spirit o'er the past
Closing now between us fast.

Bid me, then, if aught be spoken,
 Bid me cheerily "Good night";
So that, waking, aye unbroken
 Memory link it with the light.
Thus shall every morning cheer me,
Bring thine image ever near me,
With that word that seems to say,
" Part we only for a day."

31

Yet I know not why I ask thee
 Now to play a hollow part:
No, I will not, will not task thee
 Thus to veil an aching heart.
Truth and thou were never parted;
Part not now, though, broken-hearted,
Truth thy faltering tongue compel
Bitterly to say, " Farewell!"

Speak it, then, nor stay the sadness
 Brimming now within thine eyes:
Weep, O, weep, — nor think it madness
 Thus thy burning tear to prize.
Man to woe was ever plighted;
Then be mine with thine united. —
O, 't were bliss, to him unknown,
Mourning for himself alone.

ON GREENOUGH'S GROUP OF THE ANGEL AND CHILD.

I stood alone: nor word, nor other sound,
Broke the mute solitude that closed me round;
As when the Air doth take her midnight sleep,
Leaving the wintry stars her watch to keep,
So slept she now, at noon. But not alone
My spirit then: a light within me shone
 That was not mine; and feelings undefined,
And thoughts, flowed in upon me not my own.
'T was that deep mystery, — for aye unknown, —
 The living presence of Another's mind.

Another mind was there, — the gift of few, —
That by its own strong will can all that 's true
In its own nature unto others give,
And, mingling life with life, seem there to live.
I felt it then in mine: and, O, how fair,
How beautiful, the thoughts that met me there, —
 Visions of Love and Purity and Truth!
Though form distinct had each, they seemed as 't were
Embodied all of *one* celestial air,
 To beam for ever in coequal youth.

And thus I learned, as in the mind they moved,
These Stranger Thoughts the one the other loved ;
That Purity loved Truth, because 't was true,
And Truth, because 't was pure, the first did woo ;
While Love, as pure and true, did love the twain ;
Then Love was loved of them, for that sweet chain
 That bound them all. Thus sure, as passionless,
Their love did grow, till one harmonious strain
Of melting sounds they seemed ; then, changed again,
 One Angel Form they took, — Self-Happiness.

This Angel Form the gifted Artist saw
That held me in his spell. 'T was his to draw
The veil of sense, and see the immortal race,
The Forms spiritual that know not place.
He saw it in the quarry, deep in earth,
And stayed it by his will, and gave it birth
 E'en to the world of sense ; bidding its cell,
The cold, hard marble, thus in plastic girth
The shape ethereal fix, and body forth
 A Being of the skies, — with man to dwell.

And then another Form beside it stood :
'T was one of this our world, though the warm blood
Had from it passed, — exhaled as in a breath
Drawn from its lips by the cold kiss of Death.
Its little " dream of human life " had fled ;
And yet it seemed not numbered with the dead,
 But one emerging to a life so bright,
That, as the wondrous nature o'er it spread,
Its very consciousness did seem to shed
 Rays from within, and clothe it all in light.

Now touched the Angel Form its little hand,
Turning upon it with a look so bland,
And yet so full of majesty, as less
Than holy natures never may impress, —
And more than proudest guilt unmoved may brook.
The Creature of the Earth now felt that look,
 And stood in blissful awe, — as one above,
Who saw its name in the Eternal Book,
And Him that opened it; e'en Him that took
 The Little Child, and blessed it in his love.

31 *

SONG.

O, ASK me not why thus I weep;
　I may not tell thee why:
The fountain oft is dark and deep
　That gushes from the eye.

It should not be, I hear thee say,
　While *thou* art by my side; —
As if the heart could e'er be gay
　Of one so soon a bride!

It is not grief that brings the tear,
　Nor dread of coming woe;
But, O, 't is something which I fear
　No mortal long may know.

For when I hear that tone of love, —
　Unlike all earthly sound, —
It seems like music from above,
　That lifts me from the ground.

And yet I know that I 'm of earth,
　Where all that live must die:
And these my tears but owe their birth
　To bliss for earth too high.

ON KEAN'S HAMLET.

O THOU who standest 'mid the bards of old,
 Like Chimborazo, when the setting sun
 Has left his hundred mountains dark and dun,
 Sole object visible, the imperial One,
In purple robe, and diadem of gold, —
Immortal Shakspeare! who can hope to tell,
 With tongue less gifted, of the pleasing sadness
 Wrought in thy deepest scenes of woe and madness?
 Who hope by words to paint the ecstatic gladness
Of spirits leaping 'mid thy merry spell?
When I have gazed upon thy wondrous page,
 And seen, as in some necromantic glass,
 Thy visionary forms before me pass,
 Like breathing things of every living class,
Goblin and Hero, Villain, Fool, and Sage,
It seemed a task not Buonarroti's e'en,
 Nor Raffael's hand could master by their art, —
 To give the semblance of the meanest part
 Of all thy vast creation, or the heart
Touch as thou touchest with a kindred scene.

And vainer still, methought, by mimic tone,
　　And feignèd look, and attitude, and air,
　　The Actor's toil; for self will have its share
　　With nicest mimicry, and, though it spare
To others largely, gives not all its own.
So did I deem, till, living to my view,
　　Scorning his country while he sought her good,
　　In Kemble forth the unbending Roman* stood;
　　Till, snuffing at the scent of human blood,
In Cooke strode forth the unrelenting Jew.†
But these were beings tangible in vice,
　　Their purpose searchable, their every thought
　　Indexed in living men; yet only sought,
　　Plain as they seem, by genius, — only bought
By genius even with laborious price.
But who, methought, in confidence so brave,
　　Doffing himself, shall dare that form assume
　　So strangely mixed of wisdom, wit, and gloom, —
　　Playful in misery even at the tomb, —
Of hope, distrust, of faith and doubt, the slave?
That being strange, that only in the brain
　　Perchance has lived, yet still so rarely knit
　　In all its parts, — its wisdom to its wit,
　　And doubt to faith, loathing to love, so fit, —
It seems like one that lived, and lives again!
Who, then, dare wear the princely Denmark's form?
　　What starts before me? — Ha! 't is he I 've seen
　　Oft in a day-dream, when my youth was green, —
　　The Dane himself, — the Dane! Who says 't is Kean?
Yet sure it moves, — as if its blood were warm.

　　　* Coriolanus.　　　　　　　† Shylock.

If this be Kean, then Hamlet lived indeed!
 Look! how his purpose hurries him apace,
 Seeking a fitful rest from place to place!
 And yet his trouble fits him with a grace,
As if his heart did love what makes it bleed.
He seems to move as in a world ideal,
 A world of thought, where wishes have their end
 In wishing merely, where resolves but spend
 Themselves resolving, — as his will did lend
Not counsel e'en his body to defend.
Or Kean or Hamlet, — what I see is real!

A WORD.

MAN.

How vast a world is figured by a word!
A little word, a very point of sound,
Breathed by a breath, and in an instant heard;
Yet leaving that may well the soul astound, —
To sense a shape, to thought without a bound.
For who shall hope the mystery to scan
Of that dark being symbolized in *man?*
His outward form seems but a speck in space:
But what far star shall check the eternal race
Of one small thought that rays from out his mind?
For evil, or for good, still, still must travel on
His every thought, though worlds are left behind,
Nor backward can the race be ever run.
How fearful, then, that the first evil ray,
Still red with Abel's blood, is on its way!

A FRAGMENT.

I.

O, who hath lived the ills to know
Which make the sum of life below,
That hath not felt, if, 'mid the brood
Of half-wrought beings, hither sent
As if in promised punishment
Of vicious ancestry, there stood
A Form of purest symmetry, —
Where Nature seemed as she would try,
In spite of Vice, to keep on earth
Some vestige of primeval birth; —
Ah, who on such a form hath dwelt,
And hath not in his gazing felt
A sudden stream of horror rush
Back on his heart, to think how soon,
Ere yet perchance she reach her noon,
The Giant Sin may grinning crush
This living flower of Paradise, —
May send its fragrance, born to rise,
Downward, a hellish sacrifice!

There is a deep, foreboding flush,
That fain would seem a truant blush,
Doth in the smooth and lovely cheek
Of youthful Beauty oft bespeak
The victim of a swift decay;
And, when the light of love doth rise
Effulgent in her lucid eyes,
Full many a heart, that joyous fell
A captive to their radiant spell,
May now in bitter sadness tell
How, like the last protracted ray
Of the last Greenland summer day,
That flashes on the western wave,
They flashed, and sunk, — but sunk into the grave!

II.

So seemed Monaldi to the eye
 Experienced in this world of woe;
 Too blest for mortal long below, —
Too blest for one who blest would die.
Of lineage proud, his ancient name
 Had long in Fiorenza stood
 The record of the noblest blood
Which flowed for Fiorenza's fame.
And yet on him did Nature's hand
 Such rare and varied gifts bestow,
 His virtues rather seemed to throw
 A heritless, reflected grace
 Through ages back upon his race,
The mightiest of a mighty land.

Nor were the lighter gifts denied
 Of manly form or noble mien;
 Such form, if ancient Greece had seen,
Like Jason's had been deified,
 And virgin hands with flowers had dressed
 An altar for the heavenly guest,
 As if, to bless their grateful eyes,
 Apollo's self had left the skies,
 Greeting their pious sacrifice.

 * * * * *

 She had an eye of such a hue,
 So ever-varying, ever new,
 That none on whom its lustre fell
 Could e'er forget, — could ever tell
 If like the mild approach of day,
 The morning twilight's watery gray;
 Or like the noontide's dazzling blue;
 Or beamy brown, when evening dew
 Prolongs the dim, departing light;
Or the jet, that seems to quench the sight,
Of a starless, still autumnal night.
 For oft 't was like an armèd knight,
 In steel encompassed, dark and bright,
 And fiercely flashed, as if 't would lead
 Onward to some immortal deed:
 And then it seemed an elfin well,
 Imbowered in some sequestered dell,
 Where Cupids sport in ceaseless motion,
 Bathing as in an amber ocean!

 Ah, then he wished that life would prove
 For ever thus, a dream of love!
 32

But oft, — more oft, — with searing pain,
It seemed a wandering comet's train,
Streaming athwart his burning brain, —
Foreboding with its lurid flame
An evil *yet* without a name!
And well, Monaldi, mayst thou rue
This vision which thy fancy drew;
For thine was but a fearful bliss, —
A trancing, but a poisoned, kiss!

* * * * *

ON MICHAEL ANGELO.

'T is not to honor thee by verse of mine
 I bear a record of thy wondrous power;
Thou stand'st alone, and needest not to shine
With borrowed lustre: for the light is thine
 Which no man giveth; and, though comets lower
Portentous round thy sphere, thou still art bright;
 Though many a satellite about thee fall,
Leaving their stations merged in trackless night,
Yet take not they from that supernal light
 Which lives within thee, sole, and free of all.

RUBENS.

Thus o'er his art indignant Rubens reared
His mighty head, nor critic armies feared.
His lawless style, from vain pretension free,
Impetuous rolling like a troubled sea,
High o'er the rocks of Reason's ridgy verge
Impending hangs; but, ere the foaming surge
Breaks o'er the bound, the under-ebb of taste
Back from the shore impels the watery waste.

TO THE AUTHOR OF "THE DIARY OF AN ENNUYÉE,"

ONE OF THE TRUEST AND MOST BEAUTIFUL BOOKS EVER WRITTEN ON ITALY.

SWEET, gentle Sibyl! would I had the charm,
E'en while the spell upon my heart is warm,
 To waft my spirit to thy far-off dreams,
That, giving form and melody to air,
The long-sealed fountains of my youth might there
 Before thee shout, and toss their starry stream,
Flushed with the living light which youth alone
Sheds like the flash from heaven, — that straight is gone!

For thou hast waked as from the sleep of years, —
No, not the memory, with her hopes and fears, —
 But e'en the breathing, bounding, *present* youth;
And thou hast waked him in that vision clime,
Which, having seen, no eye the second time
 May ever see in its own glorious truth; —

As if it *were not*, in this world of strife,
Save to the first deep consciousness of life.

And yet, by thy sweet sorcery, is mine
Again the same fresh heart, — e'en fresh as thine, —
 As when, entranced, I saw the mountain kings,
The giant Alps, from their dark purple beds
Rise ere the sun,* the while their crownèd heads
 Flashed with his thousand heralds' golden wings;
The while the courtly Borromean Isles
Looked on their mirrored forms with rippling smiles.

E'en in thy freshness do I see thee rise,
Bright, peerless Italy, thy gorgeous skies,
 Thy lines of harmony, thy nameless hues, —
As 't were by passing Angels sportive dropped
From flowers of Paradise, but newly cropped,
 Still bathed and glittering with celestial dews!
I see thee, — and again what visions pass,
Called up by thee, as in some magic glass!

Again I feel the Tuscan Zephyrs brush
My youthful brow, and see them laughing rush,
 As if their touch another sense had given,
Swift o'er the dodging grass, like living things;
In myriads glancing from their flickering wings
 The rose and azure of their native heaven; —
And now they mount, and through the sullen green
Of the dark laurel dart a silvery sheen.

* The writer passed a night, and saw the sun rise, on the Lago Maggiore.

O, now, as once, pure playmates of the soul!
Bear me, as then, where the white billows roll
 Of yon ethereal ocean, poised above.
How touching thus from that o'erhanging sea
To look upon the world! Now, more to me
 Its wrongs and sorrows, nay, a wider love
Grows on my heart, than where its pleasures press,
And throng me round as one whom they would
 bless.

This is thy voice, kind Nature, in the heart;
Who loves thee truly, loves thee not apart
 From his own kind; for in thy humblest work
There lives an echo to some unborn thought,
Akin to man, his Maker, or his lot.
 Nay, who has found not in his bosom lurk
Some stranger feeling, far remote from earth,
That still through earthly things awaits a birth?

O, thus to me be thou still ministrant,
Still of the universal Love descant
 That all things crave, — thus visible in thee,
The type and register of what man was
Before sin thralled him, substituting laws
 That fain from suffering would his spirit free;
Nay, more, be hope, — the soul's sure prophecy
Of lost, regained, primeval harmony.

And now to thee, fair Sibyl, would I turn;
But how to say farewell I may not learn.
 We part, — but not forgetting we have met.

May that sweet sadness thou so well dost feign
To thee be ever feigned, — be but the strain
　　To which the happy soul doth often set
Her happiest moods; for joy and sadness dwell
As neighbours in the heart; — and now farewell!

THE END.

MONALDI.

MONALDI:

A

TALE.

Who knows himself must needs in prophecy
Too oft behold his own most sad reverse.

BOSTON:

CHARLES C. LITTLE AND JAMES BROWN.

MDCCCXLI.

BOSTON:
PRINTED BY FREEMAN AND BOLLES,
WASHINGTON STREET.

NOTE.

This little story was ready for the press as long ago as 1822, but having been written for the periodical of a friend, which was soon after discontinued, the manuscript was thrown into the author's desk, where it has lain till the present time. It is now published — not with the pretensions of a Novel, but simply as a Tale.

<div align="right">W. A.</div>

August, 1841.

1*

INTRODUCTION.

THERE is sometimes so striking a resemblance
between the autumnal sky of Italy and that of
New England at the same season, that when the
peculiar features of the scenery are obscured by
twilight it needs but little aid of the imagination
in an American traveller to fancy himself in his own
country; the bright orange of the horizon, fading
into a low yellow, and here and there broken by a
slender bar of molten gold, with the broad mass of
pale apple-green blending above, and the sheet of
deep azure over these, gradually darkening to the
zenith — all carry him back to his dearer home. It
was at such a time as this, and beneath such a sky,
that (in the year 17—) while my vettura was slowly
toiling up one of the mountains of Abruzzo, I had
thrown myself back in the carriage, to enjoy one

of those mental illusions which the resemblance between past and present objects is wont to call forth. Italy seemed for the time forgotten; I was journeying homeward, and a vision of beaming, affectionate faces passed before me; I crossed the threshold, and heard — oh, how touching is that soundless voice of welcoming in a day-dream of home — I heard the joyful cry of recognition, and a painful fulness in my throat made me struggle for words — when, at a sudden turn in the road, my carriage was brought to the ground.

Fortunately I received no injury in the fall; but my spell of happiness was broken, and I felt again that I was in Italy. On recovering my legs, I called to the postilion to help me right the carriage. He crossed himself very devoutly, and said it was impossible without other assistance; and how to get that he knew not, as we were several miles from any habitation. The vettura was light, and I thought we could manage it ourselves; but I remonstrated in vain. He said it could not be done; and quietly seating himself on a stone, began striking a light for his pipe. This movement seemed suspicious. Though Italy at that time was but little infested with banditti, the armies of the revolution having drained off the worst of her population, I yet could not quite free my mind

from apprehension. "We must wait," said the postilion, "till some traveller passes." At that moment I heard a shrill whistle from the glen below. This was no time for parleying ; so, snatching up my portmanteau, I cocked my pistols, and bade the postilion go on before me at his peril. I then followed him with all speed. As we passed an angle of the road, I thought he made an attempt to slip aside down a narrow defile to the left, whence I distinctly heard another whistle, as in answer to the first. This satisfied me of his treachery, and, pointing to my pistol, "the instant I am attacked," said I, "you are a dead man ; so, if you value your life, take the first path that leads to a house."

The tone in which I uttered this threat had the desired effect. He quickened his pace, and in a few minutes, cautiously whispering "to the right," he led the way into a narrow sheep-track, winding up the side of the mountain. Though swift of foot, it was as much as I could do to keep up with him, fear seeming to have lent him wings. And though the path was often obstructed by loose stones and brambles, we continued to ascend at the same pace, as I should guess, for near half an hour, when we entered upon a small plain, or mountain heath. The moon was just up, and I

thought I could discern something like a human dwelling. I asked what it was. "For the love of heaven, go not near it," said the postilion ; "'t is the house of the mad."—Suspecting him of some artifice, I presented my pistol and bade him go on. Twice he stopped and attempted to speak, but his teeth chattered so with fear that he could not articulate. Finding me, however, determined, he proceeded; but we had scarcely reached the spot, when, uttering a cry of terror, he gave a sudden spring back, and darted by me like an arrow. I looked behind me, but he was out of sight. I then turned towards the building, when I, too, involuntarily drew back : it was indeed no other than the unhappy object of the postilion's panic.

He was sitting on a stone, in a little spot of moonshine, before the door of his hovel, so that I had a full view of his figure, except the legs, which appeared to be half buried in a hole, worn into the earth by long and continued treading. But there was no motion now in his feet, nor in any part of him ; he was fixed, like the stone he sat on ; his eyes riveted as if on some object before him.— Such eyes ! I shall never forget them ; they were neither fierce nor fiery, but white and shining, like the eyes of a dead man, with their last expression fixed upon them. Of the rest of his face I have

only a general impression that it was pale, and his beard black and bushy; for I seemed then only to see his eyes, in their ghastly whiteness; and even now while I write, I shudder at the recollection of their passive, enduring look of misery.

There is a fascination in fearful objects so strong with some as oftentimes to counteract the will. I would have passed on, but something seemed to fasten me, as it were, to the spot, and I stood before him like one statue gazing upon another. Neither could I speak; not that I was checked by anything like fear; it was rather by the sad conviction that all intercourse was hopeless. I felt that I could touch no chord of a mind so fearfully unstrung, and that words would but fall upon his brain like drops of water upon marble.

Happily I was soon relieved of this painful constraint by the approach of an old woman, who, as I afterwards learnt, was an inhabitant of the dwelling. The sound of her voice seemed to have an instant effect on the unhappy being; he started as from a trance, and giving me a hurried look, as if perceiving me for the first time, darted into the cottage. I would gladly have staid to satisfy my curiosity with some particulars of his history, but the old woman, who spoke only a barbarous provincial dialect, was quite unintelligible; I under-

stood enough of it, however, to obtain from her a
direction to the nearest convent, which to my great
comfort I found was within a short distance.

Following her direction, I soon reached the con-
vent, where my reception was so courteous as soon
to drive from my mind the vexatious cause of my
intrusion, the superior himself coming forward to
do the honors of his house, and conducting me to
the refectory. The monks, who had just sat down
to supper, rose as I entered, and respectfully in-
vited me to the table. I believe I did ample jus-
tice to their hospitality ; for a sense of present
security added to my late exercise had given unu-
sual keenness to my appetite. The good fathers
seemed to take a pleasure in seeing me eat, and I
thanked them in my heart.

The gratuitous kindness of a stranger will often
touch us more sensibly for the moment than the
welcome even of a friend ; it seems to give a wider
play to our good feelings, to generalize as it were
our affections, and make us ashamed of all narrow
or exclusive likings. It was quickly perceived that
I had a proper sense of the courtesy of my enter-
tainers, and all my reserve was soon banished. I
felt as if I was amongst friends. But I was more
particularly attracted by the prior. He was a ven-
erable old man, apparently above sixty ; of a com-

manding and even lofty presence, yet tempered by benignity ; but the cast of his countenance seemed inclining to melancholy ; perhaps this might have been owing to the expression of his eyes, which had somewhat of an inward look, as if he had been used to dwell rather on past images in the memory than on those about him. As I looked on his face I could not help thinking there had once been a time when his interest in the world was as strong as mine ; when hopes and fears, and all that make up the tide of passion, had their ebbs and flows about his heart. These thoughts seemed to force my respect, and I forgot, as I listened to him, all my prejudices against monks and monasteries. It is not easy for one to inspire esteem without perceiving it ; the worthy father was not wanting in tact, and we became as sociable before the evening closed as if we had known each other for years.

Having expressed a wish to see the curiosities of the place, the good prior the next morning offered his services as my *cicerone*. As I followed him to the chapel, he observed, that his convent had little to gratify the taste of an ordinary traveller ; " but if you are a connoisseur," he added, " you will find few places better worth visiting. I perceive you think the picture opposite hardly

bears me out in this assertion. I agree with you. It is certainly very insipid, and the mass of our collection is little better; but we have *one* that redeems them all — one picture worth twenty common galleries." As he said this, we stopped before a crucifixion by Lanfranco. Next to his great work at St. Andrea della Valle, it was the best I had seen of that master. Though eccentric and somewhat capricious, it was yet full of powerful expression, and marked by a vigor of execution that made every thing around it look like washed drawings. " Yes," said I, supposing this the picture alluded to, " and I can now agree with you, 't is worth a thousand of the flimsy productions of the last age." " True," answered the prior ; " but I did not allude " —— Here he was called out on business of the convent.

After waiting some time for my conductor's return, and finding little worth looking at besides the Lanfranc, I turned to leave the chapel by the way I had entered ; but, taking a wrong door, I came into a dark passage, leading, as I supposed, to an inner court. This being my first visit to a convent, a natural curiosity tempted me to proceed, when, instead of a court, I found myself in a large apartment. The light (which descended from above) was so powerful, that for nearly a

minute I could distinguish nothing, and I rested
on a form attached to the wainscoating. I then
put up my hand to shade my eyes, when — the
fearful vision is even now before me — I seemed
to be standing before an abyss in space, boundless
and black. In the midst of this permeable pitch
stood a colossal mass of gold, in shape like an altar,
and girdled about by a huge serpent, gorgeous
and terrible ; his body flecked with diamonds, and
his head, an enormous carbuncle, floating like a
meteor on the air above. Such was the Throne.
But no words can describe the gigantic Being that
sat thereon — the grace, the majesty, its transcend-
ant form; and yet I shuddered as I looked, for its
superhuman countenance seemed, as it were, to
radiate falsehood ; every feature was in contradic-
tion — the eye, the mouth, even to the nostril —
whilst the expression of the whole was of that un-
natural softness which can only be conceived of
malignant blandishment. It was the appalling
beauty of the King of Hell. The frightful discord
vibrated through my whole frame, and I turned
for relief to the figure below ; for at his feet knelt
one who appeared to belong to our race of earth.
But I had turned from the first only to witness in
this second object its withering fascination. It
was a man apparently in the prime of life, but pale

and emaciated, as if prematurely wasted by his unholy devotion, yet still devoted — with outstretched hands, and eyes upraised to their idol, fixed with a vehemence that seemed almost to start them from their sockets. The agony of his eye, contrasting with the prostrate, reckless worship of his attitude, but too well told his tale : I beheld the mortal conflict between the conscience and the will — the visible struggle of a soul in the toils of sin. I could look no longer.

As I turned, the prior was standing before me. "Yes," said he, as if replying to my thoughts, "it is indeed terrific. Had you beheld it unmoved, you had been the first that ever did so."

"There is a tremendous reality in the picture that comes home to every man's imagination ; even the dullest feel it, as if it had the power of calling up that faculty in minds never before conscious of it."

The effect of this extraordinary work was so unlike what I had hitherto experienced from pictures, that it was not until some time after I had returned to my companion's apartment, that I thought of making any inquiry concerning the artist.

"Your curiosity is natural," said the prior ; "but I cannot talk on this subject." The good

man here turned away to conceal his emotion. I
could not with decency press him further, and rose
to retire ; when he requested me to stop. After
a little while, unlocking a cabinet, he put into my
hands the following manuscript. " There," said
he, " if you wish to know more of the picture and
its author, is what will satisfy you. I do not offer
it to gratify your curiosity : it will touch, if I
mistake not, a worthier feeling. The narrative
is brief, and, perhaps, somewhat sketchy ; but it
is sufficiently particular for the purpose for which
it was written. It was drawn up by one well ac-
quainted with most of the persons you will find
described in it."

2*

MONALDI.

CHAPTER I.

AMONG the students of a seminary at Bologna were two friends, more remarkable for their attachment to each other, than for any resemblance in their minds or dispositions. Indeed there was so little else in common between them, that hardly two boys could be found more unlike. The character of Maldura, the eldest, was bold, grasping, and ostentatious; while that of Monaldi, timid and gentle, seemed to shrink from observation. The one, proud and impatient, was ever laboring for distinction; the world, palpable, visible, audible, was his idol; he lived only in externals, and could neither act nor feel but for effect; even his secret

reveries having an outward direction, as if he
could not think without a view to praise, and
anxiously referring to the opinion of others; in
short, his nightly and his daily dreams had but one
subject — the talk and the eye of the crowd. The
other, silent and meditative, seldom looked out of
himself either for applause or enjoyment; if he
ever did so, it was only that he might add to, or
sympathize in the triumph of another; this done,
he retired again, as it were to a world of his own,
where thoughts and feelings, filling the place of
men and things, could always supply him with
occupation and amusement.

Had the ambition of Maldura been less, or his
self-knowledge greater, he might have been a
benefactor to the world. His talents were of a
high order. Perhaps few have ever surpassed him
in the power of acquiring; to this he united per-
severance; and all that was known, however va-
rious and opposite, he could master at will. But
here his power stopped; beyond the regions of
discovered knowledge he could not see, and dared
not walk, for to him all beyond was " outer dark-
ness;" in a word, with all his gifts he wanted that
something, whatever it might be, which gives the
living principle to thought. But this sole defi-
ciency was the last of which he suspected himself.

With that self-delusion so common to young men of mistaking the praise of what is promising for that of the thing promised, he too rashly confounded the ease with which he carried all the prizes of his school with the rare power of commanding at pleasure the higher honors of the world.

But the honors of a school are for things and purposes far different from those demanded and looked for by the world. Maldura unfortunately did not make the distinction. His various knowledge, though ingeniously brought together, and skilfully set anew, was still the knowledge of other men; it did not come forth as in new birth, from the modifying influence of his own nature. His mind was hence like a thing of many parts, yet wanting a whole — that *realizing* quality which the world must feel before it will reverence. In proportion to its stores such a mind will be valued, and even admired; but it cannot command that inward voice — the only true voice of fame, which speaks not, be it in friend or enemy, till awakened by the presence of a master spirit.

Such were the mind and disposition of Maldura; and from their unfortunate union sprang all the after evils in his character. As yet, however, he was known to himself and others only as a re-

markable boy. His extraordinary attainments
placing him above competition, he supposed him-
self incapable of so mean a passion as envy;
indeed the high station from which he could look
down on his associates gave a complacency to his
mind not unfavorable to the gentler virtues ; he
was, therefore, often kind, and even generous
without an effort. Besides, though he disdained
to affect humility, he did not want discretion, and
that taught him to bear his honors without arro-
gance. His claims were consequently admitted
by his schoolfellows without a murmur. But there
was one amongst them whose praises were marked
by such warmth and enthusiasm as no heart not
morally insensible could long withstand ; this youth
was Monaldi. Maldura naturally had strong feel-
ings, and so long as he continued prosperous and
happy, their course was honorable. He requited
the praises of his companion with his esteem and
gratitude, which soon ripened into a friendship so
sincere that he believed he could even lay down
his life for him.

It was in this way that two natures so opposite
became mutually attracted. But the warmth and
magnanimity of Monaldi were all that was yet
known to the other ; for, though not wanting in
academic learning, he was by no means distin-

guished ; indeed, so little, that Maldura could not but feel and lament it.

The powers of Monaldi, however, were yet to be called forth. And it was not surprising that to his youthful companions he should have then appeared inefficient, there being a singular kind of passiveness about him easily mistaken for vacancy. But his was like the passiveness of some uncultured spot, lying unnoticed within its nook of rocks, and silently drinking in the light, and the heat, and the showers of heaven, that nourish the seeds of a thousand nameless flowers, destined one day to bloom and to mingle their fragrance with the breath of nature. Yet to common observers the external world seemed to lie only

" Like a load upon his weary eye ; "

but to them it appeared so because he delighted to shut it out, and to combine and give another life to the images it had left in his memory ; as if he would sleep to the real and be awake only to a world of shadows. But, though his emotions seldom betrayed themselves by any outward signs. there was nothing sluggish in the soul of Monaldi : it was rather their depth and strength that prevented their passage through the feeble medium of words. He regarded nothing in the moral or phy-

sical world as tiresome or insignificant ; every ob-
ject had a charm, and its harmony and beauty, its
expression and character, all passed into his soul
in all their varieties, while his quickening spirit
brooded over them as over the elementary forms of
a creation of his own. Thus living in the life he
gave, his existence was too intense and extended
to be conceived by the common mind : hence the
neglect and obscurity in which he passed his youth.

But the term of pupilage soon came to an end,
and the friends parted — each, as he could, to
make his way in the world.

The profession which Monaldi had chosen for
the future occupation of his life was that of a
painter ; to which, however, he could not be said
to have come wholly unprepared. The slight
sketch just given of him will show that the most
important part, the mind of a painter, he already
possessed ; the nature of his amusements (in which,
some one has well observed, men are generally
most in earnest,) having unconsciously disciplined
his mind for this pursuit. He had looked at Na-
ture with the eye of a lover ; none of her minutest
beauties had escaped him, and all that were stir-
ring to a sensitive heart and a romantic imagina-
tion were treasured up in his memory, as themes
of delightful musing in her absence : and they

came to him in those moments with that never-failing freshness and life which love can best give to the absent. But the skill and the hand of an artist were still to be acquired.

But perseverance, if not a mark of genius, is at least one of its practical adjuncts; and Monaldi possessed it. Indeed there is but one mode of making endurable the perpetual craving of any master-passion — the continually laboring to satisfy it. And, so it be innocent, how sweet the reward! giving health to the mind without the sense of toil. This Monaldi enjoyed; for he never felt that he had been toiling, even when the dawn, as it often happened, broke in upon his labors.

Without going more into detail, in a very few years Monaldi was universally acknowledged to be the first painter in Italy. His merit, however, was not merely comparative. He differed from his contemporaries no less in kind than in degree. If he held anything in common with others, it was with those of ages past — with the mighty dead of the fifteenth century; from them he had learned the language of his art, but his thoughts, and their turn of expression were his own. His originality, therefore was felt by all; and his country hailed him as one coming, in the spirit of Raffaelle, to revive by his genius her ancient glory.

3

It is not, however, to be supposed, that the
claims of the new style were allowed at once,
since it required not only the acquisition of a new
taste, but the abandoning an old one. In what is
called a critical age, which is generally that which
follows the age of production, it is rarely that an
original author is well received at once. There
are two classes of opponents, which he is almost
sure to encounter : the one consists of those who,
without feeling or imagination, are yet ambitious of
the reputation of critics ; who set out with some
theory, either ready made to their hands and purely
traditional, or else *reasoned out* by themselves from
some plausible dogma, which they dignify with
the name of philosophy. As these criticise for *dis-
tinction*, every work of art becomes to them, of
course, a personal affair, which they accordingly
approach either as patrons or enemies ; and woe
to the poor artist who shall have had the hardihood
to think for himself. In the other class is com-
prised the well-meaning multitude, who, having no
pretensions of their own, are easily awed by au-
thority ; and, afraid to give way to their natural
feeling, receive without distrust the more confident
dicta of these self-created arbiters. Perhaps at no
time was the effect of this peculiar usurpation
more sadly illustrated than in the prescriptive

commonplace which distinguished the period of
which we speak. The first appearance of Monal-
di was consequently met by an opposition propor-
tioned to the degree of his departure from the
current opinions. But as his good sense had re-
strained him from venturing before the public until
by long and patient study he had felt himself en-
titled to take the rank of a master, he bore the
attacks of his assailants with the equanimity of one
who well knew that the ground he stood upon was
not the quicksand of self-love. Besides, he had
no vanity to be wounded, and the folly of their
criticisms he disdained to notice, leaving it to time
to establish his claims. Nor was this wise for-
bearance long unrewarded, for it is the nature of
truth, sooner or later, to command recognition ;
some kindred mind will at last respond to it ; and
there is no true response that is not given in love ;
hence the lover-like enthusiasm with which it is
hailed, and dwelt upon, until the echo of like
minds spreads it abroad, to be finally received by
the many as a matter of faith. It was so with
Monaldi.

As our business, however, is rather with the
man than the painter, we shall only stop to notice
one of his works ; and that less as being the cause
of his final triumph, than as illustrating the pecu-

liar character of his mind. The subject of the
picture was the first sacrifice of Noah after the
subsiding of the waters ; a subject of little promise
from an ordinary hand, but of all others, perhaps,
the best suited to exhibit that rare union of intense
feeling and lofty imagination which characterized
Monaldi. The composition consisted of the patri-
arch and his family, at the altar, which occupied
the foreground ; a distant view of mount Ararat,
with the ark resting on its peak ; and the interme-
diate vale. These were scanty materials for a
picture ; but the fulness with which they seemed
to distend the spectator's mind left no room for
this thought. There was no dramatic variety in
the kneeling father and his kneeling children ; they
expressed but one sentiment — adoration ; and it
seemed to go up as with a single voice. This
gave the soul which the spectator felt ; but it was
one that could not have gone forth under common
day light, nor ever have pervaded with such em-
phatic life other than the shadowy valley, the
misty mountain, the mysterious ark, again floating
as it were on a sea of clouds, and the lurid, deep-
toned sky, dark yet bright, which spoke to the
imagination of a lost and recovered world — once
dead, now alive, and pouring out her first song of
praise even from under the pall of death.

Monaldi was fortunate on the first exhibition of this picture to have for his leading critic the cavalier S——, a philosopher and a poet, though he had never written a line as either.

" I want no surer evidence of genius than this," said he, addressing Monaldi; " you are master of the chiaro' scuro and color, two of the most powerful instruments, I will not say of Art, but of Nature, for they were her's from her birth, though few of our painters since the time of the Caracci appear to have known it. If I do not place your form and expression first, 't is not that I undervalue them; they are both true and elevated; yet, with all their grandeur and power, I should still hold you wanting in one essential, had you not thus infused the human emotion into the surrounding elements. This is the poetry of the art; the highest nature. There are hours when Nature may be said to hold intercourse with man, modifying his thoughts and feelings; when man reacts, and in his turn bends her to his will, whether by words or colors, he becomes a poet. A vulgar painter may perhaps think your work unnatural; and it must be so to him who *sees only with his eyes.* But another kind of critic is required to understand our rapt Correggio, or even — in spite of his abortive forms — the Dutch Rembrant.

3*

These are men, whose hearts and imaginations seem to have been so dependent on each other, that I could easily conceive excess of misery might have driven them to madness."

But the cavalier S—— was not content with admiring only, he added the picture to his collection ; nor did he stop there, for he was one who could not look at a work of genius without a feeling of kindness for its author ; and Monaldi was soon enabled, through his friendship and munificence, to follow his own inclinations and give free scope to his powers.

By the aid of this generous friend, added to his own persevering industry, Monaldi's works, and consequently his fame, were soon spread throughout Italy ; wealth and distinction followed of course ; and, to complete his triumph, he was finally honored with a special commission from the pope himself. In short, no artist since the time of Raffaelle ever drew after him such a train of admirers. But with all this incense the head and heart of Monaldi remained the same ; it could not soil the pure simplicity of his character ; he was still the same gentle, unassuming being.

CHAPTER II.

WHEN the friends parted, Maldura, whose course
in life had long been predetermined, set out for
Tuscany. His patrimony having placed him above
the necessity of laboring for his subsistence, he
had chosen the profession of letters: and he now
selected Florence as the place most eligible for the
display of his powers, and where, if not the most
easy, it would at least be the most honorable to
realize the future object of his ambition — the fame
of a Poet. But, unlike his friend, Maldura could
not find his chief reward in the pleasure of his
pursuit ; he did not love his art for its own sake: as
the spontaneous growth of his proper nature, but
rather for its contingent fruit in the applause of
others.

That his reputation finally fell so far short of the
measure of his ambition, could not be imputed to
the want of early encouragement, much less to any
deficiency in himself of industry or confidence.
He had scarcely reached his twenty-third year,

when he was elected a member of the Della Crus-
ca Academy. This premature honor seemed an
earnest of the speedy fulfilling of his hopes; and it
gave a lightness to his heart that persuaded him it
was overflowing with benevolence. It is difficult
for any man to believe this without, in some de-
gree, acting up to his faith, and the partial testi-
mony of his actions producing the same conviction
in others. Maldura seldom received a compliment
on his talents without an accompanying tribute to
his virtues. But his reputation was still private;
for his conversation and friendly acts were neces-
sarily confined to his personal acquaintance. He
had not as yet become the talk of the public; had
heard no eager whispering as he walked the streets;
marked no pointing finger as he entered the the-
atre; and at no conversazione, had the tingling
monosyllables, " that 's he," ever once met his ear.
But he consoled himself for this by anticipating
the *sensation* which his first work would not fail to
produce: this was a long and elaborate poem, in
which, it appeared to him, every established rule
that could apply to his subject had been strictly ob-
served.

The poem was at length published. Alas, who
that knows the heart of an author — of an aspiring
one — will need be told what were the feelings of

Maldura, when day after day, week after week passed on, and still no tidings of his book. To think it had failed was wormwood to his soul. " No, that was impossible." Still the suspense, the uncertainty of its fate were insupportable. At last, to relieve his distress, he fastened the blame on his unfortunate publisher; though how he was in fault he knew not. Full of this thought, he was just sallying forth to vent his spleen on him, when his servant announced the count Piccini.

"Now," thought Maldura, "I shall hear my fate;" and he was not mistaken; for the Count was a kind of talking gazette. The poem was soon introduced, and Piccini rattled on with all he had heard of it: he had lately been piqued by Maldura, and cared not to spare him.

After a few hollow professions of regard, and a careless remark about the pain it gave him to repeat unpleasant things, Piccini proceeded to pour them out one upon another with ruthless volubility. Then, stopping as if to take breath, he continued, " I see you are surprised at all this; but indeed, my friend, I cannot help thinking it principally owing to your not having suppressed your name; for your high reputation, it seems, had raised such extravagant expectations as none but a first rate genius could satisfy."

"By which," observed Maldura, "I am to con-
clude that my work has failed?"

"Why, no — not exactly that; it has only not
been praised — that is, I mean in the way you
might have wished. But do not be depressed;
there's no knowing but the tide may yet turn in
your favor."

"Then I suppose the book is hardly as yet
known?"

"I beg your pardon — quite the contrary.
When your friend the Marquis introduced it at his
last conversazione, every one present seemed quite
au fait on it, at least, they all talked as if they had
read it."

Maldura bit his lips. "Pray who were the com-
pany?" "Oh, all your friends, I assure you:
Guattani, Martello, Pessuti, the mathematician, Al-
fieri, Benuci, the Venetian Castelli, and the old
Ferrarese Carnesecchi: these were the principal,
but there were twenty others who had each some-
thing to say."

Maldura could not but perceive the malice of
this enumeration; but he checked his rising choler.
"Well," said he, "if I understand you, there was
but one opinion respecting my poem with all this
company?"

"Oh, by no means. Their opinions were as
various as their characters."

" Well, Pessuti — what said he ? "

" Why you know he 's a mathematician, and should not regard him. But yet, to do him justice, he is a very nice critic, and not unskilled in poetry."

" Go on, sir, I can bear it."

" Why then, it was Pessuti's opinion that the poem had more learning than genius."

" Proceed, sir."

" Martello denied it both ; but he, you know, is a disappointed author. Guattani differed but little from Pessuti as to its learning, but contended, that you certainly showed great invention in your fable — which was like nothing that ever did, or could happen. But I fear I annoy you."

" Go on, I beg, sir."

" The next who spoke was old Carnesecchi, who confessed that he had no doubt he should have been delighted with the poem, could he have taken hold of it ; but it was so *en regle,* and like a hundred others, that it put him in mind of what is called a polished gentleman, who talks and bows, and slips through a great crowd without leaving any impression. Another person, whose name I have forgotten, praised the versification, but objected to the thoughts."

" Because they were absurd ? "

"Oh, no, for the opposite reason — because they had all been long ago known to be good. Castelli thought that a bad reason; for his part, he said, he liked them all the better for that — it was like shaking hands with an old acquaintance in every line. Another observed, that at least no critical court could lawfully condemn them, as they could each plead an *alibi*. Not an *alibi*, said a third — but a *double*; so they should be burnt for sorcery. With all my heart, said a fourth — but not the poor author, for he has certainly satisfied us that he is no conjurer.

"Then Castelli — but, 'faith, I don't know how to proceed."

"You are over delicate, sir. Speak out, I pray you."

"Well, Benuci finished by the most extravagant eulogy I ever heard."

Maldura took breath.

"For he compared your hero to the Apollo Belvedere, your heroine to the Venus de Medicis, and your subordinate characters to the Diana, the Hercules, the Antinuous, and twenty other celebrated antiques; declared them all equally well wrought, and beautiful — and like them too, equally cold, hard, and motionless. In short, he maintained that you were the boldest and most original poet

he had ever known ; for none but a hardy genius,
who consulted nobody's taste but his own, would
have dared like you, to draw his animal life from
a statue-gallery, and his vegetable from a hortus
siccus."

Maldura's heart stiffened within him, but his
pride controlled him, and he masked his thoughts
with something like composure. Yet he dared
not trust himself to speak, but stood looking at
Piccini, as if waiting for him to go on. " I believe
that 's all," said the count, carelessly twirling his
hat, and rising to take leave.

Maldura roused himself, and, making an effort,
said, " No, sir, there is one person whom you have
only named — Alfieri ; what did he say ? "

" Nothing ! " Piccini pronounced this word
with a graver tone than usual ; it was his fiercest
bolt, and he knew that a show of feeling would
send it home. Then, after pausing a moment, he
hurried out of the room.

Maldura sunk back in his chair, and groaned in
the bitterness of his spirit. " As for the wretches
who make a trade of sarcasm, and whose petty
self-interest would fatten on the misfortunes of a
rival, I can despise them ; but Alfieri — the manly,
just Alfieri — to see me thus mangled, torn piece-
meal before his eyes, and say *nothing !* Am I then

4

beneath his praise? Could he not find one little
spark of genius in me to kindle up his own, and
consume my base assassins? No — he saw them
pounce upon, and embowel me, and yet said
nothing."

Maldura closed his eyes to shut out the light of
day; but neither their lids, nor the darkness of
night could shut out from his mind the hateful
forms of his revilers. He saw them in their as-
semblies, on the Corso, in the coffee-houses, knot-
ted together like fiends, and making infernal mirth
with the shreds and scraps of his verses, while the
vulgar rabble, quitting their games of domino, and
grinning around, showed themselves but too happy
to have chanced there at the sport. In fine, there
are no visions of mortified ambition which did not
rise up before him. But they did not subdue his
pride. Yet it was near a week before he could
collect sufficient courage to stir abroad; nor did
he then venture till he had well settled the course
he meant to pursue, namely, to treat all his ac-
quaintance still with civility; to appear as little
concerned about his failure as possible, well know-
ing that in proportion to his dejection would be the
triumph of his enemies; but to accept no favor,
and especially to have no *friend*; — a resolution
which showed the true character of the man, who

could not endure even kindness, unless offered as incense to his pride.

This artificial carriage had the desired effect. It silenced the flippant, and almost disarmed the malignant; while those of kinder natures saw in it only additional motives for respect; indeed there were some even generous enough to think better of his genius for the good temper with which he seemed to bear his disappointment. In short, so quietly did he pass it off, that after a few months no one thought, or appeared to think, of Maldura as an unsuccessful author.

But it was scored in his heart, never to be forgotten, and he longed for vengeance. To effect this, however, he must first possess literary power; and that he knew could be gained only by success in writing.

But was he in a fit temper for poetry? There are some minds to which such a blow would have been death. Not such was Maldura's. He had not lost his self-confidence; and was willing to ascribe his failure to anything but his own deficiency; to the jealousy of his rivals, to their influence over the many; to the general apathy to his particular subject; nay, even to his originality, and to the common fear of praising what is new: so that instead of weakening, it tended rather to

strengthen his powers. He had two works on hand, a satiric poem, and a tragedy; with the first he could now go on con amore, having no lack of wit, and being now surcharged with gall; and that no one might suspect him as the author, he determined to go to Rome, and send it thence, under a feigned name, to Florence.

The poem was soon finished, and sent from Rome accordingly. About a month after, he received two letters, one bearing his assumed name and the other his real one. He tore them open as a hawk would a sparrow. Glancing at the signature of that in his own name, he read "Piccini." He was about to dash it to the ground when his eye caught the following words: "The whole town rings with the praises of this unknown poet. Every body talks of, and admires him; even Benuci commends, without a dash of irony." Maldura grinned with triumph. "Wretch!" said he, crushing the letter, "you know not that the man whom you would wound with the praise of another is himself that other. But the count Piccini shall one day know the satirist better." The other letter was from his bookseller, informing him of the rapid sale and complete success of his work, and enclosing a complimentary sonnet from Castelli.

Though Maldura had fixed his eye upon a far

higher mark than the reputation of a mere satirist, which he held almost in disdain in comparison with that to which his genius was entitled, at any rate as insufficient for his ambition, — he was yet for the present content to enjoy his triumph, and it pleased him to regard it as an earnest of the success of his tragedy.

4*

CHAPTER III.

MALDURA was now comparatively gay of heart, and mixed again with society. The reputation of his learning procured him the same attentions in Rome as in Florence ; and as there had been no outward change in him, he had no difficulty in making acquaintance.

Among the most cordial of these new friends was a distinguished advocate, a near relation of the pope, of the name of Landi. He had taken a particular pleasure in Maldura's conversation, and had often invited him to his house; but Maldura, with the perverseness which now began to be the rule of his conduct, had as often declined these invitations, and for the very reason that would have induced another to accept them — because they were really cordial. He was greedy of admirers, but his growing habit of distrust shrunk from intimacy. In a moment of caprice, however, he at last went.

The advocate received his guest with great

heartiness, and introduced him to his daughter with such encomiums as plainly marked him a favorite.

It was impossible for any one to look upon Rosalia Landi with indifference. Her beauty was of a kind which might be called universal — at least, in effect, for it was difficult to determine whether it were more striking or winning ; whether it lay more in the just proportion and harmony of her features, or in the exquisite and ever-varying expression that played over them.

For the first time in his life Maldura's heart was touched. Hitherto he had regarded woman merely as belonging to the regular materials of poetry ; had examined and analyzed their charms, only to class and describe them. Now he neither studied nor thought of studying ; he could only feel that the object before him was lovely ; and he felt too with surprise that her beauty and mind, as they each alternately won his admiration, each gave him pain almost proportioned to his pleasure. For a short time these contending emotions perplexed him ; but a glance into his heart explained all — she was the first woman with whose fate he had ever felt a wish to unite his own. From that moment Maldura marked her for himself.

Yet, sudden as was his love, it was not wholly

unmixed. Wherever there is a ruling passion the affections naturally become subordinate, and take their color from that; they have no singleness of feeling towards any object, and can have no sympathy with any except as it ministers to the paramount appetite. It was so with Maldura. The beauty of Rosalia no sooner touched his heart than it mounted to his brain. He saw her in fancy gracing his future triumphs, and himself, through her, the proud object of envy; then her father's interest, his high connexions, and their influence, all passed in array before him, to make straight and easy the opening road of his ambition.

Every time Maldura repeated his visit the stronger became these motives, and the more confirmed his love, till at last, thus mingling with all his hopes of distinction, the image of Rosalia took such hold on his heart, that he could never think of the one without calling up the other.

A few weeks after, Maldura waited on the advocate to solicit permission to address his daughter. It was readily granted, and in the most flattering manner. Landi added, that he "should have his good word, but for the result he must refer him to his child."

However sagacious in other things, there is generally in proud men a remarkable obtuseness

as to matters of the heart which often leads them
astray where they feel most confident; their habit of
looking at every thing through the misty medium
of self-love, prevents their distinguishing those
minute degrees of good will, esteem, respect, and
so on to exclusive preference, with which a deli-
cate woman graduates her manner towards those
of the other sex. But that which obscures the
distinctive shades of objects enlarges their outlines ;
hence little attentions are easily mistaken for some-
thing more, and, where often repeated, their bare
accumulation soon grows to what is mistaken for
love. Maldura was troubled with no doubts about
the issue of his suit : how it terminated may be
gathered from a part of a conversation between
Rosalia and her father.

"So far, Rosalia," said her father, "you have
answered well ; you have done Maldura justice.
But why stop with his talents ? can you find no-
thing more to commend ? "

Rosalia still continued silent.

"You surely cannot object to his person ? "

"Certainly not ; I have rarely seen one so hand-
some."

"Perhaps you dislike his manners ? "

"On the contrary, I think them uncommonly
agreeable : his address, too, is even more than

polished, 't is refined; and his powers of entertaining I believe are entirely his own."

" Very well! Go on, my dear. — Nay, why again silent? I fear — say — have you heard any thing against his morals?"

" Nothing."

" Or do you object to his disposition?"

" I know nothing of his disposition, and cannot therefore form any opinion of it."

" Have a care, Rosalia; there is no species of detraction more hard and cutting than an icy negative."

" My dear father, for worlds I would not think evil — if I could help it."

" Then you cannot help thinking ill of his disposition?"

" I did not say so. I am willing to believe it good till I have proof to the contrary."

" As yet?"

" Not a shadow of one."

" Then I am satisfied; for I believe it to be generous and noble. And I believe, also, that my child is too just to harbor any degree of dislike without cause."

Rosalia bowed in assent.

Landi proceeded: " Well, then, since you highly approve of most of his qualities, and object

to none, what prevents my dear daughter —— Do
not be alarmed, Rosalia, I am a father, not a ty-
rant. I am, besides, now an old man, and have
no other hold on the world but in you ; and in
guarding you from ill, and leading you to good, I
am only consulting my own happiness."

"Dearest father ! " said Rosalia, " I know, I
feel your goodness ; you have ever been the best
of parents ; and I should think myself unworthy
any blessing could I wilfully cause you a moment's
pain."

" I believe it, Rosalia. Neither should I think
better of myself were I disposed to enforce my
own will at the expense of your quiet. — Now that
we understand each other, let me speak plainly.
Signor Maldura has this morning asked permission
to address you. I will not trouble you by repeat-
ing my opinion of his merits ; you already know
it, and know that it could not well be higher.
Need I say after this that it would please me to
call him my son ? — that I think him, of all the
men I have known, the *very* man to make my
daughter happy ? — Will you not speak, Rosalia ?"

"Oh, father ! " cried Rosalia, throwing her
arms round his neck.

" Be calm, my child. Let us be rational."

Landi led her to a chair, and taking a seat by

her, continued: "I know, my dear Rosalia — at
least I think I know, the cause of your reluctance.
You have a tincture of romance in you, which is
natural enough at your age ; and you have formed,
I doubt not, certain peculiar notions of love, which
you hope one day to realize. You have now just
glanced into your heart, and have found in it (as
is very probable) nothing like them. I should
have been surprised if you had ; for a real lover is
not half so accommodating as one of the brain.
But the shadows of a youthful imagination pass
away with youth. Then comes a sense of the
substantial and real ; and with it a wondering that
we could ever have rejected even the humblest
every-day qualities of the heart and understanding
for these brilliant nothings. It may seem hard to
ask you, who are yet young, to choose between
them. But if I ask it, it is not to give up even
your fancies for any commonplace reality. The
qualities of Maldura are as rare as real. And if he
has not yet thrilled you with any of those tender
emotions — those pleasing pains — which your
imagination may have taught you to associate with
love, do not therefore think him the less fitted to
make you happy. Had he even inspired them,
they could not last ; a few months, or a few weeks,
would bring them to an end. Not so will it be

with the qualities he now offers for your regard ;
and not so would you find it, when courted and
honored as the wife of the first genius of the
age."

"My dear father," said Rosalia, "I would that
I could reason on this subject, but — indeed I
cannot."

" Strange ! You hint not even an objection, and
yet — Do you think I overrate him ? "

" No ; he deserves all you say of him ; but yet —"

" You would still reject him ? "

Rosalia was silent.

" If you esteem, you may certainly love ; nay,
it will follow of course."

"Did you *always* think so, sir ? "

" Perhaps not. When I was young, I was no
doubt fanciful, like others."

" And yet you did not marry till past thirty."

" Well, child ? "

"My mother died when I was too young to
know her ; but I have heard her character so often
from yourself and others, that I have it now as
fresh before me as if she had never been taken
from us. Was she not mild and gentle ? "

"As the dew of heaven."

" And her mind ? "

" The seat of every grace and virtue."

" And her person too was beautiful ? "

" Except yourself, I have never seen a creature so lovely."

" And did she make you a *good* wife ? "

Landi turned pale. " Rosalia — my child — why remind me, by these cruel questions, of a loss which the whole world cannot repair ? "

" She was then all you wished ; and yet I have heard that yours was a *love-match*."

" No more," cried Landi, averting his face. " You have conquered."

Rosalia pressed his hand to her lips.

" No, my child," said her father, after a few minutes, " though my head is old, I find that my heart is still young as ever. I will not tempt you to a lukewarm vow : you are a living counterpart of her who would have rejected a monarch for your father — like her, too, you shall choose according to the impulse of your own pure heart."

Landi, wishing to save his friend pain, lost no time in communicating the result of this conference. When Maldura heard it he stood for a moment like one suddenly waked from sleep, doubting if the words, which still echoed in his ears, were really those of another person, or the mere coinage of his brain. But it was only for a moment ; the compassionate tone of Landi, his

look of sympathy, and the tremulous pressure of his hand, soon convinced him of their reality. Yet even then he doubted; not that he had heard them, but of their truth ; he doubted Landi's sincerity, and thought it a contrivance to rid himself decently of the connexion. This suspicion brought the whole man into his face ; but he constrained himself to be civil, whilst he persisted in refusing to take any denial but from the lady herself. Landi, finding it in vain to remonstrate, at last consented that Maldura should wait on Rosalia the next morning. — The interview was short and decisive. But never was refusal uttered with more gentleness and delicacy. And never did rejected lover hear his own merits more eloquently set forth than did Maldura, even when the lips of Rosalia pronounced his doom. " Blame not my will," she concluded, " but — if any thing — my heart, that knows no control but from its own wayward fancies."

The character of Rosalia was of that nice mixture of softness and firmness which makes the perfection of woman. The first she derived from nature ; the last was the result of principle ; and while from the one she was open to every impression of the affections, the regular watchfulness of the other effectually guarded her from all that

would not stand its scrutiny. This moral subor-
dination, or rather just balance between sense and
sensibility, not unfrequently subjected her, with
superficial observers, to the imputation of coldness.
But hers was the coldness of her better judgment,
only occasional, and always with a purpose. When
her heart was opened, and with the sanction of her
principles, the whole woman gave way at once.

It was, no doubt, the consciousness of her dis-
position to this prodigal self-abandonment of the
heart that first led her to seek a less fallacious
guide than her own sanguine impulses. Happily
her father's instructions here came to her aid; and
as Landi was a man of sincere piety, it may
readily be inferred that the guide she found in
them was religion. Hence that high standard of
excellence by which she was accustomed to meas-
ure all that approached her.

CHAPTER IV.

HAD Maldura loved Rosalia Landi for herself, the
manner in which she had rejected him would have
exalted her still more in his estimation. But with
the loss of her person came a blight on his hopes
of distinction. Though he still felt the same con-
fidence in his own powers, yet he could not bear
to forego all those advantages which he had so
long counted on from his union with Rosalia ; and
he hated her as one who had scattered a glorious
vision of ambition which her sorcery had called
up as if but to mock him. But, whatever his
rage, or hopes of revenge, the fortune of his tra-
gedy, which was now on its way to Florence,
soon drove her from his mind. He had laid out
his whole strength on this performance, sparing
neither time nor labor, and giving to it the highest
finish ; so that when he sent it he felt that he had
done his best, and that should it fail it would be
from some fatality which he could not control : it
was his last stake, and he was willing to rest his

5*

all upon it; for the more he considered it, whether in the whole or in parts, the better he was satisfied that it could not fail.

The success of his satire immediately procured the tragedy a good reception at the theatre; it was already announced for representation, and Maldura had only to wait for the decision of the public. He did not wait long; the fate of the play soon reached him: it had fallen dead on the boards the first night. So wrote the manager.

This was an unlooked-for blow; and he sat for near an hour gazing upon the manager's letter, as if endeavoring to recall, he knew not what; for its purport was gone ere hardly known. But his recollection soon returned. Better had it not, than so to make visible the utter desolation within him — to show him a mind without home or object; for he could look neither back nor forward. If he looked to the future, in place of the splendid visions that once rose like a mirage, he beheld a desert; if he turned to the past, his laborious realities, once seeming so gorgeous, now left without purpose, only cumbered the ground with their heavy ruins.

In this hopeless state, however, there was one comforter which never deserted him — his indomitable pride; it was this sustained him. Had a shadow of self-distrust but crossed Maldura for a

moment, it might have darkened to insanity; but no doubts of his genius had ever entered his mind; he was therefore an ill-used man, and he hated the world which had thus withheld his just rights. His only solace now, was in the wretched resource of the misanthrope, in that childish revenge which, in the folly of his anger, he imagines himself taking on the world, by foregoing its kindnesses; for there is small difference between a thorough misanthrope and a sullen child; indeed their *illogical* wrath generally takes the same course in both, namely, to retort an injury by spiting themselves. For the full indulgence of this miserable temper, he retired to an unfrequented part of the city, and, rarely venturing out except at night, it was generally concluded that he had quitted Rome — where he was soon forgotten.

CHAPTER V.

It was about two years after the events recorded in the preceding chapter, that Monaldi arrived in Rome; where his reception was such as might have amply satisfied him, had he been far more ambitious of popular admiration. To say, however, that he was wholly insensible to praise, would not be true; so far as he believed it an expression of sympathy, it was justly valued, nay, it was then most dear to him as one of the graces of our social nature; nor did he affect an indifference to that posthumous sympathy with excellence — that purest form of fame to which so many noble minds, under poverty and neglect, have patiently looked — and looked, alas, for their only reward. Yet the love of fame was less a passion with Monaldi than the result of a sober law of his mind, which won his obedience, because it carried with it the assurance of an enduring nature. But he had no craving for distinction, much less for notoriety, or what is popularly called reputation; in-

deed, he had passed over the graves of too many
buried reputations not to have learned how their
common tenure, the fashion of one age is valued
by another.

With such an artist it cannot be supposed that
a mere adulator of his name could have found
much favor, nor, when it is added that Monaldi's
was one of those kindly natures to which the duty
of repelling is at all times painful, will it be thought
singular that a person of this description should
have been to him an object of especial annoyance.
It was to escape from one of these unmeaning flat-
terers, who seldom failed to fasten upon him when-
ever they met, that Monaldi one day turned into a
gateway in an obscure street, where one of his
figure was rarely seen. The passage leading from
it was somewhat dark, and he hoped to conceal
himself there till his persecutor had passed, when
he observed a person from within coming towards
him. The awkwardness of his situation obliged
him either to retreat, or to explain it, and he spoke.
"Your pardon, Signor — I pray you excuse this
intrusion." The stranger started. "Nay," added
Monaldi, "it will be but for a moment. In truth
I am an unlucky artist, who would merely avoid
a troublesome acquaintance."

"Begone!" said the stranger.

"Good heaven!" cried Monaldi, "sure that voice" — But the stranger had disappeared.

"It is — it must be," said he, and without further thought he entered the court. They were now under the open sky. The stranger stopped, — and Monaldi beheld his long lost friend.

"Maldura!" — was all his full heart could utter.

Maldura spoke not a word; but he suffered his hand to remain passively within the grasp of his friend.

"I see 't is with you as myself," said Monaldi at last. "But how can words add to the joy of this meeting?"

"Words! — True — they are idle." Maldura was no hypocrite, and his manly spirit revolted at expressing what he did not feel — and what he felt his heart was not yet hard enough to utter. Yet something must be said — and that neither unkind nor hollow. "You look well, Monaldi; even better than when we parted at Bologna."

"That's a long time — very long," said Monaldi. "Yet, long as it is, I need hardly tell Maldura that I could not recall many days when he has been out of my mind — especially since I lost trace of you. But where have you been all this while? you know not how many ill bodings I have had on account of your strange disappearance —

no letters — no clue — sometimes I thought you
might have embarked for Spain — as you once
talked of doing — and been shipwrecked ; then in
a more cheerful mood, I would suppose you vol-
untarily banished to some quiet solitude, that you
might give your whole mind to some great work —
for I remembered your favorite maxim, that the
sacrifice of a whole life were but a cheap price for
fame ; then again my apprehensions would take
the worst conclusion — that you had been robbed
and murdered. Tell me, where have you been ?
what have you been doing ? "

" 'T is of little consequence," replied Maldura.
" The past is past — and the wisdom of Solomon
could not make it better or worse : let it rest
then."

" Nay, I would not ask you to recall what might
give you pain, deeply as I am interested."

" I did not say it would give me pain — I said
it was useless."

" I would know then no more than will give you
pleasure. So we will talk of what remains of the
past. Your active mind cannot have been idle,
and the world expects much of you."

" The world ! " This was touching a galled
spot. Maldura's eyes flashed ; but a smile of
fiercer scorn succeeded ? " We will talk of the

world when it shall have become worth something
better than an idiot's slaver. But for ourselves —
we shall be better in the house: 't is not a palace,
as you see — but 't will afford us shelter from the
sun."

"You know I am not dainty," answered Mo-
naldi. "Or if I were, the place would be the last
thing I should think of at this time."

"I was not apologizing for it," said Maldura,
somewhat proudly, "the knaves and fools that live
in palaces might reconcile a wise man to one much
worse."

"Maldura's mind," said Monaldi — and he said
it in a tone that spoke anything but abatement of
his youthful reverence — "such a mind would dig-
nify any palace."

Maldura's heart softened in spite of himself.
He hated the world, but not its praise; and he led
the way into the house with less reluctance than
he had expected.

When the friends left school, they had engaged
to write to each other, and their correspondence
had continued with little interruption up to the
time of Maldura's first failure; when, from the
fear of betraying the secret misery occasioned by
that event, he discontinued it. Since then, Mo-
naldi had never heard any tidings of his friend,

except that he had quitted Florence, but for what part of the world, he could never learn. Maldura, however, had long been apprized of all the other's movements, his success, and fame ; but the more he heard of them, the less did he incline to renew their intimacy; indeed the contrast which they formed to his own situation was among the sorest aggravations of his misery. Had it been a stranger — any other man — so courted and followed, he thought he could have borne it ; but to find an object of envy in his humble schoolfellow, on whom he had once looked down, was a degradation which he could not forgive.

With feelings like these, it is not surprising that Maldura forbore to seek out his friend ; nor, when accident had brought them together, and he recognised his voice in the gateway, that he should have sought to avoid him. But his heart was not yet entirely hardened, and his late interview with Monaldi had touched it. Yet so new seemed to him the consciousness of any kind feeling, that it was a considerable time after Monaldi's departure before he could realize what had passed ; and then he felt as if something had gone from him which he hardly knew whether to regret or not. With one thing, however, he was satisfied — that his friend had conceived no suspicion of the change

6

in his heart; for, proud as he was, Maldura had
still a secret coveting of the esteem of others : so
that, upon the whole, he almost doubted if he
were sorry for the meeting. In fact, he was much
better pleased than he was willing to admit : for
however a misanthrope may pride himself on the
sovereignty of his hatred, as long as he continues
in this world, he can never so entirely destroy his
social nature but that some leaven of it will work
within him.

The intercourse thus renewed between the two
friends could not but differ in many respects from
that of their earlier years. Monaldi, however,
hailed it as a promise of many pleasures. His
affectionate disposition had long felt the want of a
friend ; but his studious habits, added to his natu-
ral reserve, had hitherto prevented his forming any
second intimacy; and he now dwelt with delight
on the thought of pouring out his heart into the
bosom of his early friend. But he soon found
that Maldura was not that open, social being he
had once known, that he had become cold, absent
and gloomy : though the change grieved him and
repressed his confidence, it did not lessen his at-
tachment ; and, ascribing it to some secret sorrow,
he imagined that his sympathy was more than ever
needed. His efforts, however, were in vain — the

same distant, taciturn demeanor continued to repel every act of kindness.

It is the natural consequence of a fruitless endeavor to alleviate the afflictions of those who are dear to us to become ourselves partakers of their sufferings. And if the cause of our pain be not hateful, we feel, or rather fancy that we shall feel, relieved, the nearer we are to it. Monaldi's visits to his friend, however, were seldom followed by the effect he desired; being for the most part passed in mutual silence, or in a few common remarks on indifferent topics.

It was after a morning of more than usual depression and concern on his account, that Monaldi one day called on his unhappy friend. Maldura's apathy seemed for the moment overcome; and he could not help expressing surprise at such an unwonted visit; for it was scarcely past mid-day, and he knew that nothing short of necessity could tempt the devoted artist to leave his studio at that hour. Monaldi simply replied, that he had felt indisposed to work; and he drew a chair to a window. The apartment being in an upper story, and the house somewhat elevated, commanded an extensive view of the southern portion of the city, overlooking the Campo Vaccino, once the ancient forum, with its surrounding ruins, and taking in a part of the

Coliseum. The air was hot and close, and there
was a thin yellow haze over the distance like that
which precedes the scirocco, but the nearer objects
were clear and distinct, and so bright that the eye
could hardly rest on them without quivering, espe-
cially on the modern buildings, with their huge
sweep of whited walls, and their red-tiled roofs,
that lay burning in the sun, while the sharp, black
shadows, which here and there seemed to indent
the dazzling masses, might almost have been fan-
cied the cinder-tracks of his fire. The streets of
Rome, at no time very noisy, are for nothing more
remarkable than, during the summer months, for
their noontide stillness, the meridian heat being
frequently so intense as to stop all business, driv-
ing everything within doors, with the proverbial
exception of dogs and strangers. But even these
might scarcely have withstood the present scorch-
ing atmosphere. It was now high noon, and the
few straggling vine-dressers that were wont to stir
in this secluded quarter had already been driven
under shelter; not a vestige of life was to be seen,
not a bird on the wing, and so deep was the still-
ness that a solitary foot-fall might have filled the
whole air; neither was this stillness lessened by
the presence of the two friends — for nothing so
deepens silence as man at rest; they had both sat

mutely gazing from the window, and apparently unconscious of the lapse of time, till the bell of a neighboring church warned them of it.

" Yes," said Monaldi — as if the sound had suddenly loosed his tongue — " there *is* a chain that runs through all things. How else should the mind hear the echo of its workings from voiceless rocks? Mysterious union! that our very lives should seem but so many reflections from the face of nature ; and all about us but visible types of the invisible man! Even the works of man, the passive combinations of his hand — they too have found a tongue in the elements, and become oracular to his heart — even as that proud pile of Titus, so dark and desolate within, now speaks from without, in the gorgeous language of the sun, to mine. Look, Maldura : here is to me a book of history and prophecy. You see in that distant mist the prefigurement of my future ; for my present state you need but look beneath us — on this oppressive splendor ; but for the past — thank heaven, that is still mine — the blessed past! how soothingly it speaks to me in this humble shade ! "

Maldura's distorted vision saw nothing in this but a covert sally of pride, and a half suppressed sneer passed over his features ; but his confiding friend gave it a different name.

6*

" You seem incredulous — why should you doubt
that I look on the past with envy ? "

" Some," answered Maldura, " might think that
it needed at least faith ; especially to believe it of
the favorite of popes and cardinals — for you look
back to obscurity."

" But not *you*, Maldura. For you know that
that obscurity was happy — because those I loved
were happy ; and because in them I had a true
home for all my wishes ; for we build not for our-
selves alone — at least anything that can satisfy,
or is worthy the heart ; and mine was never sub-
ordinate to the head. Others, who remember
nothing of my youth but its reserve, might perhaps
doubt it ; but not you. If I was reserved, you
well know it was neither from coldness or gloom ;
but that I was so moulded by early and severe
misfortunes. I was left an orphan ere I hardly
knew the blessing of kindred. This was the first
misfortune. Then followed another. That my
scanty patrimony might be husbanded, I was
doomed to waste the first ten years of my life
amongst illiterate boors — though, to do them
justice, they were honest. And, though unletter-
ed then myself, the thousand obscure longings, and
" deep and anxious questionings," on what I saw
and felt, which everywhere haunted me, and which

no one could resolve or satisfy, soon discovered to
me that I had but little in common with those
about me ; nay, the very expression of my thoughts
was often answered by a laugh, or by the nick-
names of idiot and dreamer You cannot wonder
then that I shrunk into myself, nor that I at length
became indeed a dreamer ; for my whole world
was within me, and would have been so now but
for one being — bless her memory. That being
was my sister."

Monaldi here appeared to be overcome by some
tender recollection ; but after a moment's pause
he proceeded, as if in continuation of his thoughts.
" No, it would be selfish to wish her back. You
remember her, Maldura ? "

The question seemed to rouse Maldura from his
abstraction, and he raised his eyes with a vacant
look. But, wishing to avoid an explanation, he
nodded in assent.

" It was in my twelfth year that we met for the
first time since my infancy ; for you may remem-
ber that she had been brought up by a distant re-
lation at Modena. What a strange faculty is this
memory ! I can see her now almost as distinctly
as if she were before me. She was only five years
older than myself, and yet when she kissed me and
looked upon me, it was with such a maternal look

— and she inquired about my little concerns in a tone so solicitous, so tender, that I could never from that hour either think or speak of her but with the veneration of a son. — Yes," continued Monaldi, while the recollection seemed to give a deeper fervor to his manner, " it was she first taught me that I had a heart — and too large for self; who made it the companion, nay, controller, of my intellect, giving it direction and purpose; and it was her praise that made me long for fame; for I felt that it would make her happy. But she was taken from me before the world knew that such a candidate for its praise was in being, or she herself had anything to dwell on save the prophetic visions which her sisterly love had travelled for into the future. But it is right, all right — she is happier where she is. I need not name the other being who came to supply her loss — nor how kindly ! Even now too I can see the stone seat in our play-yard, at Bologna — that good seat ! associated with so many nameless acts of kindness, which no one can understand but an orphan boy; and one as sensitive as desolate, and left to the cold, boisterous gaiety of a public school. Yes, Maldura, you alone in the wide world seemed to feel for my loss; and in that you did so you became to me more than the world. I exulted in

your talents; I grew proud of the prizes you won; and I looked to your future fame even with my poor sister's eyes, when she looked to mine. Why the last has not been realized I marvel — that such a mind — "

Maldura ground his teeth.

Monaldi saw the change in his countenance, and stopped : then added, " If I have touched on what is displeasing to you, forgive me. And yet it cannot be that the expression of a regret so natural — "

" The less that is said of it the better," said Maldura, with a bitter smile. " As for yourself — *you* have the world's trumpet. Keep it — I would none of its blast ; 't is made up of the breath of fools, or it may be knaves. Keep it, then, and be content. Good or bad, 't is yours, they say ; and will be, even when the grave shall have walled up your ears."

" No, Maldura — you have forgotten, or you mistake, my heart, if you think that fame alone can fill it. The very retrospect I have just made is proof enough. Why else should I dwell on scenes that are past, and quit the palpable present, to commune with shadows ? But I miscall them ; they are shadows only to my bodily eyes — to my affections they are substance — in effect the truest, so long as through the mysterious memory they

can give that thrilling play of life which present
realities deny. No ; the solitude of neglect were
better borne than solitary grandeur. We are not
made to enjoy alone — least of all things fame ;
't is a fierce splendor, that needs to be conducted
off by others ; if it rest with ourselves, it becomes
a fire that, sooner or later, must shrivel up the
heart. Had I parent or kindred — could the grave
give me back such sharers of my fame — but I will
not think of it. Cr — would you, Maldura — "

Maldura started from his seat.

" Again forgive me," said Monaldi, " I ought
not so to obtrude my regrets upon you."

Maldura turned from him as if he would hear
no more ; then, stopping awhile, said, " You have
had your marvel ; so too may I. If you count
fame nothing, why do you toil ? "

" Because I could not be idle and live ; and
because I love my art for its own sake. I should
still paint, had I the means, were I thrown on a
desolate island."

" Yet you have one thing, which many in the
world would think included all — wealth ; though
some indeed have called it trash — at least in
books."

" And do *you* think so, Maldura ? I know you
do not. Yet — " the thought now glanced on

Monaldi that his friend might be suffering from poverty ; his face lighted up, and he grasped Maldura's hand.

" What is it disturbs you ? " said Maldura, coldly withdrawing his hand.

" Disturb ! oh no ! I owe you a thousand thanks for this discovery. How could I have been so blind ! This obscure retreat, these sorry lodgings, speak it but too plainly."

" Speak what ? " asked Maldura, in amazement.

" Your secret. 'T is now mine."

The blood rushed to Maldura's forehead, and he felt as if he could have annihilated himself, Monaldi, and all who had ever known him.

" And it has made me happy," added Monaldi ; " for now I have something to live for."

The conclusion of this sentence relieved Maldura from the horror of his suspicion, but it left him still perplexed for its meaning.

Monaldi continued. " But why should I waste time in useless words. You have unwittingly betrayed the cause of your distress, Maldura ; and, pardon me that I rejoice at it. You suffer from the want of that " trash " with which fortune has overwhelmed, nay, oppressed me. Let me then put it to its right use, to the service of genius and virtue ; and where do these live purer and nobler

than in Maldura? Speak then, and say, that you will allow me to call the moiety of it yours."

As Maldura listened, his face became of an ashy paleness, his lips quivered, and his knees shook. "Pshaw!" said he; and he instantly recovered himself.

Monaldi was about to repeat his offer, when, suddenly turning upon him, Maldura gave him a look — such a look — Monaldi felt as if it had passed through him.

"Nay, what's the matter?" said Maldura, while a half compunctious feeling brought the blood back to his cheek.

"Tell me, have I offended you, Maldura?"

"No. Though I do not jump at your offer, you must not think it offends me; for, indeed, I ought to — that is — I *do* thank you. But — "

"Do not say that you decline it."

"I must; for I am above want."

"In spirit — "

"Ay, and in purse too."

"Then I will press you no further," said Monaldi.

A silence of several minutes followed.

"I fear," said Maldura at last, "I fear that I have not appeared so sensible to your kindness as I ought to be; but, I am rather unwell to-day —

indeed hardly myself — you will therefore pardon it."

"Nay," returned Monaldi, if you *did* appear a little proud of your independence, I ought not to blame you : though you should not have thought that your sharing *my* useless pelf would have made you the less free."

"But I *do* thank you. Will you not believe it ?"

"I do," said Monaldi, "from the bottom of my soul."

Maldura grasped his hand, and, pausing a moment, added, in a hollow voice, "Monaldi! you have indeed a noble heart ; and you deserve — yes, you deserve — all you possess." He then turned away and passed into another room.

"Alas !" thought Monaldi, as he walked homeward, "I fear his brain is unsettled." The thought sunk into his heart, and seemed to fix his friend there more firmly than ever.

"I have *said* it !" said Maldura when alone. "Yes, it went from me in spite of — Oh, that I had bestowed that word, so justly merited, on any other man. But I have said it ; and, true — it ought to have been said." Then, as if he would flee from his thoughts, or, rather, return to his wonted mood by a change of place, he snatched up his hat, and hurried into the street ; he had no

7

choice whither, but the half-formed wish led him
mechanically to the desolate baths of Caracalla.
These baths had long been his favorite haunt, for
there was something in their ruins he felt akin with
his fortunes, and he would often spend whole days
and nights there, sometimes sitting in their dark
recesses, and given up to misery, and sometimes
wandering to and fro, as if inhaling a kind of sav-
age refreshment from walking over the wreck of
prouder piles than his own.

CHAPTER VI.

It should have been mentioned, in a former part of this narrative, that among the honors bestowed on our artist, soon after his arrival in Rome, was the title of principal painter to the pope; which was immediately followed by an order for a series of pictures for the pontifical palace at Monte Cavallo. These works, which had occupied him for several years, being now completed, so added to his fame, that commissions flowed upon him from all quarters, insomuch that he was obliged to decline many from other distinguished personages both at home and abroad. But there was one order which he would have gladly declined for other reasons, yet, coming from the pontiff, it was a virtual command, and he was fain to accept it, though with more reluctance than the world might believe of one so flattered : this was a *"companion"* picture to a Madonna by Raffaelle. His notions were perhaps peculiar; but we give them here as indicative of his character.

He " accepted the commission," he said, " not
with the arrogant hope of producing a rival to the
picture of Raffaelle, but in grateful compliance
with the wishes of his patron." Besides, with a
just reverence for his art, he looked upon all com-
petition as unworthy a true artist; nay, he even
doubted whether any one could command the
power of his own genius whilst his mind was under
the influence of so vulgar a motive. " For what,"
he would say, " is that which you call my genius,
but the love and perception of *excellence* — the
twin power that incites and directs to successful
production? which can never coexist with the de-
sire to diminish, or even to contend with, that in
another. It would be rather self-love, than a true
love of excellence, did I value it less in Raffaelle
than in myself." He might have added another
reason : that competition implying comparison,
and comparison a difference only of *degree*, could
not *really* exist between men of genius; since the
individualizing power by which we recognise ge-
nius, or the originating faculty, must necessarily
mark their several productions by a difference in
kind. But he needed not this deduction of the
understanding; his own lofty impulses placed him
on surer ground.

Having accepted the commission, however, it was necessary that he should see the picture which he was expected to equal; he accordingly waited on the gentleman to whose collection it belonged, and was shown into his gallery. Though Monaldi had heard much of this collection, he found that report had for once fallen far short of the truth; and the pleasure of such a surprise to him may be imagined by those who have witnessed the effect of unexpected excellence on a man of genius.

He had expected to see only a fine Raffaelle; but he now found himself surrounded by the master spirits of Rome and Venice: they seemed to bewilder him with delight, and he was wandering from one to another, as if uncertain where to rest, when, passing a door at the end of the gallery, his eyes fell on an object to which every other immediately gave place. It was the form of a young female who was leaning, or rather bending, over the back of a chair, and reading. At first he saw only its general loveliness, and he gazed on it as on a more beautiful picture, till a slight movement suddenly gave it a new character — it was the quickening grace that gives life to symmetry. There is a charm in life which no pencil can reach — it thrilled him. But when he caught a glimpse of the half-averted face, the pearly fore-

head, gleaming through clusters of black, glossy
hair — the lustrous, intellectual line beneath, just
seen through the half-closed eyelids — the tremu-
lously-parted lips, and the almost visible soul that
seemed to rush from them upon the page before
her — even the wonders of his art appeared like
idle mockeries. The eyes of the reader now turned
upon him. Still he continued to gaze, and to give
way to his new and undefined emotions, till the
thought of his intrusion suddenly crossed him, and
his face crimsoned. How far the embarrassment
may have been shared by Rosalia Landi (for she it
was) was hardly known to herself, as the entrance
of her father immediately restored her to her usual
self-possession.

"It gives us no common pleasure, signor Mo-
naldi," said the Advocate, as he presented him to
his daughter, "that we have this opportunity to
make some acknowledgment for the many happy
hours we owe to you. I may add, that I use the
epithet in no indefinite sense ; for when is the
mind more innocent than while it loses itself in a
pure work of genius ? — and mere freedom from
evil should be happiness : but your art effects
more — it unites innocence with pleasure."

"We owe signor Monaldi much indeed," said
Rosalia, bowing.

Monaldi had none of that spurious modesty which affects to shrink from praise when conscious of deserving it; yet he could make no reply.

Without noticing his silence, Landi observed, that, perhaps he ought to apologize for the length of his absence. "And yet," he added, turning to the pictures, "I cannot honestly say that I regret it, since it has left signor Monaldi more at liberty to form a fair opinion; for I am connoisseur enough to know that the first impression of a picture is seldom aided by words — especially those of a fond collector. The pictures I doubt not have fared all the better without me."

They now stood before the Raffaelle, and the Advocate waited for several minutes for his visiter to speak; but Monaldi's thoughts had no connection with his senses; he saw nothing, though his eyes were apparently fixed on the picture, but the beautiful vision that still possessed his imagination.

"Perhaps report may have overrated it," at length said Landi, in something like a tone of disappointment.

"Or probably," added Rosalia, observing the blankness of his countenance, "our favorite Madonna may not be one with signor Monaldi."

"It is *your* favorite then?" said Monaldi, with

a sudden change of expression. He had no time
to think of the abruptness of this question before
Rosalia replied, —

"And we had hoped too of yours ; for it is natu-
ral to wish our opinions confirmed by those who
have a right to direct them."

"Nay," said Monaldi, "Raffaelle is one whom
criticism can affect but little either way. He
speaks to the heart, a part of us that never mis-
takes a meaning ; and they who have one to un-
derstand should ask nothing in liking him but the
pleasure of sympathy."

"And yet there are many technical beauties,"
said the Advocate, "which an unpractised eye
needs to have pointed out."

"Yes — and faults too," answered Monaldi ;
"but his execution makes only a small part of
that by which he affects us. But had he even
the color of Titian, or the magic chiaro-scuro of
Correggio, they would scarcely add to that sentient
spirit with which our own communes. I have
certainly seen more beautiful faces ; we sometimes
meet them in nature — faces to look at, and with
pleasure — but not to think of like this. Besides,
Raffaelle does more than make us think of him ;
he makes us forget his deficiencies — or, rather,
supply them."

"I think I understand you—when the heart is touched, but a hint is enough," said Rosalia.

"Ay," said the Advocate, smiling, "'t is with pictures as with life; only bribe that invisible *finisher* and we are sure to reach perfection. However, since there is no other human way to perfection of any kind, I do not see that it is unwise to allow the illusion—which certainly elevates us while it lasts; for we cannot have a sense of the perfect, though imaginary, while we admit ignoble thoughts."

"This is a great admission for you, sir," said Rosalia; "'t is the best apology for romance I have heard."

"Is it? Well, child, then I have been romantic myself without knowing it.—But the picture before us—"

"I could not forget it if I would," interrupted Monaldi, with excitement—"that single-hearted, that ineffable look of love! yet so pure and passionless—so like what we may believe of the love of angels. It seems as if I had never before known the power of my art."

As he spoke, his eyes unconsciously wandered to Rosalia.—The charm was there; and his art was now as much indebted to the living presence as a little before i had suffered from it.

"If one may judge from his works," said Rosalia, "Raffaelle must have been a very amiable man."

"We have no reason to think otherwise," answered Monaldi. "He at least, *knew how* to be so: if he was not, his self-reproach must have been no small punishment, if at all proportioned to his exquisite perception of moral beauty. But he was all you believe, according to the testimony of his contemporaries, by whom he appears to have been as much beloved as admired."

"I could wish," said Rosalia, "that tradition had spared us either more or less of the great author of that Prophet;"— they had turned to a cartoon by Michael Angelo. "They say he was morose; and many affect to find in that the reason why he does not touch their hearts. Yet, I know not how it is, whether he stirs the heart or not, there is *a something* in his works that so lifts one above our present world, or at least, which so raises one above all ordinary emotions, that I never quit the Sistine Chapel without feeling it impossible to believe any charge to his discredit."

"Never believe it!" said Monaldi with energy. "He had too great a soul — too rapt for an unkind feeling. If he did not often sympathize with those

about him, it was because he had but little in common with them. Not that he had less of passion, but more of the intellectual. His heart seems to have been so sublimated by his imagination that his too refined affections — I can almost believe — sought a higher sphere — even *that* in which the forms of his pencil seem to have had their birth; for they are neither men nor women — at least like us that walk the earth — but rather of a race which minds of a high order might call up when they think of the inhabitants of the planet Saturn. To some, perhaps, this may be jargon — but not *here* — I venture to hope." Rosalia bowed. "Nay, the eloquent confession I have just heard could not have been made had not the spell of Michael Angelo been understood as well as felt.'

"You have assisted me to understand him better," said Rosalia. "And, if I do, perhaps I might say, that he makes me think, instead of feel. In other words, the effect is not mere sensation."

Monaldi answered her only by a look, but one of such unmingled pleasure, as would have called up a blush, had not a similar feeling prevented her observing it. He felt as if he had been listening to the echoes of his own mind.

"Upon my word, Rosalia," said her father, " I

did not know you were so much of a connoisseur ;
't is quite new to me, I assure you."

Rosalia now blushed, for the compliment made
her sensible of her enthusiasm, which now sur-
prised herself: she could not recollect that she had
ever before felt so much excited.

" Nay, my dear, I am serious — and I need not
say how pleased. How you have escaped the
cant of the day I can't guess. 'T is now the
fashion to talk of Michael Angelo's extravagance,
of his want of truth, and *what not* — as if truth
were only in what we have *seen!* This matter-of-
fact philosophy has infected the age. Let the
artists look to it! They have already begun to
quarrel with the Apollo — because the skin wants
suppleness! But what is that? — a mere me-
chanical defect. Then they cavil at the form —
those exquisite proportions. And where would be
his celestial lightness, his preternatural majesty
without them? — Signor Monaldi will forgive this
strain: perhaps, I should not hold it before an
artist."

" I should be very sorry to have it believed,"
answered Monaldi, " that any artist could be
found — I mean worthy the name — who would
refuse to be instructed because the lesson does not
come from a professor. I, for one, shall always

be most happy to become a listener, especially where, from the pledge given, I shall have so just a hope of being enlightened. I am not used to complimenting; and signor Landi will pardon me if I add, that I respect my art too much to affect a deference for any criticism — come whence it may — which I know to be unsound; it is founded in truth, and the professor degrades it who palters with its principles."

"Perhaps you overrate me," said the Advocate. "But, be that as it may, signor Monaldi cannot do me a greater favor than in making me a frequent listener to himself."

Monaldi then took leave.

"So gentle — yet so commanding!" said Landi, his eyes still resting on the door through which his visiter had passed — "even lofty — yet so wholly free of pretence and affectation — not an atom of either, but perfectly natural, even when he talked of the people of Saturn. Did you observe how his face brightened then, as if he had been actually familiar with them? I can almost fancy that we have been talking with Raffaelle. He has not disappointed you, I am sure."

"No," replied Rosalia, "on the contrary" — She felt provoked with herself that she could say nothing more.

8

"I do not know," added the Advocate, "that I ever met with a young man who won upon me so rapidly. But 't is an intellectual creature — rarely to be met with."

CHAPTER VII.

WITH men of very vivid imaginations it would seem as if the greater charm were rather in the shadow than the substance. At least, it is true that they are often so well content with a pleasing image as long to overlook in its object the immediate attraction, whether of mind or heart, which first gave it interest; nor is it surprising that, when it is contemplated in the enchanted atmosphere of *revery*, it should seem to possess a satisfying charm, to the exclusion, for the time, of all consciousness of any personal relation to the living original. It was in this peculiar atmosphere that Monaldi's spirit was now reposing. Though he could think of nothing with which the image of Rosalia was not in some way or other blended, and spent hours together in *re*beholding, and *re*hearing every particular of their late interview, yet he never dreamed of asking wherefore. If he dwelt on her beauty, her grace, her voice, they were never referred to any wishes of his own; to him-

self they were as nothing; indeed his power of
reflection seemed for the time suspended; and he
yielded to their influence, feeling only their pres-
ence, wrapt as it were, passive and listless, in some
delicious spell.

But this aimless revery had a nearer relation to
himself than he was then aware of; and the most
imaginative dreamer must awake at last. Though
availing himself of Landi's invitation, he had al-
ready several times met Rosalia, yet seeing her
only in her father's presence, their conversation
had been too general to lead to anything which
might betray to him the state of his heart. But
he was now to see her on a nearer view; being
invited to pass a musical evening at the Advocate's.
On entering the drawing room he found the daugh-
ter alone. This was so unexpected, that he hardly
knew whether to be pleased or not. Before he
entered the house he would have thought of such
a tete-a-tete with delight; for he had always con-
versed freely with Rosalia, and felt while talking
with her as if the charms of her discourse made
even his own more than usually eloquent, and he
had often wished that the pleasure of listening and
replying to her had been less interrupted by a third
person. But now that he was without such inter-
ruption, he suddenly found that he had not a word

at command. He felt as if something had bewildered him, but, instead of stopping to inquire what, he began to make such violent efforts to feel at ease that the palpitation of his heart became almost audible, and he was fairly wishing himself out of the house, when Landi made his appearance. The relief which Monaldi felt at the father's entrance might now have explained the mystery, had not his attention been diverted by the Advocate's inquiries concerning the progress of his picture. But he was not doomed to remain long in ignorance.

Skill in music is so common in Italy that Rosalia hardly considered it an object of ambition; she had studied it merely for her own gratification and her father's amusement, and her execution, though good, was far from being what a connoisseur would call *brilliant;* but she had something better — an exquisite voice, and the power of enthralling even the coldest hearer. Her power consisted not in the mere expression of concords, but in that science of the heart which no written music can supply, in those delicate inflexions which seem to imbue sound with life, conveying thought and sentiment; and when to these was added the *accompaniment* of her face — the tremor of her

lips, and the scarcely perceptible elevation and depression of the lids of her dark, steel-grey eyes, following the movement through all its subtile undulations — what unconscious lover could look and listen, *still* unconscious ?

In order that his guest might become acquainted with her style, her father proposed her playing one or two pieces alone, and she began with a passage from Corelli.

Monaldi took his station behind her chair ; but a mirror back of the piano brought them face to face. This circumstance was too common to discompose Rosalia, and she went through the piece in her usual manner, except that once when she caught his eye, she had, some how or other, skipped a few notes.

To Monaldi, however, whose embarrassment had been increasing with her performance, the situation became so uneasy that nothing but the fear of appearing rude prevented his sitting down. But when she began to sing that tender air from Metastasio,

> No, non vedrete mai
> Cambiar gli affetti miei —

and he beheld her devoted look, and heard her impassioned tones, it seemed as if something within him spoke — and all he felt, and *what* he

felt, rushed to his brain. " I love her ! " said he
to himself — " I love her ! "

Monaldi had scarcely made this discovery, when
he was called upon for his accompaniment. He
started, and taking up his violin, he began hurry-
ing over the strings with such rapidity that Rosalia
was obliged to request a slower movement. Then
he became too slow, drawing out his notes as if
performing a requiem. " A little quicker," said
Landi. Monaldi changed his time. It became
worse ; neither quick, nor slow, but a mixture of
both, like the long and short gallop of a battle
piece.

" Signor Monaldi ! " cried the Advocate. Mo-
naldi's instrument fell from his hand.

The dead silence which followed this unlucky
crash brought Monaldi to himself, and the whole
train of his blunders came at once before him.
He felt his ears burn, and stood dumb with confu-
sion. Landi, seeing his distress, kindly endeavored
to laugh it off: but his efforts were in vain ; Mo-
naldi could not even make an attempt to rally ;
the thought of having appeared ridiculous, and
appeared so before Rosalia had quite overcome
him. He remained for a moment irresolute ; then
uttering a kind of half intelligible apology about
sudden indisposition, he made a hurried bow and
withdrew.

"So," said Landi, as the door closed upon his guest, "I find we are left to finish the evening tete-a-tete. Well, 't is no great hardship; 't is not the first time I shall be indebted to you for my evening's entertainment. Sit down, my dear, and play me something from Pergolesi.

Rosalia obeyed.

"What is it you are playing?"

"Your favorite."

"Well, go on."

Rosalia continued, but her father listened in vain; he could catch no sound like Pergolesi's. He heard her through, however, with kindness and patience, and then very considerately recollected that he had letters to write.

CHAPTER VIII.

THERE is a certain region of the heart which may well be called the sanctuary of every individual; where even the humble and oppressed may (thank heaven) claim a sovereignty; it is there too, where the hopes and fears, and all that give a color to the outward, may be said to dwell; and, though in the pressure of crowds, where we can retire unobserved, and feel ourselves distinct, intangible alike — if such be our pleasure — both to friend and foe.

Perhaps there is nothing more sedulously guarded than this secret recess in pure woman's heart: there indeed it *is* a sanctuary — insomuch that, to keep it inviolate, it would sometimes seem as if she had closed it to herself. Hence it is that some women may even love long before they are aware of it. For in that place of mystery is born, if we mistake not, a pure woman's love; and hence too it may be, as if partaking of the nature of its birth-place, that it is so long shadowy to the every

day eye — even so shadowy, as to be unconsciously
nursed, nay, to grow to maturity, and still continue
a shadow, till some magic accident — a word, a
look, the merest trifle — gives it a name and sub-
stance.

In some such wise was Monaldi's image allowed
to linger, and linger, in the heart of Rosalia, until,
from an undefined shadow, it gradually took shape,
and was quickened into life. Long before they
met she had seen, and admired his productions;
and when she saw the man, his noble countenance
and unassuming manners more than answered to
what she had imagined him.

Where our expectations have been highly
wrought, it is no small gain if we are not disap-
pointed. It was so in this instance; and Monaldi
had scarcely left her before she found that he had
risen in her opinion even as an artist. As they
became more acquainted she found in his mind
and heart all that she had ever imagined, or asked
for. Yet still she knew not that the image he
had left in her memory was anything to her but
a harmonious picture, which it was natural to
dwell on, and to dwell on with pleasure; not that
a transient feeling would not occasionally whisper
of something *more;* but the hints were vague, and
always sure to be repressed by a constant fear

of — she knew not what: absence indeed might soon have quickened her apprehension; but she saw the original almost daily; and there is no saying how long her self-ignorance might have continued had it not been for a trifling incident.

The more Monaldi dwelt on the mortifying occurrence of the unfortunate evening, the stronger became his conviction that Rosalia could not but regard him with something like contempt; and so fully did this thought possess him, that near a fortnight elapsed before he had the courage to wish to see her. But the wish once allowed overcame his fears, and he hurried away to the Advocate's.

As he approached the scene of his last visit, the recollection of his folly became too overpowering, and he was on the point of turning back, when the sound of Rosalia's voice again changed his purpose. She was singing the well-remembered air from Metastasio — and he heard again the the same thrilling tones which had first revealed to him the state of his heart — they now drew him onward like a charmed thing. The touching simplicity with which the second stanza begins,

> Quel cor, che vi donai,
> Più chieder non potrei —

could not be heard with indifference even from a

less gifted voice than Rosalia's; but, given by her,
and with that look of love, which now more than
ever spoke from her eyes — it must have been felt
by the coldest heart. She had just ended the se-
cond line as Monaldi entered the drawing-room,
and their eyes a second time met in the mirror.
Had an apparition stood before her, the sight had
hardly been more startling. She felt as if her
conscious application of the words had been act-
ually detected. Her voice died on her lips, and
her face became colorless as marble.

"Good Heaven! Rosalia, you are ill!" said
Monaldi, wholly forgetting himself in alarm.

It was the first time he had ever addressed her
so familiarly, and the blood now mounted like a
crimson cloud to her forehead. The quick-sighted
lover no longer thought of illness — but the
thought which followed made him almost doubt if
he were awake.

"I will let my father know that you are here,"
said Rosalia, rising; but she was unable to move.

"But one moment," said Monaldi, taking her
hand, though hardly conscious that he did so.
"Rosalia." She gently withdrew her hand. "I
beg pardon, Signora I should have said. But why
affect a form, the bare utterance of which seems
to chill me? The time is come when I must use

it no more, or with a meaning still dearer. Yes —
Rosalia, I will speak with that openness, which
your own ingenuous, your *direct* nature knows not
how to condemn — I love you."

For one minute Rosalia felt as if she would will-
ingly have sunk into the earth. Her secret had
been betrayed — this confession assured her of it —
and had been betrayed by *herself.*

"'T is all a dream then!" said Monaldi, turning
away. "But what a dream to awake from! Yet
how I torture her — she cannot say yes, and her
gentle nature shrinks from saying no. Rosalia,
again pardon me. I have but one word more, and
will no longer distress you; think no more of this
rash avowal — there is nothing due to it — 't was
involuntary, and one, believe me, which I could
not have made in a moment of reflection — for
without hope — no, I should never then have had
the presumption to hope — forgive it then — and,
if you can, forget that I have dared to make so ill
a return for the notice with which you have but
too much honored me."

Rosalia attempted to speak, but her lips moved
without sound.

"I ask no answer," continued Monaldi mourn-
fully; "I deserve none — but rather — and let that
be my atonement — that I leave you, and forever."

9

"No, no," said Rosalia in a voice hardly audi-
ble. A moment of breathless silence followed,
while she caught at the back of a chair, as if it
could impart the strength which she needed to pro-
ceed; but the sound of her own voice restored her
to herself.

"Monaldi — your frankness —"

"Can you forgive it?"

"I will do more, Monaldi, I will return it."

She held out her hand to him; but her strength
failed her, and he caught her on his bosom.

CHAPTER IX.

Within a short lover's age Monaldi became a husband; and his happiness would now have been complete could he have felt assured that peace was again restored to his friend. But Maldura had long since disappeared, having left his lodgings the day after Monaldi's offer; nor could the least trace of him be discovered. Monaldi felt the disappointment the more, as he had now persuaded himself that no melancholy, however wayward, could long withstand the sympathy of his wife.

Maldura's absence was occasioned by a letter from Sienna, announcing the death of a rich relation, and calling him there to take possession of his inheritance. A few years back this accession of wealth would have filled him with joy. But what is wealth to the crumbled hopes of intellectual ambition? It cannot rebuild them. Maldura received the intelligence without the moving a muscle. Though it gave no pain, it could give no pleasure; for he was no sensualist; he had never

had but one vice — the lust of praise — which, seated in his brain, seemed like a voracious reptile, to swallow up every thought as soon as born, till, bloated with overgorging, it had left no room for the growth of another. To a vice like this money was useless, except with a coxcomb. But Maldura was no coxcomb; and he disdained to beg or bribe — even for praise. Yet he notwithstanding took possession of his fortune; there was no one on earth whom he loved; and there was some satisfaction, he thought, in possessing that which many wanted; he was content to be rich because others were poor.

Having arranged his affairs, he now began to consider whither to direct his course. He had quitted Rome, as he believed, forever, and Florence was associated with too many bitter recollections to be thought of again; but where to go he knew not, for having no longer any object, there was nothing to draw him to one place more than another. In this state of indecision having one evening strolled into a coffee house, a stranger near him mentioned the name of Monaldi. He thought he had schooled himself to hear it with indifference; yet he leaned over his table towards the speaker. The stranger was giving an account to a person next him of Monaldi's marriage. Mal-

dura listened with little change of feeling till he heard the name of Rosalia Landi. He could hear no more, but starting up, rushed out of the house.

"I go to Rome," said Maldura to his servant, as soon as he reached home. "To-night, sir!" exclaimed the man, staring. "Yes, to-night— business calls me." "Why, 't is almost dark, sir." "I want not your attendance," said Maldura, impatiently; "I go alone. Now see to my portmanteau, and order a horse to the door." The servant obeyed, and Maldura was soon on his way.

It was enough, he thought, to have been rejected; but to be rejected for one whom of all others he most envied, and therefore most hated; to know that the woman he had once loved, and the man he had once almost despised, were now as one; that they were prosperous and happy; that without title, rank, almost without family, they were yet objects of the public gaze, of public admiration; and that go where he would, talk with whom he would, he must hear forever of the painter Monaldi and his beautiful wife; to know all this — whilst himself was unknown, miserable — drove him to madness. He uttered no curse; he did not weaken by words the deadly purpose which lay at his heart. What that was, he had not yet defined, in

9*

any of its particulars, even to himself; yet he only waited to mature it till he should find a proper instrument to give it action ; till then he was contented with brooding over its general form, and steadily looking forward to its birth.

In this mood Maldura pursued his journey. He had now reached Radicofani, and was slowly moving up the mountain, the reins given to his horse, his eyes closed, and his thoughts busy about the future, when a voice before him suddenly commanded him to stop. He raised his eyes, but, it being after nightfall, he could only discern the figure of a horseman standing in his path, and presenting what he supposed to be a pistol.

Maldura was wholly unprepared for defence, for he had quitted Sienna in too much haste, and was too intent on the object of his journey to think of providing himself with arms; besides, it is doubtful whether, in his present state of mind, he would have taken the precaution, had it even occurred to him.

" Your purse, or your life," cried the stranger.

" Take which you will," replied Maldura, calmly ; " they are both to me worthless."

" Your purse, then," said the robber.

Maldura deliberately handed him his purse. " Does that content you ? "

"If it be gold," returned the other, weighing it in his hand.

"'T is all gold, I assure you."

"Don't lie, friend," said the robber, — "the weight of your purse has saved you, whatever its contents."

"Maldura never uttered a lie to man breathing! nor could the fear of such a man as Fialto extort one from him." The robber started. "I know you, Count," added Maldura; "that voice, which has ruined so many women, was never heard to be forgotten."

"You know me, then?" said the Count, after a slight pause. "Well, sir, you shall also know that the count Fialto never leaves any witnesses against him above ground."

"Put down your weapon," said Maldura, coolly. "My life is nothing to me, as I have told you, nor would it be were it prolonged to a century; but to *you* it may be worth something. In short, I need your services, Count; and, more — I have where- with to pay for them."

"Is the devil in you, Maldura, in good sooth; or are you only playing the part of one, like our worthy friars at an *auto da fè?*"

"If you had said a hell, I should answer yes, — but I lack a devil."

" And therefore apply to me ? "

" Ay ; you are the very one I have been wishing for."

" Thank you ! — Well, I must needs be a very patient devil to bear this."

" Your patience has served you, Count, in worse cases. Have not I seen your presence empty a coffee house in ten minutes ? Yet you avenged it only by a curl of your lip — and wisely ; for none but a madman would have thought of disputing tastes with a score of stilettos. No, you are not the fool, Count, to hazard either life or interest for a reputation past mending. I address you in your vocation — and there 's surely no wrong done in adding the title."

" You have certainly the prettiest way," answered Fialto, " of persuading a man to sign himself rascal. But words are words ! so it matters little by what name I live. Now, my good fellow-caitiff, what is your infernal errand ? "

" In a word then," said Maldura, " I have been injured."

" Proceed."

" And would be revenged."

" Well, what prevents you ? Are all the druggists dead in Italy ? "

" Pshaw ! I want assistance."

"Nay, I never stab or poison, except on my own account."

"I would have you do neither."

"What then?"

"'T is a matter that requires considering; and I would talk it over with you more at leisure, and in a place less exposed. I do not like this parleying in the dark; there may be ears about."

"True, you talk like an adept; the grave is the only place free of them. But dare you trust yourself with me?"

"With an hundred such."

"'T is more than I would," observed Fialto dryly. "Well then, follow me."

Though the infamy of Fialto's character had long excluded him from all sober society, his natural and acquired endowments were yet too dazzling not to obtain him a ready reception with the gay and young; and there were some even among the graver class, more nice perhaps in their taste than their morals, who, attracted by the brilliancy and extraordinary variety of his conversation, scrupled not to court his acquaintance in private when their prudence would have made them ashamed to acknowledge it in public. Among this latter number had been Maldura. But the fascination of Fialto was not confined to listeners of his own sex;

if his wit and eloquence made them content to be
swindled of their money, the uncommon beauty of
his person, and his insinuating manners gave him
no less advantage over the hearts of the women.
No woman, it was said, could withstand the witch-
ery of his eye; and many a husband and father,
have often stolen home from the assembly where
chance threw him in their way, but too happy if
their wives and daughters had escaped it. But
among his many seductions, the most notorious,
and the one for which he was most dreaded, was
that of a Nun. Of this, however, he was only
suspected, for no proof of it appearing, even the
Holy Office was obliged to acquit him.

Maldura had often heard of Fialto's gallantries,
and of this among the number; whether they
were true or not he cared little; it was enough
that they were imputed to him, that he was con-
sidered a dangerous man; and when he added to
this character the certainty that the Count had
long since run through his fortune, that he had
been a gambler, a swindler, and was now become
a robber, he thought it impossible to find an ac-
complice better suited to his purpose.

Such were his thoughts when, entering a thick
wood, his companion desired him to dismount.
"We must leave our horses here," said Fialto;

"my habitation is not far off." They then struck
out of the wood, and began to ascend a wild and
barren country.

It was one of those still nights from which a
quiet heart seems to imbibe a peace more profound.
Not a breath of air was stirring, nor a cloud to be
seen ; all nature seemed buried in slumber — all
but the wakeful eyes of heaven — while the fitful,
uncertain light they shed upon the grey rocks, that
here and there jutted up from the black hollows of
the mountain, appeared to give them an undulating
motion, as if sleep had softened them into life, and
they were heaving with breath. But the repose of
the scene touched not the turbulent hearts of the
travellers, seeming rather to wall them about, and
shutting them up from the external world, to give
freer play and bolder daring to the evil spirits
within. As Maldura looked out upon the dark-
ness he felt as if it had compressed his soul to a
point, as if his whole being, once spread abroad,
modifying, and modified by, the surrounding ele-
ments, were now suddenly gathered back, like the
rays of an extinguished lamp, and absorbed in one
black feeling of revenge. His libertine companion,
not less selfish, but more in humor with the world,
availed himself of his abstraction in maturing the
unfinished schemes which he hoped to turn to his

future profit and pleasure. They thus walked on in silence, till winding up a narrow, broken path, they stopped at the foot of a steep rock, forming the base of a cliff.

"Our journey is ended," said the Count; "this is my castle when my good friends in the world become importunate." Then, taking a flageolet from his pocket, he ran over a few wild notes, when hearing the tinkling of a sheep-bell, apparently from a great distance, he stopped. "I am answered. All is safe." So saying, he led the way to a cleft, overhung with bushes, about midway up the rock, the projections on its surface serving for steps.

"What folly is this?" said Maldura.

"Part those bushes," replied his companion.

He did so; and a door appearing, they entered a cavern.

"'T is he at last!" cried a female voice. Maldura leaned forward to look at the speaker, but he instantly drew back. She stood near the entrance holding a lamp, and as the light fell upon her large dark eyes, it gave them a brightness so fearfully contrasting with her other livid, shrunk features, that he thought he had never beheld so strange a mixture of life and death.

"Marcellina," said the Count.

"It is he!" she cried, recovering her breath. "Thank God!" Then instantly closing her eyes she added half to herself. "But no — to Him — I am nothing to him now;" and a visible tremor ran over her limbs.

"Tut!" said Fialto. "Well, Marcellina, and how are you?"

"Alas, 't is a long time," said she —

"Since I have been here? I know it."

"I thought you would never come."

"Don't be foolish; I have brought you a visiter. Have you anything to entertain him with?"

"Such as I have he is welcome to."

"Well, whatever it is, Maldura I dare swear needs no cardinal compound of pinochii and truffles to sauce it down, He 's a poet; and those of his tribe seldom feast, except on posthumous dinners with posterity. But I beg his laced cloak's pardon; I see he has *cut* the chameleons — of course now an ex-poet, for a fat purse makes but lean verses."

Had Maldura wavered in his purpose this accidental allusion to his blasted hopes would soon have fixed it. He affected to smile, but his face darkened with vengeance.

"What, ashamed of your trade, man?" said the Count, observing the change in his counte-

10

nance. " Well, 't is the way of the world ; we never quarrel with what we are, but what we *have been ;* and I can't say but even I might be ashamed of dicing, could I once leave it off. As it is, however, I 'm content to think it a very pretty, gentlemanlike vice. But I see you are impatient — so, we 'll e'en to business."

" Nay, but you will first tell me — " said Marcellina, making a timid attempt to detain her companion.

" Come, come," said Fialto ; " we will talk about our own affairs another time. My friend, I dare say, is hungry ; this keen air of the mountains whets one's appetite confoundedly."

Marcellina sighed, and silently began to prepare for supper.

The travellers in the mean time retired to an inner apartment in order to confer on the subject of their alliance. Maldura then stated his purpose and the Count his conditions ; at length, after some discussion, the affair was arranged to their mutual satisfaction.

" Such is my plan," concluded Maldura ; "but should you do more, and succeed so far as to cause their separation, the sum shall be doubled."

" Nay, if you wish it," replied Fialto, " I will even take her to myself."

" No," said Maldura, " force would only defeat my object."

" You mistake me : I mean with her own consent."

" Impossible ! "

" That's a word I never knew the meaning of. Give me but a month — "

" Never. Proud as you are, Count, and with as much reason as you have to be so, there is yet one woman in the world to whom all your arts, were they ten times more seductive, would be as nothing : that woman is Rosalia."

" 'Faith, you have touched my pride ; for, do you know, I'm a purity-fancier."

" Hold ! — you must not attempt her ; for, as you would certainly fail, she would as certainly betray you to her husband. What then becomes of his jealousy ? "

" So, I am only to sin by implication ? "

" She must not even hear your name, at least as connected with hers ; for she knows you — as who does not ? "

" Ay, I dare say she has heard that I carry a rosary of broken hearts, strung like beads, about my neck ; and that I count them every night before a taper of brimstone, to keep good angels from

obstructing my hopeful course to — where certainly I 've no great inclination to push my fortune."

"You certainly have the credit of a free chart."

"The world does me too much honor! No, I don't more than half deserve it."

"Well, the half is enough to prevent any decent woman putting herself in your way."

"Oh, if the painter's wife is *afraid* of me, she 's mine to a certainty."

"I don't question your logic, Count," said Maldura, with a half-suppressed sneer; "yet you are not, perhaps, aware that a virtuous woman might avoid a libertine from other motives besides fear. There may be such a thing as *antipathy*."

"Umph!" answered Fialto, drumming on the hilt of his dagger. "By the way, that 's a very pretty jewel on your finger."

"'T is yours," said Maldura, taking off the ring and presenting it.

"By no means," said the Count, though somewhat hesitating; "we are not on the *road* now. Besides, you are my guest — I could not in honor accept it."

"Then wear it as a pledge of my good faith."

"Well, as a pledge. But what if this Monaldi should refuse to be jealous? For I have known

husbands who never dream of a gallant till they
stumble over him."

"I know him too well to doubt your success.
Wherever he fixes his affections there will be his
whole soul ; and though not suspicious, yet will
her constant presence in his mind make him acutely
sensitive to the least breath that touches her."

"Say no more ; I see he is most happily dis-
posed to be miserable."

"Well, do we now understand each other ?"

"Yes. But you have given such a description
of this paragon, that I dare not answer if — "

"Fialto," said Maldura sternly, "if you keep
not within the charter — "

"What then ?" retorted the Count, fiercely.

"I — hold the purse."

"I bow before thee, most mighty wizard ! That
little word would bind even Love, though he had
as many wings, and were as strong as a whirlwind.
Only repeat it when I become restiff, and you 'll
find me as docile as the pet-cat of an old maid."

"Then we are agreed."

"Agreed ! Why, man, thou art a licensed sor-
cerer ! There is nothing on earth, bearing about
with it a full wit and an empty stomach, can with-
stand thee. Thou hast the true *charm*, to soften,
or harden hearts at pleasure ; and if I obey thee

10*

not, 't will only be because some mightier magician shall have conjured me out of my appetite."

They now returned to Marcellina, and sat down to supper.

" But how is this, Marcellina?" said Fialto; " this is the very flask of Montepulciano that I brought you a month ago."

" I reserved it for you," answered Marcellina.

" That was foolish. You 'll at least partake of it now." She shook her head. " Will you not join us ? "

" No," she replied ; 't is enough — " she would have added, " to see you — " when a frown from Fialto checked her. But he could not check the language of her eyes. She had taken her seat at a little distance opposite, and, watching every turn of his countenance, seemed to hang upon it with a fondness so intense and devoted — as if in her whole mind there was but one thought — that of the object before her. Yet there was a gloom in her love which occasionally gave her an expression almost awful.

Maldura had marked these looks, and the story of the nun crossed his mind. He looked again, and the more he examined her, the stronger became his suspicion that she was the person ; for though her form was wasted, her features shrunk

and wrinkled, and her hair prematurely gray, the traces of their former beauty were still too visible to leave a doubt that she had once been lovely.

Had any one but Maldura beheld this piteous object, and then looked on her betrayer, and surveyed his elegant, yet muscular, limbs, his fresh black hair, his smooth forehead, the cold sparkle of his eye, the healthful color of his cheeks, the smile that curled his lips, and the gaiety that danced like a youthful spirit over the whole ; and then thought of his heart — the black life-spring of all this seducing beauty — he would have shrunk from him with horror, and turned for relief even to his wretched companion. But Maldura felt not the contrast, or if he did it was only to confirm him in the choice of his instrument.

Though Fialto scarcely looked towards Marcellina, he could not help feeling that her gaze was upon him, and willing to divert his mind from certain uneasy thoughts which that awakened, he suddenly broke the silence into which their meal had relapsed by inquiring, "if Maldura had heard anything lately of a certain Cagliostro ?"

"Yes," answered Maldura ; "I am told he is now figuring away in England."

"He is certainly the cleverest scoundrel I ever met with. But he is one of those unfortunate

geniuses who come into the world at the wrong time ; he should have been born two centuries sooner, when he might have had half christendom under his foot."

" You knew him then ? "

" I met him once in Madrid. What devil carried him there with his tricks I never could guess; but it must have been Beelzebub himself that carried him out of it; for no other could have given him safe conduct through the Inquisition."

" Can nothing but the devil," asked Maldura, fixing his eye on the Count — " can only the devil extricate a man thence ? " Fialto affected to cough. " *You* can tell," continued Maldura, " for, now I recollect, there was once a foolish story about a nun — "

Marcellina uttered a shriek, and fell senseless. For a moment Fialto stood like one stunned ; then, smothering a curse, he sprang to her assistance. Maldura offered his services, but the Count waving his hand, he prudently drew back.

" Am I awake ? " said Marcellina, at length recovering. " I have had a frightful dream. Ah! never could I live through such another. I thought, dear Fialto, I thought — "

" You must not speak, Marcellina," said the Count ; " you are too weak — it hurts you."

"But I must tell you this to relieve my mind."

"Nay, you must not."

"'T is only a few words — I thought that a familiar of the Inquisition — "

Fialto ground his teeth with rage, yet fearing to trust himself with speech, he made a sign for Marcellina to be silent; but she was too intent on her own thoughts to observe him.

"Where was I?" she continued; "oh, well — and the familiar I thought came into my cell — "

"Peace!" cried the Count in a voice of thunder. Marcellina, you *know* me — I will never forgive you if you refuse to obey me."

"Then I should be cursed on earth too — you are obeyed."

"You must go to bed," said Fialto.

She assented by an inclination of her head; and he was supporting her to her chamber, when she caught a glimpse of Maldura.

"There! there he is again!" she screamed.

Fialto hurried her into the chamber, and closed the door after him.

"It is so!" said Maldura to himself. "He is now in my power, and *shall* be faithful."

It was near an hour before Fialto returned.

"How is she?" asked Maldura.

Without answering the question, Fialto contin-

ued for some time to pace the cavern with his
arms folded; at length stopping and slowly raising
his eyes, "Maldura," said he —

"Proceed, sir," quietly returned Maldura; for
he guessed the subject of Fialto's thoughts, and
was prepared.

"What think you — of what has just passed?"

"Thoughts, Count, you know are free; they
come unbidden, and stay without leave; the mind
therefore — so it use them not — cannot be an-
swerable for their birth or nature."

"You are metaphysical, sir."

"'T is my humor. This being true, he is but a
fool, should their nature be dangerous, who wil-
lingly betrays them to another."

"I understand you, sir. But you should have
added," observed Fialto, half drawing his stiletto,
"one trifling qualification — unless he find it his
interest to betray them."

"Your dagger, Count," said Maldura, "would
waste its edge on me; for I should not care if you
had seduced a whole convent."

"Fool to have brought him here!" muttered
Fialto to himself.

"Count Fialto," said Maldura, "I am now in
your power. If you fear me, this is a most conve-
nient place to bury your fears in." Fialto's hand

went to his dagger. " If there be no other way to secure your peace, strike ! You will do more — you will rid me of a hateful existence."

" Maldura, I will be plain with you," said Fialto. " You say right — you *are* in my power ; and I would bury my secret with your corpse on the spot where you stand but that I know that men, good or bad, never act without motive : and you can have none to betray me — at least for the present. Should you have hereafter, why, then, I shall need no prompter ; and my hand has never missed whom my eye has marked. Then, take your life ; not as a gift for which I expect gratitude — I know you too well to delude myself with any such improbability — 't is not in the heart which I have read to-night — that frown is idle, sir — but I give it, because I hold it of no moment to me."

" The expression you were pleased to notice," replied Maldura with the same composure, " had a deeper root than you can yet reach. You are free to criticise my morals as you like, provided only I be not bound in return to mend them by those of my judge. But a truce to this. I will meet you, Count, on your own ground, and with equal plainness. Your secret with me is as with the dead. My soul has no purpose save the one you know — no pleasure, no profit in anything which man could

name to me ; what then should I gain by your
death ? or the death of all the libertines in the
world ? — Nothing. I should still be the same —
the same human weed, fastened to the same spot,
and still hating its own rankness."

"I *do* trust you," said the Count, extending his
hand. "So, good night. You will find a pallet
in that recess."

CHAPTER X.

Nothing more occurring, the confederates proceeded the next morning on their way to Rome, taking care, however, always to separate when they came to a town. According to this plan, when they reached Viterbo, Maldura entered and quitted it alone, and had proceeded some miles before Fialto overtook him.

"We are in luck," said the latter, as he rejoined his companion, "I have seen Monaldi; he was pointed out to me as he was getting into a carriage just as I entered the inn yard. It seems he is on his way to Florence, to see to the putting up of some picture he has painted for a church there. So said the inn-keeper."

"But his wife," interrupted Maldura —

"There was no lady with him. And he will be absent a fortnight at least. Rare! eh?"

"Yes," said Maldura, "if she remain at home. A fortnight, did you say? That's time enough" —

11

" Ay, for any woman to transfer her affections —
at least in the calculation of a jealous husband."

" Well sir, let us on."

On their arrival in Rome, Maldura took lodgings
in a part of the city remote from his former abode,
and where from its obscurity he thought he was
least likely to fall in with Monaldi, whom he was
determined to avoid unless some circumstance
should occur to render their meeting necessary.
Fialto established himself nearer the scene of ac-
tion, and began his operations by making it appear
as if he haunted the painter's dwelling; passing
and repassing it a dozen times a day; sometimes
stopping before it under one pretence or another,
then giving a side glance towards the windows,
and suddenly turning another way if any one
chanced to observe him, and sometimes curveting
to and fro for several minutes on a restiff horse,
and occasionally affecting to take something from
his pocket and throw it into the court. All this
was done to excite the attention of the neighbors;
nor was it long before it succeeded. The first
effect, however, was that of mere surprise to see
him so often in the same street; generally ending
with simple exclamations, as, " Oh, here's *the
same gentleman*," or "here he comes again!"
Then they began to wonder what brought him

there. But when they remembered his frequent glances at Monaldi's house, the mystery was explained; the transition was but too natural from the handsome cavalier to the painter's wife.

Such was the state of things when Monaldi returned. His arrival was accordingly noted by his neighbors with as many shrugs and winks as are usual in similar cases. But there was one amongst them to whom it seemed to afford particular pleasure; for now, as he thought, was a fair opportunity to give play to his resentment in many a good "*fling*" at the great man. This person, whom Monaldi had unconsciously offended, was a worker in mosaic, and kept a shop directly opposite him. The cause of the offence was the negative one of sometimes being silent when Romero expected to be praised; not that Monaldi had ever denied him praise when he thought it due, for he was too conscientious to withhold it even from an enemy, but only that he had fallen short of the exhorbitant measure which the other demanded; an injury often more important than one that is positive, for while the latter is bounded by its word or deed, the former is limited only by the vanity of the injured.

"Good morning, signor Monaldi," said Romero, "so, you have been a long journey. Ay, 't is *well* you are come back."

This speech would hardly have been noticed but for its peculiar emphasis.

"Well, sir?" repeated Monaldi, "why *well?*"

"Oh, nothing — only — a man, you know, is always better at home — especially " —

"Sir."

"Umph! — Don't it look like rain? Carluccio, why don't you attend to the shop?"

"You were observing," said Monaldi.

"Oh, nothing of consequence — at least to me," replied Romero, closing his shop door. "Good day, sir; I must see to my customers."

" 'T is of a piece," thought Monaldi, "with his usual forwardness; he wants to talk and has nothing to say." And the speech and Romero passed from his mind.

Nothing more occurred for several days, till one morning, as Monaldi was going out, he saw a man standing at the entrance of his gateway. As he approached, the stranger suddenly drew his hat over his eyes, and precipitately retreated; not however, before the former had distinctly seen his face. Monaldi quickened his pace in order to overtake him, but on entering the street, the man was lost in the crowd; and before he had time to form any conjecture on the incident, his attention was diverted by a message from the pope, requiring his attendance.

But going the next day to a window which overlooked Romero's shop, he observed the same person standing at the door, and apparently conversing by signs with some one in his own house. The recognition, even connected with such a circumstance, might have passed off without a thought, had not the stranger on catching his eye again drawn his hat over his face and hastily entered the shop. This last action gave an importance to the other which he could not overlook. And for the first time in his life, Monaldi became conscious of suspicion; but of whom, or of what, he could not tell. He felt that the stranger was somehow or other connected with him or his household, and the sensations excited by the thought became still more painful from its being undefined.

Who the man was perplexed him. "Yet might it not be some one he had formerly known? No; he could not recollect meeting him before the day preceding. Who was he, then?—Perhaps Romero could inform him. But Romero was prying and familiar; and should he ask the motive for the inquiry—what answer could be given? No, he would not question him. Yet the more he thought of it, the more he felt inclined to apply to him; but something—he knew not what—always checked him.

11*

In this mood he continued to pace the room for a considerable time, when, going again to the window, he saw the stranger come out of the shop, and again make a sign as he thought, toward his house. " I *will* know who he is." But before he had reached the street, the stranger was gone.

For near a fortnight after Monaldi observed the same person almost daily hanging about the neighborhood, and always betraying the same solicitude to avoid him. Still no opportunity offered of learning who he was. Wearied at length with fruitless conjectures, and willing to divert his mind with other thoughts, he was one evening prevailed on to accompany his father-in-law, to see a new opera. Rosalia had also been invited, but she declined on account of a headache.

They had been but a little while in the theatre, when Landi directed Monaldi's attention to a box opposite.

" Do you observe that gay cavalier ? "

" Which ? " asked Monaldi.

" He that has just entered, with the embroidered waistcoat."

Monaldi looked, and beheld the *stranger*. " Who is he ? " he asked quickly.

" 'T is the notorious count Fialto."

" Fialto ! " repeated Monaldi.

"What makes you start so?" said Landi.

"N – nothing."

"But you are ill?"

"No — not at all," answered Monaldi, endeavoring to assume a cheerful look — "quite well, I assure you."

"I fear you labor too much," said Landi.

"Perhaps so. But go on — you were speaking of this Count."

"I pointed him out to you," continued Landi, "because I think him an anomaly in physiognomy. To look at his noble countenance, no one, ignorant of his character, would for a moment suspect that such a face could possibly belong to anything vicious; and yet, were all the wickedness in this house extracted from the hearts of each individual, I verily believe it would fall short in the gross of that in his."

"You seem to know him?"

"Not personally. But his character is no secret. There is no crime of which he is not capable."

"I have heard as much."

"But his deadliest sins are against those of the other sex. The catalogue of his seductions would appal any common libertine."

"He seems indeed no common one."

"Nay, his person, of itself, is a mere subordi-

nate — but a fine statue, on which many women might gaze with impunity; 't is only when animated by his master-mind — when his devil's heart rises to his angel's tongue, that it becomes an object of worship — fatal to the rash woman who shall then dare to look and listen."

Monaldi knew not why, but he felt, while his father-in-law was speaking, as if all his blood were beating at his heart. But the opera was now begun, and the exquisite tones of Crescentini soon made him forget that there was such a being as Fialto in the world.

The first act passed off without anything worth noting, except that Monaldi's attention was again drawn towards the opposite box by the entrance of a person with a letter for Fialto, who, glancing over it hastily, immediately withdrew; but this excited no sensation in Monaldi except that of pleasure in the other's absence, which left him at ease to enjoy the remainder of the opera.

There are few cares which do not yield for a time to the influence of fine music. Monaldi had felt it, and he was returning homeward full of happy thoughts, when arriving within a few paces of his house, he perceived a person lurking about his gateway. The impulse of the moment determined him to stop; and being just then under a lamp

which hung before the image of a saint, he turned
his back towards it, and muffled his face in his
cloak. He had scarcely done so when the person
passed him. Monaldi was thunder-struck : there
could be no mistake — the light had fallen full on
the other's face — it was Fialto.

There is a little cloud often described by travel-
lers, and well known on the Indian seas, which at
first appears like a dark speck in the horizon ; as
it rises its hue deepens, and its size increases ; yet
the approach of it is gradual, and the air mean-
while is soft and motionless ; but while the inex-
perienced mariner is perhaps regarding it as a mere
matter of curiosity, his sails unbent, and loosely
hanging to the masts — in the twinkling of an eye,
it seems to leap upon the ship — and, in a moment
more, sails, masts, and all, are swept by the board.
With like desolation did this little incident smite
the heart of Monaldi : he felt as if some sudden
calamity had laid his peace in ruins ; yet he could
give it no distinct shape, nor even comprehend the
evil that would follow. He knew not with what,
or with whom to connect Fialto's visit ; but that
Fialto had been in his house seemed almost beyond
doubt ; he had not indeed seen him come out of
it — yet why was he hanging about it at this hour ?
" But how did this appear to concern himself? "

He had scarcely asked the question, when twenty
circumstances occurred in answer; but chiefly by
the Count's uniform solicitude to avoid him; his
confusion when detected gazing at the house, his
disappearance from the theatre soon after Monal-
di's entrance; his absence during the rest of the
evening, though it was a new play; and his sudden
reappearance in this place, and at such a time;
these were too evident in their bearing to allow of
any misapprehension, and Monaldi was forced to
admit that Fialto's purpose, whatever it was, had,
in some way or other, relation to himself. There
was an obscurity in this conclusion which thick-
ened on his brain like an Egyptian darkness; not
a thought could pierce it; even the avenues to
conjecture were closed; he could only feel that he
was surrounded by a thing impenetrable, and he
had no resource but to wait till some further cir-
cumstance should give form and direction to his
undefined misgivings. Nor was he long without
one. The closing of a window above roused him
from his reverie. He looked up and saw a light
in his wife's chamber, and a female figure passing
from the window. Rosalia and Fialto now met in
his thoughts.

There is no act of the mind more abhorrent to
a delicate man than that of admitting a criminating

thought against an object once held sacred; and
should a hundred circumstances arise to disturb,
and excite him to suspicion, it will at first be gen-
eral, and fall anywhere, rather than on her he
loves; for though it is the connection of these cir-
cumstances with *her* — which the mind *feels*, with-
out acknowledging — that makes his misery; it is
only when their direction is too plain to be mis-
taken that he suffers himself to perceive its object.
So was it with Monaldi: the devotedness of his
love had invested his wife with a charm which had
hitherto kept her name and her image far from the
troubled circle of his thoughts. But Fialto's man-
ner — the finding him so near his house — the
hour — the light in his own bed-chamber — the fe-
male at the window — were all too distinctly joined
in his mind, not to mark the object of suspicion.
The agony which followed was unutterable; — but
it could not continue long; for Monaldi was natu-
rally confiding; then he revolted at injustice; and
to whom, if so, should he be unjust? The ques-
tion drove him from self, to one infinitely dearer;
and his generous nature now pleaded for her with
all its energy. " Did he not *know* her? — as well
— yes, as well as himself. Her whole heart had
been open to him; he had seen it daily, from the
day of their union — and he had found it pure;

he was no dotard — intensely as he loved — and he must have seen the stain had there *been one* — no artifice, no hypocrisy could have hidden it so long. And on what did he ground his suspicion? On a coincidence which a hundred accidents might innocently occasion." He almost hated himself as the word occurred to him. He then remembered that he had left his wife unwell; and it was very natural that she should retire to rest early; indeed it would have been more strange if she had waited his return. This last thought reassured him, and he entered the house. His confidence, however, was hardly restored when a contradictory circumstance again staggered it; he found his wife sitting in the very room where he had left her. "What, here! Has she then heard me enter? — and comes she down now to make me believe that she has passed the whole evening here?"

"You are home early," observed Rosalia, "I hope you have been entertained."

"Perhaps too early," replied Monaldi, hesitating, and almost shuddering at the strangeness of his own voice; "you seem surprised. What if *I* should be so at finding you *here?*"

"Me? Why so? Oh, I suppose you thought my head-ache would have sent me to bed. But it is quite gone off."

"Indeed! and pray — *who* has cured it?"

The question seemed forced from him by torture, and his utterance was so thick that Rosalia asked what he said.

"Your head ache. I asked *who* has cured it."

"Oh, my old doctor — nature."

"Rosalia!" said Monaldi.

"What? but what disturbs you?"

"Nay, what *should* ?"

"I am sure I know not."

"If *you* know not — but I'm afraid you have passed but a dull evening *alone*."

"Oh, no, I have been amusing myself — if it may be called amusement to have one's flesh creep — with Dante. I had just finished the *Inferno* as you came in."

"As I came in? The Inferno, I must own, seems hardly a book of entertainment for a lady's bed-chamber."

"I don't understand you."

"Or will not."

"Dear husband!" said Rosalia, looking up with surprise, and a feeling as yet new to her, "you talk in riddles."

"Is it a riddle to ask why you should choose to read in your chamber? For *there you were* when I entered."

12

"Who, I? No — I have not been up stairs this evening."

"A lie!" groaned Monaldi, turning from her with an agony that would not be suppressed. "Oh, misery! 't is then too — too —"

A maid servant at that instant came in to tell her mistress that, as the night was damp, she had shut her chamber windows, though without orders.

"You have done well," said Rosalia.

"Thank God!" said Monaldi, as he heard this explanation. "Away — away forever, infernal thoughts!"

Monaldi's emotion had not escaped his wife, but the entrance of the servant prevented her hearing his words. His altered expression now struck her. "Surely I have been dreaming," said Rosalia.

"Of nothing bad, I hope, my love," said Monaldi, now like another being, and gently drawing her towards him; "for your dreams — if that dreams are pictures of the mind — should be like those of angels."

"I know not of what," answered Rosalia, "but it was something very painful. I thought you seemed unhappy. Was it so?"

"Never was I less so than now. Less so! that's a poor negative. No, my Rosalia, I feel a present, a positive, tangible happiness, which gives the lie

to all who hold that we enjoy it only in the past
and future. My heart is full ; so full, that I ask
nothing of time — of anything but thee — and to
hear thee, to look upon thee."

"Oh, Monaldi, I am blest above women !"

"And dost thou think so ? "

"At least I know not how I could be happier.
For what more could I ask, with such a husband ? "

"Or I, with such a wife? Amen ! with my
whole soul."

"I have sometimes thought," said Rosalia, "and
I hope without pride, that the very bad could not
know such bliss ; nay, a love, like mine. For,
could I love thee so, pure and exalted as thou art,
did I love evil ? I could not : I should then love
myself, and thee only as ministering to my selfish-
ness. No ! the love I bear thee is but the efflu-
ence of thy virtues given back to thyself ; and it
seems to elevate me ; to refine my heart for the love
of Him who is purest, best — who is Goodness."

CHAPTER XI.

A few days after this, Monaldi received a message from the worker in mosaic, requesting to speak with him.

"You will excuse my freedom," said Romero, as Monaldi entered the shop, "but I wished to have your opinion of a work I have lately begun. You may give me a hint, perhaps, that will be of service. 'T is a miniature copy of that Magdalen by Guido."

Monaldi examined the copy, and comparing it with the original, commended the general fidelity, but pointed out several parts which he thought might be improved.

Romero thanked him with an air of pique, and observed, "I should not have troubled you for your opinion, had not the work been for a friend of yours — the count Fialto."

"*My* friend!" said Monaldi, with some surprise — "the most —— You are mistaken, sir; I have no acquaintance with him."

" I beg pardon," replied Romero ; " but I con-
cluded that he was so from seeing him come out
of your house."

" My house ! " repeated Monaldi.

" Or, perhaps 't was another person ; for since
you don't know him no doubt I was mistaken.
Indeed now, I rather wonder how I came to sup-
pose him your friend ; for the Count's character is
none of the best. But that 's nothing to *me*, or he
should not be so free of my shop ; for he comes
here three or four times a week to see how my
work gets on ; in faith, so often, that, to say the
truth, had I a pretty daughter, or —a *wife*, I
should n 't much relish it."

Monaldi looked up at the word *wife*, and saw a
meaning in Romero's eye not to be mistaken. But
the look was unnecessary ; his shaft had already
reached the mark.

" Well, I am much obliged to you, signor Mo-
naldi," concluded Romero, returning to his work,
and shall be careful in future how I call the Count
your friend."

When Monaldi left the shop the houses seemed
to reel and the ground to bend beneath him. A
sickening faintness had come over him, and he felt
as if it were impossible to cross the street ; but,
making an effort, he reached his gateway, and
12*

leaned against it for support. His strength, how-
ever, soon returned; sooner than his memory, for
it was some time before he could fix on the cause
of his agitation, only recollecting that some dread-
ful truth had suddenly glanced on his brain, and
as quickly vanished. But a slight incident will
often do more in recovering what is lost in the
mind than its most intense efforts. Rosalia was
singing a new polacca, which was then popular,
but of which Monaldi had often expressed his dis-
like. It was the only instance in which their tastes
differed. This difference, at another time too
slight even to be noticed, now startled his imagina-
tion. The hair-line which divided them now
opened to a frightful chasm. He turned for a
moment towards the court of his house, then, press-
ing his hand to his brain, rushed from the gate.
Whither he was going he knew not; yet it seemed
as if motion gave him the power of enduring what
he could not bear at rest; and he continued to
traverse street after street, till, quitting the city,
he had reached Ponte Molle, where, exhausted by
heat and fatigue, he was at length compelled to
stop.

It was one of those evenings never to be forgot-
ten by a painter — but one too which must come
upon him in misery as a gorgeous mockery. The

sun was yet up, and resting on the highest peak
of a ridge of mountain-shaped clouds, that seemed
to make a part of the distance ; suddenly he dis-
appeared, and the landscape was overspread with
a cold, lurid hue ; then, as if molten in a furnace,
the fictitious mountains began to glow ; in a mo-
ment more they tumbled asunder ; in another he
was seen again, piercing their fragments, and dart-
ing his shafts to the remotest east, till, reaching the
horizon, he appeared to recall them, and with a
parting flash to wrap the whole heavens in flame.

Monaldi groaned aloud. " No, thou art nothing
to me now, thou glorious sun — nothing. To me
thou art dead, buried — and forever, — in *her*
darkness ; her's, whose own glory once made me
to love thee ; who clothed me with a brightness
even more than thine ; who followed me like a
spirit, in sleep even, visiting my dreams, as if to
fill up the blank of night — to give a continuous
splendor to my existence. Oh, idiot, driveller ! so
to cling to a shadow — a cheat of the senses ! —
What is she to me now ? what can she ever be ?
— she that is — that ever was " — He could
not utter the word.

A desolate vacancy now spread over him, and,
leaning over the bridge, he seemed to lose himself
in the deepening gloom of the scene, till the black

river that moved beneath him appeared almost a part of his mind, and its imageless waters but the visible current of his own dark thoughts.

But the mind unused to suffering has a difficulty in admitting calamity not to be easily overcome ; one evidence is seldom enough ; for though it may perplex and torture for a time, the very sense of pain will soon force the faculties to return to their wonted action, to pursue again their plans of peace and hope.

Misery was new to Monaldi; he had now endured it for more than two hours ; and the intense longing for relief brought on a reaction. " No," said he, starting up, " some fiend has tempted me, and I have mocked myself with monsters only in my brain — she *is* pure — *she must be !* "

CHAPTER XII.

By the time Monaldi reached home, he had nearly brought himself to believe that all he had suffered was from mere delusion.

But he had scarcely crossed his threshold before the violent beating of his heart warned him of a relapse; and he had stopped, with his hand still resting on the latch of the door of the anteroom, to collect his thoughts, when his wife, who was advancing on the other side, and mistaking him for a servant, bade him come in.

" Mercy ! " cried Rosalia, drawing back as he entered, " how you frightened me."

Her surprise at his sudden appearance, though perfectly natural, instantly struck on the troubled brain of her husband as the alarm of guilt, and the worst thought — that perhaps he had supplanted her gallant — now crossed him. " Ay," said he, with a tone of bitterness, " 'tis even *I !* "

The change in his manner now really alarmed

her. " Good heaven ! Monaldi — what is the matter ? "

" I did not know," said Monaldi, his lip quivering as he spoke ; " I knew not till *this* day that I could ever become an object of terror."

The look of wildness and misery with which this was uttered struck to Rosalia's heart : she could make no answer, but, throwing herself on his neck, burst into tears. Monaldi shrunk from her touch as from the coil of a serpent, and he would have shaken her off had not an undefined something in his memory restrained him.

" Dearest husband — oh, speak to me ! " said Rosalia, as soon as she could find words. " Are you ill ? "

" No."

" Then why do you look so ? Has anything happened ? "

" Nothing."

" Oh, do not say so ; something must — or you would not be thus."

" How thus ? "

" As you never were before."

" True, I never — Pshaw — there 's nothing the matter ; and I have told you I am very well."

" Nothing ! " — this was the first instance of reserve since their marriage. Rosalia felt its chill

as from an actual blast, and her arms mechani-
cally dropped by her side. Ah, Monaldi! you
have yet to know your wife. And yet I ought —
I *do* honor your motive ; you would spare her pain.
But if you knew her heart, you would feel that
your unkindest act would be to deny her the privi-
lege of sharing in your sufferings. Hitherto, up
to this sad moment, I have been the wife of your
joys ; a twin being with you in happiness, sharing
with you the consciousness of a double existence ;
for all your thoughts, your wishes, your emotions
were mine ; and they were all joyous — all — up
to this hour. And can you think then so poorly
of my heart to suppose that for this accumulation
of life — into which, as I look back, almost an age
seems pressed — that for all this, which I owe to
you alone, it yearns not to make return ? And
what is the heart's wealth but sympathy ? Shall
mine become niggard in your distress ? No, Mo-
naldi ; the heart capable of knowing such felicity
in another's being must wither if it share not in
his woe as in his weal.

There is a certain tone — if once heard, and
heard in the hour of love — which even the tongue
that uttered it can never repeat, should its purpose
be false. Monaldi heard it now ; there was no
resisting that breath from the heart ; he felt its

truth as it were vibrating through him, and he continued gazing on her till a sense of his injustice flushed him with shame. For a moment he covered his face ; then, turning gently towards her, "Rosalia," said he, in a softened accent — but his emotion prevented his proceeding.

"Speak, my dear husband, and tell me that you think me not unworthy to be *one* with you in sorrow. Oh, Monaldi, it seems as if there would almost be pleasure in the pain endured with you ! But this I *know* — and the conviction is wrought into my nature — that my soul would not exchange its community even of misery with thee for all of pleasure or of joy which the world could give without thee."

"My wife ! thou art indeed my own !" said Monaldi, clasping her to his bosom. "Oh, what a face is this ! how poor a veil would it be to any thing evil. Falsehood could not hide there." Then quitting her for a moment, he walked up the room. "I have read her every thought," said he to himself; "had they been pebbles at the bottom of a clear stream, they could not have been more distinct. With such a face she cannot be false." As he said this, an expression of joy lighted up his features, and he turned again to his wife. There needed not a word to interpret his look ; —

she sprang forward, and his arms again opened to receive her.

"My own Monaldi!" said the happy Rosalia.

"Your own indeed! Oh, Rosalia, you know not — you have never known, your whole power. From the moment we first met, it seemed as if my spirit had gone from me, and taken its abode in thee; giving up every thought, every impulse to be moulded according to thy will. And thou hast made me happier, ay, and wiser, in the mingling with thy pure nature; so happy, that I have sometimes almost doubted if I were not dreaming of the future intercourse between the souls of the blest."

"Let me then, dear husband, continue to you this happiness."

"It lives, as it ever must, in thee."

"Then let me lighten the present load that weighs on your mind; let me share it with you, as I have shared in your joys."

"What load? Am I not happy? — Feel it," said he, placing her hand on his heart; "is it not light?"

"Now. But —"

"But what?"

"Your late distress."

"Did I appear so much distressed?" asked

13

Monaldi, while his conscience smote him for the question.

"You looked — oh, never may you look so again."

"Nay, 't was half your imagination."

"Monaldi," said Rosalia gravely; I know you too well: you *will not* say you had no cause for it."

He felt the rebuke, and a pang went to his heart as the meditated falsehood rose to his tongue. It was the first untruth he had ever deliberately consented to. Yet how could he lay open what had passed within him? It would make her miserable; and himself — no, she would not hate, but she must despise him. "Yes, it must be," said he to himself; "it will at least spare her." He then confessed that he had been a good deal discomposed by a conversation with a brother artist, from whom he had learnt certain facts concerning the baseness of a person in whom he had once felt an interest; and that the shock, together with his long walk, had been, as she had seen, too much for him.

Such was the deception to which Monaldi's unfortunate situation now tempted him. He felt degraded as he uttered it, and was about to excuse himself from giving the particulars, when Rosalia, by a timely interruption, saved him the mortifica-

tion of further duplicity. "No more," she said; "'t is enough for me to know that calamity has spared you. Besides, I have no woman's curiosity; or, if I have, a friend's misdeed is best buried in silence; 't is a cause of sorrow into which a wife even may not with delicacy pry."

He took her hand without making any answer.

One day back this sentiment would hardly have struck him; it would have entered his mind only as a part of the harmonious whole which made her character; now it came contrasted with his own dissimulation, and he thought, as he looked on her, that he had never before felt the full majesty of her soul.

The meaning of his eyes was felt at her heart, and the blushing wife hid her face in his bosom; for, whether maid or wife, a blush is the last grace that forsakes a pure woman; 't is the abiding hue with her nature; and never is it seen so truly feminine as when, like hers, it reveals the consciousness of merited praise.

Their happiness now seemed complete, Monaldi even doubting if he had ever been so blest; when a loud ringing at the gate gave a sudden turn to his thoughts. The sound, in spite of himself, recalled the suspicion which had crossed him on entering; for the alarm of his wife was still unex-

plained; it had passed from him, but no sooner
did it return than a rapid revulsion took place in
his feelings. He moved away from her, and,
averting his face, rested his head upon his hands
against the mantlepiece. But the parting with
peace is hard; and he made an effort to retain it.
"Might she not explain it to his satisfaction?"
He looked at her as the question crossed his mind,
and his suspicion almost vanished. Yet he could
not but wish to know the cause of her alarm; he
should not else feel *sure*. And he again drew
near her.

"Rosalia," said he.

"What would you?"

"I was thinking — or rather, it just occurs to
me, that when I came in you appeared to be ex-
pecting some one. May I ask whom?"

"What, I? No. I expected nobody. You
know 't is not the hour for visiters."

"And yet you seemed alarmed when I entered,
as if — "

"What?"

"I were the wrong person."

"Whom could I expect but you?"

"Nay, your exclamation showed that you did
not then think of me," said Monaldi, endeavoring
to assume a jocular air.

" True I did not, for the length of your absence made me conclude that you were gone to St. Luke's.[1] I was going into the hall as you lifted the latch ; but as you did not come in, I supposed it old Gieuseppe, who, you know, is somewhat slow in his movements: so I spoke."

This explanation was too simple and natural not to produce the desired effect. Monaldi felt its truth, and his brow again became clear.

" But why are you so curious ? " asked Rosalia.

" Nay, don't put me to my trumps for whys and wherefores," replied Monaldi, smiling. " You may place it to the account of idleness, which, you know, generally speaks first and thinks afterwards."

A servant now entering, informed Monaldi that the person who rang at the gate had inquired for him ; but, on being told he was at home, replied it was no matter, and went away.

Suspicion seldom returns without increase of poison, especially if it light on a cicatrized wound. The report of the servant seemed instantly to overthrow all that Monaldi had just imagined too firm to be shaken. " What, ask for me, and go away without seeing me ! " His evil star now mounted

[1] The Roman Academy of Art.

13*

the ascendant, and he immediately connected the
stranger's inquiry with his wife. "Was it him,
then, she was expecting when I returned? It must
be so; and the inquiry — it no doubt means, can
she be *safely* seen — and *alone*."

Such were his thoughts when he turned from
the servant to Rosalia. The sternness of his eye
shocked her, and she sank back in her chair.
"Can it be possible?" said he to himself. "But
I will sift it calmly." Then turning to the man,
he asked, "What sort of person — was he a gen-
tleman?"

"I believe so," was the answer.

"You *believe*! Could you not see?"

"No, sir; his face was so muffled up, I could
not get a glimpse of it."

"Ha! — Do you know," said Monaldi, still ad-
dressing the servant, but looking towards his wife,
"do you know the count Fialto?"

The man answered in the negative.

"Fialto!" repeated Rosalia, half audibly.

Monaldi caught the echo, and, dismissing the
domestic, stood before her for some time without
speaking. "Ay," said he at length, "Fialto!
Does the name disturb you?"

"Good heaven!" cried Rosalia; "what does
this mean?"

" Can it have a meaning ? "

" Monaldi, I know not what to make of you."

" Nor I of — But you have not answered my question."

" You have asked none."

" No ? " Recollect yourself — 't was about this Count."

" What of him ? "

" I only asked why *his* name, more than any other, should so alarm you."

" Alarm me ! No, why should I be alarmed ? "

" Perhaps I was mistaken, and you — were quite tranquil."

" I was surprised, I confess," replied Rosalia ; " and my surprise was natural, when I heard the name of such a man joined with a visit to you."

" Why ? "

" Because he is so infamous that I cannot but think it degrading to you to hold any intercourse with him, even in the way of your profession ; to which alone I can ascribe this visit."

For a moment Monaldi's suspicion was stagger-ed. He turned from his wife, and fixed his eyes on the floor. " Could I believe," said he mentally, " that her heart spoke this ; that it is not a gloss, a cunning turn for escape. It might be — and it might not. Heaven and hell are not more wide

asunder than the speech and purpose of a dissembling woman. Should she be false!— But I will not be rash. Yet there is a way — yes — and I will stir her heart, be it of mortal elements; find out the feverish spot, if there be one — lay my finger on it — so that she shall wince, ay, as from a coal of fire."

"Monaldi, why are you thus? What makes you so absent? Are you displeased that I have spoken thus of this man?"

"Let him speed to hell!" said he, pacing the room violently.

"Dearest husband!" cried Rosalia, stopping him and clinging to him, "what makes you talk thus?"

"Words may sometimes have no meaning."

"But your's have. Something dreadful possesses you."

"'T is nothing."

"Oh, Monaldi!"

"I have been foolish — very foolish. I ought to be *happy* — ought I not?"

"Oh, if *I* can make you so! You are my all — my very all on earth. I have no wish, no will but yours; and my heart — oh, the wretchedness it now feels — which *you* make it feel — too well bears witness that it is yours, even as if it were

beating in your own bosom. Tell me then —
command me — what shall I say, or do, to re-
store your peace ? "

Monaldi covered his face, as if he feared to trust
himself to look at her ; but his resolution endured
but for an instant. " Oh, you are an angel ! — or
— yes," said he, pressing her hand to his forehead
— " you *are* an angel. That face would pass the
gates of Paradise unquestioned ! . . . But a face,
a mere face ! " he added to himself — " it has
duped thousands ! " The hand dropped from his
grasp. " And words — yes, they are the devil's
coin, that has bought millions of souls for eternal
slavery. I ought not to trust to them — so many
circumstances weigh against her — I ought not.
She must be proved. If she stand the proof, then,
and not till then — "

" Your words indeed," said Rosalia, " are always
kind, even beyond my merit ; but your manner — "
There was something, though she knew not what,
in the impression it had left, which she could not
bear to think of, and she stopped.

" My head is dizzy," said Monaldi, waiving her
from him — " I cannot talk ; " then, throwing
himself, or rather sinking into a chair, he relapsed
into silence. What passed in his thoughts was
too deep for the eye, for his expression indicated
nothing.

Rosalia watched his countenance, and thought she perceived his emotion subsiding. But he was meditating a desperate stroke, and sought to control his features.

" Do you not feel better now ? " she asked.

" Who ? " said Monaldi ; for the question seemed to wake him as from a dream ; but instantly collecting himself, he added, " Ay — yes, much better. It was a strange feeling — but it has passed off, and I may yet smile perhaps."

" Oh, that I could see you."

" But not now : it would be too much like the smile of that martyr ; and you would not have me set my face by a picture — become the second hand of a shadow ? "

Rosalia, who did not perceive the bitterness of this levity, began to feel somewhat relieved. " Perhaps," she said, " when you tell me what has so moved you, I may pour a balm into your heart that will make you smile even there."

" No, not yet ; one day you will know."

" Why not now ? "

" No, you would not bear it — (yes, it would crush her if innocent)."

" Nay, there is nothing with, or for thee, that I would not bear."

" No, not now, it must not be. But I will tell you a story."

" A story ! "

" Yes," said Monaldi, " will you hear it ? "

The wretched wife could only answer with a look of anguish ; for the dreadful surmise crossed her that his brain was unsettled.

" 'T is the story of a young artist, once a man of some promise — but whom misery has now levelled with the million. Can you conceive of this ? "

" But too well ! " replied Rosalia, in a voice that spoke the full extent of her fears.

" Indeed ! Then you think that a *painter even* may have a heart to break ? "

" Oh, my husband ! why — why —"

" Nay," interrupted Monaldi — " what need of any other world has a fellow that builds fantastic ones of his own ? Or what has he to do with feelings off his canvass ? The world think him *all head* and will tell you of some who have deliberately mangled, nay, even murdered, their models for the sake of catching a clever agony. What think *you* of such grave facts ? "

" They are senseless calumnies."

" Perhaps so. But to the painter."

" Speak on," said Rosalia, watching his lips with a breathless eagerness, yet dreading every instant to hear what would confirm her suspicion.

Monaldi proceeded. "He had a young and beautiful wife, who was every thing — life to him; for he lived only in her; such too did he think he was to her: in a word, they had married for love. Do you mark! — for love."

"I do."

"Well, the first year of their union had passed; and the husband looked back upon it as on a vision dreamed of in some happier planet; yet the past was but a shadow to what he saw in hope — a hint, a type only, to his sanguine imagination, of a more blest reality to come. Foolish mortal! he should have remembered that he was yet on earth; that the thing he loved was of earth — but animated dust, subject to be mixed with, to be debased by other, and grosser, particles of its own element. But his delusion was short. There was a man — I was about to call him a devil; but I need not rake hell for his qualities; they are human. Yes, he was a *man* — man in its worst sense; selfish, cruel, sensual. Don't shudder at the picture; for this triple curse of his nature was hidden from the eye; it lay close in his heart — deep buried in a form of fascinating beauty, and kept from sight by the magic of a tongue that could make even vice seem lovely. Know you one like him?"

"Heaven forbid!"

"No, a woman's eye would not pierce the exterior — it could not read his soul till he had wholly tainted hers. But that — no, it could not yet — "

"What could not yet?"

"Nothing. Well, this man had fixed his eye on the painter's wife. By some means or other, not material to the story, the husband suspected it had reached her heart. Yet he kept it to himself. Do you attend?"

"Go on," said Rosalia, still racked with doubt; "I hear every word."

"'T is a dismal tale — but so is life."

"Oh, do not say so."

"Perhaps 't is not; we have yet to prove it. Well, the husband was one night persuaded to go to the theatre: his wife, I know not why, perhaps she pleaded a *head-ache* — remained at home. Do you mind? — she remained at home."

"Well."

"In the box opposite him the husband saw *this man*. The first act was hardly begun when, a billet being brought to him, he left the house. The husband saw what passed; his mind instantly connected the note with his wife. Do you hear?"

"I do."

"Then you *understand*?" said Monaldi, lower-
14

ing his voice, and looking into her eyes as if he would search her very soul.

" What am I to understand? " said Rosalia.

" That she took advantage of her husband's absence to make an assignation: so he thought — and so —— Ha! she shakes not — it does not move her a jot," said he to himself. " Can her self-possession be forced? Could she hear this with eyes so steady? They did not even wink — but kept on mine, fixed and unconscious, as if she were a picture. Could guilt stand so the look, the tone — my whole prejudging manner? Impossible! Merciful Heaven! should she be innocent! "

" Will you not go on? " said Rosalia.

" Directly," replied Monaldi, rising, and moving to a window. The twilight had already faded to a faint streak in the horizon, and the smaller stars were fast gathering in the west; it was what he was wont to call his soul's hour. He threw up the window, and the night-breeze came fresh upon his flushed forehead. " Sweet air of Heaven! thou, at least," said he, "art pure. Oh, that I might once more bless thee! that I might love again the light of these stars, and mount, and mix in spirit with yon happy clouds, sailing in peace over the troubled earth! " The wish instantly

forced the past into the present, and the contrast struck him to the quick. "Why," he asked, "am I not *now* as once?" His lingering doubt soon answered the question. And doubts are never inactive; if they cannot go forward they are sure to go back. So it was with Monaldi's; they had no sooner returned than he was flung back in agony to every suspicious word, look, and hint. "No, they are all too connected to be without an object — and what object can they have but her? Do they not all point to her? They do: and her self-possession *must be* assumed. But I will put it to a fiercer test. If she has a particle of love for the wretch, *that* must touch her."

Rosalia now approached, and taking his hand, begged him to go on with his story; for her dreadful misgivings still hung upon her; and she felt impatient to hear him speak, in the hope, faint as it was, that the connexion of his thoughts would be such as to do away her fears. "Come, my love," she said, "finish the tale: 't is indeed a sad one; but I wish to hear how it ends."

"Do you? S'death, she mocks me! I see it now, her coolness is acted. Yes, she shall hear it — and hear the catastrophe that ought to have been hers."

"Come, sit by me," said Rosalia.

Monaldi grasped her hand. " Rosalia — " his voice now deepened to a tone almost terrific — " Rosalia, there are workings of the elements even in the centre of this solid earth. Think you they work of themselves ? "

" No."

" Think you then that He, who gave them impulse, cannot see through the miles of thick matter that incrusts them ? "

" Yes ; the eye of Heaven sees all that is made."

" And all that is done ? "

" Certainly."

" Yet there are creatures, who call themselves rational, that will do deeds that sink their fellows in misery — deliberately do them ; nay, watch and fast, ay, and would pray too, did hell need it, for their black hour of luck ; yet *wink* not even under that all-seeing eye. Perhaps they think not of it ; or foolishly hope to hide them in night. Wretched hope ! Though the sun were extinguished, and a thicker darkness than ever mortal dreamt of wrapt her about, yet would that eye, swifter than light, pierce to the bed of the adulteress."

Monaldi still perceived no change in her.

" What is she made of ? " said he to himself. " I talk to the dull ear of a corpse ! But there are hearts, which defy Heaven, that will yet shrink at

the touch of a human hand. If her's be such, she
shall feel it."

The intense anxiety of Rosalia, together with
the harrowing nature of its cause, had given a fixed-
ness to her expression, which, contrasted with the
rapid and violent transitions of thought and feel-
ing in her husband, made her appear to him quite
calm and collected. At a time of less excitement,
he might have been startled at the almost petrified
gaze with which she watched his slightest move-
ment; but now he only felt the contrast of her
stillness with his own tumult.

"But the story," said Rosalia —

"I fear you will not relish it."

"Nay, I would hear it, nevertheless."

"Where was I?"

"At the theatre."

"True — I *was* there. But 't is strange *you*
should wish to hear it; with a woman's nerves
too. Yet no — nothing 's strange to me now. I
have heard of one who had his funeral *rehearsed* :
I once doubted it; but I was then inexperienced.
Well, listen. So far her case, if guilty — now to
what should have followed.

" In order to give time for the paramours to
meet, the husband delayed his return home for
near an hour; then, having a master-key, he let

14*

himself in without noise. The parlor, as he expected, was vacant. Mark — I am coming to a close. The wife, it seems, was in her chamber ; and the chamber, like *ours*, at the head of the stairs — *suppose it ours.* When the husband reached the landing-place, hearing a stir in the room, he concealed himself behind the pedestal of a statue — as, it might be, *the one near our chamber.* Do you note ? Keep the *place* in your mind."

" I will."

" And *imagine it in this house.*"

" Well."

" Oh, 't will be *better! —* Where was I ? — Oh, behind the statue. He had scarcely taken his station there, before the door opened. His suspicion was now confirmed ; the wife was giving her paramour a parting embrace. To hell ! cried the husband, springing upon them with a furious bound — and his sword in an instant pinned the wife and the wretch Fialto to the door ! "

" Horrible ! " said Rosalia, shuddering.

" Ha ! " cried Monaldi, crushing her hand within both of his, " was it well done ? "

Rosalia, whose christian temper revolted at murder, even to avenge the most atrocious wrong, was too much shocked to reply. But her face

spoke anything but guilt; and Monaldi *felt* its meaning, yet fearing to trust to it, he hurried on.

"But Fialto; speak — did *he* deserve it?"

"The galleys even," said Rosalia, with a look of disgust.

"How! is that worse than death?"

"Is he not still living, and at large? You spoke of him to-night as if you supposed him the person who rang at the gate."

"True, true — he does live; he recovered."

"Infamous wretch!"

"What, not forgive him! His beauty remains the same; and that, with your sex, will atone for many sins."

"*This to me?* Oh, Monaldi!"

"She *is* innocent!" exclaimed Monaldi, falling on his knees, and clasping his hands. "Thank God!"

"*Who* is innocent?" said the astonished wife.

"You!"

"I! Of what?"

"Of everything — of the shadow even of evil. Thou art all purity!"

"What is this enigma? Monaldi, why do you say this to me?"

Monaldi's eyes fell: for a moment the question confused him; but soon recovering, he replied,

"Can you ask? Are you not the very opposite of
the wretched adulteress? And can I know it —
feel it, as I do, without bursting forth in joy?"

The coherence of the tale had now satisfied Ro-
salia of her husband's sanity. But the time he had
chosen — his manner of telling it — and his unusual
excitement, still perplexed her. "It must," she
thought, "in some way concern himself, or it
would not have taken such hold of him. But how?
Might it not be what he first alluded to; the same
that caused his emotion before he returned home?
It was the perfidy, he said, of one he had formerly
esteemed. But could this Count have been that
friend? It must be so; for it seems he thought
him the person who just rang at the gate, and
the mention of his name naturally brought the
story more vividly to his mind. Then he might
have known the unfortunate husband. Yes; it is
so."

These thoughts passed so rapidly through Rosa-
lia's mind, that the first and last seemed almost to
meet in the same instant. "It is so," she repeat-
ed aloud. "Monaldi, I no longer wonder, for I
now understand the cause of your emotion."

Monaldi stood aghast. He thought she had
divined the object of his suspicion, and her con-
tempt seemed ready to overwhelm him.

"You know," she added, "the unfortunate husband."

He breathed again. "I do."

"Is he your friend?"

"There is but one on earth dearer — yourself."

"Monaldi, I honor this deep feeling, now I know the cause — much as I have suffered from it."

"And did you suffer?"

"More than I can express; for I thought — it makes me shudder as I recall it —"

"What!"

"That your brain was injured."

"Alas," thought he, "how near the truth!"

"What a heart is yours! If you feel thus for another, what would have been your misery, had *you* been the poor husband."

"Do not let us think of it," said he, "it makes my flesh creep to imagine even —"

"Ah," said Rosalia, with a melancholy smile, "that same imagination would be a fearful master over such a heart as yours."

"Never can it become so," replied Monaldi, kissing her forehead; "never, while my heart clings to such a reality. Look on me, Rosalia — Oh, how beautiful is Truth when it looks out from the eyes of a pure woman! Such, if ever visi-

ble, should be its image — the present shadowing
of that hallowed harmony which the soul shall
hereafter know in substance."

" My husband!" Rosalia could say no more.

The night now closed upon them, and they sunk
to sleep with hearts too full for another wish.

CHAPTER XIII.

Monaldi's fears were now allayed; for though some of their causes were still unexplained, he studiously drove them from his mind, as too light to outweigh the evidence which his former experience and Rosalia's whole manner had opposed to them.

This respite was not a little favored by Fialto's absence, almost a month having passed since Monaldi had seen him. But the Count was not idle; he was only waiting till chance should furnish him with means to strike the last blow. With this view he had contrived to make himself acquainted with all Monaldi's movements, which he effected by means of a domestic who had formerly been one of his creatures. Antonio, the name of the man, had imposed on Monaldi by an artful tale of distress, and been taken into his service from motives of charity. But Antonio was not of a nature to be turned from his course by any act of kindness; he seldom troubled himself about any motives but his

own, and his present one, the hope of a large re-
ward, was strong enough to keep him faithful to
his employer.

It was not long after this, that Monaldi received
a letter from the steward of one of his estates near
Genezzano, requiring his presence on some urgent
business; and mentioning the circumstance, to-
gether with his intention of setting out on his jour-
ney the next day, while Antonio was waiting at
dinner, it was accordingly made known to Fialto
without loss of time."

Nothing could have suited the Count better.
Genezzano was more than thirty miles from Rome.
Monaldi must calculate on being absent at least
two days.

What use Fialto made of these circumstances
will appear by the following letter, written as if in
answer to one from Rosalia.

" A thousand, thousand, thousand thanks, dear-
est Rosalia, for your precious letter. The rapture
— but a truce with raptures till we meet — for I
have only time to say, that I shall be punctual to
the hour you have appointed — at twelve to a
minute. Oh, that tomorrow were come! Could
anything be more fortunate than this journey to
Genezzano! I could almost worship your easy

man for his accommodating spirit. He is certainly a most obliging husband — perhaps 't is to make up for not leaving us longer together the other night, when he went to the theatre. You desire me not to reply to your note, " because 't is unnecessary — and you fear needless risks." But for once I must disobey you ; and do so that you might learn to rely more in future on the prudence of your devoted FIALTO."

The letter being prepared, the next step was to have it seen by the husband. But chance again made that easy, for it was now the very evening on which he was accustomed to make his weekly visit to St. Luke's. Fialto knowing this, had therefore only to take his former station at the gate, and, pretending to mistake Monaldi for a servant, put the letter into his hand. The night was as dark as could have been wished for so evil a purpose. He accordingly took his station at the proper time, when a loud coughing by Antonio gave notice of his master's approach. Immediately after, Monaldi's footstep was heard in the gateway. " So, you are come at last," said Fialto, speaking low and rapidly ; " but not a word, good Gieuseppe, we may be overheard. There, take that to your mistress ; and there 's postage." So

15

saying, he thrust the letter, with a piece of gold,
into Monaldi's hand, and in another moment he
was gone.

The rapidity with which this was said and done,
left no time for reply, had Monaldi attempted it ;
but the words " Gieuseppe " and " mistress " were
enough ; he did not even hear the rest, for they
seemed to stun him, and he stood for a while pass-
ing the letter from one hand to the other in a kind
of vacant distress, till the sharp sound of the gold
as it fell and rang on the pavement, again brought
him to his senses. It was then he began to feel
that he was possessed at last of what would decide
his fate. He returned to the house, and, shutting
himself up in his library, placed the letter on the
table before him. Its superscription was plain —
to his wife ; yet he hesitated for a moment whether
he should open it. But his mind was not in a
state for refining ; he could perceive only one
alternative — complete conviction or interminable
suspicion ; and he broke the seal. The letter
dropt from his hand, and his head sunk on the
table in agony. But this blow, though surer, could
not have the same effect with the first ; for his
mind had been prepared by previous suffering, had
been warned, as it were, of the probable evil, and
been tempered by that warning to bear what might

else have driven him to madness. He had now indeed a nearer and more certain cause for wretchedness, but it was what had once been expected, and wanted the force of newness; besides, it was now distinct, had a positive shape; and the power of enduring calamity is generally proportioned to its reality; as the mind can oppose its strength to what is real, as substance resisting substance, but has no strength, no power to repel the intangible and ever-multiplying phantoms of the imagination.

Monaldi felt that his doom was now sealed, and he rose from his seat with a desperate calmness; for his last doubt was gone, and with it seemed to have fled every conflicting emotion. In this state he continued for almost half an hour, his arms folded, and his eyes wandering without object, when a glance at the letter gave a fiercer impulse to his thoughts. He took it up, and again attempted to read it; but he had scarcely finished the first sentence, when, dashing it with fury to the floor, he stamped upon it with a violence that shook the very walls. "Witch, sorceress, devil!" he cried, half choked with rage — "thus, thus will I crush thee!" At that moment the door opened and Gieuseppe entered. "Wretch!" cried Monaldi, seizing him by the throat. "I beg pardon," said the man, trembling. "I did not know you

were at home, sir, but hearing a noise, I thought
something had fallen."

This speech gave Monaldi time to recover him-
self. "True," said he, "it was that bust; it must
have been carelessly put up; but you need not
stay to replace it now, — I am engaged."

"Yes," said Monaldi, as the servant withdrew,
" and *I too* will play the hypocrite. Truth is no
match for falsehood; 't is only hypocrisy can cir-
cumvent treachery. I will still appear the *easy
man*, the *obliging husband* — and the pander Gieu-
seppe shall still think his master the blind gull.
Yes, I will *seem* to go this journey — still seem to
make amends for returning so soon from the the-
atre. Oh, my true Genius, how clearly didst thou
note to me that polluted hour! Yet how she bore
herself — with what a face she looked when I told
the tale that painted it! Oh, woman, could your
heart be seen in your face, we should love toads
sooner. But thou, painted toad! like a scorpion
will I meet thee. The appointment, it seems, was
made by her; and she forbids an answer. Yes,
she knew he was not the man to fail. This
letter then is not expected — of course its miscar-
riage will not be discovered. Nothing could have
fallen out better — better! for what? For the
sealing of my misery! Then be it so — ha! ha!

Oh, that I had an enemy — how impotent would
now be his wrath! what would be the gall of ten
thousand deadly hearts now poured upon mine —
mine, that is filled with it? that already sweats it?
But I will not keep it long there; it shall soon
out like a flood — shall drench, shall drown this
hot bird of paradise — ay, even in her very nest!
Yes, I will go this journey, and she, Gieuseppe,
and all, shall see me go with a cheerful face, and
a light heart — yes, light of the world; for no-
thing here can again touch it, it moves now in
an element of its own. And when they think
me at Genezzano — ha! ha! I shall then reach
my zenith."

So saying, he rang the bell, and left Gieuseppe
to clear away the fragments of the bust. Then
quitting the house, he proceeded to the Academy.

It may seem strange, but it is nevertheless true,
that with some natures there is a point in misery
where they will sport with their sufferings, and ap-
pear to take a kind of dreadful pleasure in magni-
fying them, nay, even task the future, and fly to it
with the hope for something more, some deeper
woe, to keep their minds in action — which solves
the mystery.

Monaldi needed no additional proof of his wife's
infidelity; his conviction was complete; yet he

15*

thirsted for more — for the last drop of the bitter-
est of all draughts.

But the part of a dissembler was still new to
him, and difficult, and had always been revolting
to his nature; it was now become more so that
it seemed to be forced upon him by her in whom,
of all on earth, he had most confided. Yet he
went through it: that he did so was not a little
owing to the shortness of his trial, it being near
midnight before he returned home; perhaps, how-
ever, more owing to the trusting temper of his
wife, who, seeing only his apparent cheerfulness,
could hardly have suspected an opposite feeling
without a change in her character; for, except in
very glaring cases, the senses may be said to live
in an atmosphere of the mind.

Had Monaldi's suffering been unmixed with the
hope of vengeance, he might have found disguise
impossible; but falsehood is of the family of re-
venge, and a snare and a mask are never wanted
when needed; it was this prepared him for the
meeting, and he entered the house with a smile.
Rosalia looked up, and gave it back from her
heart; for the smile of one we love cannot be seen
unanswered.

"How beautiful," thought Monaldi, "may even
a lie look! — Oh, Sin, take always this form, and

the world, with all its grave philosophy, its solemn pomp of reason, is yours. But *I* know its hollowness, its — " The thought was too revolting ; yet still the smile remained — but it was the smile which misery gives as her last token, the mark, which she sets upon her own.

Before Monaldi returned home, he had worked himself up to this interview by desperately recalling every past endearment, every audible and silent manifestation of tenderness ; in short, all that he was wont to go to and brood over in secret ; but they came not now as once, like definite and luminous points in his life ; for now every word, and look, and delicate caress brought with them the hateful image of Fialto. " They are no longer mine," said he ; " they never were ! And I can hear them, see them — do all, but feel them again. Can she touch again the heart that loves only purity ? The fictitious life which her false spirit gave to it is gone — forever. 'T is now dead. Could it feel this stony stillness were it not so ? Let her talk and look then — she will talk to ears that hear not, look to eyes that are glazed. But yet — yes, I will mock her ; mock her with a phantom of the love she has murdered — murdered while she smiled ; she shall still think it lives, and lives for her ! "

Morally his heart *was* dead. But what must
have been the agony with which a heart so gentle,
so generous and noble, stiffened into death !

Let no one marvel at this change, sudden as it
may seem; for there is no limit to human incon-
sistency. A single circumstance has often trans-
formed the firmest nature, making the same being
his own strongest contrast; many things — injury,
ingratitude, disappointment — may do it; in a
word, anything which robs a man of that which
gives a charm to his existence; and chiefly and
most rapid will the change be with those of deep
and social feelings, who live in others. Such is
man when left to himself; and there is but one
thing which can make him consistent — RELIGION;
the only unchanging source of moral harmony.
But Monaldi, unhappily, knew little of this. Not
that he was wholly without religion; on the con-
trary, his understanding having assented to its
truths, he believed himself a good christian; but
he wanted that vital faith which mingles with every
thought and foreruns every action, ever looking
through time to their fruits in eternity. The kind-
ness and generosity of his disposition had hitherto
stood in its stead; he had delighted in making
others happy, and thought nothing a task which
could add to their consolation or welfare. But

hitherto he had been happy, and his life had seemed to him like one of fresher ages ; like the first stream that wandered through Eden, sweet and pure in itself, and bearing on its bosom the bright and lovely images of a thousand flowers. Would one so full not sometimes overflow ? or would one *so filled* often thirst for what is spiritual, for what belongs to the dim and distant future ? preparing in the hour of peace for the hour of temptation ? Then he had met with no adversity, with no crosses to wean him gradually from this delightful paradise ; no sorrow to lift his soul to that where trouble cannot enter. But though the present world seemed enough, and more than enough for him, in reality it was nothing ; it was only through *one* of earth that he saw and loved all else ; she alone filled his heart, modified his perceptions, and shed her own beauty over every vision of his mind. Now she was lost to him ; torn away by a single wrench : And could this have been without leaving a fearful void ? To Monaldi's heart she was all ; and his all was now gone, leaving it empty. An empty human heart ! — an abyss the earth's depths cannot match. And how was it now to be filled ? His story will show.

The further operations of Fialto depending on the success of his letter, he had instructed Antonio

to watch his master's motions, and report accord-
ingly. It was possible, he thought, that Monaldi
might escape the snare by openly accusing his
wife, and examining Gieuseppe; in which case the
conspiracy would end at once; a result, however,
but barely possible. It was more probable that
Monaldi would set out on his journey without
coming to an explanation; if he did so, only one
conclusion could follow — that he would return
secretly, and at the hour of the assignation;
whether to satisfy his doubts or revenge was im-
material; and for this event Fialto was provided,
having ordered Antonio to engage a person to
watch his master and follow him back to the city,
in order to give notice of his return, the signal
agreed upon being a little Venetian air, which
the man was to play as soon as Monaldi should
have entered his house.

At an early hour the next morning Antonio
made his report, and Fialto found his hopes con-
firmed. Monaldi had set out on the journey ap-
parently in good spirits, and unattended. The
spy was also gone; and a truer hound was never
put on the trail.

It was now again night, and it only remained
for Fialto to gain admittance into the house. To
make this easy, Antonio had purposely lost a bet

to Gieuseppe, to be paid in a flask of Orvietto. While the servants were engaged with the wine, Antonio stole out, and admitted the Count secretly, in the disguise of a friar.

Antonio having locked the door of his master's dressing-room, had secured the key early in the morning, in order that Rosalia might suppose he had taken it with him; of course she would not think of going to it now. In this room, or rather closet, Fialto took his station; he then threw off his disguise, and locked the door. The closet opened into Rosalia's bed-chamber, and the chamber was up only one flight of stairs, and looked upon the street; a circumstance which the Count had considered with a view to his escape, to facilitate which he had provided a ladder of ropes, for, bold as he was, he had little taste for perils that promised nothing.

The clock struck eleven, and Fialto heard the chamber door open, and a light step pass the closet; this was followed by a slight movement as of one undressing. " 'T is she," he thought. Then it was still again. He looked through the keyhole to see if she was in bed, and saw her kneeling before a crucifix. " How like my poor nun! — Pshaw — that 's past. What eyes! But what 's her beauty to me — at least now? The yellow

face of a sequin is more to my present liking.
Yes, Maldura's gold has made me a match for St.
Antony. There," added he, withdrawing his eyes,
" go to bed in peace; I doubt 't is the last time.
But there are millions who never taste it — and
why should she? she may find a substitute, as I
do, in pleasure."

A few minutes after, he heard her rise and get
into bed. " She has left the lamp burning. So
much the better ; there will be no mistake as to
my person. 'T is a foolish business though ; but —
Ha ! what 's that ? " It was only the faint sigh
that usually precedes sleep. He put his ear to the
key-hole, and heard a low, regular breathing. " So
soon gone ? And she sleeps like an infant. Would
that I — but that 's folly."

Fialto's thoughts now took a rapid flight to long
past and almost forgotten scenes ; and Rosalia,
Monaldi, and his purpose, all seemed to have van-
ished from his mind, when the chiming of the last
quarter brought him back to the present.

" Dare I trust myself now," thought he, after a
pause ; " dare I venture to look at her ? And why
not ? Are not all my passions bagged in Maldura's
purse ? — I will look at her."

There is a majesty in innocence which will
sometimes awe the most reprobate. As Fialto

stood by the bed, a strange sensation came over him, and something like compunction crossed his brain; but it sunk not deeper — for nothing of like nature had reached his heart for many years; and the feeling, whatever it was, passed off in words.

"How like death," said he, "to all around her; and yet how living in herself. And her thoughts — how they play over her face; to her, perhaps, they are the parts of a world — a world all her own. Pity she should ever wake to another. That smile, I never saw but one like it." Some early recollection here probably crossed his mind, and he turned away. "Curse thee, Maldura, for a villain in essence! Wert thou starving, like me, there might be some excuse. But I — I *am* starving; and that 's enough. Nay, suppose I were weak enough to forego this exaction of my necessities, would those eyes ever deign to drop a tear for me after I am gone? No, her precious morality would bid her rejoice. Yes; and the most moral world too would all join her; ay, all." Fialto's evil genius here touched the right chord; for nothing makes vengeance so indiscriminate as the consciousness of being generally hated. "Yes, they would trample on my grave, and make a jest of the dead libertine. But I 'll spoil their sport for the present.

16

Ha! the signal!" At that moment the spy's guitar was heard from the street. Fialto immediately raised the window, and, throwing out his disguise, let down the ladder of ropes. This was hardly done when he heard a cautious step ascending the staircase. He then slipped off his coat, and took his station beside the bed, till hearing the step approach the door, he awoke Rosalia. In the same instant Monaldi burst into the room. Rosalia shrieked, and Fialto, springing to the window, in the next moment was in the street.

"Mercy! oh, mercy!" cried Rosalia, throwing herself at Monaldi's feet, whom the confusion of her terror made her mistake for a robber.

"Ay, strumpet!" said he, in a voice scarcely articulate, "more than you have shown to me." So saying, with a frantic laugh, he plunged his dagger into her bosom. She fell back with a groan, and her blood, spirting up, covered his hands. A horrible silence now followed, and Monaldi stood over her, as if a sudden frost had stiffened his face and figure in the very expression and attitude with which he gave the blow.

Rosalia had been stunned by the fall; but the flowing from her wound soon brought back her senses; she looked up, and for the first time recognised her husband. "Merciful heaven! you —

from you!" The blow now reached her soul, and she covered her face with her hands. "Oh, Monaldi — why have you done this?"

"Repent — repent," said he, moving away.

"Stay, oh stay!" cried Rosalia, with a piercing energy.

"What would you?"

"Much. But look at me — I am your wife, Monaldi."

"Wife! Never. But I have forgiven it. You are nothing to any one now but — to Him who made you. Look to it, then — waste not your limited hour on one you never loved."

"Never loved — whom?"

"Oh, woman, cannot death make thee honest? Me!"

"You! — oh, Monaldi. But, ha! there must be something — yet my brain is so confused — that man — it was not a dream; no, I was awake. Tell me — who siezed me just now in the bed? it could not have been you."

"Oh, hardened to the core! Rosalia, know you that you are dying?"

"Too well — I feel 't is my last hour."

"Repent then."

"Oh, tell me," said Rosalia — "'t is too late — I am very faint;" and she sunk back exhausted.

Monaldi now looked on her with a compassion that made him shudder; for, base as he thought her, he felt as if he could give his heart's blood to save her soul. " No," said he, " she must not die so." Then, hastily making a bandage with his handkerchief, he succeeded, with some difficulty, in stanching the wound. In a few minutes her strength returned.

" Thank God! there may yet be time; I 'll for a surgeon ; " and he made a movement as if to leave the room.

But Rosalia perceiving it, with a violent effort threw herself forward, and, clasping his knees, locked them with an agony that shook his whole frame.

" Why is this?" said Monaldi; "why trifle thus ? Make your peace with heaven."

" Heaven is merciful; be thou so too. No, my husband, you are not cruel; this last act shows it — you have bound up the wound, and bless you for it. Then deny me not — but tell me — why was this deed? Oh, speak."

" And you do not know ?"

" As I have hope of heaven."

" Woman!" said Monaldi, shaking her off with horror, " thou standest even now in presence of the Eternal; darest thou then lie ?"

"I do not lie — before heaven, I do not."

"Horrible! And you know not perhaps him I found here?"

"As God is my judge. I was asleep when he seized me, and that seemed at the very instant you entered."

"Yet you asked for mercy —"

"My terror confounded me, and I supposed you both robbers."

"Know you then that writing?" It was Fialto's letter.

Rosalia took the letter, and, glancing at the signature, for a moment seemed convulsed with emotion; but it was only for a moment, and she read it through with steadiness. She then calmly placed it beside her, and attemped to kneel, but her strength failing her, she could only clasp her hands and raise her eyes to heaven.

"I murmur not," she said — "I murmur not, oh, Father, that thou hast been pleased to permit this work of darkness against me; for thou art all-wise as thou art good. And not for myself do I now call on thy name — thou knowest that I am guiltless — but for him I leave. Spare him, merciful Being; impute not this blow to him; for even now he repents it; and, oh spare him, in thy great mercy, when he shall know my truth, when

16*

he shall find too late that the love I bore him had
only thee for its sharer — that, but for thy grace,
it had been idolatry. Oh, spare him then, for he
will need thy mercy."

Monaldi listened as she spoke, like one in a
trance ; he lost not a word, and they fell on his
heart like arrows of fire ; for so comes truth when
it comes too late ; yet he neither spoke nor moved,
as if the agony of conviction had brought with it
a doubt whether the falsehood he had believed
were not less intolerable.

Rosalia now turned to him, and in a feebler,
though still unbroken, voice continued. " Monal-
di, hear me, for the hand of death is upon me. I
die *innocent* — innocent of all but too much loving
thee. Your deed — 't is my last prayer — may
God, as I do, forgive it. You were greatly tempt-
ed ; for the seeming proof of my guilt could not
be stronger. Why it was contrived, only the
Searcher of hearts can tell ; for I know not an
enemy that we have. Yet that you or I have —
and a deadly one — is sure. But him, too, I for-
give."

" No ! " said Monaldi, in a voice of anguish,
" never could a wanton so speak ! "

" Now, oh, now," said Rosalia, " I die in peace ;
you believe me."

" I do," he cried, straining her to his bosom, " with my whole soul! Oh, Rosalia, my wife — " but he could not go on ; for though his eyes were dry, a convulsive sobbing choked his utterance.

" Nay, my husband, do not take it so to heart. Think of my hopes — of my blessed change. Oh, no — death has no sting for a christian."

" Death!" cried Monaldi, starting up — " death!" The word seemed, as it were, to explode in his brain, and his head whirled. Then came fearful imaginings, and with them a confused rush of the past, mingling with the present.

Rosalia now felt her strength fast ebbing ; but her heart still clung to her husband, and she begged that she might die in his arms. He made no answer ; she called to him again — but he was talking to the air.

" Dead! dead, did you say? No, she lives. — But what's here? These accursed hands — look, Rosalia — see the heart they tore from you. Red, red — it beats ; look, look, how it leaps! No; you shall not go — speak to me — ha, gone! now now I have you again."

" His brain wanders !"

" Ha! it speaks — strange ! strange ! "

" Save him, oh, save him!" cried Rosalia. She

could add no more; her head sunk upon her
shoulder, and her eyes closed.

"Who brought it here?" said Monaldi, shrink-
ing from the body; "'t is cold. Let the bones be
buried, though Fialto's; they should not lie on the
ground. Landi, why are you here? Oh, 't is you,
Rosalia — so you stabbed him! Well! — ha! ha!
very well. How he bleeds! Blood! blood! Give
me your hand. Nay, that's bloody too. But
hark! those bloody daggers — don't you hear
them?" look; there are a thousand. Monstrous!
they fight in the air — they follow us! Oh, save
her! save her!" he cried, with a piercing shriek,
and rushed from the chamber.

CHAPTER XIV.

Fialto had been returned about an hour, and was deliberating whether to call on Maldura then or to wait till morning, when Antonio, livid and breathless, staggered into the room.

"How now!" said the Count, somewhat startled at his appearance. "What brings you here? speak, man — what makes you look so like a thing dug up?"

"She 's dead," said Antonio.

"Who is dead?"

"She, my mistress."

In spite of Fialto's hardness he felt a twinge at his heart. "Poor thing!" said he, after a short pause. "This is more than I bargained for. But how was it, Antonio?"

"That is more than I know," replied Antonio. "All I can tell is, that about one o'clock, just as I had fallen asleep, I was suddenly roused by a frightful shriek — such another I never heard. What it might be, never entered my head; for I

was so confused that I had quite forgotten your plot, and what was likely to come of it; so I sprang out of bed, and ran to the staircase. Holy Francesco, how he looked!"

"Who?"

"My master—his face and hands bloody, and his eyes so wild—the great lamp was burning in the corridor, and I saw him rush past it."

"Come, leave crossing your lizard's liver," said Fialto, "and go on."

"I have done," answered Antonio: "he was gone before I could reach the corridor.

"Dolt! your mistress—how know you she is dead?"

"I entered her chamber with the other servants, whom the same noise had brought from their beds. She was lying on the floor, and —"

"Enough," said the Count, "I have other business for you now."

"I hope," stammered Antonio—"I hope 't is nothing like —"

A look from Fialto cut short the sentence. "I must hence to-night," said he, "so I shall want horses: look to it that they are in readiness within an hour. In the meantime I will see Maldura. Do you hear? within an hour."

"His hands bloody!" said Fialto, after Antonio

left him. "Then the deed was his. I did not think the painter had so much of the devil in him. Maldura said he was all milk; that he would part and pine, but never dare shed blood. Had he been a fool it might have been so; but there is no trusting your gentle tempers where there's a spark of genius: they are like quiet waters over volcanoes. Thou art a precious hell-hound, Maldura! Yet I might have foreseen this, for I have known such men — but I did not. Well, 't is done; and — let it go. So there 's an end on 't."

CHAPTER XV.

There are some men who can daily await, and even count the hours up to, a threatened bereavement, with little discomposure; not so much from want of feeling as from a constitutional repugnance to the admission of any definite form to a future evil; they know it will come, but it is virtually a *mere name* so long as they possess the present. Yet there is a moment when the present and future may be said to unite, and to produce, like the mingling of light and darkness, a kind of twilight image of both: 't is in the last counted hour. As in grief, so it is in guilt: and so was it with Maldura. Whilst his revenge was maturing, he had watched its progress with a moody quietness; but now that the deadly fruit was ripe, and he saw it hanging by the last fibre, ready at the breath of the next minute to drop into his hand, he could not help shrinking back with a fearful misgiving of its bitterness.

He had retired to bed at his usual hour. But

he had closed his eyes and composed his limbs in vain; he could not sleep; the tide of his thoughts was not to be stopped, neither could he force them into other than the troublous channel they had taken; they still rushed on in spite of his will; till, wearied and maddened by his fruitless efforts, he sprang out of bed. He then dressed himself, and, taking a book, began to read aloud; but the sounds he uttered conveyed no meaning to his brain. At last the clock struck one — the half hour — two. " 'T is over!" said he, throwing the book from him. " Fool! torment yourself no longer for what is past recall. Pshaw! this shaking is mechanical — the coward body. Well, here 's a remedy for that," seizing a goblet of wine. " Yes, the soul is still firm; as it should be in triumph. Ay, triumph; for revenge — what is it? A mere speculation? a freak of the mind, beginning in a day-dream, and ending as it began — in nothing? Has it not relation to time, place, object? and can a thing unreal hold such relation? No. 'T is then a reality; if so, can it come of nothing? No; 't is a consequence of something. What then is that something? — Injury! Let the Monaldis then blame themselves. If they would know the cause of my revenge, let them remember, that *she* reject-

17

ed me — that *he* supplanted me. Tush! no more
of this."

With such wretched sophistry did Maldura en-
deavor to silence his conscience, when Fialto en-
tered.

"Nay, start not," said the Count, as Maldura
drew back to let him pass; "'t is your good ge-
nius — the best, I'll be sworn, in your whole cal-
endar of devils. What, dumb? No greeting for
your faithful Abaddon — your plenipotentiary to
the powers below? Why, man, you look as if I
had actually come thence, and brought with me
an atmosphere unpolite."

"You have license, Count," observed Maldura,
"to speak of yourself as you please."

"And of you too, I hope."

"You come, I suppose, to tell me the affair is
over."

"A word first," said Fialto. "I take it, Mal-
dura, you are a man of honor?"

"Why that question, sir?"

"Because it often happens, that when a pupil
first enters Lucifer's school, he thinks it regular to
begin in the lowest forms, such as lying, word-
breaking, cheating, &c."

"Fialto," interrupted Maldura fiercely, "if I
thought you dared suspect me — "

"Not so hot, man. I suspect no one. I only wish to be sure of my ground."

"Well, sir, what is your drift?"

"Merely to know if you mean to abide by your contract."

"Dare you doubt it?"

"You know I dare anything. But you have well spoken; and I do not doubt you. Now to business. The draughts on your banker at Bologna, I think, are already signed?"

"There, sir; look at them."

"Right. But there were five hundred sequins in gold for present expenses. Ah, they are in this bag. All right."

"To a baiocco, sir," said Maldura.

"I don't doubt it," said the Count, sweeping the gold and bills from the table. "And thus ends my diplomacy; for the game is up, and the wages of sin are won!"

Though Maldura had anticipated this, and thought himself prepared, he needed all his pride to conceal the numbing horror that now seized him. 'T is over then," said he, faintly; "well —" but he could not proceed.

"Ha! he quails," said Fialto to himself. "'T is well; he shall shake yet to his midriff for putting

me on this cursed business. But how 's this, my
gallant principal — you don't seem to rejoice ? "

" You don't know me," replied Maldura, en-
deavoring to force a laugh ; but the sound only
rattled in his throat.

" Ay, that was a merry laugh, but rather too
dry. You should drink, man ; joy is thirsty by
nature — especially of the grim breed. There,
pledge me now in a reeling bumper to the black
knight of revenge."

" 'T is sweet ! " said Maldura, emptying the
goblet, and assuming an air of hardihood.

" What ? "

" Revenge."

" Oh, delicious, no doubt. But I hav 'nt given
you the particulars."

" Why, no matter for them now ; 't is enough
that the affair is over."

" As you please. But there 's one thing I must
touch on. There was, I think, an additional
clause, a kind of codicil to our contract — that if
your *friends* parted, the reward was to be doubled.
Was it not so ? "

" It was ; but you cannot claim that *yet*."

" Suppose I could ? You remember you are a
man of honor."

"You may see I have not forgotten it," answered Maldura, producing another draught.

"'T is mine then," said Fialto, seizing it.

"Impossible!"

"Then impossibilities have come to pass."

"Count Fialto," said Maldura, rising. "I doubt you trifle with me."

"In honorable earnest," replied Fialto, carelessly. "They parted exactly at one o'clock; that is, if Antonio's watch be right."

"Parted! and you know it so soon?"

"Even so; and, what's better, *so* parted, that all the priests in christendom could never reunite them."

"How! what mean you?"

"The woman's dead — that's all."

"Dead!"

"Ay, dead as Santa Rosalia herself. Glorious! is n't it? What, dumb with joy? I thought you would be, and kept it for a bonne bouche that would send its savor to your very heart. But that is not all — the best is to come; she was murdered — murdered too by her milksop husband!"

Maldura staggered, and fell back into his seat.

"Ha!" continued Fialto, advancing, and raising his voice, "why don't you laugh — shout? Hey? shout — dance, sing *io triumphe*, man! for

17*

the deed is done past all undoing; ay, done, and bruited, and chronicled too by this time in all the infernal gazettes!"

"Monster!" exclaimed Maldura, recoiling from him."

"Which of us!"

"Leave me, fiend!—blasted be the hour that brought us together."

"What, ho! did you think to raise the devil, and expect him to leave his work half done? I thought you knew him better; for I never saw one who looked and talked so like his cater-cousin. Marvellous! Why, you were wont to brood over this precious plot like some dark hell-bird in the incubation of an imp; and now that the thing is hatched, you shrink, and turn craven before your own offspring."

"Begone, villain!" cried Maldura, starting up, and moving to a distance.

"Softly, my worthy compeer," said the Count. "*Devil* as often as you please; but my honor brooks no vulgar appellation of earth."

"Leave me then, devil! and curse me no more with your hateful presence."

"Hateful! What, hateful to Maldura?" said Fialto, with a sneer. "Then I must be *above* him. On my life, this is supposing me to have reached

an elevation in iniquity to which I never dared aspire. But you do yourself injustice. Why, *I* am but a thing of clay — a mere receptacle of appetites; and, evil though they be, they are yet human; in other words, I'm a man — bad, if you will, but too gross, too material, to be named with — what shall I call thee? The very sentiment, the idea, the unimpassioned essence of sin! If I prey on others, I only transfer something from their needs to my own; if I deceive, 't is only for a craved advantage; and if I pull down, 't is only to build up for myself; so that nothing is lost. In short, my utmost scope is barely to anticipate time, and now and then, perhaps, to forestall fortune in her eternal mutations. But thou — thou art above profiting by thy actions; for thou deprivest for the pleasure of bereaving — destroyest for the gust of destruction; in a word, thy sins find their end in nothing, and vanish, like abstractions, in the dark, joyless abyss of thy soul."

Maldura, trembling with rage, unsheathed his dagger — but guilt had cowed him; he stood a moment irresolute, and the weapon dropped from his hand.

"I would that I could pity thee," said Fialto, observing the action and fixing his eye on the dagger; "but — pah! my soul sickens at a coward."

"Ruffian! robber!" screamed Maldura, snatching up the dagger, and rushing on him with fury.

"Another step," said the Count, presenting a pistol, "and your brains shall spatter these walls."

Maldura retreated a few paces, and, seizing a chair, with a horrible execration, dashed it in shivers against the wall. "Thus! thus!" said he, "shall it be with thee! Remember the *nun!*"

"Dost thou threaten?" replied Fialto, advancing; then stopping short— "No," he added, "I will not hazard my life by taking thine in this place. Besides, thy menace is too impotent to claim a thought; my secret is safe enough in thy cowardly keeping. The nun wants no better guard than the ghost of Rosalia; they are now leagued; summon the one, then, and raise the other— if thou darest. Ha! does the name of Rosalia shake thee? How then wilt thou stand it when all Rome shall couple it with thine— her destroyer? That thou art so, and without benefit to thyself, is why I hate thee. As for my part in the business— I acted in my need, and under thee, thou superlative tempter! so the world would not waste a curse on me. But what tempted thee? Oh, I forgot— thou art a poet. Well, thou hast reached the ideal of sin; and I give thee joy of thy bloody chaplet."

"Leave me, or poniard me, unmerciful dog!" cried Maldura, in a voice hoarse and scarcely articulate.

"Thou shalt have thy wish," said Fialto, turning contemptuously towards the door. "But I leave thee this advice, Maldura: Ride not wide of Rome. Should we meet again at Radicoffani, my stilletto, perhaps, may do, for once, some service to the world." So saying, he left the house, and a moment after the clatter of hoofs gave notice of his departure.

As the sounds caught his ear, Maldura felt as if there was one fiend less to tug at his heart; but the relief was transient, for another minute brought their echoes to his brain, hurrying him back in memory to his first meeting with Fialto — then from place to thought — from thought to word, and plot, and action — through their whole horrible meanderings to his present hell. His agony now became choking, and, grasping his throat as though he would tear it open, he thought he would give the world for a groan; but even that was denied him, and he fell on the floor without uttering a sound.

Thus ended this compact of sin. It could not have ended otherwise; for there is no sympathy in evil, whose natural consequence is hatred.

Yet the evil may not hate themselves; if they do not, however, 't is only because of that instinctive sophistry with which the mind is ever ready to defend itself from whatever is painful; but the delusion is limited to themselves; for the vices of others they have a clear-sightedness which even the minutest deformities cannot escape. Indeed, evil is but another name for moral discord; its law, revulsion; and its final issue the shutting up the soul in impenetrable solitude.

CHAPTER XVI.

WHEN Antonio, with his fellow servants, entered his mistress's apartment and saw her weltering in blood, and stretched, apparently, lifeless on the floor, he was too much shocked at the part he had borne in her catastrophe to wait for a second look, but, concluding her dead, availed himself of the general confusion to slip away and convey the intelligence to his employer. The consternation of the other domestics may easily be imagined; but, fortunately, there was one amongst them, an aged housekeeper, who, on removing the body, and perceiving it still warm, had the presence of mind to send for a surgeon. In the mean time Rosalia was put into a warm bed, and such other restoratives being applied as are usual in similar cases, she soon began to show symptoms of life. Immediately after, the surgeon arrived. "One minute more," said he, "and I should have been too late." He then proceeded to probe the wound, when, drawing a long sigh, Rosalia opened her eyes.

On further examination, the surgeon pronounced
her wound a flesh one ; but she had suffered so
much from loss of blood, he observed, that nothing
but the utmost care and absence of all excitement,
could possibly save her. He then ordered the
room to be cleared, and enjoined that on no ac-
count she should be allowed to speak. This last
injunction became necessary in consequence of
several ineffectual attempts she had made to in-
quire after her husband. The surgeon further
added, on catching the word husband, and con-
necting it with certain surmises which had been
hinted to him of Monaldi's concern in the affair,
that he would recommend it to her not to see any
one — " not excepting even her husband." Rosa-
lia answered with an imploring look, but the surgeon
observing, that her life depended on her obedience
in this particular, she was obliged to acquiesce.
For the same reason the interdiction was also ex-
tended to her father. It was with great difficulty,
however, that Landi could be prevailed on to
forego seeing his daughter ; but the surgeon was
peremptory, and he was forced to obey. It was
fortunate for Rosalia that the knowledge of her
husband's absence was thus kept from her ; Mo-
naldi having disappeared, and gone no one knew
whither ; as to his insanity, the few incoherent

words he had uttered previous to her fainting, had either passed from her mind, or, considered merely as the effect of violent emotion, were little heeded.

We left Maldura in a state of misery only to be conceived by the guilty, or by those to whom a holy abhorrence of sin reveals its frightful nature. It was in vain he summoned the casuistry which had hitherto supported him in the contemplation of crime. It came now, as formerly, and with a sound of might, but it spent itself like the wind against a solid rock; for he had now to do, not with hypothesis, but a based reality, darkening the present, and stretching its long shadow into the future. Before the accomplishment of his purpose his life had seemed a burden, and he would have welcomed death as a release from trouble; but now, though the burthen was heavier and more galling, the thought of death only filled him with dismay, and he shrank from it as the traveller shrinks from an abyss whose edge his foot feels in the dark, but whose depth neither his eye nor his imagination can fathom.

Thus will the sense of guilt sometimes cow the proudest philosophy. The atheist may speculate, and go on speculating till he is brought up by annihilation; he may then return to life, and reason away the difference between good and evil; he

18

may even go further, and imagine to himself the
perpetration of the most atrocious acts; and still
he may eat his bread with relish, and sleep soundly
in his bed; for his sins wanting, as it were, sub-
stance, having no actual solidity to leave their
traces in his memory, all future retribution may
seem to him a thing with which, in any case, he
can have no concern; but let him once turn his
theory to practice — let him make crime palpable
— in an instant he feels its hot impress on his soul.
Then it is, that what may happen beyond the
grave becomes no matter of indifference; and,
though his *reason* may seem to have proved that
death is a final end, then comes the question:
what does his reason *know* of death? Then, last of
all, the little word *if*, swelling to a fearful size,
and standing at the outlet of his theories, like a
relentless giant, ready to demolish his conclusions.

But Maldura's sufferings were now to be sus-
pended, for the report of Rosalia's recovery at last
reached him. This unlooked-for intelligence was
followed by a spasm of joy scarcely to have been
exceeded had he been suddenly reprieved from an
ignominious death. He felt like one emerging
from the hopeless darkness of a dungeon to the
light and free air of day; and though the hope
which had once sustained him was gone forever,

and he had nothing to look to, he yet began to
fancy, and even to feel, without stopping to ask
why, that his former relish of life was now return-
ing. But his respite was short. It was natural
that release from a great, though only imagined,
evil should render him for a time less sensible to
such as were minor and actual; but they were
light only from comparison, and no sooner did the
weight of the former begin to pass from his mem-
ory, than the pressure of the latter became more
perceptible, till at last, in spite of every effort to
resist them, they became the subjects of his daily
and hourly contemplation.

Amongst these, the sorest, and that which time
rather added to than diminished, was the destruc-
tion of Monaldi's peace, perhaps of his life; for
Monaldi had never been heard of since the fatal
night, and whither he had gone, or what had be-
come of him, was still uncertain.

Whilst Maldura believed himself injured, and
the victim of the world's injustice, he gave him-
self up to a moody sullenness, either shut up at
home, or brooding in darkness in the solitude of
ruins. But now that his sufferings were occasion-
ed by his own crimes their effect was different.
He became restless; deserting his former haunts,
and mixing with the world; visiting every place of

public amusement, giving entertainments, and form-
ing new acquaintance; then, tiring of these, he
would change his abode, engage in new diversions,
and collect new associates; then he would remove
to another, then run the same round, till that was
exhausted; then to another, then from city to city,
from village to village, wandering and journeying,
day and night, and seeking and catching at every
kind of object, however insignificant, that might, if
possible, draw his thoughts from himself: and such
is the last object of guilt; for novelty while pursued
is the world's substitute for hope; when possessed,
its opiate for remorse — the opiate indeed of a mo-
ment — yet for that moment will the guilty toil
more intently and desperately than in their days of
innocence for the promise of heaven.

It was in one of these wanderings that Maldura,
returning towards Naples, in company with a party
of pleasure, was separated from his companions
by a circumstance of no uncommon occurrence.

The day had begun sultry, but was now closing,
after a refreshing shower, with one of those de-
licious atmospheres known only in the south; so
sweet! so bright! — as if the common air had
suddenly given place to the humid sighs of answer-
ing orange groves and the intermingled breath of
enamored flowers — as if the dripping trees and

fields had actually been flooded by liquid gold
from the sun; then the hum of insects, the twit-
tering of birds, and the ceaseless darting of innu-
merable lizards, so filling the ear and eye with
sound and motion, as if the very ground and air
were exulting in life! Such a scene was not for
Maldura, and, trusting to his horse to follow in the
track of his companions, he had closed his eyes,
when, reaching the brow of a hill, a general ex-
clamation from the company made him look up.
"Glorious! magnificent!" now burst from one
and another. It was the bay of Naples; a scene
not to be painted by words — even though its
waters were likened to a sea of sapphire, its moun-
tains to amethysts, and its skirting city to a fillet
of snow; these indeed might give their color. but
not the harmony of lines, nor the light and shadow,
nor the dazzling expanse — and never the living,
conscious joy with which they seemed to send up
their shout of praise to the immeasurable depths
above. There is a voice in nature ever audible to
the heart — which no hardness can shut out — and
for its weal or wo, as the heart may be. Maldura
heard it now — breaking upon him like a clap of
thunder. He instinctively turned from the scene,
and looked towards Vesuvius. But even from that
he shrank; for the terrible Vesuvius was now smiling

18*

in purple, and reposing beneath his pillar of smoke
as under a gorgeous canopy: the very type of
himself — gay and peaceful without, yet restless
and racked with fire within. A groan was rising
to his lips, but a resolute effort enabled him to sup-
press it; yet dreading to trust himself any longer
to the observation of his party, he hastily dis-
mounted, under pretence of decyphering a half-ef-
faced inscription on the road, and bade them ride on.

His companions being now out of sight, Maldu-
ra was about to remount, when the girth of his
saddle gave way. This accident made it necessary
for him to seek assistance, and he was proceeding
for this purpose to a village a little off the road,
when he thought he descried through the trees
something peeping above the ruins of an ancient
tomb like the roof of a hut. As he approached
he perceived it to be the shed of a half-demolished
hovel; but thinking it might possibly still afford
shelter to some wandering swine-herd, he fastened
his horse to the branch of a wild fig-tree that grew
out of a crevice in the ruin, and, walking round,
had just come to the side of the hut, when he
heard a low murmuring sound as of voices within.
He stopped a moment, doubting if it were safe to
enter; should he encounter robbers, the odds
would be against him. Whatever the sounds

might proceed from, he thought it at least but prudent to reconnoitre, and observing a rent in the wall he looked through it; but he could only perceive a dark heap lying in a corner, and something like a human leg thrust from beneath it. Being satisfied that he had nothing to fear, Maldura entered. On a nearer view the heap in the corner proved, as he had conjectured, to be a man asleep. "Ho! fellow!" said he; "awake — I need your assistance." With a languid motion the figure turned upon his back, and slowly drawing down the dark and tattered mantle, that enveloped his head and body, a little below the eyes, appeared to look up. Maldura, catching a glimpse of his ashy forehead, as it gleamed through the flakes of his long black hair, bent forward to see if the man were awake; but his eyes were so dark and sunken that he could only discern two bright specks. "Come, rouse thee, fellow," said he, impatiently, "I want your aid." The man made an effort to rise, and the garment fell from his face. "Monaldi!" exclaimed Maldura, recoiling with horror.

"Who calls me?" said the other. "What do you want? — oh, you are are a *Sbirro*. But you come too late — I am dead — ha! ha! You cannot touch me now!"

"Fiend, devil that I am!" groaned Maldura.

"His wits are gone — and I — open — gape, hell, and swallow me!"

"Go, go," said the maniac.

"I will, I will," cried Maldura, "and rid you of a monster!" So saying, he rushed from the hovel, when, stumbling over a loose stone, he fell to the ground. He sprang upon his feet again, but the accident had given a moment for reflection. "No!" he said, while a multitude of thoughts passed with the rapidity of lightning through his brain. "No — I will still endure the torturing sight — though it transform me to the like — and endure it, if possible, to save him."

This resolution calmed him in an instant; but it was not till after a considerable time that he could summon sufficient fortitude to return to the hut. When he did so he found Monaldi again covered and seemingly asleep. On lifting the mantle, however, he perceived that he was still awake — but so exhausted, either by disease or famine, that he could no longer move.

As Maldura beheld the ravages which misery had so rapidly made on his late happy friend, and gazed upon the livid remains of his noble countenance, the gaunt and angular outline of his once graceful form, he felt that he had need of all his courage to hold to his resolution.

"Horrible!" said he, turning away with a suffocating feeling. "But this is no time even for remorse — he must not lie here." Then hastily quitting the hut, and, vaulting on the bare back of his horse, he set off at full speed for the village.

It was now the first time since Maldura left Florence that anything like a feeling of self-approbation had even glanced on his heart; for now, in spite of his remorse, the consciousness of performing a duty forced a passage to his breast; and feeble as this was — even as the thread of light that ravels its way through hundreds of fathoms of darkness to the half quenched eye of the condemned miner — it yet seemed to cheer his heart almost with hope.

Having ordered such accommodations as the village post-house afforded, Maldura returned with assistance to the hovel, and soon saw his wretched friend comfortably lodged.

A messenger was then despatched for a physician, but, there being none nearer than Naples, it was near midnight before he arrived. The apparently exhausted maniac had in the meantime, through the mistaken indulgence of his attendants, been suffered to gorge himself with food. This brought on a lethargy, then suffocation and spasms, ending in a frightful paroxysm of raving; in the height of which the physician entered.

The agony of Maldura during this scene had become almost insupportable ; but when the physician observed that the injudicious treatment of the patient was the probable cause of his frenzy, and gave hope of his recovery, he dropped senseless. He had borne misery, as we have seen, and almost despair, with a degree of firmness ; but the transition of the latter to hope, even feeble as it was, proved too much for him. As he had, however, only fainted, he was soon revived, when, observing that he still appeared to be much weakened, the doctor advised his going immediately to bed.

" No," said Maldura — " I must remain where I am, though the sounds I hear rive me like fire from heaven."

" Alack ! " said the hostess, who was then bathing his temples, " he has caught the other's madness."

" No, woman," replied Maldura with a ghastly smile, " mine is from hell."

" My good sir," said the physician, " this is no place for one in your state — you must to bed."

" Look at him," continued Maldura, turning towards Monaldi, and without regarding the speaker — " look at that human ruin."

The maniac now, attempting to rise, appeared first to discover that he was bound. For a moment

he endeavored to free himself with a kind of childish impatience, but finding himself baffled, he sent forth a cry so shrill and piteous that the attendants involuntarily put their hands to their cars.

"Nay, hear it," said Maldura, who alone seemed to listen unmoved, but whom the sound had smote deeper; "hear it — 'tis the crash of a wrecked mind — yet even that — even him I envy — For what is his state to mine ? No — the world cannot see the hell from which my spirit looks — nor know the longing with which it strains over the gulf between us. Bid me not leave him, in the fear that suffering like his can injure *me*."

Thus did the pride of Maldura, stony and colossal as it seemed, fall before the voice of conscience, even as the walls of Jerico before the horn of Joshua.

But the triumph of conscience was not yet complete. Though his presumption was gone, and he no longer sought to resist or evade the sense of his crime, he could not wholly subdue a worldly feeling of shame at the thought of appearing despicable in the eyes of others. He had therefore no sooner given vent to this burst of remorse, and perceived its effect on the astonished hearers, than he felt as if he could have sunk into the earth.

" Poor gentleman ! " said the landlady, crossing herself with a mixture of fear and compassion — " he seems to have some terrible sin on his mind."

" Peace woman ! " said Maldura, " leave the room."

" San' Gennaro protect us ! " muttered the hostess." I can at least take a good conscience away with me — which is more than I shall leave here."

Whatever the physician may have thought, he was prudent enough to keep it to himself; he however again urged Maldura to retire ; but, finding him still obstinate, he left his patient in his charge, promising to repeat his visit at an early hour the next day.

This was the first penance to which Maldura had ever brought himself to submit. And never did desperate contrition encounter a greater. For, taking his station at the foot of the bed, and keeping his eyes fixed on Monaldi, he scarcely moved during the whole night; and, though every sound and look seemed to go through him, he still continued to stand listening and gazing, hour after hour, till the wretched maniac, exhausted by raving and the violence of the fever, sunk at last to sleep.

The day was already far advanced before the

physician arrived. " Your friend," said he, turn-
ing to Maldura, " if I mistake not, will awake in
his senses: it may be, only to know that he is
dying; yet, as it is possible he may recover, we
will hope for the best. All depends on the strength
of his constitution, and his being kept quiet."

Maldura attempted to speak — " My dear sir,"
continued the doctor, perceiving his emotion, " I
will not ask if you wish the recovery of your
friend; but, if you do, you must remain here no
longer. His crisis is at hand, and I dare not
answer for the issue should either your presence,
or any other cause produce the least agitation.
" Tis not for your sake, but his — " " No more,"
said Maldura, " You shall be obeyed. But when — "
" You may see him to-morrow," interrupted the
physician.

CHAPTER XVII.

WHEN Monaldi awoke the next morning, his reason was returned; but he was so feeble that his attendants could only perceive it in the change of his countenance. The sympathy in such a transition is not confined to friends or relatives; for there is no species of calamity more universally touching than madness, and no joy more general than that which follows the restoration of reason. Though surrounded by strangers, no sooner did Monaldi open his eyes and begin to speak through them like an intelligent being, than, with the exception of his, there was not a dry eye seen in the room; and when he at last spoke, and inquired where he was, their joy became so tumultuous that the physician was obliged to order them away.

This is but one instance of the many anomalies of human nature; for amongst all these whose humane sympathy was here excited, there was scarcely one, perhaps, who might not, in other cir-

cumstances, have easily been tempted to cheat, or slander, or betray the very object of their present compassion.

Whether this feeling be called virtuous, or not, it is not to be relied on as any evidence of goodness. There is nothing indeed deserving the name that is not equally so under all circumstances; an integrity which principle alone can ensure; the true proof of which is where, opposed to our interest, it triumphs over self. And yet this incidental virtue has its use, nay, it seems to be a common providential tax, that not even the bad should escape adding something, however small, to the general stock of happiness; for even the most selfish must be limited in his conflicts, and find thousands about him to whom he may be kind and compassionate without the cost even of a calculation; the world would else be at a stand, and the mass of men locked up in individual jealousies amidst the universal barter of benefits.

When the Physician had pronounced Monaldi out of danger, and he had so far recovered as to sit up and converse without difficulty, Maldura ventured to enter his chamber.

"Is it you, Doctor" said Monaldi, for the dim light of the room prevented his seeing distinctly.

"No," replied Maldura; "the doctor is in Naples, and will not return before to-morrow.

"Sure I should know those tones," said Monaldi, reaching forward, "and yet it cannot be. Who is it then?" Maldura then drew nearer. "Blessed Heaven! Maldura! But, speak — is it indeed my friend? or does this uncertain light mock me?"

"You are not deceived," said Maldura: "'t is even he whom you once —— It *is* Maldura."

"It is indeed!" said Monaldi, as soon as his emotion allowed him utterance. "My best, my earliest friend. But how came you here? Yet I need not ask; for the kindness of Maldura's heart would have traced me."

Maldura turned away and covered his face in agony; for he had now to taste the bitter draught of praise unmerited — of praise made still more bitter in coming from the unsuspecting victim of his own villany.

"Nay, do not weep," said Monaldi, mistaking the cause of his emotion. "I seem, it is true, a sorry spectacle, but that is nothing: I have been snatched from death — and more — I am restored with reason. Do not weep then, but rather rejoice, and aid me in giving thanks to that merciful Being who has still spared me, guilty as I am."

Maldura, making an effort to collect himself, again took the hand of his friend. "Monaldi," said he, "I would pray with thee, but —— "

"You believe *not?*" said Monaldi mournfully. "Alas, I had hoped that your early opinions had passed away with the vainglory of youth."

"You mistake me," replied Maldura, "I thought not to deny your request, but only to defer for awhile —— "

"But why?" interrupted Monaldi. "Is not praise due for signal mercy?

"Because you know not yet the full measure of that mercy."

"What mean you?" cried Monaldi, starting up in the bed. "Is there — can there be — alas! no; the world is nothing now to me. Yet I will not repine; for this is mercy— oh, how far beyond my deserts, that I am still permitted, though with a life of sorrow, even *here* to atone for that accursed deed. But I speak perhaps of what to you is a mystery." Maldura was silent, for he knew not how to reply. "It must be so," continued Monaldi, "else you would not be here."

"Not so," answered Maldura.

"You know it then?"

"But too well."

"And yet, because your friend — you come to

19*

comfort a murderer. So pure yourself, yet so
compassionate of guilt! There is but one Maldu-
ra."

Maldura only replied with a groan. "Would,"
he thought, "there were never one!"

"But no," added Monaldi; "I do injustice to
your principles. You come to call him to repent-
ance."

"No — *you* need not — at least in the degree."

"Say not so," cried Monaldi; "you know not
the damning nature of my crime. The guilt of
blood is on me — that were enough — but that
blood too was *innocent*. Yet, dreadful as is this
aggravation, still do I bless Heaven that I was per-
mitted to know it ere we parted. No, Maldura,
deeply as it sinks me in misery, I would not ex-
change this blissful conviction, wrought as it was
in agony and blood, and breathed into my soul by
her dying lips — for all the joys (might even my
spirit taste them) which the whole world could
give."

"Thank Heaven!" thought Maldura, "he be-
lieves her innocent. He has now only to bear the
shock of joy."

"Doubt you then," continued Monaldi, "that I
need repentance?"

"I do not doubt — though I repeat my words."

"I cannot understand you."

"Nor will you until you know — but I wander from my purpose."

"What purpose?"

"You shall hear. But have you courage? Do you think you could bear —"

"What?"

"The fulness of joy."

"Oh, torture me not," said Monaldi, grasping his hand with violence. "A dream of hope has come to me — speak quickly — for I fear that I could not survive its vanishing."

"Then, live," said Maldura, "for your wife —"

"Speak!" said Monaldi, with a piercing scream.

"She lives!" said Maldura.

Monaldi, losing his hold, fell back speechless on the bed. Maldura instantly sprang to his assistance; but he had not fainted. "Heaven be praised!" said Maldura, "at least one mountain is off my soul."

For a long time Monaldi lay without word or motion; at length, drawing a deep sigh, he gently clasped his hands, and raising his eyes upwards, seemed to be engaged in prayer. His wretched companion knelt beside the bed, and bending over it, continued in that posture till, overwhelmed by the sense of guilt, he sunk exhausted on the

floor. This was the first prayer that Maldura had
uttered since his days of childhood ; and the con-
sciousness that it was so, carried his thoughts back
over a dreary and long-forgotten waste of years :
no wonder then, that he sank appalled, when, at
every step, some buried sin, now rising up before
him, added to the long array, like an army of
spectres.

"My friend," said Monaldi, reaching out his
hand, "come near me. My strength has return-
ed."

"Blessed be God!" said Maldura, "if that *I*
might say so."

Monaldi, pressing his hand, made a sign to him
to sit by the bed. "I am strong enough," said
he, "to hear the particulars. How was it? how
did she survive the blow? I thought I saw her
die — but my reason was gone."

Maldura then related in a few words what he
had gathered from report ; and concluded by tell-
ing him that he had already written to Rosalia and
her father to acquaint them with his situation, and
that he had since despatched another messenger
with the tidings of his recovery.

"And yet her ashy cheek — the leaden eye,
which has so long haunted me," said Monaldi,
"were they not real? Speak to me, Maldura —

for this strange place — all I have heard, seem so like a dream."

" 'T is all real," answered Maldura.

" Mysterious Providence, how dost thou watch over and baffle the sinner for his good! And you saw her?"

" No. I said not that I saw her —"

" Nay, then," interrupted Monaldi, with a distrustful look.

" But I had the account from your family surgeon. I think his name is Vannini."

" 'T is true then!" cried Monaldi, "the whole world would not make me doubt it now. Bless him! Oh, Maldura —" He stopped, for the fulness of his joy verged to pain, for a minute almost to agony, when a flood of tears relieved him.

" Devil!" thought Maldura, "and I would have broken this heart."

" Give me your hand," said Monaldi. " Yes, 't is real."

The touch shot maddening to Maldura's brain. He withdrew his hand, and covered his face.

" What is the matter — are you ill?" asked Monaldi.

" Think not of me," said Maldura. " I would have but one thought — of yourself."

"So like you! yourself ever last. Then be it
so. You tell me that my poor wife was soon re-
covered. Did she — yes, she forgave me — she
must have inquired after me."

"You were sought after through every town
and village. Even now, I believe the search is
continued."

"Thank Heaven! she was spared *that* shock.
Had she discovered me at one time — Oh, my
friend, you know not what I have suffered."

"But too well," thought Maldura. "And yet,"
he added aloud, as if willing to take from the load
on his conscience, "the loss of reason must have
blunted you too much."

"You say right. What I endured at that time
I know not ; 't is now but a dark dream to my
memory. But this is not my first return to reason.
I had a lucid interval of many days — such
days ! — No, your innocent heart cannot even
shadow them — *you* have not felt remorse."

"I must bear it," said Maldura to himself.
"Then let it come — all ! Go on."

"When I came to myself I awoke, as I thought,
with a sensation of extreme cold. I was lying on
the snow, on one of the desolate ridges of the
Apennines. How I came there I knew not — and
I thought I was dreaming ; but I soon found that

I had recovered from madness. I shuddered.
Yet my recollections of it were dim and shadowy,
and they passed away. Not so what followed —
the remembrance of the night which sent me forth
a maniac ; my poor wife — murdered, and inno-
cent — yet forgiving her murderer. This was the
misery, Maldura. I had taken vengeance upon
me, when I should have forgiven even my deadli-
est enemy. I was a murderer of one who loved
me ! No — you must first know remorse to know
what I have gone through. But I will not recall
it."

" Nay, on — I would know *all*," said Maldura,
whose self-abhorrence now became greedy of pen-
ance.

" Perhaps you are right," answered Monaldi.
'T is wholesome for the mind to look on past suf-
fering — and most so when happy. And I — 't is
hardly painful to recall it now. But one instance
is enough. About sunrise one day I found myself
standing on the edge of a precipice ; I looked
down, and saw, some hundred feet below me, and
rising from out a bed of mist, a multitude of
jagged rocks. On the peak of one of them I per-
ceived something white ; I drew nearer, and found
it to be the skeleton of a mule. The surest foot,
thought I, may stumble at last. It seemed a type

of myself. As the mist cleared away, I looked
again, and a little lower down I descried the bones
and tattered garments of a man. The skull had
fallen from the body, and lay grinning upward as
if in mockery of my horror. Presently it appeared
to move ; a moment after, a small snake wound
itself out of one of the eye-holes. At another time
this would have made me shudder; but I now
caught at it with a perverse avidity : it seemed to
call up the living man before me. I saw him with
all his innumerable nerves, and those sensitive
messengers speeding with the abhorred touch of
the reptile to his brain. I saw his hair bristling
with terror, and heard his cry echo among the
rocks. I then thought of his form in death, now
blanched and mottled with weather-stains, impen-
etrable to injury, though man and beast were
leagued against it, though the mountain I stood
on should topple down and grind it to powder. A
horrid feeling of envy gushed from my heart. I
called it happy, and hung over it with a kind of
furious longing — gazing, and gazing — till, me-
thought, something — I know not what — seem-
ed to force me from the precipice, and I fell on
my knees. It was the first time I had dared to
do so."

"'T was for *me* to have envied it !" said Mal-
dura, thinking unconsciously aloud.

" You ! " exclaimed Monaldi.

" Go on," said Maldura.

" I know not how long I continued in prayer," resumed Monaldi, " but when I arose my despair was gone ; my remorse was now changed to repentance. Then followed hope — such hope — oh, my friend, as only the broken heart can know when the healing comes from Heaven."

" But such as mine," said Maldura, in a half-smothered voice — his heart failed him, and he stopped.

Monaldi continued. " How my reason again wandered — But I see it distresses you. We will leave the past then, and talk of the future — or rather of the present. But why do you shake so, and look so pale ? Nay, forgive me that I have asked such a question — as if you could hear my tale unmoved. Oh, Maldura, you have the heart of a child."

" This is too much," said Maldura, moving away from the bed.

" Nay," said Monaldi, " do not think of my sufferings ; they are passed. Think only of my present happiness ; for I know not the mortal with whom I would now exchange lots. Come, my friend, dwell no more on the past, but think of the

20

world I possess. For is not that a world, beyond
which the heart has no craving ? And what more
could I ask, with such a wife, and such a friend ? "

"You never *had* a friend," said Maldura.

"Never had ! " repeated Monaldi, with a feel-
ing rather of perplexity than astonishment. " Mal-
dura, why do you talk so wildly ? "

Maldura made no reply, but, returning to the
bed, drew a chair near it. His eyes were bent
downward, and he seemed inwardly struggling
with some violent emotion. " 'T is done ! " he
said at last, while a flush of gloomy satisfaction
passed over his brow : " the proud neck bends to
the yoke."

"Whose neck ? " asked Monaldi.

"Monaldi," said Maldura, without heeding the
question, "you said you believed your wife inno-
cent. On what was your faith founded ? "

"On her own words."

"On nothing more ? "

The faint color, which the excitement of the
moment had brought to Monaldi's cheek, now
suddenly gave place to a corpse-like whiteness.

" 'T is even as I thought," said Maldura to him-
self ; "another fiend might rekindle his suspicions
with a breath." And he repeated the question.

" Wherefore do you ask ? " said Monaldi.

" You shall know. But answer me. Had you no other ground of faith ? "

" They were her dying words — at least so thought she as well as I. I needed no more."

" And would they serve you, think you, as a lasting panoply? And you — would no insinuation, no future circumstance touch you with doubt ? "

" I think — nay, I *know* they would not. Yet why — oh, do not torture me — but if you know aught — speak at once."

" You have said enough," replied Maldura, " to determine my course. You would not again murder, for your heart is changed ; but for the rest — Monaldi, you need more than your wife's words ; and you shall have it. You *believe* — but *I know* her to be innocent."

" You ! "

" You shall have proof which you cannot doubt. Listen — You first saw Fialto in your gateway ?"

" Fialto ! How know you — "

" No matter. Answer me."

" I did so."

" You saw him then almost daily in Romero's shop, or sauntering by your house ; looking up at your windows, and always seeming confused when

detected. Next you met him at the theatre —
then as you were returning home near your house."

Monaldi listened with amazement. "Good
heaven! you could have learnt these particulars
only from the wretch himself."

"You will know how I came by them. Had
not you a servant called Antonio?"

"Yes."

"He was a creature of Fialto's. Through him
his employer became apprized of all your move-
ments — your visit to the theatre — your projected
journey to Genezzano: this last intelligence sug-
gested the letter, which was put into your hand,
as if by mistake. You were addressed as Gieu-
seppe —"

"Monstrous!"

"Ay — there are devils that walk the earth
even now. But listen. Then followed the last
damning proof. The effect of the letter was anti-
cipated — it needed but little knowledge of man
to have done it — your suppressing it; your feign-
ed journey; your return. Accordingly Fialto was
prepared to meet you, the wretch Antonio having
admitted and secreted him at an early hour in
your dressing-room."

"Enough," cried Monaldi; "I need no more."

"Nay, I must through. Your approach was

then announced by a preconcerted signal from one who had dogged you from Rome, and back. Soon after, your step being heard on the stairs, Fialto stole forth from the closet; you were at the door; he sprang towards the bed, and seized your sleeping wife."

"Merciful heaven! that human malice should have so pursued me!"

"Was it not a web worthy of fiends?"

"Horrible!"

"You had been unlike man to have broken through it."

"The frightful scene still makes me shudder. But, tell me — what was the motive for this cruel villany?"

"Revenge."

"Revenge! — for what? I had never injured him. I knew not even the name of Fialto till we met in the theatre."

"Think not of *him*; he was but the instrument — and a fit one too, for his name alone were enough to blast the peace of any house he might enter. What he did was for that with which hell is paved — for gold."

"Of whom speak you then?"

"Of the devil that employed him — to whose

20*

black and envious soul the libertine Fialto's seems almost bright; of one who hated you."

" Hated me ! I have never harmed living creature, knowingly."

" Know you not then that virtue, genius, success, are all, to the evil mind, causes of hatred? You doubt it. Oh, the pure in heart are slow of faith in evil. But you shall have proof — living proof. Do not interrupt me. There was a time when you, Monaldi, were but one of the multitude. You may recall it if you look back to your days of boyhood — to the school at Bologna. You were then deemed one of little promise — next to nothing. No doubt your quiet and retired habits led to the opinion ; but so it was — and the opinion was general. You may remember too the reputation which *I* then held ; your own estimation of my talents ; that of our masters ; of the whole school. I stood alone — the first — without a rival. Could there have been a greater contrast ? No. The general voice had placed us at opposite extremes: and I thought it just. Yet, because of your praise, I courted your acquaintance. Your confiding heart readily opened to receive me, and — in an evil hour, you called me — *friend.*"

" Stop ! " cried Monaldi, convulsively grasping Maldura's arm ; for a suspicion of the truth now

flashed upon him, and his horror became intolerable.

" 'T will soon be over," replied Maldura.

" I cannot hear it," said Monaldi — " I must not."

" I must on," answered Maldura ; " for the finger of Power is upon me — and I cannot choose but speak." Then, averting his face and looking from Monaldi, he continued with increasing rapidity. " Elated with praise, full — nay, drunk with hope — and sure of fulfilling every early prediction — I began my career. But I will not go over the horrible ground — at every step I sunk — lower and lower — 'till — yes, I must speak it — till my very name was blurred with the common mass. What followed then ? Envy and loathing of all above me."

Monaldi groaned. " Impede me not," said Maldura, hurrying onward, " but listen. I now return to you. What was then your course ? From obscurity, neglect, almost from contempt ; when no one even thought of, dreamt of such a being — with the suddenness of a meteor you burst upon the world. In a moment all eyes were upon you — every tongue, every heart was yours. How think you *I* heard, saw, felt all this ? — how beheld this fame — this boon of the world, for which alone

I had *coveted* life — snatched from my grasp, and lavished unmeasured on the very man with whom my proud spirit would have once disdained to contend ? I cursed you from my heart."

Monaldi gasped for breath.

Maldura continued. " You can now understand my greeting when we first met in Rome — why, knowing your voice, I fled from the gate-way — why I rejected your daily kindnesses — why almost spurned your last generous proffer. But your fame was not all that haunted and goaded me ; though I could not forgive, I should yet have endured it in silence. Your reputation was followed by another offence still deadlier to my pride : you supplanted me in my love. For in my days of hope I had loved your wife — had offered my hand — and been rejected. You afterwards saw and won her. *This* was the blow that felled me. The news of your marriage passed through my heart like lightning, scathing every human feeling — and I swore by my misery that I would blast your happiness."

Monaldi's teeth chattered as with an ague : his hands were crossed upon his breast, his head sunk between his shoulders, and his whole body drawn up as if under the influence of terror ; yet his eyes remained fastened on Maldura, as though a

fearful charm made it impossible to withdraw them. But Maldura saw not — thought not of this effect of his disburthening conscience ; his thoughts were on himself, and, his eyes turned from Monaldi to the opposite wall, he continued to speak like one impelled by the rack. " It was for this purpose I sought Fialto. 'Twas I — I was his employer. 'Twas I caused him to hang about your house — to waylay you from the theatre — to write the letter. Yes, it was I — " repeated Maldura, when, with a terrific shout, Monaldi leaped from the bed. " Avaunt fiend ! "

Maldura stood aghast.

" Back ! back to hell ! " vociferated Monaldi.

" Yes, I deserve it," said Maldura, — " Hell is my place. Even now " —

" What 's your name ? "

" Is it — can it be ! " said Maldura — " Heaven forbid. Do you not know me ! 'T is I — Maldura."

" You Maldura ! " cried the maniac, with a scornful laugh. Maldura's hair rose with horror. " Thou liest ! Maldura was my friend — he was honest, righteous. He had no wings as thou hast. Avaunt, devil ! "

" 'T is over ! " said Maldura, clasping his hands in agony — " my measure is full — " and he rushed from the chamber.

CHAPTER XVIII.

" Where — which way ? Show me to him," said Rosalia.

" Be patient, my child," said her father. We must not be abrupt. So sudden a meeting might prove fatal. Let us wait till our good hostess has apprized him of our arrival."

" With all my heart," replied the landlady ; " though, I should think, the better person for this office would be his friend, Signor Maldura."

" True," observed Landi. " But first, tell me — How is he ? "

The landlady then related the particulars of Monaldi's illness, and was just concluding with an account of his entire recovery, when, pale and ghastly, Maldura entered.

" Horrible ! " said Maldura, drawing back at the sight of Landi. " His wife too — Monster ! now am I doubly cursed ! "

" Speak ! What's the matter ? " exclaimed Rosalia and Landi in the same breath.

"You will know but too soon," replied Maldura, retreating towards the door.

"For mercy's sake!" cried Rosalia. "Stop, tell —"

"Stay me not," said Maldura in a choaking voice — "there's a curse about me." So saying, he dashed open the door, and ran with frantic swiftness from the house.

If it be hard to part with the dead, and to see one borne to the grave with whom we have been accustomed to associate all our wishes and schemes of happiness, and without whom nothing in life seems capable of imparting enjoyment, there is yet a consolation in the thought that our grief is only for our own suffering, since it cannot reach one to whom our loss is a gain. What then must it be to feel this entire avulsion from the living; to know that the object with whom our very soul was mixed, and who is thus parted from our common being, still walks the same earth, breathes the same air, and wears the same form; yet lives, as to us, as if dead — closed, sealed up from all our thoughts and sympathies, like to a statue of adamant. What must it be to know too that this second self, though callous and impenetrable from without, is yet within all sense? The partial palsy-death of the body is but a faint image of this half-death of the twin-

being wife and husband. And Rosalia soon felt it
in all its agony.

The alarm occasioned by this last scene was so
sudden that neither father nor daughter thought
more of first making known their arrival, but, fol-
lowing the landlady, entered Monaldi's chamber.
He was sitting on the bed, his hands clenched on
his knees, and his eyes fixed on vacancy. Rosalia
sprang forward, but at the sight of his countenance
she shrunk back and stood gazing on him in silence.
And next to madness was the dreadful conviction
within her. She would have folded him in her
arms ; but the thought of the touch of the be-
numbed, vacant being before her sickened her, and
she sunk back in her father's arms. But she had
not fainted : the energy of hope that he might
again recover, came like a ministering spirit, and
nerved her for the occasion.

"You must go with me," said Landi.

" No," replied Rosalia, in a low, but firm, voice ;
"I am *his* even in madness. Do not fear for me ;
the shock is now over. But, speak to him." Landi
then advancing spoke to him by name ; but Monaldi
making no answer, he drew nearer and took his
hand. For a moment Monaldi turned to look at
him, then withdrawing his eyes as if with terror —
"away, away ! " he cried. " Why come you

again? thou liest — Maldura did not do it — 't was
I murdered her. Look — look at her — 't was I —
she was my wife — she 'll confess it herself. But
no, she cannot — she 's dead."

"No, she lives — she is still yours!" cried Ro-
salia, going to him.

"Ha! there are two!" cried the maniac with a
frightful shriek. "Take them away — I did not
murder both."

The father and daughter stood silent and mo-
tionless; their very breath seemed suspended; and
for several minutes not a sound was heard but the
quick, low panting of the affrighted maniac. Lan-
di, alarmed for the reason of his daughter, drew
her into another room, when she fell on his neck
and wept. But we close the scene; for we can-
not describe that which no tears relieved — even
that blessed dew, which, in most other cases, soft-
ens agony.

21

CHAPTER XVIII.

LITTLE now remains to be told of the unfortunate Monaldi. He was taken home by his friends, and every means used to restore his reason; but without effect. He would remain for days together, fixed in one spot, with his eyes bent on the ground, and without speaking, or appearing conscious of what was passing about him. Whilst in this state nothing could rouse him but the voice of his wife, which never failed to bring on a paroxysm of raving, when he would sometimes fancy himself Fialto, then Maldura, but more often that he was one among the dead, and that Rosalia had come to upbraid him; for he had in some way or other connected her image with a spirit.

This was a bitter aggravation to Rosalia's wretchedness, since, by forcing her to avoid him, it deprived her of her last melancholy pleasure, that of administering to his comforts. Her struggle was long and severe, before she could bring

herself to quit him ; she at last,.however, consent-
ed to remove to her father's. But nothing could
prevail with her to forbear visiting the house, where
she would often pass entire days, sometimes sitting
in an adjoining room, and listening to his footsteps,
or wandering to and fro, and hanging with fond-
ness over every spot and object with which she
could associate his slightest word or look. Oh,
woman, when thy heart is pure, and thy love true,
what is there in nature to match thee ! Though
he whom thou lovest become maimed, wasted by
disease, or blanked by madness, yet wilt thou cling
to him, and see in the ruin only that image which
he first left in thy heart.

It was after one of the longest of these parox-
ysms, that Monaldi was one day seen to go into
his painting-room. This unusual circumstance
was immediately caught at as a symptom of re-
turning reason ; and the hopes of his friends were
raised on finding, a few days after, that he was at
work on a picture. But his impenetrable silence,
and the deep gloom which still hung about him,
soon shewed, that, if he had recovered at all, it
was only in part ; for though his look was no longer
vacant, nor his actions without purpose, he yet
moved and looked as if he noticed nothing. What
he was employed on no one knew, for, without

speaking, he once discovered so much distress at
the intrusion of a servant, that no one after dared
enter his room. In this mood did Monaldi pass
month after month, regularly shut up, and occu-
pied as if in his perfect senses. At length, after
a fit of weeping, that seemed to fill the whole
house with wailing, he one day came out of his
room, and desired that his father-in-law might be
sent for. Though the order was rational, there
was still something so frightful in his expression,
that the servants at first all drew back ; nor was it
till they recollected its coherence that any one pre-
pared to obey him.

With a beating heart, and eyes lighted up with
hope, Landi instantly followed the messenger.
Monaldi met him at the door.

" You know me then ? " said the Advocate.

Monaldi spoke not a word, but led him in si-
lence to his painting-room.

He watched Landi's countenance. " You feel
it ? " said he, " though only a picture — *I* have
known the original. What is there, I have *seen*."
As he said this, his lips quivered and his knees
smote each other.

Monaldi's insanity could no longer be doubted,
and Landi turned from the picture with a hopeless
sigh.

"Nay, speak not," said Monaldi, thinking he was about to reply: "my time is measured; fo my work on earth is done — and I must burthen it no longer. Landi — thou art reputed wise. Yes, amongst the living thou art so. But what is thy wisdom with the dead? Folly! Your earthly philosophy teaches that the Prince of evil is hideous. And you think to serve the world by it. Miserable folly! Men flee from what is frightful. So would they from sin, did it take the shape you have given it. But *I* — I have seen it, face to face — enthroned in the majesty of hell. Look! That is the form in which he whom men call Satan appears to the living. Ay, 't is with that deadly beauty he wins your souls. But the *evil mind,* which you now see mixed with it, transpires not on earth, when he tempts you; 't is only in hell that his victims behold, and hate it — when too late. Look to it then, you of earth — you, to whom I leave this warning — look to it."

The wild mixture of reason and madness in this speech, and the extraordinary work before him, so confounded Landi that it was several minutes before he became sufficiently collected to perceive that Monaldi had disappeared. His last words then occurred to him, and though obscure, he yet understood enough to be alarmed,

21*

and set off immediately in search of him. But in vain.

From that day nothing was heard of Monaldi till more than a year after; when, he was accidentally discovered at the cottage of a lone woman among the mountains of Abruzzo; but as neither menace nor entreaty could prevail on him to return home, his friends were compelled to humor him, and to content themselves with making his situation as comfortable as the nature of his abode admitted.

Of Rosalia [continues the manuscript] little more need be said. Her affliction is still unabated; for time, which wears away all grief for the dead, has no power with her who is at once both wife and widow. Monaldi is never out of her thoughts; and, her only consolation being that of feeling herself near him, she has become a boarder at a convent in his neighborhood.

Maldura's fate may be told in a few words. He became a brother of this convent soon after his last interview with Monaldi, and died about two years ago; if not lamented, at least pitied for his sufferings, and respected for his penitence. It was at his instance that the picture just mentioned was procured for the convent. He wished to have it near him, he said, that he might never forget what a mind he had blasted.

So died Maldura; from whose miserable life
may be learned this useful lesson: that without
virtue, the love of praise is a curse; that distinc-
tion is the consequence — not the object, of a
great mind ; that it cannot be made so without
the desire of supplanting ; and that envy, jealousy,
or any similar feeling — whatever the pursuit —
may always be regarded by those who have them,
as sure warnings that the true love of excellence
is not in them — without which nothing great and
permanent ever was produced.

The career of his accomplice was sooner ended,
and, if less painful, it was still less enviable ; for,
though Fialto had always laid the unction of minor
villany to his soul when he compared himself with
Maldura, he was, for many reasons, of a character
more hopeless. If ambition hardens the heart,
sensuality kills it. The natural and social feelings
of the ambitious man, nay, also the conscience,
may all indeed be lost in selfish insulation ; yet
there are causes which sometimes revive them —
such as time, disappointment, or even the attain-
ment of his object — whether it be power or re-
venge ; when they often react, as in Maldura's
case, by repentance. But there is little hope of
these in the course of the libertine ; to whom
failure supplies excitement, and success adds

habit, which time only confirms; and it must be so; for it being the nature of his vices to identify the affections with the senses, the whole heart becomes animal, thence a pander to the body, till its baser functions are wasted; nor stopping even then, but, in the restlessness of habit sending at last its prurient desires to the brain, and mocking the wretched remnant of the man to the very grave. The old age of a confirmed libertine is therefore seldom better than a loathsome *phantasmagoria* of a vicious youth. The Count Fialto was saved at least this second childhood of sin. He had embarked soon after quitting Rome, with the poor Nun, and his ill-got wealth, on board a small vessel bound for Marseilles. The vessel was never more heard of; but the bodies of the Count and his companion were found by some fishermen, washed up, about three weeks after, on the island of Gorgona.

THE END OF THE MANUSCRIPT.

CONCLUSION, BY THE TRAVELLER.

HAVING been pressed by my friendly host to pro-
long my visit at the convent, it was only two days
after I had finished reading the manuscript, and
whilst I was still musing on its melancholy con-
tents, that the prior entered my apartment.

"I have come," said he, " to make known to
you one of those remarkable coincidences which
the inexperienced are apt to imagine confined
to romances, but which I have lived long enough
to know are more common to real life. You have
just read the imperfect story of my poor friend in
time to be a witness to its closing scene. He is
now dying."

" Dying !"

" So it is supposed ; for his senses are returned ;
and I have just been sent for to administer the
last rites of the church."

" After what you have said," I replied, " I sup-
pose I may be allowed to attend you."

" Not as a stranger," returned the good priest ;
" but you have shewn that you have a better title.

A tear shed in sympathy makes men brethren who have never before met; 'tis a touching evidence of our common descent."

My heart was too full from what I had been reading to continue the discourse, and I followed the prior in silence.

As we entered the cottage, we were met by the old woman, who desired us to wait a moment till she had acquainted the *lady* with our arrival.

It seemed strange that a mere narrative should attach us so deeply to one we never saw; but so it was; the thought of meeting Rosalia made my heart beat as if I had known her for years, and I felt I know not what; perhaps it was most like the feeling we have for a beloved sister — the purest, and most delicate sentiment of which our nature is capable.

After a few minutes Rosalia came out, and, taking the good priest by the hand, led him to the sick man's chamber. On their way he inquired the state of her husband. She did not speak, but, lifting her eyes upward, answered by a look which said more than any words could have told. I could wish always to remember that look: it was not one of grief, nor even of melancholy; it was all rapture — yet so solemn that it filled me with awe; seeming to announce, while she pro-

phetically saw, the approaching beatification of him she loved.

" 'Thou art worthy," thought I, "to have been loved to madness. There is no *self* in that look ; 't is all Monaldi's, for thy soul is too rapt with the thought of what awaits him to be conscious even of thy own privation."

The religious rites being over, the Prior returned to conduct me to the chamber. At first I hesitated, for I began to doubt if my presence might not be an intrusion.

" Not so," said the kind old man ; " as my friend you cannot intrude. Besides your interest in the poor sufferer is already known to his wife ; and for him — he is now in a state reckless of all human forms. I would have you see him ; for the death of a christian — the death in hope — has no parallel in sublimity on our earth."

As we entered the chamber Rosalia was kneeling beside her husband, her head resting on his bosom. She raised her head at our approach, but did not rise. A faint smile passed over the face of the dying man, and he beckoned the prior to the other side of the bed ; then, taking a hand of each, he closed his eyes for a moment, and seemed absorbed in prayer.

" I have been praying," said Monaldi, when he

looked up, — "I have been praying that my life might not pass away without profit to those I leave behind me; not to thee, father, for thou hast long known the virtue of sorrow; nor to thee, my beloved, who comest now to partake with me this triumph of affliction; but to the world; that they might see in my life that Supreme Love, which turneth the very misery from our misdeeds into a cleansing fountain; that they might learn from it, that affliction, rightly understood, is a spiritual blessing."

"Thou sayest well, my son," said the Prior; "for the sufferings of this world are healthful medicine to the soul; even the holy apostles tasted it. Let those who grieve then remember the words of Him who suffered for us — 'blessed are they that mourn, for they shall be comforted.'"

Monaldi continued, "Of worldly happiness I have had my portion — perhaps, as much as mortal could bear — but my strength fails." Here he stopped.

I now looked at Rosalia; but no description can give a picture of her face at that moment.

After a few moments, the husband proceeded; "Rosalia," — she pressed his hand in token of her attention. "Have we not known such happiness? — 'T is nothing to that we shall know when

we meet again. You will not grieve then for the little space that parts us — even *now*," he added, in a fainter voice; "for I feel that my hour is come. Yet grieve not that it is so — 't is but the beginning of peace, which passeth all understanding. And — blessed be thy name, Parent of good! for now know I that thou lovest whom thou chastenest."

He then crossed his hands upon his breast, and, raising his eyes, fixed them upward, with such an expression as I could hardly believe belonged to the human countenance.

"This is not the mere crumbling of a mortal body," thought I — "its passage to dust — but a revelation — touching our highest instinct, and giving it evidence of the invisible world;" for it seemed as if I could see his soul raying through his eyes, and already pass into it; holding communion, even by those bodily organs, with the just made perfect. I was so overpowered by this holy vision (for so I might almost call it) that my eyes involuntarily fell — when I raised them again he was gone.

THE END.

22